The Collections
of the
Cincinnati
Art Museum

The Collections of the Cincinnati Art Museum

Cincinnati Art Museum
Copyright © 2000 by the Cincinnati Art Museum

Copy Editor: Karen Feinberg
Photo Editor: Katherine Russell
Designer: Joel Williams
Indexer: Perri Weinberg-Schenker
Printer: The Merten Printing Company, Cincinnati, Ohio
Photographers: Tony Walsh; Ron Forth; P.J. Gates; D. Allison; and T. Condon, Brown Photography

Library of Congress Cataloging-in-Publication Data

Cincinnati Art Museum.
 The collections of the Cincinnati Art Museum.
 p. cm.
 Includes index.
 1. Cincinnati Art Museum--Catalogs. 2.
Art–Ohio–Cincinnati–Catalogs. I. Title.
 N550 .A84 2000
 708.171'78–dc21
 00-010884

ISBN 0-931537-19-3

The Collections of the Cincinnati Art Museum is made possible through a generous donation by Mr. and Mrs. Thomas Cooney.

Support for photography provided by the Scripps Howard Foundation.

The Cincinnati Art Museum gratefully acknowledges the generous operating support provided annually by the Greater Cincinnati Fine Arts Fund, the Ohio Arts Council, and the City of Cincinnati.

Table of Contents

Foreword

With the publication of this new handbook I am reminded of the often-repeated saying that the best measure of a museum's strength and vitality is its permanent collection—that is, those works of art which it acquires and holds in trust for the benefit of its audiences. In this regard, the Cincinnati Art Museum is truly fortunate, for it possesses collections that are deep in many different areas and include their share of masterpieces. We are justifiably very proud of our collections: few other museums in this country can boast of holdings as varied, as interesting, and as significant as ours.

Nearly 16 years have passed since the last handbook of the collections was published, and much has changed. This new handbook allows us to celebrate the many important works that we have acquired by gift or purchase during this time. It also offers us an opportunity to honor once again the remarkable contributions that many generations of curators and donors have made to the development of the Museum's rich and varied holdings. This is evident in the purchases made by the Women's Art Museum Association in the early 1880s, in the public subscription that enabled the Museum to acquire the Steckelmann Collection of African Art in the following decade, and in the exceptional Old Master and modern European paintings bequeathed by Mary Emery and Mary Johnston in the twentieth century. The collections have been shaped by those who cared deeply about sharing their love of great works of art. We will always be grateful to them for their passion, their discernment, and their devotion to this institution.

The Cincinnati Art Museum has a long, admirable tradition of publishing handbooks and catalogs of the permanent collections. This is important because it represents an ongoing commitment to scholarship and the obligation of sharing knowledge of the works in our care. It is fitting, then, that with one of our first publications of the new century—and the new millennium—we focus once again on this wonderful resource.

Our thanks for making this project possible are extended, first and foremost, to Mr. and Mrs. Thomas Cooney. The generous gift that they made to underwrite the production of a new handbook is only one of the many ways in which they have supported the Cincinnati Art Museum over the years. We are fortunate to count Tom and Lynn as friends, for their giving is motivated not only by a great love for this institution, but also by an appreciation of its service to the community as a cultural and educational resource.

An enterprise such as this invariably requires the work of many members of the Museum's staff. For the long hours that they spent on the development of this new handbook I would like to acknowledge the contributions of Sarah Sedlacek, publications and web site coordinator; Jackie Reau, director of marketing and public relations; Stephen Bonadies, director of museum services and chief conservator; Jennifer Reis and Scott Hisey, photographic services coordinators; Pat Murdock, our recently retired interim director of development; Rob Deslongchamps and David Dillon, preparators; Eli Meiners, art handler; Charles O'Nan and David Tunison, temporary art handlers; Debbie Molzberger, retail coordinator; Linda Pieper, curatorial offices secretary; Brian Heim, marketing assistant; Amber Lee Stafford, assistant curator of education; Marianne Quellhorst, assistant director, grants and government relations; Debbie Bowman, chief financial officer and head of operations; Carol Renfro, finance accounting manager; Môna Chapin, head librarian; and Peggy Sambi, curator of education.

The greatest credit for the success of this publication belongs to the members of our curatorial staff. For this reason I offer my heartfelt thanks to Anita Ellis, director of curatorial affairs and curator of decorative arts, who supervised the entire project with intelligence and good cheer, and whose vision is reflected in every aspect of the handbook; Cynthia Amnéus, assistant curator of costumes and textiles; Dr. Julie Aronson, curator of American painting and sculpture; Jennifer Howe, associate curator of decorative arts; Dennis Kiel, associate curator of prints, drawings, and photographs; Dr. Glenn Markoe, curator of classical and Near Eastern art; Kristin Spangenberg, curator of prints, drawings, and photographs; Dr. John Wilson, former curator of European painting and sculpture; Ellen Avril, former associate curator of Asian art; Daniel S. Walker, former curator of ancient, Near Eastern, and Far Eastern art; and Jim Houghton, former assistant curator of education.

Timothy Rub
Director

A Brief History of the Cincinnati Art Museum

T he Cincinnati Art Museum, one of the oldest and finest visual arts institutions in the United States, can trace its roots to the nation's 1876 Centennial Exhibition, held in Philadelphia. This first great international fair in the New World enthralled Americans, who were quick to recognize that their artistic and industrial products were inferior to those sent to the fair by England, France, Germany, and Japan.

Cincinnati, the industrial, commercial, and cultural hub of the Ohio River valley, was eager to change this situation. By 1859 the Queen City of the West was second only to Philadelphia as the largest industrial city in the country. Moreover, before the Centennial, Cincinnati boasted the largest industrial exhibitions in the country. It is not surprising that Alfred Traber Goshorn, a leader in Cincinnati's industrial fairs, was selected as the director general of the Centennial Exhibition.

On March 12, 1877, spurred by the challenge to create art that could compete successfully with that of Europe, leading Cincinnatians—both men and women—met "to ascertain what sympathy and encouragement a movement in the direction" of an art museum would receive. Elizabeth Williams Perry had led the Women's Centennial Executive Committee of Cincinnati, which sponsored a creditable display of women's work for the Centennial Exhibition. She outlined in part the women's thoughts on the subject:

> The ladies are aware of the magnitude of the proposition to inaugurate successfully a movement for a museum, with its masterpieces of fine and industrial art, its library and training schools. They believe…it should be on a scale of completeness which would furnish thorough instruction in the various branches of fine and industrial art.…

Undaunted, the ladies agreed to "prepare a scheme for the organization and establishment of an Art Museum" in Cincinnati. Thus the Women's Art Museum Association (WAMA) was founded. To gain support for their enterprise, the Association worked zealously by sponsoring receptions, lectures, exhibitions, and publications.

On September 8, 1880, Charles W. West announced that he would donate $150,000 toward the founding of an art museum in the Queen City, provided that this sum was matched by public subscription. Within two weeks after West's announcement, the *Cincinnati Commercial* reported that $107,750 had been raised. By October 9, West's donation had been surpassed by popular subscription.

On February 15, 1881, the goal of the WAMA was achieved when the Cincinnati Museum Association was incorporated. The site chosen for the new museum was verdant Eden Park, where natural beauty would harmonize with the experience of great art. More practically, the site was located near downtown, overlooked the industrial basin, had a commanding view of the great Ohio River, and in 1881 was high enough to escape the worst industrial pollution.

The next challenge for the WAMA was to acquire collections to be displayed in the proposed new museum building. Once again the ladies were equal to the task. By May 17, 1886, the dedication day for the newly constructed Neo-Romanesque building, the structure was filled with collections of Cincinnati pottery, Etruscan and Greek pottery, American Indian pottery from the pueblos of New Mexico and from Central America, a collection of European laces, and Reuben Springer's art collection of European paintings, glass, and ceramics, to the delight of all Cincinnatians. Cincinnati newspapers dubbed the new institution "the Art Palace of the West."

Since then the Museum has added many notable objects to its collections and has undergone many expansions. In 1887 and 1888, more than 21,000 works relating to the archaeology and art of the American Indian were added to the permanent collections. In 1889 the Museum trustees purchased the Carl Steckelmann Collection, making the CAM one of the first museums in the country to show African objects as art. Alfred Traber Goshorn donated his collection of Louis Comfort Tiffany's Favrile glass in 1897, and in 1904 a memorial collection of works by Robert F. Blum was given by his sister, Mrs. Henrietta Haller.

Architect Daniel Burnham's Schmidlapp Wing, constructed in the Doric Greek style, opened on May 18, 1907 to provide exhibition space for casts of Greek and Roman sculpture. During the next three years, the entire building was wired for electricity. In 1914 the Dr. William Howard Doane Collection of 291 musical instruments from Asia and the Western world expanded the Museum's scope.

At the height of the great influenza epidemic of 1918, the Museum was closed for over a month. In 1927, at the death of Mrs. Thomas J. Emery, her superb collection of master paintings was bequeathed to the Museum. The Museum closed from September through December 1929 to install the new Emery and Hanna Wings and to complete the Herbert Greer French Wing. Together these wings surrounded an open courtyard, and also united the Museum and the Art Academy of Cincinnati building for the first time.

continued

The fiftieth anniversary of Charles West's founding donation was celebrated in 1930 with the opening of the Emery, Hanna, and French Wings. Seven years later the Museum opened the Frederick H. and Eleanora U. Alms Wing, a three-level structure that included the library (later known as the Mary R. Schiff Library), the auditorium, and gallery space. In 1939 the Museum acquired a collection of Nabataean art from Khirbet Tannur, excavated by Dr. Nelson Glueck. This is the only major collection of ancient Nabataean art outside Jordan.

World War II began to take its toll in 1942, when the second floor of the Museum was closed on July 1 as an economy measure and because of the lack of staff in wartime. That year also marked the death of Herbert Greer French, who bequeathed his world-class collection of prints to his beloved Museum. In 1946 Miss Mary Hanna gave her collection of master paintings to the Museum; they were shown in the reopened galleries on the second floor.

The Robert Lehman Collection, considered the world's greatest private assemblage of paintings, drawings, art objects, and jewelry, was exhibited in the galleries from May through June 1959. Attendance records surpassed those for its showing in Paris the previous year, with 112,972 visitors in 58 days. In January 1964 *Whistler's Mother (Arrangement in Grey and Black)*, by James Abbott McNeill Whistler, was on loan to the Cincinnati Art Museum, to great acclaim. The Adams-Emery Wing, the last wing to date to be added to the original building, was opened in 1965.

Carrying on the tradition of excellence set by the Lehman Collection exhibition, the Museum has organized other events as well. The magnificent show of arms and armor titled *Treasures from the Tower of London* drew a record 143,713 visitors between October 6, 1982 and January 9, 1983. In 1986 *The Vital Gesture: Franz Kline in Retrospect* offered the first in-depth evaluation of this modern master. From October 21, 1988 to January 8, 1989, viewers were thrilled by *Masterworks from Munich: Sixteenth to Eighteenth Century Paintings from the Alte Pinakothek*, a survey of old masters' paintings.

An extensive two-year, $13 million renovation project, completed in January 1993, restored the grandeur of the Museum's interior architecture and uncovered long-hidden architectural details, as well as created new gallery space and improved lighting and climate control.

From October 20, 1996 to January 5, 1997, the Museum organized another great exhibition: *Mistress of the House, Mistress of Heaven: Women*

in Ancient Egypt. This exhibition, which examined the role of women in ancient Egypt, drew scholarly as well as popular praise nationwide.

In the 1990s, several major collections were added to the Museum. During 1990 and 1991, Mr. and Mrs. Charles Fleischmann supplemented their 1980–1981 gift of portrait miniatures by donating an additional 800 miniatures by American and European artists such as the Peale family and Richard Cosway. Through the years between 1990 and 1995, Howard and Caroline Porter gave their collection of approximately 2,500 twentieth-century Japanese prints representing more than 250 artists, including Munakata Shikō. In 1999 The Procter and Gamble Company donated more than 90 pieces of outstanding English silver from The Folgers Coffee Silver Collection.

True to the original intent of the WAMA, the Cincinnati Art Museum offers visitors an encyclopedic 6,000 years of world art distinguished by extremely high quality. In addition to the art of ancient Egypt, Greece, and Rome, the Museum contains extensive collections of Near and Far Eastern art, Native American and African art, furniture, glass, ceramics, silver, costume, and textiles. The painting collections include works by European masters such as Sandro Botticelli, Titian, Anthony van Dyck, Frans Hals, Peter Paul Rubens, and Thomas Gainsborough, as well as superior modern works by artists such as Claude Monet, Vincent van Gogh, Paul Cézanne, Pablo Picasso, Amedeo Modigliani, Joan Miró, and Anselem Kiefer. The fine American collection holds works by noted artists such as John Singleton Copley, Thomas Cole, Frederic Church, William Harnett, Grant Wood, Edward Hopper, and Richard Diebenkorn, as well as major works from the 1970s and 1980s by modern masters such as Ellsworth Kelly, Andy Warhol, and Cincinnati's own Jim Dine. Equally important are the Museum's many paintings from Cincinnati's "Golden Age" (1830–1900) by esteemed Cincinnati artists including Thomas Worthington Whittredge, Robert S. Duncanson, John H. Twachtman, Elizabeth Nourse, Robert Blum, and Frank Duveneck, as well as Cincinnati's world-renowned Rookwood pottery and Cincinnati art-carved furniture.

In 1877, when the Women's Art Museum Association decided to generate public support for the foundation of an art museum in Cincinnati, the women were not lost in pipe dreams. Their goal, however challenging, was real. Their achievement was a remarkable success not only for themselves but for all Cincinnatians, as "the Art Palace of the West" continues triumphantly into the twenty-first century.

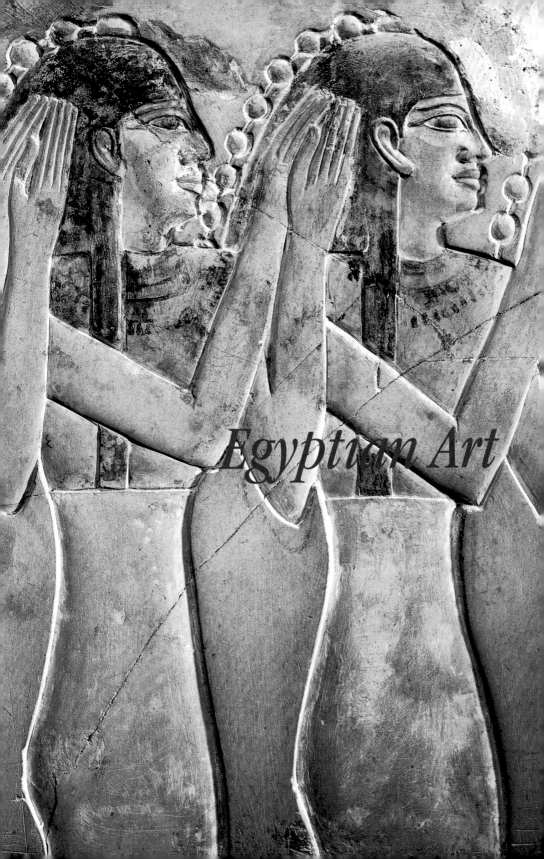

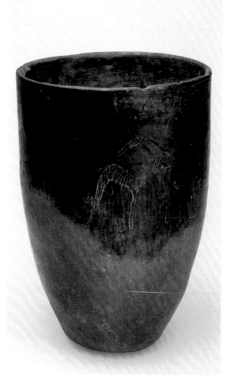

Beaker
Egypt
Predynastic period, Naqada I, 4500–3650 BC
Earthenware with smoke-blackened decoration
H. 10 1/2 in., diam. 6 3/8 in. (h. 26.7 cm, diam. 16 cm)
Museum Purchase with funds provided by the Oliver
Charitable Lead Trust Fund, 1999.61

In the latter half of the Predynastic period, the era before the unification of Upper and Lower Egypt, Egyptian potters produced a distinctive handmade pottery known as black-topped ware, utilizing the rich alluvial silt of the Nile. This pottery was marked by a red-washed exterior with a blackened upper surface. The darkened area below the rim was the deliberate product of a technique that allowed soot to accumulate on the pot's upper surface during the firing process.

The Museum's beaker belongs to a handful of vessels in this technique which bear incised figural decoration. The animal subject, a horned quadruped, represents a gazelle or (more probably) an aoudad, a wild sheep indigenous to North Africa; its form was scratched into the surface after firing. This technique, called graffito, left little room for error; a sure hand was required to execute the design, which is silhouetted dramatically against the vessel's darkened ground. The archaeological contexts of related vessels suggest that the Cincinnati beaker derived from the burial of an important individual, perhaps a local chieftain.

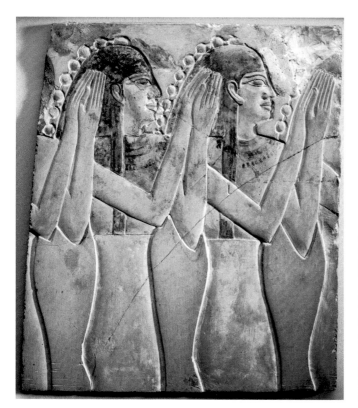

Female Attendants Clapping Hands

Egypt, Deir el-Bahri, Thebes

Middle Kingdom, Dynasty 11, reign of Mentuhotep II, ca. 2049–1998 BC

Limestone and pigment

13 x 11 in. (32 x 27.9 cm)

Gift of Mrs. Joan L. Stark in memory of Louise J. Roth, 1998.54

In ancient Egypt, musicians performed regularly at religious rituals and festivals in temples and palaces, at banquets, and in military and funerary processions. This relief, depicting a train of female singers or dancers that formed part of a larger musical procession, decorated the corridor of the tomb of Queen Nefru, wife of the Eleventh Dynasty Egyptian king Mentuhotep II (ca. 2049–1998 BC). Each performer, shown clapping hands, wears a white sheath dress and a broad floral collar. They are coiffed in the favored style of the period: long wigs with locks pulled forward to rest on the chest. Unique features of this scene are the ornamental strings of large round balls attached to the hair. Traces of white paint on these globular ornaments suggest that they were meant to represent silver. Actual strands of such beads, hollow balls in precious metal separated by spacer beads, have been found in tombs dating to this period. The style of carving on the relief, with figures deeply recessed in intaglio, is typical of the Eleventh Dynasty. The Cincinnati fragment retains much of its original painted decoration: black for the wigs, yellow for flesh tones, and blue, red, and green for the floral collars.

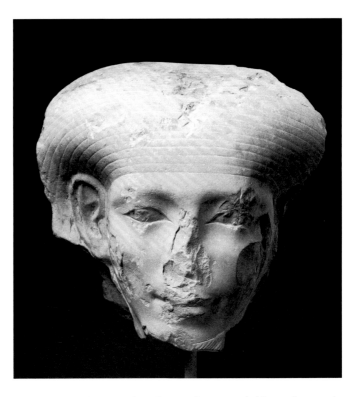

Head of a God

Egypt (probably Hawara)

Middle Kingdom,
late Dynasty 12,
1850–1800 BC

Limestone

10 x 10 15/16 x 8 3/16 in.
(25.4 x 26.2 x 20.8 cm)

John J. Emery Fund,
1970.170

This beautifully carved head comes from a nearly life-sized statue of a god. The image was one of a series of such deities, both male and female, that presided over the 42 administrative districts, or nomes, into which ancient Egypt was divided.

In characteristic fashion, the subject wears a plaited beard and a striated wig, both indications of divinity. The absence of a *uraeus*, or sacred cobra, on the forehead reveals that the figure was not a king. As with most Egyptian deities, his features, which are rendered in human form, are idealized and perfect. The large, splayed ears are particularly characteristic of sculpture of the Middle Kingdom (2040–1640 BC). The carving style and the fine white limestone strongly suggest that the sculpture came originally from the pyramid complex of Pharaoh Amenemhet III at Hawara in Middle Egypt.

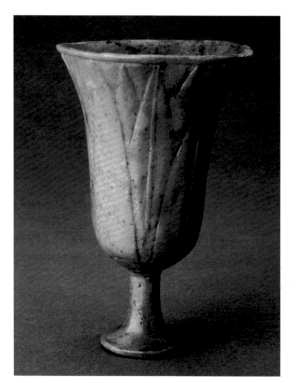

Lotus Cup
Egypt
New Kingdom, Dynasty 18, 1550–1300 BC
Mold-made faience
H. 5 in., diam. (top) 3 3/8 in.
(h. 13.3 cm, diam. 8.6 cm)
Museum Purchased with funds given in
honor of Mr. and Mrs. Charles F. Williams
by their children, 1948.87

The Egyptians believed that the immortal spirit of the deceased remained linked to and dependent on its earthly body. Egyptian tombs were full of items designed to help and guarantee the soul's rebirth and its successful passage to the afterlife. Almost everything included with a burial symbolized rebirth and renewal. This point is illustrated well by this blue faience cup, which probably came from an ancient Egyptian tomb. The vessel depicts the blue lotus, actually a fragrant water lily much loved by the Egyptians. Because its petals opened at sunrise and closed again at night, this flower was associated with life eternally renewed by the rays of the sun. The fully opened blossom on the cup forms the receptacle for wine, a favorite drink of the Egyptians. The lotus symbolized the eternal cycle of life governed by the sun.

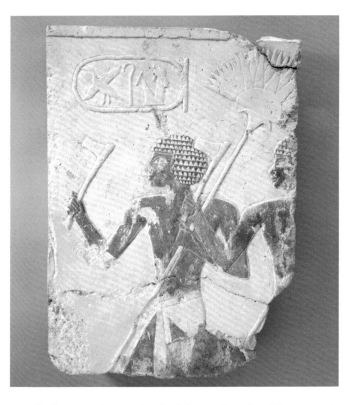

Royal Marines

Egypt,
from Deir el-Bahari,
Thebes

New Kingdom, Dynasty 18,
Reign of Hatshepsut,
ca. 1470–1460 BC

Limestone and pigment

12 3/16 x 9 1/4 in.
(32.5 x 23.5 cm)

Museum Purchase:
Gift of Millard F. and Edna
F. Shelt, by exchange,
1997.5

This fragment of a painted wall relief comes from the celebrated temple of Hatshepsut at Deir el-Bahari, a sacred precinct on the west bank of the Nile at Thebes, Egypt's religious capital. Erected by Hatshepsut as a mortuary temple for herself and her father, Tuthmosis I, in honor of the god Amun, this grand terraced structure is one of the most beautiful and most impressive monuments surviving from Egyptian antiquity. The fragment, which decorated the temple's upper court, depicts two sailors equipped with battle-axes in the royal Egyptian navy. The sailors originally formed part of a much larger military procession marking the Beautiful Feast of the Valley, a yearly festival celebrating the return of the Theban gods to their religious shrines. The present relief formed the beginning of one such military file accompanying the arrival, by royal barge, of the obelisks of Hatshepsut and her husband, Tuthmosis II. The lead figure, the procession leader, bears a fan-shaped military standard. Above him appears a royal cartouche with the inscription *pa heka* ("the ruler"); probably this referred to Hatshepsut herself, who had assumed the throne as pharaoh.

The sculpture is distinguished by its crisp, delicate carving, executed in shallow relief. The marked difference between the two figures' facial styles suggests that they were the work of two separately trained artists working side by side. The relief preserves much of its original painted decoration: red ochre for the flesh tones and black for the wigs.

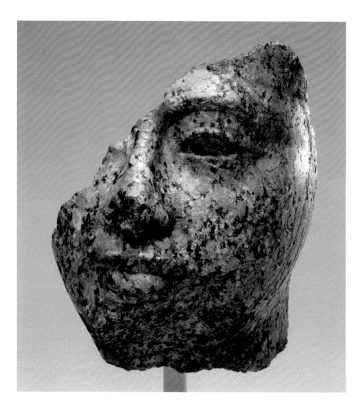

Fragmentary Head of a King

Egypt

New Kingdom, Dynasty 18, reign of Amenhotep or later, 1391–1307 BC

Red granite

10 1/2 x 7 5/8 in., diam. 4 7/8 in. (26.6 x 19.4 cm, diam. 10.7 cm)

John J. Emery Fund, 1945.63

This fragmentary sculpture, broken from a seated or standing statue of a king, is the product of a gifted artist trained in a court workshop. Its royal identity is clear from the traces of its headdress and from the beard strap visible along the head's left side. The strap secured the "false" beard of Osiris, god of the netherworld; the king wore this accessory on ceremonial occasions. Stylistically the sculpture may be assigned to the later part of the Eighteenth Dynasty (1550–1307 BC). The full rendering of the lips suggests a date close to the Amarna Age, the period of Amenhotep IV, or Akhenaten (1353–1335 BC). On the basis of recent stylistic analysis, it has been suggested that the subject may be Akhenaten's father, King Amenhotep III (1391–1353 BC), renowned as a builder and a patron of the arts. The fleshy, drooping eyelid and full cheeks suggest a mature monarch at the peak of his career. The sculpture is carved from rose granite quarried near Aswan in Upper Egypt. Its mottled, variegated surface was particularly favored by Egyptian royal sculptors.

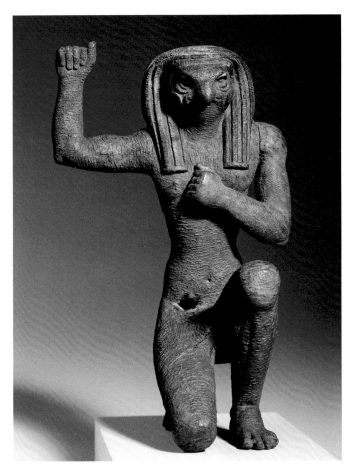

Falcon-Headed God in Pose of "Soul of Pe"

Egypt

Third Intermediate Period, Dynasty 22, 945–712 BC

Cast bronze, originally with inlaid eyes and wig

10 11/16 x 5 15/16 x 3 7/16 in. (27.1 x 15 x 11.2 cm)

Gift of Mr. and Mrs. James H. Stone, 1957.145

In ancient Egypt, the gods who attended the pharaoh, especially at rituals associated with coronations and periodic ceremonies of royal renewal, included supernatural spirits from much earlier, prehistoric times. Among these very ancient spiritual beings were the souls of Pe and Dep, falcon- and jackal-headed male figures represented as balancing on one knee with one fist clenched on the chest and the other raised. This fine bronze statuette of a soul of Pe was once part of a group of such figures made for an altar in a temple sanctuary. Its eyes and the recessed strips of its divine wig were formerly inlaid with colored stones or glass. The surface of the body has been roughened deliberately, perhaps to help secure an overlay of sheet gold.

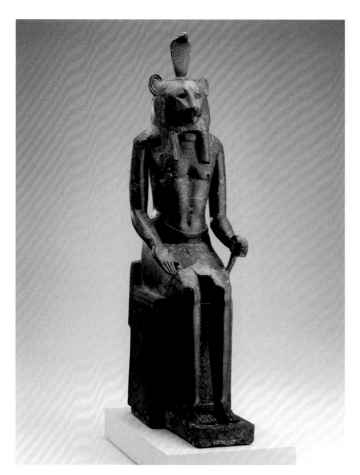

Lion-Headed God
Egypt
Late period, 750–730 BC
Cast and incised bronze
25 7/16 x 5 1/4
x 11 13/16 in.
(64.6 x 13.3 x 30 cm)
Museum Purchase,
1957.149

M any Egyptian gods and goddesses were associated with animals. An animal's physical characteristics were often incorporated into the deity's depiction, either fully or in abbreviated fashion, in the form of an animal head. Among quadrupeds, the lion was especially favored for its symbolic connotations of power, aggressiveness, and fury; almost 40 Egyptian goddesses have been represented in leonine form.

The subject of this statuette is a lion-headed god seated on a block throne. He is dressed in a short, belted kilt, and wears a lappet wig and a floral collar. His headdress consists of a rearing cobra, or *uraeus*. The scenes of worship incised on the throne's sides and back suggest that its occupant may have been the warrior-god Horus of Buto, a city in the western Nile delta. Like many Egyptian deities he originally held a scepter, a symbol of power and sovereignty, as revealed by the empty socket in the left hand. The figurine was cast by the lost wax process, which involved a wax model and a clay mold. The statue's eyes and nipples are enhanced by a coat of silver.

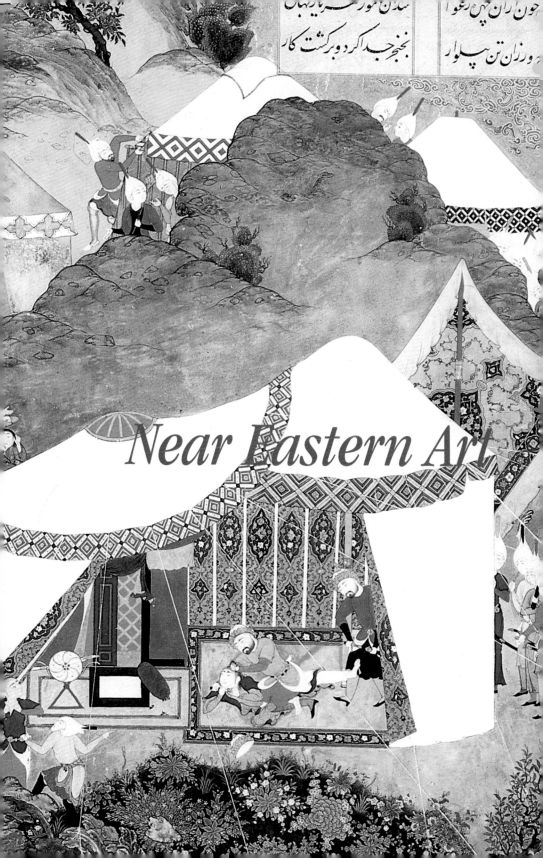

Near Eastern Art

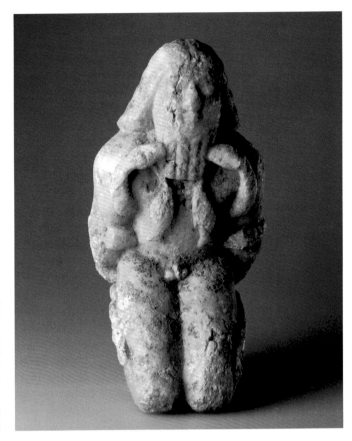

**Kneeling Figure Bound
with Serpents**

Iraq

Sumerian, early Dynastic
period, 2600–2400 BC

Alabaster

11 13/16 x 6 13/16 x 6 in.
(30.1 x 15.7 x 15.2 cm)

Mary Hanna Fund, 1957.33

This alabaster statuette, which depicts a kneeling, bearded figure bound by serpents, is a product of the Sumerian civilization of southern Mesopotamia. Along with the Egyptians, the Sumerians were among the earliest ancient peoples to develop a truly urban, literate society with an evolved legal and administrative system.

The identity and context of the bound, naked figure depicted here are an enigma. It has been suggested that the subject is a mythological hero such as Gilgamesh, whose epic feats include a victorious combat with a serpent. This figure, however, appears less a combatant than a victim of the paired snakes, which entangle his arms and chest. His kneeling posture, with arms bound and drawn behind the back, indeed conforms to the depiction of prisoners in ancient Near Eastern art. For this reason, he is more likely to represent a subdued foreign enemy than a triumphant hero. An exact replica of this statuette, slightly smaller in scale, can be found in the Iraq Museum in Baghdad.

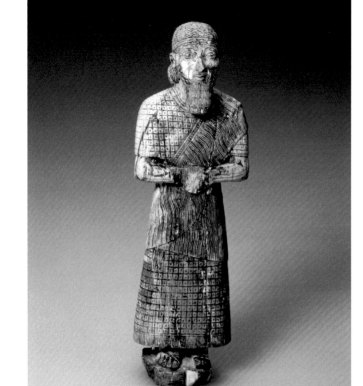

Statuette of Worshiper
Iraq or western Iran
Late eighth century BC
Ivory
7 15/16 x 2 5/8 in.,
diam. 1 5/8 in.
(20.1 x 6.6 cm,
diam. 4.1 cm)
Gift of Mr. and Mrs. Warner
L. Atkins, 1955.70

Under the patronage of the Assyrian kings, the art of ivory carving flourished in the ancient Near East. At the capital of Kalhu (modern Nimrud in northern Iraq), thousands of exquisitely carved ivories, many of them inset with colored glass and gems, were uncovered in palace chambers. Most of these were decorated vessels, implements, and plaques; the latter often were designed as furniture inlays.

The Museum's figurine is a rare, nearly unique example of an Assyrian sculpture in the round. The statuette probably was commissioned by an Assyrian aristocrat. The subject, a bearded man with a filleted headdress, wears an ankle-length robe and a fringed shawl. He stands with arms joined at the waist. His resolute gaze and clasped hands clearly identify him as a worshiper in the act of prayer. The figure's full-length garment with its rows of perforated squares was characteristic clothing for gods and royalty. These squares, imitated here in embroidery, represented gold plaquettes, which originally were sewn onto fabric.

With its expressive gaze, monumental appearance, and finely modeled facial features and coiffure, the Museum's figurine is a masterpiece of Assyrian art.

Near Eastern Art

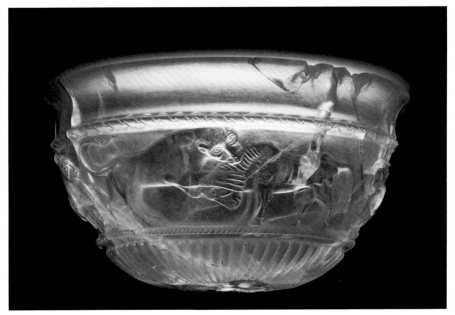

Bowl with Frieze of Lions Attacking Bulls

Iraq or western Iran

Seventh or sixth century BC

Rock crystal

H. 3 1/4 in., diam. 6 13/16 in. (h. 8.3 cm, diam. 17.3 cm)

Museum Purchase, 1957.500

This rock crystal bowl is carved in shallow relief with a lively frieze in which lions are stalking and attacking bulls. The theme is common and venerable in Mesopotamian art, dating back to the Sumerian period (third millennium BC). The Museum's bowl may be dated more precisely by its shape and by the style and iconography of its figured decoration, which is paralleled most closely in Assyrian and later Persian art of the seventh and sixth centuries BC. The rosette medallion and the radial fluting on the underside are common decorative features of drinking bowls (*phialai*) from that period in both hammered metal and cast glass. In the rendering of musculature and body fur, the lions on this bowl closely resemble the felines depicted in the great lion-hunt palace reliefs of King Ashurbanipal at Nineveh, carved around 645 BC.

The execution of this bowl in rock crystal is quite unusual, however. The bowl is the largest and most elaborately decorated example of its type known to exist. Because of the difficulties inherent in working such a medium (the piece was carved from a single block of stone), the manufacture of rock crystal items in antiquity must have been a rare, specialized craft associated with a palace industry centering on glass production.

The figured frieze, with its three lion-and-bull pairs framed by cable designs, is rendered skillfully and imaginatively; in each pair, the craftsman has taken particular care to vary the attitude and posture of victim and aggressor. Especially poignant is the scene of a lioness attacking a bull. Staring resolutely outward, she pounces and tears at her bovine victim, whose head is bowed by the force of the attack.

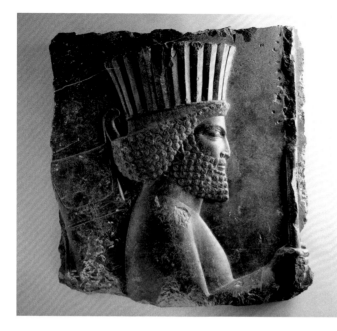

Persian Guard
Iran (Persepolis)
Achaemenid period,
reign of Xerxes,
ca. 480 BC
Limestone
24 x 23 in. (61 x 58.4 cm)
Gift of Mr. and Mrs. John
J. Emery, 1961.288

Founded in the sixth century BC by the Achaemenid monarch Cyrus the Great (550–530 BC), the Persian empire emerged as the largest political and military confederation ever seen in the ancient world. By the fifth century BC it encompassed all of the continental Near East—from Turkey east to Afghanistan, and from Egypt north to the Black Sea. Administrative control of the empire was centralized in a series of Iranian capitals. One of the foremost of these centers was Persepolis, a city situated on a vast plateau in the modern province of Fars. Here a series of royal palaces, pavilions, and reception halls, each elaborately faced with relief carvings, were erected by successive monarchs of the Persian Achaemenid dynasty, beginning with Darius the Great (522–486 BC).

The Museum's relief carving comes from one such complex, the so-called Council Hall erected by Darius' son and successor, Xerxes (486–465 BC). Preserved is the upper portion of the figure of a Persian royal guard, who marches in procession with an upright lance (visible along the right-hand edge of the relief). His identity is clear from his elegant fluted headdress and his paraphernalia, which include a quiver case and bow (its bird-shaped terminal can be seen behind the head).

This fragment originally belonged to a procession of full-length figures representing the king's royal bodyguard. There Persian archers, in fluted tiaras and full-length robes, appeared alongside their counterparts from neighboring Media. The Medes can be readily identified by their distinctive trousers and domed hats. Four of the eight processional figures that made up this frieze are preserved fully on site, thus allowing us to visualize the full figure from which the Museum's fragment derives.

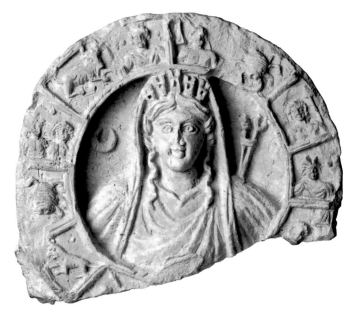

**Roundel with Bust
of Atargatis-Tyche
and Zodiac**

Jordan

Nabataean,
late first century AD

Limestone

11 x 14 x 5 in.
(29.5 x 35.6 x 13.3 cm)

Museum Purchase,
1939.233

For more than three centuries (from the second century BC through the second century AD) the independent kingdom of the Nabataeans, with its capital at Petra, flourished in the Transjordan and neighboring regions. Originally nomads, the Nabataeans established themselves as influential merchants who drew their wealth largely from the lucrative spice and incense trade of southern Arabia.

The sculpted roundel in the Museum's collection depicts the Syrian deity Atargatis, represented here in the form of Tyche, a Hellenistic Greek goddess who typically served as the city's protector. She is clearly identified by her distinctive headdress, which recalls the fortified walls of a city.

Atargatis is surrounded by the 12 signs of the Zodiac, images that became popular in the Roman world of the second century AD. This association clearly underscores the astral or celestial significance of the goddess, a fact reinforced by the appearance of a lunar crescent above her right shoulder. The arrangement of the zodiacal symbols in two halves (moving counterclockwise and clockwise from the top) suggests that the Nabataean calendar contained two yearly cycles: a natural new year beginning with spring, and a civic new year that began in autumn.

The Museum's roundel originally was supported by the winged figure of a *nike*, or goddess of victory, which now resides in the Jordanian Archaeological Museum in Amman. Like the other Nabataean sculptures in Cincinnati, the Tyche sculpture was excavated at Khirbet Tannur, a remote mountaintop sanctuary located southeast of the Dead Sea.

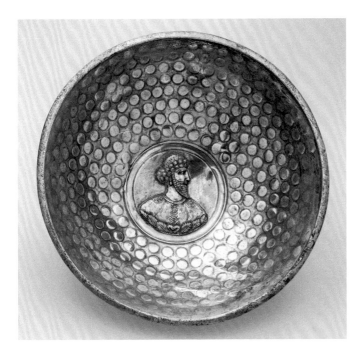

Bowl with Portrait Medallion

Iran

Early Sassanian, late third or early fourth century

Silver

2 15/16 x 9 3/8 in.
(7.6 x 23.7 cm)

Gift of Mr. and Mrs. Warner L. Atkins, 1955.71

This silver bowl was produced under the patronage of the Sassanians (224–651 AD), the last of the great Persian dynasties. Near Eastern arts and culture flourished under the Sassanian kings, who established an empire extending from present-day Syria to Afghanistan. As under the Achaemenids and Parthians before them, the craft of metalworking attained a particularly high level of sophistication in their time.

The Museum's bowl is a distinguished example of this tradition. The vessel features a medallion depicting a bearded male bust. The subject's identity is unknown, although the absence of any royal regalia suggests a high-ranking nobleman rather than a king. The general concept of a portrait medallion originated in the Roman West, where examples are to be found on vessels of metal and cut glass (among other settings).

The medium of glass probably influenced the style of this bowl's subsidiary decoration—a series of convex discs arranged in concentric circles. Produced by a process of punching from the exterior, these circlets reflect light and give the bowl a luminescent quality. The overall effect is like that of cut faceted work on Roman and Sassanian glass from the same period.

The Museum's bowl belongs to a select group of seven such vessels depicting male and female busts set within medallions. Like others in the group, this medallion is a separately cast and hammered piece of silver, which has been fastened to the bowl by crimping.

Near Eastern Art

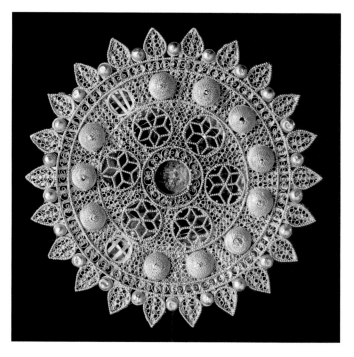

Decorative Roundel

Iran

Eleventh century

Gold sheet, wire,
formerly set with stones

Diam. 3 in. (7.7 cm)

Gift of John J. Emery,
1961.289

The Islamic artistic tradition is noted for its longstanding interest in the interplay of geometric and abstract floral designs. The integration of these elements is expressed elegantly and imaginatively in this exquisite gold jewelry ornament, the product of an eleventh-century Iranian craftsman. Its concentric design, featuring a band of six-petaled rosettes set against a dense background of scrolling S-curves, is executed in a combination of filigree and granulation, two decorative techniques inherited from the craft traditions of the ancient Near East. The Cincinnati piece is matched precisely by a roundel of identical proportions in the Metropolitan Museum of Art, New York; the two ornaments were almost certainly produced by the same workshop. Originally inlaid with precious stones, the Cincinnati roundel probably served as a decorative appliqué sewn onto an article of clothing.

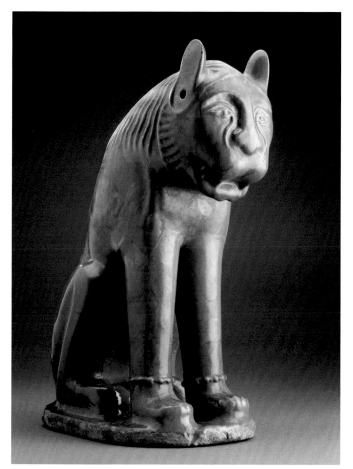

Seated Lion
Iran
Seljuk period, late twelfth
or early thirteenth century
Glazed earthenware
14 in. (35.8 cm)
Museum Purchase,
1958.518

This skillfully crafted ceramic lion was produced in Iran around 1200, when the region was controlled by the Seljuks, a Turkic nomadic people from central Asia who had adopted Islam and its material heritage. With their arrival, the decorative arts flourished in Iran. In ceramics, an unprecedented variety of shapes and techniques were introduced.

The Cincinnati lion is one of the largest known examples of a class of ceramic animal figures that formed a specialty of the city of Rayy in north central Iran. Although its original context is unknown, it probably served a courtly, ceremonial function. Since ancient times, the lion itself had been a potent symbol of royalty in the Near East. The playful characterization of the subject—the arched back and the drooping head with forlorn expression—typifies the modeling style applied to felines of this period. In addition to its anklets, the figure originally bore earrings that were suspended from perforations in the ears. In characteristic fashion, the Cincinnati sculpture bears a simple monochrome glaze in turquoise, a color especially favored in Islamic art of the Near East.

Near Eastern Art

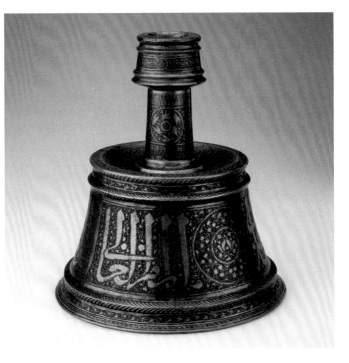

Candlestick

Egypt

Mamluk Dynasty,
mid-fourteenth century

Brass, originally inlaid
with silver

14 x 14 1/8 x 13 in.
(35.5 x 35.9 x 33 cm)

Elizabeth R. Williams
Bequest Purchase,
1976.203

B eginning in the twelfth century, the art of decorative inlaid metal work flourished in the Near East under Islamic patronage at centers such as Mosul in Iraq and Damascus in Syria. This art reached an unusual level of sophistication in Egypt under Mamluk patronage (1250–1517), centered at Cairo, Egypt's capital.

The Cincinnati candlestick is a splendid example of this tradition. Like most Mamluk metalwork, the piece is made of brass, which had supplanted bronze as the primary medium. Originally it was inlaid with silver, traces of which survive. In typical fashion, a wide band of thuluth, the monumental cursive favored by the Mamluks, forms the primary decoration on both the base and the shoulder, revealing the Mamluk artist's predilection for monumental calligraphic design. The inscription, which contains traditional expressions of honor—"the Wise," "the Efficient," "the Lord," "His High Excellency"—is dedicated to a chief officer of "al-Malik al-Nasr," an honorary title adopted by several Mamluk rulers. Stylistic features suggest that the dedicant was Sultan Hasan (reigned 1347–1351 and 1354–1361), a renowned patron of the arts who commissioned a number of metal and glass objects.

The base and stem of the Cincinnati candlestick are composed of two separate pieces of brass, which were decorated by two different artisans working in the same style. The graceful floral arabesque in the background is typical of fourteenth-century brasswork from Egypt and Syria; so are the flying ducks and the lotus blossom, an Oriental legacy from the Mongols.

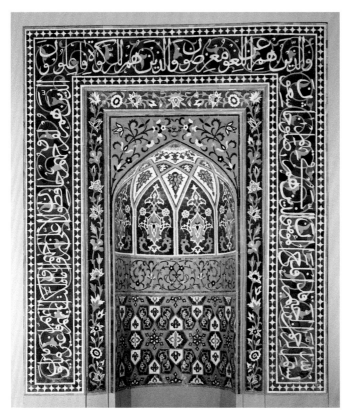

Mihrab (prayer niche)

Iran or central Asia

Late fifteenth
or sixteenth century

Glazed ceramic tile

106 1/2 x 89 in.
(270.5 x 226.1 cm)

Gift of the Museum Shop
Committee and its 90
Volunteers, 1971.59

D aily prayer is a principal obligation of the Islamic faith. Five times a day the devout Muslim prays while kneeling toward Mecca, Islam's holy city and the site of Allah's revelation to the prophet Muhammad. Thus the focal wall of every mosque, with its central prayer niche or *mihrab*, faces in this direction. The niche itself commemorates the spot where the prophet stood while leading his congregation in prayer.

The Cincinnati prayer niche is a magnificent example of one such *mihrab*, which originally formed part of a late fifteenth- or early sixteenth-century mosque in eastern Iran or central Asia. It is decorated in a mosaic tile technique, in which individually cut pieces of ceramic tile are assembled to form an elaborate composition. In a color palette typical of Islamic glazed tile work, cobalt blue and turquoise are the dominant background colors; details are highlighted in white, brown, and sage green. The recess is decorated with delicate floral patterns set within a geometric framework (above) and a vaulted architectural setting (below). The whole composition is divided by a horizontal band with scrolling arabesque. In the frame surrounding the niche, a calligraphy frieze in cursive Arabic records an often-cited verse from the Koran, which refers (among other things) to piety and alms giving, important principles of Islam.

Near Eastern Art

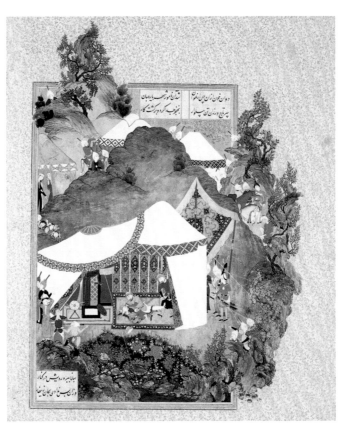

Sultan-Muhammad
(attrib.)

Iran

Tur Beheads Iraj

Safavid period,
ca. 1530–1535

Gold, color,
and ink on paper

18 x 12 in. (47 x 31.8 cm)

The Edwin and Virginia
Irwin Memorial, 1984.87

One of the most notable and widely circulated Islamic literary works was the great Persian national epic, the *Shahnama*, or Book of Kings. Composed by the Iranian poet Firdowsi in the early eleventh century, this 60,000-verse epic recounts the tales and exploits of Iran's pre-Islamic heroes and kings from earliest times to the seventh-century conquest.

Tur Beheads Iraj is an illustration from the most sumptuous manuscript of the *Shahnama* ever produced, an ambitious work containing 258 miniature paintings. The book was commissioned by Shah Tahmasp, the great patron of arts and literature of the Safavid dynasty (1501–1736). The Cincinnati folio has been attributed on stylistic grounds to Sultan-Muhammad, a senior court artist in Shah Tahmasp's studio. Long recognized as one of the two greatest Persian painters, Sultan-Muhammad was noted for his expressiveness and vivid use of color, which are clearly evident in this painting.

The subject, the murder of Prince Iraj by his brother Tur, is one of the most dramatic illustrations in the manuscript. In Sultan-Muhammad's rendering, the drama of the event is heightened by the contrast between the stark white forms of the tent (where the beheading took place) and the verdant, gentle landscape surrounding it.

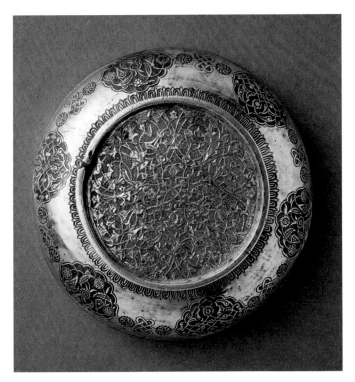

Court Bowl

Turkey, Ottoman period, second half of sixteenth century

Gilt and enameled silver

Diam. 4 1/4 in. (10.7 cm)

John S. Conner Fund, Gloria W. Thomson Fund for Decorative Arts, and Museum Purchase: Gift of Mrs. J. Louis Ransohoff, by exchange, 1990.1279

The decorative arts flourished in Turkey under the royal patronage of the Ottomans, who built an empire that extended from Iraq to eastern Europe and North Africa. The sixteenth century in particular was a "golden age" in the history of Ottoman art and architecture. During this time, bookbinding, painting, glassmaking, textile weaving, pottery, and wood and stone carving prospered; a high level of technical mastery was reached in each of these crafts. Decorated metalwork was another important component of Ottoman court production. In fact, several of the Ottoman sultans, including Suleyman I and Selim I, were trained as goldsmiths, a sign of the esteem in which this craft was held. The royal workshops or imperial design guilds catered to the Ottoman taste for luxury, producing a dazzling array of vessels in precious metals for the sultan's personal service.

This silver bowl is probably an example of such imperial workmanship, reflecting the refined elegance characteristic of sixteenth-century court production. Because the vessel's walls are relatively thick, the artist was able to develop separate, independent schemes of decoration on the inner and the outer surfaces. The exterior (illustrated here) carries a design in deep relief, consisting of a series of linked ornamental medallions; the interior bears an elaborate repeat pattern, executed in shallow incision, of interlaced arabesques and lilies. In the center of the interior is a medallion enameled in green, turquoise, and black, which was fashioned separately and added to the vessel, perhaps by the owner, after purchase.

Near Eastern Art

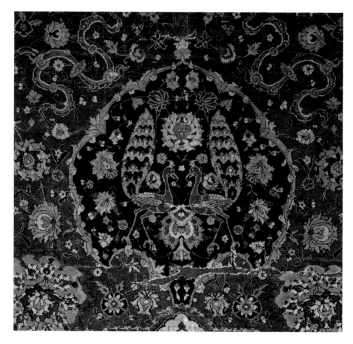

Detail:
**Fragment of a
Medallion Rug**

Eastern Iran

Second half
of sixteenth century

Wool pile on cotton and
silk foundation

150 in. x 153 in.
(379 x 388 cm)

John J. Emery Endowment,
1982.117

In the sixteenth century, under the imperial patronage of the Safavid dynasty (1501–1736), the craft of rug weaving was greatly elevated in status and prestige. Royal workshops produced large and sumptuous carpets of great technical sophistication. This fragment of an early medallion rug is a brilliant example of this court tradition. Its style, composition, and color scheme suggest that it came from Herat in the eastern realm of ancient Persia (present-day Afghanistan). In a manner typical of carpets from this region, it shows the influence of both Indian and classical Persian rug weaving.

This fragment represents the top half of a carpet that was originally some 30 feet long. In grace and complexity of design, fineness of weave, and richness of coloring, it is virtually unsurpassed among existing Persian carpets. The rug bears the central medallion design characteristic of sixteenth- and seventeenth-century Persian carpets. The field is embellished with elaborate palmettes and cloud bands derived from Chinese art motifs; these form the backdrop for a carefully designed system of scrolling vines inhabited by birds. The border consists of a series of interlocking units that create an elegant pattern of alternating circular and elongated medallions. On the basis of the distinctive pattern of horizontal wear and the residue of wax drippings on its surface, this carpet probably was cut down to fit its setting—in all likelihood, the altar of a church in Spain or Portugal.

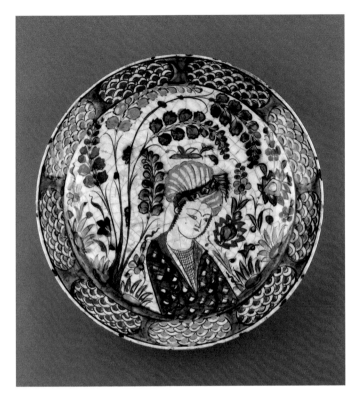

Under the Safavids (1501–1736) in Iran, a wide array of craft traditions flourished, including an active glazed pottery and tile industry. This earthenware plate is a handsome example of a distinctive underglaze-painted ceramic ware called Kubachi after a small hill town in the Caucasian province of Daghestan, where numerous examples have been found. Kubachi itself was not known as a center of pottery production; it is likely that the ware was made elsewhere, perhaps in Tabriz, then an important commercial center in northwestern Iran. Sometime in the mid-sixteenth century, the Kubachi ware tradition developed a polychrome style marked by designs in brownish red, green, blue, and yellow ochre outlined in purple black on a cream slip under a thin crackly glaze. Although the decoration of Kubachi ware is usually based on floral designs, a number of bowls and tiles feature humans and animals on a leafy ground.

The Cincinnati dish depicts the bust of a turbaned young nobleman set against a backdrop of willowy, flowering stalks. The freehand drawing style and the subject's languid gaze are strongly reminiscent of contemporary Persian painting from the reign of Shah Abbas the Great (1589–1628). The influence of Ottoman Iznik pottery is visible in the colors employed, while the scale-pattern wave border design is loosely adopted from Chinese models transmitted through late Ming Dynasty export porcelain ware.

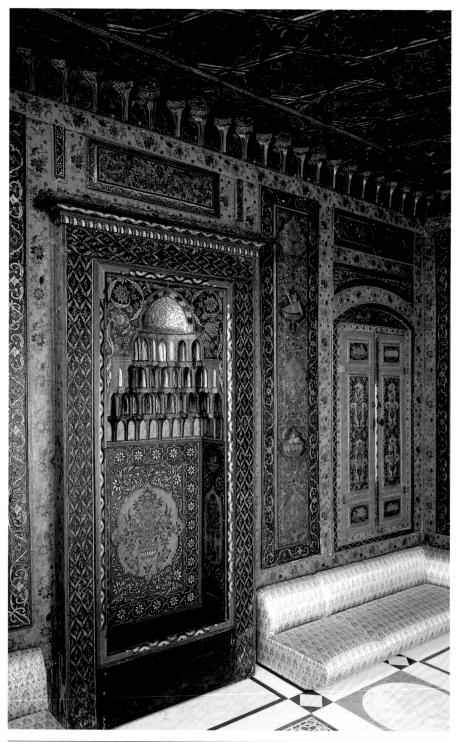

◀ *Period Room from Damascus*
Syria (Damascus), 1711–1712
Carved and gessoed wood with painted decoration
Gift of Andrew Jergens, 1966.443

The Museum's Damascus Room is truly a unique holding for an American public museum. Datable to the early eighteenth century, it ranks among the earliest of period settings from Syria, second only to the celebrated Nur al-Din Room at New York's Metropolitan Museum of Art. Its painted walls offer a distinctive insight into the decorative tastes current in Damascus, then under Ottoman rule.

The room's lavish painted decoration reveals that it served as a principal parlor in the villa of an affluent eighteenth-century Syrian family. Surviving houses from the period provide an accurate picture of the room's original setting. Probably it served as an upstairs entertainment room for its owner, an adherent of the Rifa'i brotherhood of Sufism, an ancient Islamic mystic practice. In characteristic style the parlor features a mihrab, or prayer niche, on its main interior wall, which had windows that overlooked the adjoining street or alleyway. The opposite side of the room would have opened onto an interior courtyard.

The room's ornate decoration has been painted on a raised ground of gesso (a mixture of gypsum and gum arabic) enhanced with applied gold leaf. Its subjects are typical of the Ottoman decorative style: vases of flowers and dishes of fruit (apples, pears, strawberries, grapes, and pomegranates) framed by stylized leaves and blossoms in elaborate patterns. All show the influence of contemporary Ottoman textile work infused with elements of European baroque art.

The decorative style of the room's wall panels, which are dated by inscription to 1711–1712, is contemporary for the period. The elaborate coffered ceiling, however, follows a traditional plan that dates back at least to the thirteenth century. Its imaginative floral and geometric patterns are based on a strict sequence of repeated designs that are unified within a network of four-pointed stars. The four coffers situated at the ends of the horizontal rows contain elaborate arabesques in stylized Arabic script repeating a passage from the Koran: "Each does according to his own disposition."

The room originally formed part of a multistoried house in Damascus that apparently was dismantled during the city's renovation in the early twentieth century. Cincinnati philanthropist and art patron Andrew Jergens purchased the components of the room, along with its contemporary furnishings, on a trip to the Middle East in 1932. Subsequently he had the room's decorative wood paneling installed on the upper floor of his Gothic-style home in Cincinnati's Northside district. In 1968 the Jergens family donated the room and its furnishings to the Museum for the enjoyment of the Cincinnati public.

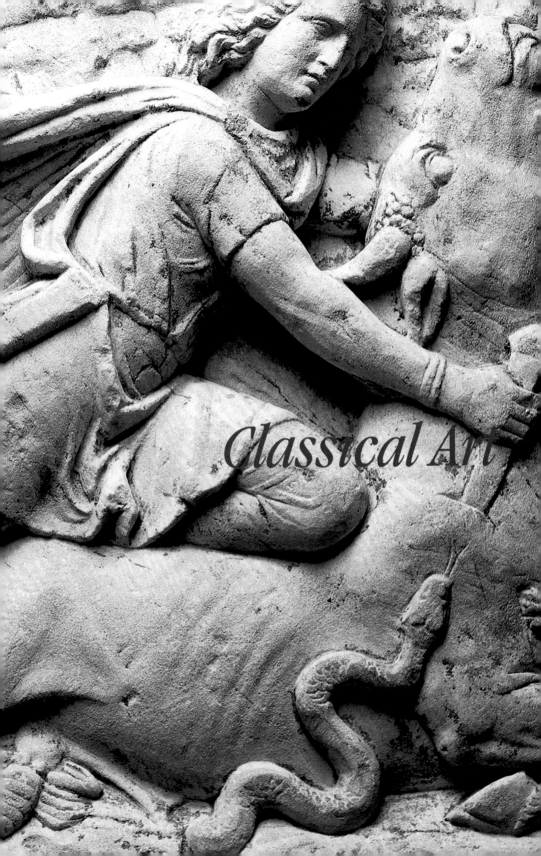

Classical Art

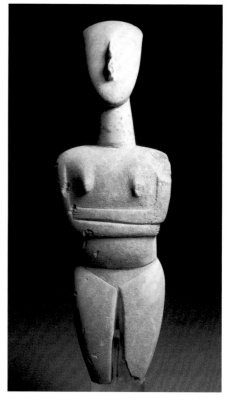

Female Figure
Central Aegean
Early Cycladic II period, 2500–2400 BC
Island marble
26 3/16 x 8 5/16 x 3 5/16 in. (66.5 x 21.1 x 8.4 cm)
Museum Purchase: 1960.484

The Museum's figure is a splendid example of a sculptural type that originated in the central Aegean in the third millennium BC. Termed "Cycladic" after the island group from which they derived, sculptures in this early Bronze Age tradition are distinguished by their charm, technical virtuosity, and refined aesthetic. The repertoire of the Cycladic sculptors, who employed an indigenous, fine-grained white marble, was quite varied and included representations of both male and female subjects in a number of poses and activities. By far the most widespread subject was the nude female shown here in reclining position with legs held tightly together and slightly bent at the knees, her arms cradled or folded above the waist. In characteristic fashion the Cincinnati figure displays a remarkably slender, tapering torso, its length dramatically emphasized by a tall, handsome neck, a high, oval face, and a long, ridged nose.

Little is known about the original function of such figures in Cycladic society. The burials in which some have been found suggest that they may have served as guardian figures, placed in the grave to accompany or attend the deceased in the afterlife. The Museum's figure, an unusually large example of its type, originally would have had a vivid, more colorful appearance, with eyes, cheeks, and probably hair enhanced with blue and red pigments.

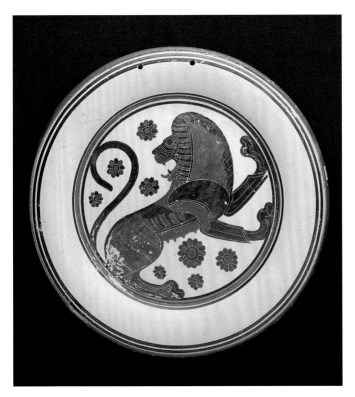

Plate: Seated Lioness

Greece (Corinth)

Ca. 580 BC

Earthenware with slip-painted decoration in the black-figure technique

Diam. 11 7/16 in. (29 cm)

Israel and Caroline Wilson Endowment, William W. Taylor Endowment and various funds, 1976.205

From the eighth through the sixth century BC, the city of Corinth was one of the chief centers of Greek pottery manufacture. Its painted wares were exported widely throughout the Mediterranean. The Museum's plate was executed by one of the great masters of Corinthian vase painting, the Chimera Painter, who is named after the mythological creature (part lion, part goat, and part serpent) depicted on another of his ceramic works. A draftsman in the black-figure technique (which originated in Corinth), the Chimera Painter is known for his monumental compositions.

The Museum's plate, with its splendid crouching lioness, is no exception. The feline subject reflects the strong influence of Near Eastern art, which permeated the Greek Corinthian tradition in the seventh century BC. The rendering of the animal's face reveals the contemporary influence of Assyrian art, probably transmitted through imported decorated textiles. In typical Corinthian fashion, a purplish-red glaze is used to highlight features of the face, mane, and body, while delicate incision defines and clarifies the decorative detail. The presence of two suspension holes in the upper rim reveals that the plate was intended to be hung as a decorative piece.

Classical Art

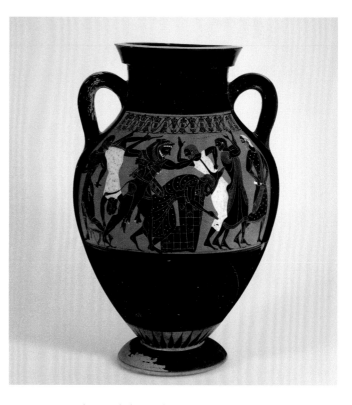

Amphora:
Herakles and Busiris

Greece (Attica)

Ca. 540 BC

Earthenware with slip-
painted decoration in the
black-figure technique

H. 8 in., diam. 19 5/16 in.
(h. 20.3 cm,
diam. 49.1 cm.)

Museum Purchase: 1959.1

From an early period, the amphora, a two-handled vessel designed for storing and transporting oil and wine, was a favored shape among Athenian black-figured vase painters. Generic scenes of battle, athletics, and courtship were popular subjects, as were episodes drawn from Greek mythology. The Museum's amphora features a unique scene depicting the struggle between the Greek hero Herakles (Hercules) and Busiris, legendary king of Egypt. According to the myth, the Egyptian monarch, in an effort to protect his land against impending plague, adopted the custom of sacrificing foreign visitors to the god Zeus. Herakles, determined to put an end to this inhuman practice, disguised himself as a commoner and allowed himself to be seized for sacrifice by the Egyptian king. At the altar, he revealed himself. As portrayed on the Museum's vessel, Herakles turns the tables on his captors and slays Busiris. Having dispatched the malevolent king (his lifeless body is shown slumped over the altar), Herakles then attacks two attending white-robed Egyptian priests, one of whom he brandishes in place of the club that he usually carries.

The composition on this vase is enlivened by numerous decorative touches such as the elaborate painted patterns that ornament the Egyptian priests' garments and the altar itself. The amphora is a work of the Swing Painter, an Athenian black-figure mannerist, whose work is marked by a distinctive, often whimsical style.

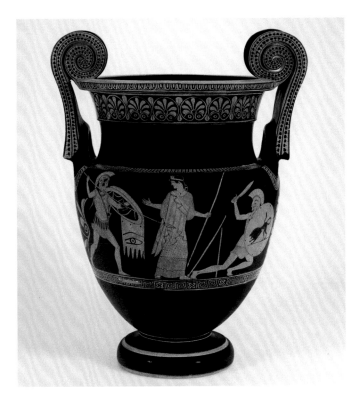

Volute Krater
by the Niobid Painter

Greece (Attica)

Ca. 460–450 BC

Earthenware with slip-painted decoration in the red-figure technique

H. (to rim) 17 1/4 in.,
h. (to handle top) 20 in.
(43.6 cm, 50.8 cm)

John J. Emery Endowment,
1987.4

This large krater, a receptacle for mixing wine and water, is attributed to the Niobid Painter, an Athenian red-figure artist of the mid-fifth century BC. As a ceramic artist, the Niobid Painter was interested in depicting specific themes and historical episodes drawn from mythology and epic poetry. The obverse of the Cincinnati krater depicts one such episode, taken from the Homeric cycle on the Trojan War. Here a goddess with a diadem, holding a spear, intervenes in a combat between two warriors. One advances with lance poised, while the other falls backward with sword drawn in self-defense. The most likely contestants in this battle are the Greek hero Achilles and his Trojan adversary Hector. Their duel, described in Book 22 of the *Iliad*, was a popular subject among Athenian vase painters. Alternatively the scene may depict Aphrodite protecting her Trojan son Aeneas from the onslaught of the Greek Diomedes. Several details in the warriors' equipment are noteworthy, particularly the graceful, crouching lion that forms the shield blazon of the right-hand warrior and the apotropaic, or evil-averting, eye that decorates the leather apron hanging from his opponent's shield.

Classical Art

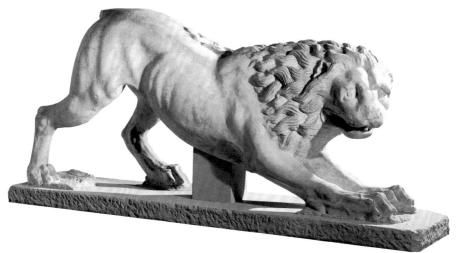

Lion Funerary Monument

Greece (Attica), ca. 350 BC

Pentelic marble

33 1/4 x 15 3/4 in., diam. 76 3/4 in. (84.5 x 40.0 cm, diam. 195 cm)

John J. Emery Fund, 1946.40

Among the animals that guarded Greek tombs (including bulls, hounds, and leopards), the lion remained the favorite over some three centuries, beginning around 600 BC. The lion's popularity as a funerary marker is easily understood. As king of the animal realm, it served as an effective and appropriate grave guardian, capable of warding off evil. A symbol of virtue, the lion also memorialized the valor of the deceased. For this reason, it often functioned as the central ornament for mass communal graves erected in honor of the war dead.

The Museum's lion exemplifies this tradition well. Like others of its genre, it originally stood, either alone or as one of a pair, at the corner of an elevated family burial podium. Its monumental size and the quality of the carving suggest that it adorned the grave of a prominent Athenian, perhaps a military officer. The work is clearly the product of an Athenian sculptor. The marble was obtained from the famed quarries of Mount Pentelikos near Athens, which supplied material for the Parthenon and other monuments of classical Athens. The lion's crouching pose and expressive, muscular form are typical of Athenian art of the fourth century BC.

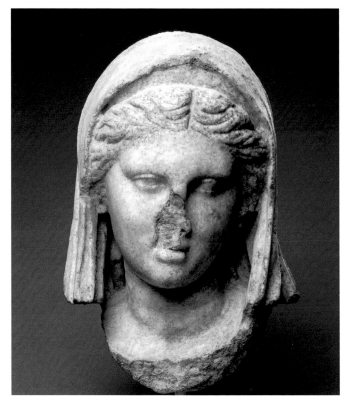

***Head of a
Mourning Woman***

Greece (reportedly from
Chalcis, Euboea)

Late fourth century or
second–first century BC

Marble

13 1/2 x 9 3/16 x 8 3/4 in.
(34.3 x 23.3 x 22.2 cm)

John J. Emery Fund,
1945.66

B eginning in the Geometric period (the ninth and eighth centuries
BC), the graves of affluent Greeks were frequently marked by con-
spicuous monuments above ground. In early tombs from Athens,
large painted vases often served as memorial markers. Beginning in the
sixth century, numerous types of stone statue (including standing nude
youths and maidens, horsemen, and animals) adorned the burial plots of
the wealthy. The most popular form of burial marker, however, was the grave
relief or stele, a carved tombstone with painted or sculpted decoration.

This beautiful, veiled head of a young mourning woman comes from such
a marker, either from a deeply carved and recessed stele or perhaps from
a freestanding statue. The soft, refined modeling and proportions of the
head and the serene, thoughtful gaze reflect the stylistic influence of the
fourth-century Greek sculptor Praxiteles. At present it is unclear whether
the Museum's head is a contemporary work of the fourth century BC or a
late Hellenistic revival of the Praxitelean style dating to the second or first
century BC.

Classical Art

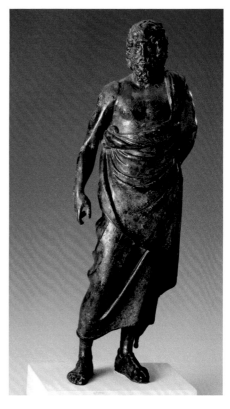

Male Statuette
Greece or western Asia Minor
Hellenistic, 150–50 BC
Bronze
9 1/2 x 3 x 1 13/16 in. (234.81 x 8.0 x 4.6 cm)
Gift of Michael Schaible in honor of his father, 1957.504

The "lost wax" technique (a casting process involving the use of a wax model) was widely employed in ancient times for the production of small figurines, many of them intended for dedication in shrines and sanctuaries. Such statuettes, which are found throughout the Greek world, represented a wide range of subjects including deities, worshipers, and animals. The Museum's statuette depicts a standing bearded male draped in a loose outer garment, known in ancient Greek as a *himation*. Although the subject's identity is unknown, his distinctive pose, coiffure, and dress suggest that he is an individual of some importance. If he is a deity, he may be identified as Asklepios (Asclepius), a Greek god of healing and medicine, whose cult was particularly widespread in Hellenistic times. This identification is supported by a number of features, such as the pattern of the draped garment, the laurel wreath worn on the head, and the distinctive snaky curls of the hair. If the subject is a mortal, he may be a poet.

The Museum's statuette probably was modeled after a monumental bronze original. An Athenian origin is suggested by the figure's close relationship to a well-known type of Asklepios cult statue associated with the god's shrine on the Acropolis in Athens. A masterwork of bronze casting, this statuette reveals the level of sophistication and technical virtuosity achieved by Hellenistic Greek bronze craftsmen.

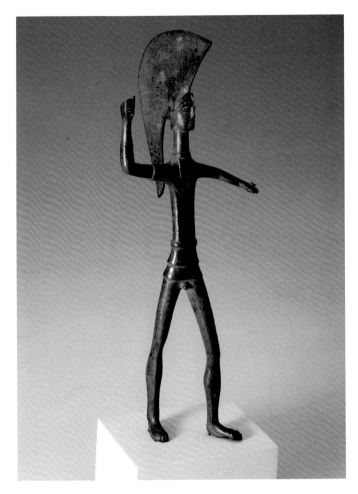

Warrior Statuette
Italy (Umbria)
Fifth century BC
Cast bronze
10 1/2 in.
(26.7 cm)
Gift of William Baer,
1906.40

A s history records, the Etruscans, the ancient inhabitants of present-day Tuscany in northwestern Italy, were an extremely religious people who regularly offered votive gifts in bronze or clay to their gods. Such offerings often took the form of a statuette depicting the divinity besought or the dedicator himself. The warrior figure was one popular type of offering.

The Cincinnati statuette exhibits the stance characteristic of classically inspired warrior figures from the hill country of Umbria: striding forward and holding a spear (now lost) in the upraised right arm. An identifying feature of dress is the Athenian-style helmet with its upturned cheekpieces and large, sweeping crest. The Cincinnati figure's slender, elongated proportions and abstract anatomy impart a sense of dignity and grace. The precise identity of such warrior figures is still unknown. They may have been meant to represent mortal soldiers or a divinity such as the Etruscan war god Maris, the equivalent of the Roman deity Mars.

Classical Art

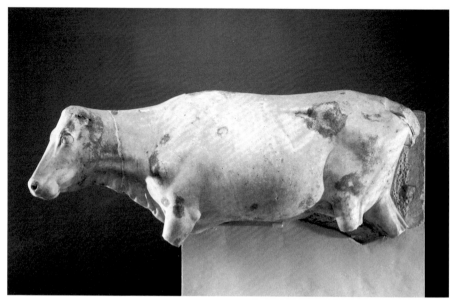

Sacrificial Heifer from an Altar Relief

Italy (said to have been found near Anzio)
Roman, first century AD
Marble
19 7/8 x 11 3/4 in., diam. 51 1/2 in. (50.4 x 29.9 cm, diam. 130.8 cm.)
John J. Emery Fund, 1946.9

In the Imperial era, which began under the emperor Augustus, a tradition of state-sponsored art was established in Rome and its territories. With state or municipal funds, public monuments of various kinds were commissioned to commemorate religious, political, and military events. Such monuments reminded the populace of the piety of the imperial house and of the centralized authority of the state. One common form of public religious monument was the altar—a raised stone structure dedicated to a god, which served as a focal point of worship and ritual sacrifice.

This life-sized depiction of a heifer or young cow was part of such an altar, perhaps dedicated to the goddess Juno, to whom the cow was sacred. In a fashion typical of such sculptural decoration, the Museum's heifer is depicted in profile relief; only its head, which angles away from the background, is sculpted fully in the round. The heifer's refined naturalism, with attention to the realistic modeling of ribs and veins, reveals a strong debt to Hellenistic Greek art.

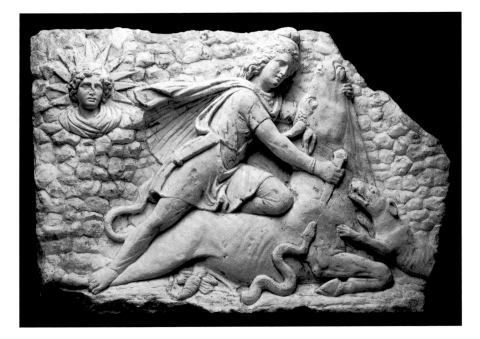

Mithras Slaying the Bull
Italy (said to have been found in Rome)
Roman, 150–200 AD
Limestone
24 1/2 x 37 1/2 x 7 in. (62.2 x 95.2 x 17.8 cm)
Gift of Mr. and Mrs. Fletcher E. Nyce, 1968.112

In contrast to the sacrifice of a heifer, the ritual sacrifice of a bull figured prominently in an entirely different religious ceremony, which centered on the worship of the Persian god Mithras. Mithraism was one of many foreign cults that gained popular acceptance in Rome and its provinces. It was especially favored by members of the army, who embraced it because of its promise of immortality and personal salvation.

The Museum's relief shows the ritual slaying of the bull by Mithras himself. Depicted in the conventional idiom, the Iranian god corrals his victim by the muzzle and plunges a short sword into its throat. The act is attended and sanctified by the presence of the sun god Helios (the Roman Sol), who appears at the upper left as a radiate bust. A dog, a snake, and a scorpion, conventional Mithraic symbols, assist in the act.

As revealed by the archaeological contexts of similar sculptures, this relief served as the focus of worship in one of the many underground sanctuaries in Rome devoted to Mithras. The work, which can be dated to the latter half of the second century, is among the finest of surviving Mithraic cult depictions from Rome.

Classical Art

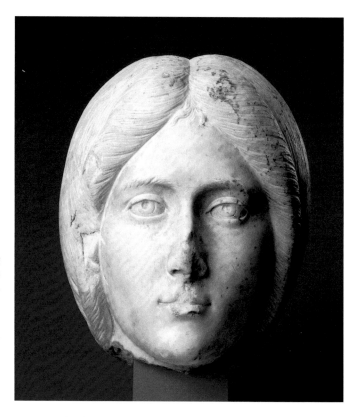

**Portrait Head
of a Noblewoman**

Italy

Roman, Severan period,
ca. 190–210 AD

Marble

9 3/16 x 9 5/16 x 9 1/2 in.
(25.0 x 25.2 x 24.0 cm)

John J. Emery Fund,
1946.5

Much of Roman art is rooted in the ancient funerary rites and traditions of Rome, the capital city. This is particularly true of portrait sculpture, which may be traced to the ancient practice of preserving and displaying painted wax funerary masks of ancestors. Roman portraits served both a public and a private commemorative function. As the latter type of memorial, they were often placed in the niches or decorative recesses of private homes or family tombs.

The earliest surviving Roman portraits, which date to the first century BC, were carved in a rather hard, unromanticizing style marked by exaggerated attention to time-worn facial detail. In the long reign of Augustus (27 BC–14 AD), however, Greek classical ideals were revived. This classicism influenced subsequent likenesses created for the imperial court and members of the Roman aristocracy, who often followed imperial style and fashion in their portraits. Contemporary fashion was followed particularly in female portraits, where current hairstyles were represented accurately in stone.

On the basis of the coiffure, the Museum's female portrait head may be identified as a member of the imperial court under Julia Domna, wife of Septimius Severus. The smooth, taut surface treatment of the skin and the heavy-lidded gaze are typical of works from this period.

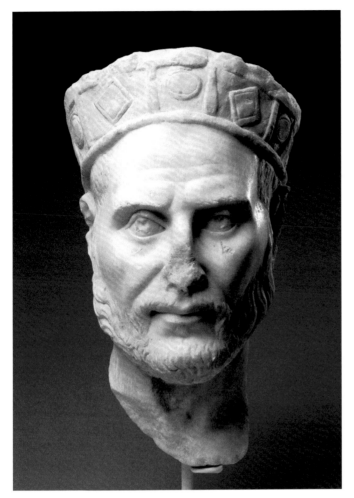

***Portrait Head of a
Priest or Magistrate***

Greece or Asia Minor

Roman,
late third century AD

Marble

14 1/16 x 8 5/8
x 6 3/16 in.
(35.7 x 21.9 x 15.7 cm)

Bequest of William H.
Chatfield, 1973.292

C ommemorative portraiture of the Roman Imperial era (31 BC–
330 AD) took a wide variety of forms. Statues of the emperor him-
self or of other high court officials, dressed in a toga or outfitted in
full armor, were commonly displayed in temples and public squares or mar-
ketplaces. Another popular commemorative format was the portrait bust,
a type ideally suited for placement in the decorative recesses of private
homes or family tombs.

This work is a fine example of Roman portraiture. An expression of
intense concentration is conveyed by the piercing, wide-eyed gaze and the
tense, muscular structure of the face. The cylindrical crown or diadem iden-
tifies the sitter as a man of priestly or magisterial rank. The portrait may
have been commissioned by the dedicant himself, or (more probably) by
the city or municipality in which he served. On stylistic grounds it may be
dated to the late third century.

Art of Asia

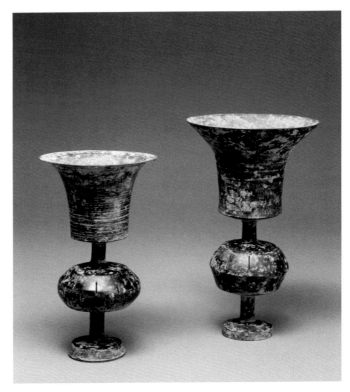

Pair of Goblets

China
(Shandong province)

Neolithic Longshan
culture,
ca. 2700–2100 BC

Burnished earthenware

9 1/4 x 7 11/16 in.
(23.5 x 19.6 cm)

Museum Purchase with
funds provided by the
Oliver Charitable Lead
Trust, 1996.449a,b

The Neolithic Longshan culture flourished in northeastern China during the third millennium BC. As archaeological excavations have demonstrated, it excelled in jade carving and ceramics. A pair of goblets in the Museum's collection are superb examples of the black pottery that represents the highest achievement of the Longshan ceramists.

Made of a fine-grained clay turned on a potter's wheel, Longshan black vessels are characterized by extremely thin walls (1 to 3 mm) and an unusually bold silhouette. Each goblet in the Museum's set is composed of separately thrown parts joined together to form the hollow bulb in the stem. Like other examples of Longshan black pottery, these pieces are distinguished by their minimal surface decoration and by their rich black color, achieved through reduction firing (in which oxygen is removed from the kiln). Their burnished surface presents a handsome metallic sheen.

Excavated examples of comparable Longshan black ware have been found exclusively in tombs of the wealthy, where they were deposited, along with jade ritual items, next to the deceased. Such burial contexts suggest that these vessels were designed as ritual paraphernalia, an interpretation supported by their extreme fragility. Probably they were used in special rites in which drink was shared with the ancestral spirits.

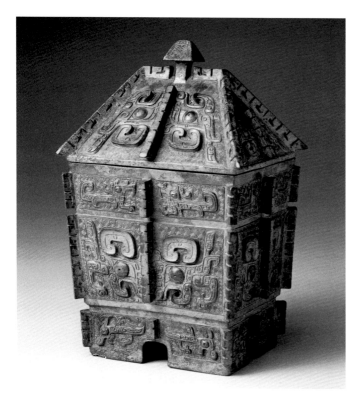

***Ceremonial Wine
Vessel*** (fangyi)

China

Shang dynasty, Anyang
period, twelfth century BC

Cast bronze

11 3/8 x 7 1/2 in.,
diam. 6 1/2 in.
(28.9 x 19.1 cm,
diam. 16.5 cm)

Gift in honor of Mr. and
Mrs. Charles F. Williams
by their children, 1948.75

As in later periods of China's history, aristocrats of the Shang dynasty (sixteenth to eleventh century BC) practiced ancestor worship, commissioning sumptuous cast bronze vessels as containers for ceremonial offerings of food and wine to the dead. In adherence to such rites, a variety of costly bronze vessels were committed to the tomb. By such practices the Shang nobles sought to appease the spirits of their ancestors, thus ensuring the continuation of their dynastic power.

The Museum's vessel, called *fangyi* in ancient Chinese, functioned as a storage container for wine used in rituals—actually a grain liquor made from millet. The vessel type comes from the classic and most highly developed phase of the Shang period and exemplifies the technical mastery achieved by bronze foundries that served the Shang capital of Anyang. Like other ancient Chinese bronzes, the Museum's *fangyi* was cast in multisectioned clay molds. This casting method, which was unique in the ancient world, was brought to a highly sophisticated level by Chinese metalworkers, who were able to produce precise, detailed surface decoration. Superbly designed and flawlessly cast, this *fangyi* bears a typical decoration consisting of paired dragons and *taotie* (a fantastic dragonlike mask with horns and bulging eyes) set against a spiral-patterned background.

Art of Asia

Images of Guanyin and Da Shizhi
China (Hebei province)
Northern Qi dynasty, ca. 575
Marble with traces of pigment
Guanyin, 68 7/16 x 20 1/4 x 20 1/2 in. (173.9 x 51.4 x 52.1 cm)
Da Shizhi, 69 x 20 5/8 x 20 3/4 in. (175.3 x 52.4 x 52.7 cm)
Museum Purchase: 1952.110, 1952.111

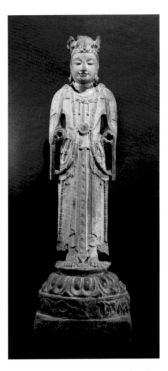

Although Buddhism reached China as early as the first century, it was not firmly established in northern China until the late fourth century, under the influence of the Northern Wei dynasty (386–535). Beginning at that time, numerous shrines and temples were adorned with depictions of the Buddha in various manifestations.

The Museum's two sculptures, which form a pair dating to the Northern Qi dynasty (550–577), depict *bodhisattvas*, Buddhist beings who have fulfilled the requirements for attaining enlightenment but remain available to aid mortals in their pursuit of salvation. The pair originally formed flanking elements in a divine triad centered on the image of the Buddha Amituo (Amitabha), or the Buddha of Infinite Light, Lord of the Western Paradise or "Pure Land." On the basis of similarities in facial features and ornamentation, the Museum's statues can be identified with an Amitabha image dated by inscription to 575.

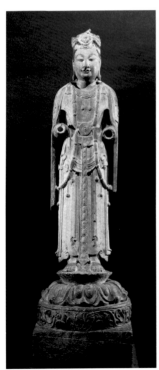

Although dressed and posed identically, the two bodhisattvas can be distinguished by their diademed headdresses: one diadem is ornamented with a vase, while the other bears a Buddha figure representing Amituo himself. The vase emblem identifies its wearer as Da Shizhi (Mahasthamaprapta), representative of Amituo's power and wisdom, who greets those entering the Pure Land with a gesture of offering and veneration. The Buddha image marks its wearer as Guanyin (Avalokitesvara), the bodhisattva of compassion, who meets the faithful at their death and guides them to the world beyond. Pure Land doctrine, whose popularity increased in the mid-sixth century, offered rebirth into Amituo's paradise to faithful individuals who called on the deity by name. In the Pure Land, according to Chinese belief, reborn souls would dwell in an environment conducive to attaining spiritual enlightenment, the ultimate goal.

In their roundness of form and ornate embellishments, these statues typify the new sculptural style of the Northern Qi dynasty, introduced through foreign influence from India during the Gupta period (320–600). Each figure, dressed in a pleated *dhoti* (a loincloth worn by Hindu men), is richly adorned with pendants, belts, buckles, and chain necklaces that criss-cross through a disk suspended just above the waist.

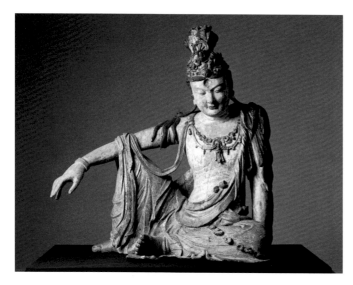

Water-and-Moon
(shuiyue) *Guanyin*

China (provenance
unknown)

Xixia or Jin dynasty, twelfth
or early thirteenth century

Wood with traces of
pigments and gilt

39 x 31 x 21 in.
(99 x 79.1 x 55.5 cm)

Museum Purchase:
1950.73

The *shuiyue* (water-and-moon) Guanyin represents a uniquely Chinese form of the Bodhisattva of Compassion, who meditated on the illusory nature of phenomena; this was linked metaphorically to the moon's reflection in water. According to Buddhist scriptures, this bodhisattva lived on Potolaka, an island located in the seas south of India. The Chinese, however, associated Guanyin's island home with Mount Putuo, off the coast of Zhejiang, which became a major Buddhist pilgrimage destination. Here, in a grotto, the *shuiyue* Guanyin lived and meditated in seclusion.

The Museum's statue depicts the bodhisattva seated characteristically in the pose of "royal ease" (*maharajalila*), leaning on the left arm, with the right knee bent to support the extended right arm. In sculptures of the Xixia, Song, and Jin dynasties, Guanyin's gender remains ambiguous but anticipates the complete feminization of the deity that occurred later in China. The inclination toward a female form on the present sculpture may be detected in the delicate rendering of the hands and in the soft modeling of the face and arms. Emphasis on Guanyin's feminine aspects underscored the bodhisattva's tenderness and compassion. A graceful, relaxed pose and a calm expression heightened the emotional appeal of a humane and approachable deity.

In a fashion typical for bodhisattvas, the Museum's Guanyin is elaborately adorned with long fluttering scarves and a heavily jeweled tiara and necklace. The hair, upswept in an elaborate coiffure, falls in ropelike tresses across the shoulders and upper arms. The deeply carved drapery and heavy ornamentation hint at the original sumptuousness of this temple image, which once stood on an elaborately carved wooden base in the form of a rock garden with a high backdrop representing the grotto dwelling. The figure, which has been assembled artfully from multiple blocks of wood, was gilded and painted with bright pigments.

Art of Asia

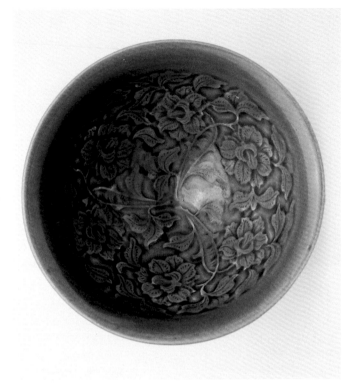

Bowl

China (Shaanxi province)

Northern Song or Jin dynasty, twelfth or thirteenth century

Stoneware with olive-green glaze

2 3/4 x 6 11/16 in., diam. 6 11/16 in. (7 x 17 cm, diam. 17 cm)

Museum Purchase: Phyllis H. Thayer Purchase Fund, 1996.13

U nder the influence of earlier glazed wares of southern China produced in the late Tang dynasty and the Five Dynasties (ninth and tenth centuries), the Yaozhou kilns in Shaanxi province perpetuated the green-glazed stoneware tradition of northern China. The Museum's delicately potted bowl is of the characteristic Yaozhou olive-green color, which derives from a small amount of iron oxide in the glaze when fired in a reduction atmosphere. During the firing process, the nearly transparent glaze pools in the carved or molded recesses of the vessel surface, creating a darker tone that accentuates the decoration.

Floral motifs, especially featuring the peony and the lotus, are abundant on Yaozhou ceramics. The peony, which symbolizes wealth and rank, was the most popular cultivated flower in Song-dynasty China, and it is praised in treatises of that period. The Museum's bowl is decorated with a finely executed motif of intertwined pairs of herbaceous peony (*shaoyao*) blossoms, repeated three times on the interior. The herbaceous peony, which is mentioned in a late Tang-dynasty book of poetry, sometimes served as a farewell gift and a token of love.

The his rare handscroll by Ma Yuan, one of the preeminent court painters of the Southern Song dynasty, depicts the mountain retreat of four aged scholar-officials known as the Four Sages of Mount Shang. For moral reasons, according to literary accounts, these four individuals chose a life of seclusion rather than serve as administrators under the arrogant Gaozu, first emperor of the Han dynasty (reigned 206–195 BC). When the emperor decided to disinherit his eldest son, the heir apparent, in favor of another son, the empress and one of the emperor's trusted counselors devised a plan to convince the emperor not to change the imperial succession. According to the plan, the Four Sages were to be persuaded to briefly leave their mountain retreat to entreat the emperor on behalf of his eldest son. The Sages agreed to go to the emperor; they gained his trust through their moral reputation, and the rightful heir was restored.

The theme of the introspective scholar occurs often in the paintings of Ma Yuan, who showed scholars engaged in leisurely pursuits that are metaphors for neo-Confucian self-cultivation. In the Museum's scroll, the four recluses play chess and gather mushrooms. Behind them a stream emerges from a rocky ravine to join a larger body of water in a torrent of surging waves. The turbulent waters symbolize the political unrest outside the sages' peaceful retreat. The subject of the four Shangshan scholars later became a particularly poignant allegory for those loyal Song literati who experienced the Mongol takeover of China in 1279, as indicated by the 36 inscriptions that follow the painting.

Ma Yuan
(active ca. 1190–ca. 1225)
China
The Four Sages of Shangshan
Southern Song dynasty, ca. 1225
Ink and light colors on paper
13 x 121 in. (33.6 x 307.3 cm)
Anonymous Gift, 1950.77

Art of Asia

**Wenshu, Bodhisattva of Wisdom,
at a Writing Table**

China (Shanxi province, from the lower
temple of the Guangshengsi)

Yuan dynasty, 1354

Glue tempera on clay
over mud and straw

164 1/8 x 117 1/16 in. (416.8 x 297.3 cm)

Gift of C.T. Loo, 1950.154

In Shanxi province today stand many of China's oldest and best-preserved timber-frame Buddhist temples. These architectural complexes consist of numerous halls housing sacred images of Buddhas, bodhisattvas, and other deities. Their interior walls often bore painted murals depicting groups of deities and patrons or illustrations of Buddhist scriptures. The Museum's mural fragment, executed on a preparation of mud mixed with straw overlaid with clay sizing, comes from one such structure: the lower monastery of the Guangshengsi (Temple of Vast Triumph), located near Zhaocheng in the Fen River valley of Shanxi province.

This wall painting depicts Wenshu, the bodhisattva of wisdom, receiving the mantra or scriptures from Tejaprabha, the celestial Buddha who protects from natural disasters. Seated in an elaborate thronelike chair at his writing table, Wenshu awaits the Buddha's revelation, symbolized by the flaming orb behind his head. On his desk are the writing implements of a Chinese scholar: a brush holder with extra brush, a pile of books, an extra scroll, an ink stone with ink stick, and a water dropper. Next to the desk, a vermilion-skinned servant holds a bundle of scrolls. As the bodhisattva of wisdom, Wenshu was an important patron for Chinese civil service candidates who sought high-level government appointments by earning the coveted *jinshi* degree.

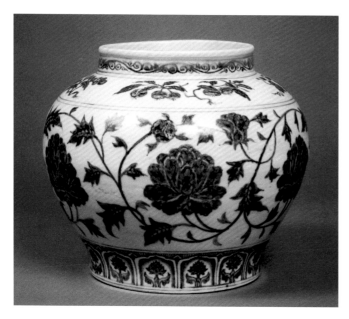

Guan Jar

China (Jiangxi province, Jingdezhen)

Ming dynasty, early fifteenth century

Porcelain painted in underglaze blue

H. 8 1/4 in., diam. 10 in. (h. 21.0 cm, diam. 25.4 cm)

John J. Emery Endowment and George M. ToeWater Endowment, 1987.147

From earliest times, the Chinese have excelled in the ceramic arts. Prominent among their achievements was the invention of porcelain, a hard-bodied, high-fired, translucent white ware utilizing native kaolin, a fine white clay. The Chinese invention of porcelain spurred not only domestic but also global demands, fueling China's export trade to the West. During the Yuan dynasty (1279–1368), a significant development in the decoration of porcelain occurred at Jingdezhen in Jiangxi province, site of the later Ming imperial porcelain factories: Chinese potters, encouraged by Near Eastern traders, applied decoration utilizing cobalt oxide to achieve a rich underglaze blue, highly favored in the West.

The Museum's jar (of the shape called *guan* in Chinese) belongs to a large group of Chinese blue-and-white porcelains manufactured for the Near Eastern trade. It was found in Damascus, Syria, a primary Western market for such wares. In the 1960s alone, more than 800 examples surfaced in the shops and stalls of cities such as Aleppo and Damascus, where they had survived in private hands since their export in the fourteenth and fifteenth centuries.

In a fashion typical of such export wares, the painted decoration on the Museum's jar combines elements of Western origin such as the scrolling vine (seen on the neck and body) with Chinese motifs such as tree peony blossoms. The delicate fruiting sprays of grapes, lychees, loquats, and pomegranates depicted on the shoulder are based on illustrations from Chinese pharmaceutical texts. A rare design element is the band of lappets with lotus blossoms that encircles the base of the jar. This motif is known on only one other vessel: a *guan* in the famous Ardebil shrine at Teheran, whose entire design closely resembles that of the Museum's jar.

Art of Asia

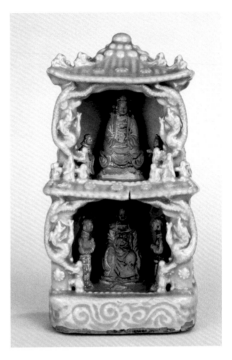

Taoist Shrine
China (Zhejiang province, Longquan kilns)
Ming dynasty, early fifteenth century
Porcelaneous stoneware with green glaze and traces of lacquer and gilding
10 15/16 in. (27.8 cm)
Gift of Dr. Robert A. Kemper, 1991.163

aoism, which emerged as a distinct belief system in China in the third to second centuries BC, promotes harmony with the Tao, the intangible, inexhaustible Way of all things. A central figure in Taoist belief was the goddess Xiwangmu, the Queen Mother of the West. As Chinese literary texts reveal, Xiwangmu lived in a lofty palace with towering jade buildings on Mount Kunlun, the link between earth and heaven. From there she ruled over a paradise in the far West and was believed to possess the secrets of longevity and immortality.

Flanked by her child acolytes, Jintongzhi, the Golden Boy, and Yunu, the Jade Girl, Xiwangmu sits enthroned in the upper niche of a two-story pavilion, whose luminous green glaze resembles jade. Appropriately, the shrine's molded surface is adorned with numerous symbols indicating its divine location. The stylized flowers, perhaps meant to be peach blossoms, refer to the peaches of immortality, which ripen only once in 3,000 years. The serpentine creatures twining around the pillars refer to the dragons that transport souls to Mount Kunlun. Zhenwu, Lord of the Northern Quadrant, occupies the lower niche.

The Museum's shrine model probably served as a visual aid for a Taoist worshiper in his transcendental communication with the gods. The blessing of immortality was a primary goal in Taoist belief, and Xiwangmu's jade palace was a dwelling place for the soul in the afterlife. This model was produced in the famed Longquan kilns of Zhejiang province, long known for their celebrated green-glazed ceramics.

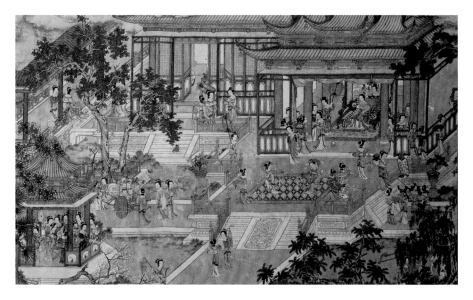

This Qing dynasty handscroll depicts the springtime activities of court ladies in the women's quarters of the imperial palace during the Han dynasty (206 BC–220 AD). In their mist-enshrouded complex of pavilions, lakes, and lush gardens, they pursue elegant activities associated with spring, such as swinging under willow trees, chasing butterflies, gathering flowers, and playing chess. In an elaborate pavilion in the center of the scroll sits the empress, attired in formal regalia, entertained by dancers and musicians. Palace women—some on foot, others in fanciful carts—approach her with gifts symbolizing wishes for long life and happiness.

Blossoming trees and shrubs appear in profusion throughout the painting. Their presence, along with the focus on activities related to the gathering of flowers, recalls the Festival of the Hundred Flowers, a spring fertility rite observed by women during the second month of the lunar year. Motifs throughout the painting express concerns about fertility, emphasizing the roles of women in the imperial household and the expectation that they will provide the emperor with a potential heir to the throne.

The painting's theme is venerable, stemming from the tradition of Tang-dynasty handscroll paintings and originating with the Song dynasty in a lost painting by the artist Li Gonglin. The subject became especially popular among Qing-dynasty painters of the early eighteenth century, when the Museum's scroll was produced. The style and the accomplished execution of the painting suggest that it may have been the work of an artist associated with the imperial court or perhaps of a professional painter working in Suzhou, a major cultural center at that time.

Detail: ***Spring Morning in the Han Palace***

China

Qing dynasty, late seventeenth or early eighteenth century

Ink, colors, gold on silk

22 1/8 x 405 in. (56.2 x 1028.7 cm)

Museum Purchase: Lawrence Archer Wachs Trust, 1995.1

Art of Asia

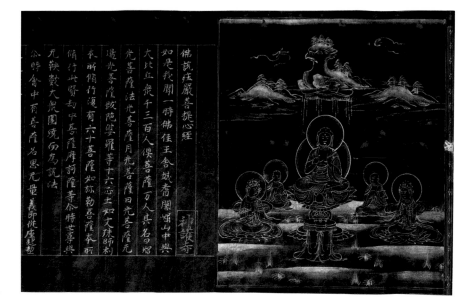

Detail: ***Sutra with***
Frontispiece Depicting
the Preaching Buddha

Japan
(Kyoto, from Jingo-ji)

Late Heian period, 1185

Gold and silver
on indigo-dyed paper

10 1/8 x 134 1/2 in.
(25.7 x 341.6 cm)

John J. Emery Fund,
1985.12

Through the verbatim copying of Chinese sutras (Chinese translations of the Buddhist scriptures), the Japanese aristocracy adopted Buddhist doctrine as well as the Chinese written language. The copying of sutras was considered an important act of piety in the Buddhist faith. Wealthy Japanese patrons thus sought to acquire spiritual merit by presenting temples with lavish sutra sets.

This scroll comes from a set of about 5,000 works commissioned in the twelfth century by the Emperor Toba for Jingo-ji, a temple near Kyoto. Such scrolls were not used in worship but were stored in temple repositories and brought out only on special occasions. Although a large number of scrolls was needed to complete the set, no expense was spared in the choice of materials used, including indigo-dyed paper and gold and silver inks. The frontispiece of this scroll follows the standard formula for the set. The Buddha is shown seated in an abbreviated landscape, preaching to his followers. Above him looms a mountain with a birdlike head symbolizing Vulture Peak, where the Buddha preached 16 sermons to his followers.

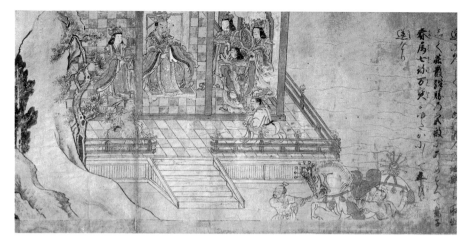

T his scroll is an example of *emakimono* or narrative painting in the handscroll format, a tradition that reached its zenith in the twelfth through the fourteenth centuries in Japan. Designed initially for secular themes, *emakimono* eventually became a format for depicting the spiritual adventures of historical or legendary characters. Narratives recounting confrontations with Buddhist hell and judgment, demons, and torture warned the populace of the consequences of evil behavior. Such themes remained popular until the fifteenth century, when the Zen sect of Buddhism, with its emphasis on meditation, became more prominent in Japanese culture.

In this scroll, elegant calligraphic *sosho* (cursive) script and lively illustrations are used to relate the story of a wealthy prince who was sentenced to hell for a life of debauchery but was given a second chance on earth through the pious deeds and prayers of his brother. Failing to make amends, the prince was judged again and sentenced to further rounds of torture in hell. The scroll is opened to the scene in which the prince is being dragged away by a demon despite the wailing protests of household attendants.

In the final scene, which follows a long *sosho* narrative, the prince has been stripped of his robes. He kneels, bound and tethered to a demon, before Emma, Judge of Hell, who is seated at his writing table. Surrounding Emma are his attendants: one reads the charges brought against the prince, while another points to the right and speaks.

Detail: ***Hell Scroll***

Japan

Namboku-cho period,
late fourteenth century

Ink and colors on paper

13 3/4 x 212 1/4 in.
(35.0 x 539.5 cm)

Mr. and Mrs. Harry S.
Leyman Endowment,
1987.1

Art of Asia

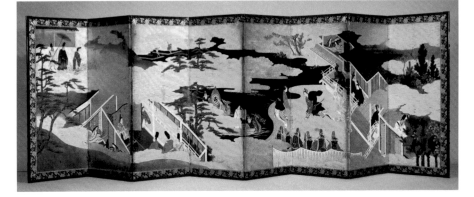

Pair of Eightfold Screens: Scenes from the Tale of Genji

Japan

Edo period, late
seventeenth century

Ink, colors, and gold
on paper

45 x 151 1/4 in.
(114.3 x 384.2 cm)

The Edwin and Virginia
Irwin Memorial, 1964.292

During the Edo period, a revival of interest in traditional Japanese literature inspired works of art illustrating the world's oldest novel, the *Tale of Genji*. This work was written in the early eleventh century by Shikibu Murasaki, a lady-in-waiting at the Heian court; it became a source of subject matter for paintings commissioned by wealthy townspeople in the great urban centers of Kyoto, Osaka, and Edo. Executed by professional artists trained in the Kano or Tosa style, such paintings rely on the traditions of *yamato-e* (painting in the indigenous Japanese style). These traditions include conventions such as *fukinuki-yatai* ("blown-off roof"), in which interior scenes are shown from a birds-eye perspective through an open roof.

The Museum's pair of screens bear illustrations of various scenes from the 54 chapters of the book. (Only the right-hand screen is shown here.) At the far end, in a scene from Chapter 7, "An Autumn Excursion," Prince Genji, the protagonist, and his brother-in-law, To no Chujo, dance before the emperor's court during a visit to the Suzaku Palace. They perform to the accompaniment of musicians situated on Chinese-style boats on the lake. The lower left-hand side of this screen shows an illustration of a vignette from the book's first chapter, "The Pawlonia Court," in which the 12-year-old Genji appears in adult robes after his initiation into manhood. Seated before a folding screen with floral decoration, the young initiate holds a falcon, one of the gifts presented to him in honor of the occasion.

Nagasawa Rosetsu (1754–1799)

Japan

Snowy Landscape with Scholars in Pavilions

Edo period, ca. 1789–95

Hanging scroll: Ink and light colors on silk

43 1/8 x 18 7/8 in. (109.5 x 48 cm)

Museum Purchase: Lawrence Archer Wachs Trust, 1996.56

I n the history of Edo-period painting, Nagasawa Rosetsu stands out as one of the most compelling individualist painters. While under the tutelage of Maruyama Okyo, whose work is characterized by an emphasis on realism and nature subjects, Rosetsu developed an affinity for Western spatial perspective. *Snowy Landscape,* assignable to the latter part of the artist's middle period (1789–1795), features the deft brushwork and innovative approach to composition and space that characterize Rosetsu's best works. The subject is ostensibly a gathering of scholars in winter, a favorite theme of eighteenth-century Nanga painters working in the Chinese literati painting tradition. Japanese treatments of such themes include a lighthearted-edness and humor that are rarely evident in their Chinese precursors.

Rosetsu's painting not only captures the figures' eccentricity in a humorous way but also provides an unexpected twist by featuring the servants rather than their scholarly masters as the primary subjects. Even the painting's inscription is expressed in a servant's words. The servants sweep snow from the bridge, adjust the blinds, or peer out of a pavilion, attracting our attention by their activities. One servant standing on the bridge even engages the viewer directly. The scholars, by contrast, appear passively in the background, seated within two pavilions; the nearer group enjoys wine and conversation. Rosetsu plays with the spatial relationships in the painting, using traditional Eastern piled-up perspective for the left-hand side while displaying his command of Western perspective for the right, a vista in which sailboats dissolve into the distant mist.

Art of Asia

Morita Shiryu (b. 1912)
Japan
Ju (big tree)
Showa period, 1968
Four-panel lacquer screen; 162 x 122 13/16 in. (411.4 x 311.9 cm)
Museum Purchase: Gift of John Sanborn Conner, by exchange, 1981.517

The origins of Zen are concerned with a legendary event in the life of the historical Buddha. One day, rather than sermonizing to his disciples, the Buddha held a flower in his hand. Only one disciple understood this gesture. So began the emphasis on meditation and on the relationship between master and pupil that marks the Zen Buddhist sect. Established in Japan in the thirteenth century, Zen has influenced nearly all of Japan's artistic and cultural traditions. Japanese architecture, garden design, literature and drama, music, ceramics, painting, and calligraphy all embody elements of Zen aesthetics and philosophy.

Morita Shiryu, a contemporary Japanese calligrapher, applies Zen principles and aesthetics both to his process of artistic creation and to the form and subject of his works. The theme of this four-panel lacquer screen is *ju*, the pictograph for *big tree*. Morita works in a variety of media; he is known especially for his large screens, in which he combines the free expression of the brush with the rich materials of gold and black lacquer. The artist infuses his subjects with the essential nature of the thing represented. In this case, the pictograph for the tree sprawls like an old, gnarled pine across the black plane.

In keeping with Zen tradition, Morita meditates before creating. Then he paints the character spontaneously; the flexible brush responds to every movement of his fingers, wrist, elbow, shoulder, and body. To inscribe the pictograph on this screen, Morita used two very large brushes held together as one.

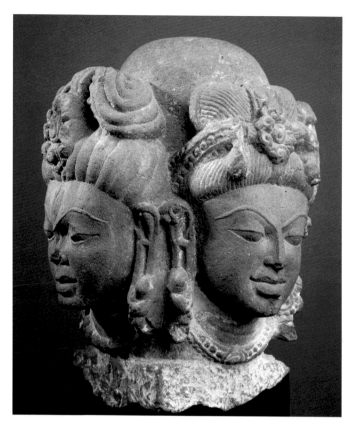

Five-Faced Lingam
(pancamukholinga)
India (Madya Pradesh
or Rajasthan)
Eighth century
Red sandstone
15 1/4 in. (38.7 cm)
Bequest of Mary M. Emery,
by exchange, 1982.123

In the complex Hindu pantheon, deities possess various manifestations, or aspects, to express their diverse powers. This five-faced stone lingam, or phallus, illustrates in sculptural form the various aspects of the Hindu god Shiva as the absolute totality who creates, defines, and encompasses the universe. Each of the four faces surrounding the central shaft is identified with a name and bears its own unique attributes. The primary image (to the right in the illustration), the youthful Tatpurusa, is associated with the element of air and wears large, heavy earrings and a strand of large beads around his neck. His hairstyle is that of an ascetic: thick, matted locks fall to the sides in great coils and are adorned with a diadem. To the left is the elegant feminine image of Vamadeva, the beautiful goddess associated with water. Sometimes she is called Uma, a name for Shiva's spouse. Opposite Vamadeva-Uma is Aghora, or Bhairava, the demonic form of Shiva, who is associated with fire. The grimacing skull that adorns his hair represents Shiva's horrific aspect as an ascetic who wanders cremation grounds. The fourth face, which has been defaced, depicts Sajyojata, the manifestation of Shiva associated with earth. The fifth aspect of Shiva, called Isana, is represented by the curved summit of the phallus itself. Associated with ether, or space, it represents Shiva as creator, the source of all aspects of existence.

Art of Asia

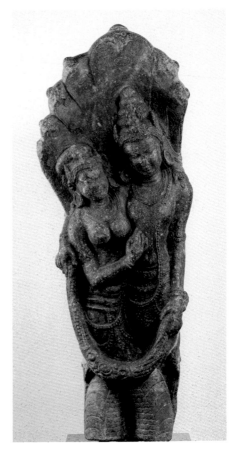

Serpent King and Queen
India (Bihar)
Pala dynasty, ninth century
Gabbro
38 3/8 x 15 in. (97.5 x 38 cm)
Museum Purchase with funds provided by
Mr. and Mrs. Carl Bimel Jr., 1998.55

This relief depicting a serpent king (*nagaraja*) and queen was produced under the patronage of the Pala kings, who controlled the Ganges Valley of eastern India from about 750 to 1200. The snake (*naga*) has a long history in India; snake imagery was incorporated early on in both Buddhism and Hinduism, the two major religions of the ancient Indian subcontinent.

The Museum's relief belongs to a series of works in a related genre which came from one or more temple complexes in Magadha, a region located south of the Ganges River in the present-day province of Bihar. Like the others of its type, the relief decorated the wall or doorway niche of a Hindu or Buddhist sanctuary. Depicted are a *naga* king and queen embracing before a fan-shaped canopy of serpent hoods, their tails entwined in a love knot. They are represented in the conventional form of a loving couple. The king, with his right arm around the queen, holds a garland against her shoulder; the looping sash unites them. Both figures wear jewelry befitting a deity: bracelets, armlets, necklaces, circular earrings, and elaborate head ornaments. The king wears a tiered crown; the queen, a crested diadem.

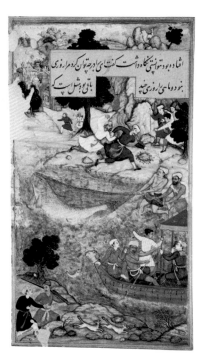

بحرون ومامی آروزی چنه / افثاد وبودند و تو یستی نگاه وداشت کفتای ای درچه توان کرد مرا روزی / باقی موبهل است که

Manohar (late sixteenth century)

India

The Fisherman Unable to Hold the Giant Fish

Mughal, ca. 1595

Page from a Gulistan of Sa'di; opaque watercolor and gold on paper

10 9/16 x 5 13/16 in. (26.8 x 14.8 cm)

Gift of John J. Emery, 1950.284

A compilation of moralistic tales, the *Gulistan* or *Rose Garden* is the best-known work of the great thirteenth-century Persian poet Sa'di. In this work, the poet illustrates lessons of life through stories that sometimes involve the author himself as participant. The Museum's painting, by Manohar, originally belonged to an episode in an illustrated edition of the *Gulistan* commissioned by the Mughal emperor and art patron Akbar.

The episode in Sa'di's *Gulistan* (Tale 24, Chapter 3) reads as follows: "The fisherman caught a giant fish in his net, but the fish escaped. This had never happened before, and the fisherman was reproached by his fellow fishermen for losing his catch. He replied, 'Alas, my brethren! What could be done, seeing it was not my lucky day, and the fish had yet a day remaining? A fisherman without luck catcheth not fish in the Tigris, neither will the fish without fate expire on the dry ground.'"

In this painting, Manohar has elected to show the giant fish caught in the net just before its escape, the moment of highest drama. While the fisherman and a companion struggle to hold the catch, various hunters, fishermen, and excited spectators rush to the scene. In the fashion of northern European landscapes of that time, a town nestles in the distant hills. A distinguished painter in the Mughal court of Akbar, Manohar was a highly skilled portraitist and was fond of animals, especially foxes and hounds. Both qualities are illustrated clearly in this painting, one of eight folios from this distinguished manuscript held by the Museum.

Art of Asia

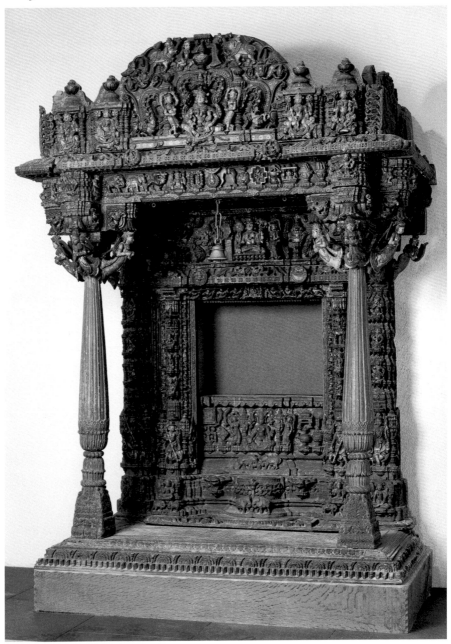

◀ *Jain Shrine*

India (Gujarat, Patan)

Early seventeenth century

Wood, painted and gilded

85 3/8 x 66 1/8 x 33 1/4 in. (216.9 x 168 x 84.5 cm)

The William T. and Louise Taft Semple Collection, 1962.459

Jainism was founded around 600 BC by an ascetic saint named Mahavita. Though it is one of the oldest indigenous religions in India, it did not become a dominant cultural influence, as did Buddhism and Hinduism. Nevertheless it attracted a devout following among members of the merchant class in the western province of Gujarat, who commissioned the building of numerous temples in the sixteenth and seventeenth centuries. The Museum's shrine, an elaborately carved canopy with two freestanding supporting columns, was one such commission. It served as a focus of domestic worship for an affluent Jain family in Patan, a small town in Gujarat northwest of Ahmedabad.

Jainism, which espoused an extreme practice of nonviolence (*ahimsa*), revolved around the worship of 24 Tirthankaras or "spiritual victors," also known as *jinas*, from which the name *Jain* is derived. An image of one of these Tirthankaras originally occupied the central niche of the Museum's shrine; centered in the narrow frieze immediately above is the seated figure of another *jina*, worshiped by eight flying figures bearing garlands. In a fashion typical of Jain temples, figures and symbols adorn every surface of the structure. Such variety reflects the complex visual vocabulary of Jainism, which incorporates many symbols and elements of Hindu and Buddhist iconography, including the eight auspicious symbols. These eight symbols surround the seated, four-armed figure of Sri Laksmi, goddess of wealth, depicted in the large frieze over the niche.

It is difficult to determine which image of Tirthankara was originally housed in this shrine, but a clue may be found in the four-armed goddess seated above the roof. Her attributes suggest that she may be Ambika, the female attendant to Neminatha, the twenty-second Tirthankara.

Art of Asia

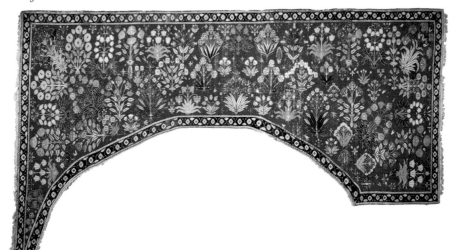

Shaped Carpet

India (probably Lahore)

Mughal, ca. 1640–1650

Wool pile on cotton
foundation

176 x 101 in.
(447 x 256.5 cm)

Gift of Mrs. Audrey Emery,
1952.201

From its beginning in the sixteenth century, the artistic tradition of the Indian court under the Mughal emperors was influenced heavily by Persian culture and taste. Mughal carpets of the seventeenth century, with their scrolling vines and palmettes, often imitated Persian design models. Along with the Persian-influenced type, however, there emerged a native Indian rug tradition with totally different designs and style of drawing and color. One such design consisted of rows of different varieties of flowering plants (including iris, tulip, and poppy), which were drawn and colored with a far greater concern for naturalistic representation than in Persian art.

With its brightly colored flowers arranged on a cherry red ground, the Museum's carpet belongs to this latter type. Its arch-shaped configuration suggests that it may have been used at the side of a dais for a prominent court official. Alternatively, it may have accompanied a central circular carpet.

On the basis of its style, this carpet may be dated to approximately 1640 or 1650, in the reign of Shah Jahan (ruled 1628–1658). Its stylistic source may be the European herbals of the sixteenth and early seventeenth centuries, which were brought to India by European travelers and missionaries.

***The Elephant Hunt of
Maharaja Anup Singh
of Bikaner***

India (Rajasthan, Bikaner),
ca. 1695

Opaque watercolor, gold,
and silver on paper

12 1/4 x 15 1/2 in.
(31.1 x 39.4 cm)

Gift of Mr. and Mrs.
Charles Fleischmann in
memory of Julius
Fleischmann, 1979.129

The elephant hunt, a periodic event in the life of the Indian imperial court, was intended to augment the royal stables. One such outing is described in a late-sixteenth-century account: "The hunters are both on horseback and on foot. They go during the summer to the grazing places of this wonderful animal, and commence to beat drums and blow pipes, the noise of which makes the elephants quite frightened. They commence to rush about, till from their heaviness and exertions no strength is left in them. They are then sure to run under a tree for shade, when some experienced hunters throw a rope made of hemp or bark round their feet or necks, and thus tie them to the tree. They are afterwards led off in company with some trained elephants, and gradually get tame."

This Rajasthani painting from northern India graphically records an elephant hunt organized by the Bikaner Maharaja Anup Singh. In the foreground an old, domesticated elephant has been tied to a tree as a decoy to pacify a herd of wild elephants, shown playing in a pond. In the middle distance another group of elephants, both young and old, are driven by invisible beaters toward a group of hunters waiting in ambush in the trees; the lead elephant, perhaps the herd elder, already has been trapped. The entire spectacle is observed in the distance by Anup Singh himself, who is seated in a howdah, along with his court retinue. The Museum's painting is one of the great surviving works from the court of the Bikaner Maharaja, a great patron of art and literature.

Art of Asia

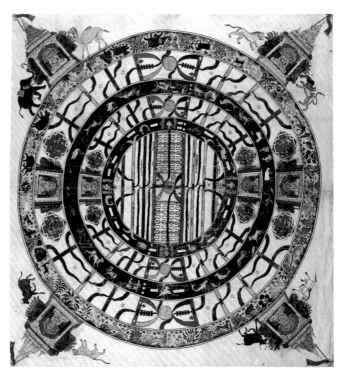

**Yantra of Jambudvipa:
Map of the Known
Universe**

India (Rajasthan)
Bikaner school

Ca. 1725

Opaque watercolor on
cotton cloth

37 x 37 in.
(94.4 x 94.4 cm)

Gift of Mr. and Mrs. Carl
Bimel Jr., 1995.81

An important type of painting in the Jain religious idiom is the *yantra*, a mystical diagram of the universe. Maps of this type typically were painted on cloth and were used as an aid to meditation. The *yantra* is drawn on a large scale and follows a schematic configuration based on the circle and the square.

Depicted in the center of the Museum's map is a disk representing Mount Meru, the Universal Mountain, focal point of the Jain universe. Around its diagrammatic landscape appear five encircling rings representing *jambudvipa*, the known universe, composed of various continents, countries, seas, rivers, planets, and constellations. This complex is divided into four alternating zones of seas and continents; the seas are populated by humans and sea creatures, both real and imaginary. The map terminates in an outer ring featuring birds and animals in a continuous landscape. In each of the four corners of the diagram is a Jain saint; these are known as *jinas* or Tirthankaras. Symbolizing the four cardinal directions, they sit enshrined in sumptuous pavilions flanked by beasts. Four other *jinas* appear enshrined along the central axis of the painting, flanked by male-and-female couples.

Mounting for a Sword Scabbard

India (Uttar Pradesh, Lucknow)

Ca. 1780

Gilded silver

11 in. (28 cm)

Museum Purchase: Given in honor of the 30th Anniversary of the Cincinnati Art Museum Docent Program; gift of The Fleischmann Foundation in memory of Julius Fleischmann; and Bequest of Reuben Springer, by exchange, 1991.50

During its majestic heyday in the latter half of the eighteenth century, the north Indian city of Lucknow enjoyed an unprecedented flowering of the arts. Capital of the province of Avadh (Oudh), it boasted the wealthiest and most ostentatious court and cityscape in northern India. The cultural arts at Lucknow reached a peak under the Mughal governor Asaf al-Daula (reigned 1775–1797).

The Museum's chape (the terminal fitting for a sword scabbard) is a magnificent example of the pierced metalwork produced during that period in Lucknow. Made of gilded silver, it is decorated with an engraved openwork pattern of a meandering tendril interspersed with gilt blossoms, rosettes, and stylized irises; the front is adorned with six peacocks shown foraging in the foliage. In quality of workmanship and aesthetic appeal, this chape is unsurpassed among surviving works of that period. Its maker has achieved distinction in the attention to detail and the subtle modeling of plant and animal forms. Technically the chape is a major feat; it was manufactured from a single sheet of silver, which was cut in openwork design, folded along its top edge, and skillfully joined with solder at the bottom. The Museum's chape originally graced a wooden scabbard for a sword of Indo-Muslim style (*shamshir*).

Art of Africa

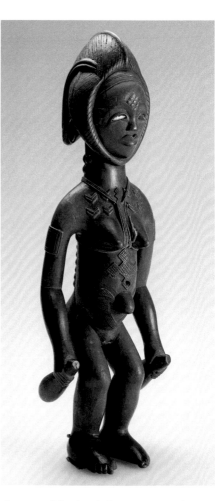

Female Figure

Gabon (Ogowe River region)

Late nineteenth century

Wood, glass inlay, applied wire, string

15 1/2 in. (39.4 cm)

Museum Purchase: Steckelmann Collection,
gift by special subscription, 1890.1545

The precise origin and context of this female figure, a woman holding calabash rattles, are unknown. Stylistically it is related to a category of white-faced "spirit masks" used in funerary dances by numerous tribes along the Ogowe River in Gabon; these include the Ashira, the Bapunu, and the Lumbo. Generally such figurative sculptures served a protective as well as a fertility-enhancing function.

The Museum's statuette is part of an extensive collection of objects amassed between 1885 and 1890 by Carl Steckelmann of Columbus, Indiana, who served as an agent for an English trading company active in the Congo. Like many other items in the collection, this figure was derived from the coastal areas of the French and the Belgian Congo. Its rhythmic contours and precise carving make it one of the most important surviving examples of classic African art in America today. The Museum's statue is distinguished by the elaborate, raised scarification patterns that decorate its face and body.

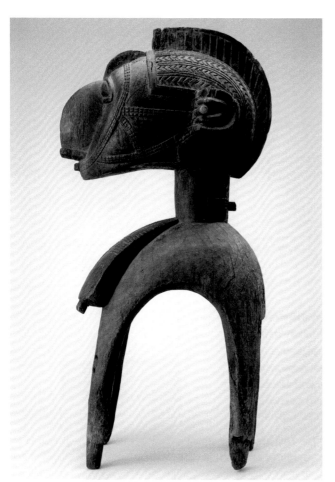

Shoulder Mask (Nimba)

Guinea (Baga people)

Late nineteenth–early twentieth century

Wood, originally with raffia attachment

45 in. (114.3 cm)

Gift of Charles and Harriet Edwards with funds from the Lawrence Archer Wachs Trust, 1998.43

This impressive carving represents a ritual mask of the Baga, one of three main tribes who inhabit the Atlantic coast of southwestern Guinea. Worn by members of the dominant Simo secret society, it depicts the spirit Nimba, goddess of increase and fecundity.

An embodiment of the goddess and of "mother earth," the Nimba mask was associated both with human procreation and with the fertility of the fields. According to nineteenth-century accounts written by travelers in the region, it was carried about in the marshes and tall grasses of the Baga rice paddies. A potent fertility symbol, the goddess Nimba was also invoked by infertile women in the Simo society. The headdress, in fact, represents an idealized female figure; the long, flat, pendulous breasts identify her as a mature woman who has given birth to many children and has nurtured them to adulthood.

The most monumental of ritual African masks, the Nimba mask towered eight feet above the ground when worn over the shoulders by a Baga dancer.

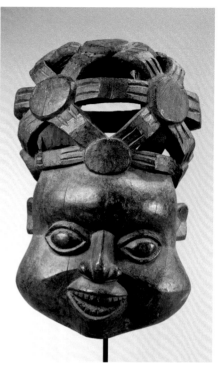

Mask

Cameroon, western grasslands region
(unidentified culture group)

Late nineteenth century

Wood

28 1/2 x 17 1/4 in., diam. 13 1/2 in.
(72.4 x 43.2 cm, diam. 34.3 cm)

Museum Purchase: Gift of Al Vontz, 1991.133

The Museum's mask comes from the grasslands region of western Cameroon, an ecologically diverse area that is home to many ethnic groups. Numerous independent chiefdoms exist there, varying in population from a few hundred to many thousand. Within such chiefdoms, which are governed by a king and a class of male title holders, masks play an important regulatory and symbolic role. Masks such as the Museum's example were owned by large or important lineages. Their ownership was licensed by the chief and the regulatory society for a fee, and the owner was under obligation to maintain them. Lineage masks were worn primarily on two occasions: at the chief's annual harvest festival and at an adult male's death ceremony. Such observances were accompanied by drums, xylophones, and rattles.

The Museum's mask is distinguished by its elaborate openwork super-structure, which depicts a pair of stylized spiders. The spider is a common icon in grassland prestige art. A nocturnal creature that lives in the ground and emerges after sunset, it inhabits two worlds—the realm of the living and of the dead. The living depend on communication with the wise and powerful ancestors; thus the spider, who travels between the two worlds, functions as a mediator and an animal of divination. The chief, the center of his universe, also can be compared to a spider in its web. On this mask, the full cheeks refer to the chief's prosperity and well-being, and to privilege in general.

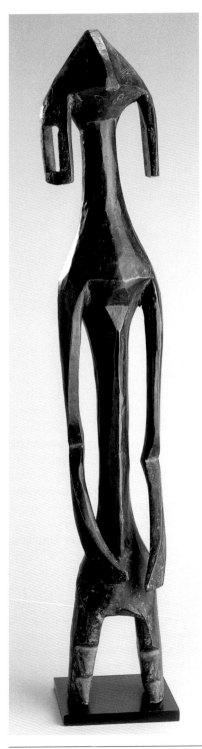

Human Figure

Nigeria, Benue River valley (Mumuye people)
Late nineteenth or early twentieth century
Wood
37 x 6 1/4 in., diam. 5 1/4 in. (94.4 x 16 cm, diam. 13.5 cm)
Museum Purchase: Gift of Mr. and Mrs. Leonard Minster,
by exchange, 1989.108

This striking sculpture is a distinctive creation of the Mumuye, a tribal group occupying the northern Benue River region of eastern Nigeria. Only in the last few decades have the cultural traditions of the Mumuye, inhabitants of the remote, rocky Adamawa plateau, become known to the West. Present-day scholarship has not only led to a stylistic attribution of their work but has increased the understanding and appreciation of their rich sculptural heritage.

Mumuye figures were used in a variety of ways and in a number of contexts. Some were employed by diviners and healers in diagnosing and curing illness; others were used to guard the home, dispense justice, or reinforce an elder's status. Probably the carvings were meant to represent ancestors and other important figures. They were usually kept in a house, where offerings were made to them.

The sculptures of the Mumuye display several distinctive characteristics, most noteworthy of which are the pendent earlike elements that flank the face. These are thought to represent either distended earlobes or perhaps earrings. The Museum's figure, with its masterful carving, graceful silhouette, and commanding presence, ranks among the finest Mumuye sculptures in the world.

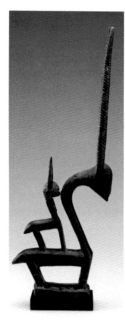

Antelope Headcrest

Mali (Bamana people)

Twentieth century

Wood

26 1/4 x 10 3/8
x 1 3/16 in.
(66.6 x 26.3 x 3.0 cm)

Gift of Mary Mills Ford,
Olive Lloyd Mills, and
Marcia Mills Bogart in
memory of Edward Lloyd
Mills, 1964.157

Antelope Headcrest

Mali (Bamana people)

Twentieth century

Wood, iron staples

13 5/8 x 23 x 4 3/4 in.
(34.5 x 58.4 x 12.0 cm.)

Museum Purchase: Gift of Mrs. Alfred Anson,
Mrs. Albert Strauss, and James H. Stone, by exchange,
1988.151

These two carved headpieces are products of the Bamana, the largest cultural group in the western Sudan, who inhabit western and central Mali. Most Bamana sculpture is created for use in the ritual activities of male initiation societies called *jow*, age-graded associations through which males pass as they develop from child to adult. One such society, the Chi Wara, is named after an antelopelike mythical creature, half animal, half man, who introduced agriculture to humankind. The antelope headdress is used ceremonially in masquerades associated with the agricultural cycle. It is worn during planting and harvesting seasons, when masked tribe members dance in the fields and in the village square. The masquerade is performed by two men, representing a male/female pair, who dance bent over with antelopelike movements.

The Chi Wara figure can be represented as either male or female. The female is typically depicted with a baby, symbolizing the earth and humankind. The antelope's long horns represent the successful growth of millet, the staple crop of the Bamana. The Museum's two head ornaments, with their vertically and horizontally aligned horns, represent two distinct types or styles: one is associated with the area around Segou, and the other with the Bamako region. On the second example, the adult female's head projects in abstract fashion from the baby's body. Each sculpture rises from a pierced rectangular platform, which originally attached to a basketry cap.

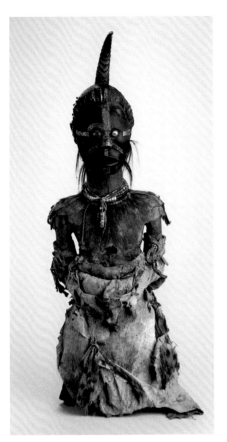

Power Figure

Zaire (Songye people)

Late nineteenth or early twentieth century

Wood, antelope horn, animal skin, fur, applied metal, beads, fetish material

43 1/4 x 15 9/16 in., diam. 16 5/6 in.
(109.8 x 39.5 cm, diam. 41.5 cm)

Gift of the Edwards-Britt Collection, 1976.418

M agic is particularly widespread among the Songye, an extensive tribal group centered in the province of Kananga in south central Zaire. Songye magical practice is exemplified by the use of medicine or power figures (sing. *nkishi*), which enhanced fertility and served a protective function.

The Museum's statue, a standing male torso, is an especially imposing example of this type. Like others of its kind, it is clothed heavily in skins and hides. On its lower portion, it bears a leather and hair loincloth and a stitched raffia mat with leopardskin apron. This image stands in a characteristic rigid, upright pose and cradles a miniature power figure tucked in the top of its loincloth. As on many Songye figures, the legs are not carved, and the torso merges with the cylindrical base.

The magical power of the *nkishi* derived from the fetish materials, or *bishimba*, applied to it. Such medicine bundles of hair, mud, and other organic materials were believed to have potent magical properties. Other elements of adornment, such as the skin clothing, the metal nails and spikes, and the black antelope-horn headdress, also added power to the figure and enhanced its protective function.

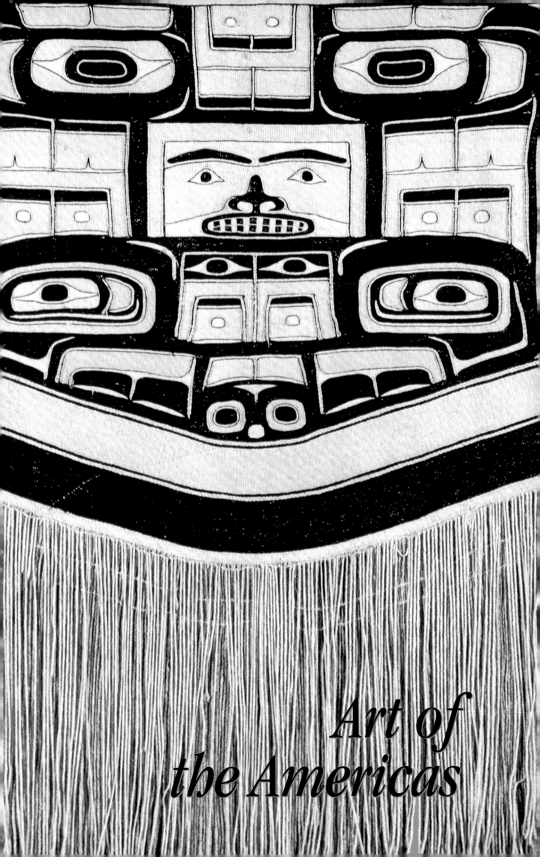

Art of
the Americas

Art of the Americas

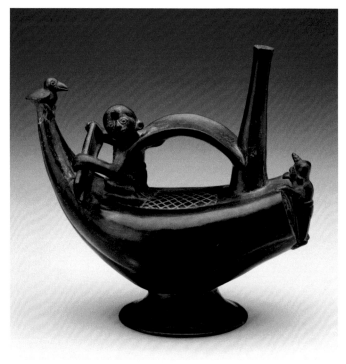

**Spouted Vessel
Modeled as a
Balsa-Reed Boat**

Peru (Chimu/
Lambayeque culture)

Ca. 1000–1400 AD

Earthenware

8 3/4 x 9 1/2 x 5 in.
(22.2 x 24.1 x 12.7 cm)

William W. Taylor
Endowment and Museum
Purchase: Bequest of R. K.
LeBlond, by exchange,
1988.59

Flourishing from about 800 to 1470 AD on the north coast of Peru, the Chimu were the main rivals of the more famous Inca, by whom they were conquered shortly before the Spanish arrived. The Chimu had a complex cultural and social structure, including skills in media such as pottery, weaving, and metalwork. Chimu ceramic vessels, able to withstand the passage of time and the ravages of burial, are among the most common of surviving artifacts.

Though most Chimu blackware is of indifferent quality because it was mass-produced, the Museum's vessel stands out as a sculptural masterpiece. It charms through gesture and personality, simplified forms, and direct treatment of the subject.

The body of the vessel is a boat similar to the tule boats still in use in Peru today. The vessel is mold-made, as are the three figures, the arched handle, the spout, and the ring, which were attached by hand to the boat. The whole vessel is finely finished and burnished to a lustrous black glow. The piece has been attributed to the Lambayeque culture of the north coast; according to a legend from that culture, the first king of the Lambayeque people reached the area in a reed boat.

The vessel is also a whistle. Air can pass from the spout through the vessel to a whistle mechanism located at the front of the strap handle. Whether the vessel comes from Chimu or Lambayeque, it is a superb example of pre-Columbian ceramic art.

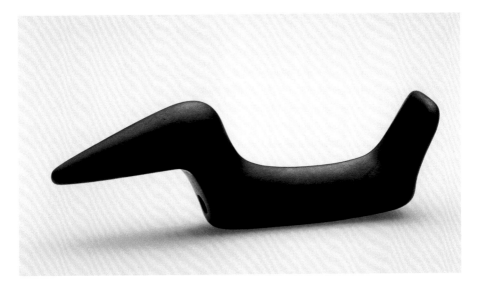

T oward the end of the Archaic period (4000–1500 BC), a variety of ground and polished stone objects made their appearance in eastern North America. One distinctive form, known as the birdstone, was characterized by an elegant, simplified shape depicting a wingless bird with a short, upturned tail and flat-bottomed body. Its precise function remains unclear. Like the "bannerstones" of an earlier period, it may have served as a weighted appendage for an *atlatl*, a launching stick for spears. The longitudinal perforation suggests that it was designed to be attached or secured to an implement of some sort.

With its elegant form and highly polished surface, the Museum's birdstone is a particularly refined example of its type. Like most birdstones, it shows no sign of use; this fact points to a ceremonial rather than a utilitarian function. It may have served a magical purpose, perhaps as an effigy of an actual bird decoy. Indeed, the distribution of the birdstone—over an area encompassing the Great Lakes basin and the Upper Ohio River Valley—supports this idea. A common grave good, the birdstone was clearly valued as a funerary offering. Through an elaborate network of exchange, it circulated widely through the eastern Woodland region of North America.

Birdstone

United States
(Ohio, said to have been found near Cincinnati)

Late Archaic
or early Woodland,
ca. 1500–500 BC

Slate

2 x 5 7/8 in.,
diam. 1 1/4 in.
(5.0 x 14.9 cm,
diam. 3.0 cm)

Gift of Judge Joseph Cox,
1888.512

Art of the Americas

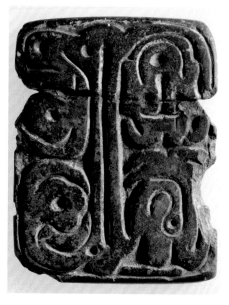

Engraved Tablet

United States, found in Waverly, Ohio (Adena culture)

Early Woodland period, second half of the
first millennium BC

Shale or siltstone

3 3/8 x 2 5/8 x 5/16 in. (8.6 x 6.6 x 0.8 cm)

Gift of Mrs. William M. Galt, 1939.140

During the early Woodland period, in the final centuries of the first millennium BC, the native populations of the central Ohio River Valley flourished under the Adena culture, known from its principal site near present-day Chillicothe in southern Ohio. Like the Hopewell peoples who followed them, the Adena were great mound builders; hundreds of their ceremonial funerary complexes have been found over an area extending from southeastern Indiana to southwestern Pennsylvania.

One of the distinctive features of the late Adena complex in Kentucky and Ohio is the presence of small, rectangular stone tablets incised with curvilinear designs. The Museum's example is one of 13 that have been discovered so far; all come from mounds in Ohio, Kentucky, and West Virginia. Like most pieces in the group, the Museum's tablet bears a highly stylized representation of what appears to be a raptor, or bird of prey. Raptorial birds, symbols of the sky and the celestial sphere, were represented so frequently that they must have played an important symbolic role in the Adena and later Hopewell cultures.

Traces of pigment found on several of these tablets indicate that they were used as stamps, possibly for decorating organic materials such as textiles or the walls of bark houses. They also may have served as body stamps designed to distinguish and identify members of a particular cult or kin group.

This specimen, known as the Waverly tablet, was uncovered in 1872 by a farmer in Pike County, Ohio, while he was leveling his field. A similar tablet in the collections of the Cincinnati Historical Society was discovered at the site of a large tumulus located at what is now the corner of Fifth and Mound Streets downtown.

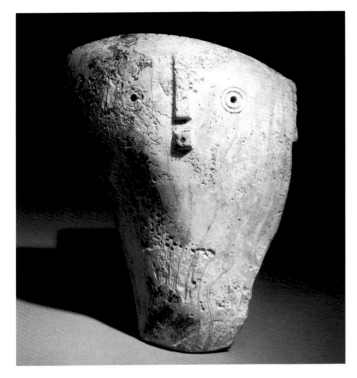

Mask-Gorget

United States, said to have
been found in Tennessee
(late Mississippian culture)

Ca. 1300–1500

Marine conch shell
(Buscyon perversum)

7 15/16 x 6 13/16
x 2 3/16 in.
(20.0 x 15.7 x 5.5 cm)

Gift of Thomas Cleneay,
1887.20607

I n the final centuries before the Europeans' arrival, a new cultural
tradition evolved in the Mississippi Valley from the mound-builder
cultures of the preceding Woodland period. Stimulated by renewed
contacts with Mesoamerica (Mexico and Central America), the Mississip-
pians developed a civilization and culture with a highly developed
ceremonial structure and belief system based on the concept of ritual death
and regeneration. This belief system, known as the "southeastern ceremo-
nial complex" or "southern death cult," was distinguished by an elaborate
iconographic tradition recorded on engraved shell pendants and drinking
cups and embossed copper plaques.

The Museum's shell mask is one such manifestation of this tradition. De-
signed as a gorget (a pendant to be worn on the chest), it depicts a stylized
human face with staring, pierced-hole eyes and a nose and mouth in relief.
Such masks, which were contained in sacred war bundles, reflect the im-
portance of warrior cults in Mississippian society.

Mississippian chiefdoms, like other Middle Woodland communities,
were linked by an extensive network of trade and cultural exchange that
extended north from the Gulf of Mexico to southern Canada. Like native
copper from the Great Lakes region, the marine shell, indigenous to the
waters of the Gulf Coast, was an imported luxury item. Masks made of such
shells have been found as far away as New York State. They were probably
carried in trade.

Art of the Americas

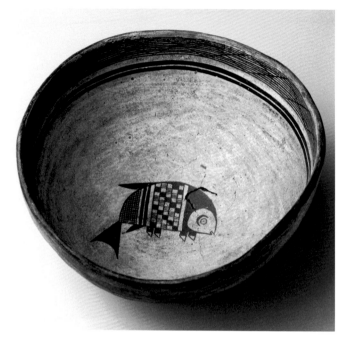

Bowl

United States, New Mexico
(Mimbres culture,
Mogollon tradition)

Ca. 1000–1300

Earthenware, white slip

H. 3–4 3/8 in.,
diam. 8–8 7/8 in.
(h. 9.5–10.5 cm,
diam. 20.8–22.5 cm)

Gift of Mrs. W.O. Owen,
1901.48

The Mimbres people, inhabitants of the highlands and deserts of southern New Mexico, formed part of a vast trade network in the greater Southwest. The pottery created by this branch of the Mogollon is distinctive in prehistoric Southwestern ceramic art. The bowls, produced by village women, fulfilled both a utilitarian and a ceremonial function. The most finely decorated examples, which represent only a small portion of the output of painted pottery, served a funerary function. As excavations have revealed, such bowls were frequently placed over the head of the deceased in burials situated directly beneath the floor of the family house. This custom suggests that the Mimbres were acutely aware of their lineage.

The pottery of the Mimbres, executed in a distinctive black-on-white style, is known for its vibrant, representational depictions of humans and animals. Some tell a story and have multiple figures; most, however, as on the Museum's vessel, show a single figure, usually an animal, represented individually or paired. The subjects—rabbits, lizards, insects, bats, birds, fish, mountain sheep—are depicted in a charming, often whimsical fashion. The Museum's bowl features a fish, a common motif on such painted bowls. Because water was a matter of great concern to the lives of the Mogollon farmers of the arid Southwest, many Mimbres designs include references to water animals.

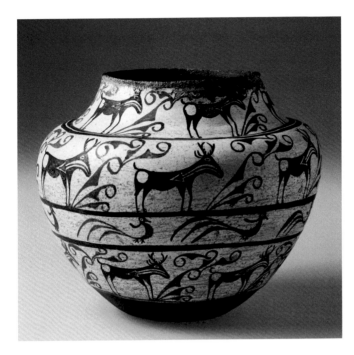

Water Jar (Olla)
New Mexico, Zuni Pueblo
Ca. 1875
Earthenware,
white slip, pigments
H. 11 1/2 in.,
diam. 13 11/16 in.
(h. 29.2 cm,
diam. 34.7 cm)
Gift of the Women's Art
Museum Association,
1885.48

The ceramic arts best exemplify the extraordinary cultural continuity that is the hallmark of the Indian Southwest. Modifications in materials and technology aside, the pottery of the region has remained remarkably stable from its first appearance around 300 BC to the present. While nearly all Southwestern Indians participated to some degree in the pottery-making tradition, the Pueblos of northwestern New Mexico, with their longstanding ceramic history, surpassed all others.

One of the best-documented and most graceful of Pueblo ceramic traditions is that of the Zuni. Beginning in the mid-nineteenth century, Zuni polychrome painted pottery evolved from an integrated geometric tradition (based on the triangle) to a more ornate style with an emphasis on the curvilinear. The Cincinnati vessel exemplifies the latter tradition, the hallmark of which was the animal file. The primary subjects, arranged in concentric friezes, consist of small birds, rabbits, and deer, which are presented against a background of subsidiary scrollwork.

An essential aspect of the Zuni-style deer is the red arrow of life or breath, which extends from its mouth to its heart. A characteristic Zuni feature, the heart line has been borrowed by other Pueblos, including the Hopi and the Acoma. The Cincinnati vessel, a water jar or *olla*, was acquired by James Stevenson during an ethnographic expedition sent to the Zuni by the Smithsonian Institution in 1879. It was given to the Cincinnati Art Museum in 1885 by the United States National Museum in exchange for Cincinnati Rookwood pottery.

Art of the Americas

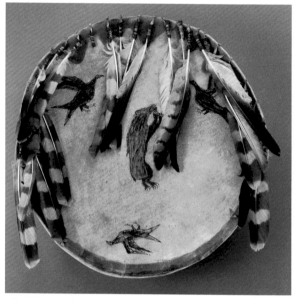

**Shield and
Shield Cover**

Northern Plains
(probably Nakota, Yankton Sioux)

Late nineteenth century

Buffalo rawhide, native tanned leather,
calico cloth, hawk feathers, pigment

Diam. 20 1/16 in. (51.0 cm)

Gift of General M.F. Force, 1894.1210

The shield, central to the life of the Indians of the northern Plains, served both a defensive and a ceremonial function. The Museum's example was probably an actual war implement, although it may have been used ceremonially in dance as well. Constructed of fire-hardened buffalo hide with a soft deerskin cover, it was worn around the neck and supported by a skin strap (which survives intact on the back). When the warrior was attacking, he wore the shield over his chest; when retreating, he swung it to the rear to protect his back.

Among the Plains Indians, a shield symbolized a man's status as a warrior and protector of his people. The magical power of the shield's painted design derived from the owner's visionary experience, during which sacred animals, messengers from the Almighty, answered his prayer for protection in battle. The primary animal subject on the Museum's shield is a bear (most likely a grizzly), shown charging or perhaps rearing up on his hind legs. The aggressive posture and prominent claws emphasize the vitality of this image, a symbol of physical and spiritual power to the Plains Indians. The bear, depicted whole or abstracted in the form of a bear paw, was a popular image on shields. Because the bear was thought to share many characteristics with humans, it was considered one of the animals most closely associated with healing and protective power. Here it stands surrounded by three large fork-tailed birds, probably swallows.

The inscription on the back of the shield identifies its maker and probable owner, a Yankton chief by the name of Wadutawakinyan, or Scarlet Thunder. It was acquired in the late nineteenth century by a retired army officer, General M.F. Force, who later enjoyed a distinguished career as an appellate court judge in Cincinnati.

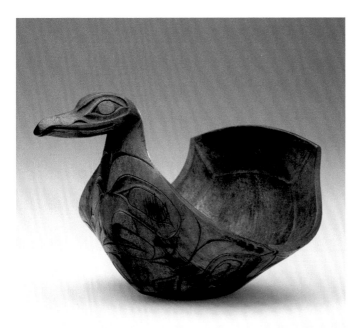

Ceremonial Oil Dish

Canada, British Columbia,
Queen Charlotte Island
(Haida)

Mid-nineteenth century

Mountain sheep horn

4 7/8 x 5 1/2 x 7 1/16 in.
(12.4 x 14.0 x 17.9 cm)

Source Unknown,
x1965.15

The massive spiral horns of the mountain sheep furnished craftsmen along North America's northwest coast with material for many kinds of portable objects, primarily bowls and spoons. The mountain sheep's horn is tough and hard, but it can be carved when thoroughly soaked. Heating the horn by steaming or boiling renders it soft and pliable, allowing it to be shaped and spread in a wooden form. When cool and completely dry, the horn retains its new shape.

The Museum's dish was produced by such a technique, probably by a craftsman of the Haida tribe of Queen Charlotte Island, located off the British Columbian coast. The work of a master carver, this piece is exceptional in its artistry. The fine-grained structure of the horn enabled its maker to achieve crisp, detailed relief carving of the vessel's underside, which bears the image of a hawk on the front and a bear on the back. The bowl itself is carved and shaped in the form of a small seabird, possibly a merganser. Its graceful, long-beaked head has inlaid eyes of abalone shell.

As elsewhere in northwest coast art, animal images such as the hawk and the bear were social symbols, emblematic of ancestry and status. The Museum's vessel, with its thin, translucent walls and its refined shape and carving, was clearly produced for an individual of considerable wealth and social standing. The horn of the mountain sheep itself was a valued commodity for the Haida, who acquired it by trade with peoples from the mainland. Like others of its type, the Museum's dish served as a receptacle for seal oil, a delicacy used at formal feasts as a dip for dried and smoked fish.

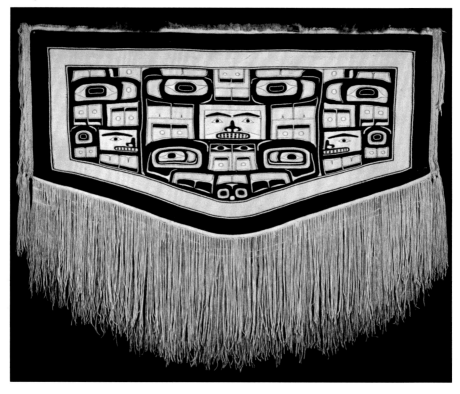

◀ *Chilkat Ceremonial Dance Blanket*

Alaska (Tlingit)

Mid- to late nineteenth century

Mountain goat wool, cedar bark fiber, otter fur, dyes

64 x 48 in. (162.6 x 121.9 cm)

Gift of Dr. and Mrs. W.W. Seely, 1888.282

A symbol of great prestige in the nineteenth century, the Chilkat blanket was an important part of a chief's regalia among the Tlingit and neighboring tribes of the Alaskan coast. The dance blanket, called *nakheen* ("fringe about the body") by the Tlingit, was an indicator of rank and wealth. The term *blanket* is a misnomer; the *nakheen* was a ceremonial garment designed to be wrapped around the body. When the wearer danced, the blanket's long fringe swayed with the movement.

The privilege of wearing a dance blanket was inherited; both men and women were potential recipients. Aside from its function in ceremonial dance, the *nakheen* served as a gift in the potlatch, a complicated gift-giving ceremony usually given by a chief to confirm his rank and privilege among his people. The acceptance of the blanket and other gifts by the guests was an acknowledgment of the host's rights. The *nakheen* also could serve as a burial shroud.

Woven of durable mountain goat hair and tough cedar bark, the Chilkat blanket is a masterpiece of construction and design. The men created the designs; the women did the actual weaving. The design was painted onto a full-size wooden board, which the weaver used as a "blueprint." The format was standardized, consisting of a central totem and flanking motifs in mirror image. The Museum's blanket features the clan or house emblem of the diving killer whale, flanked by the crest of the raven, one of two Tlingit tribal subdivisions. The Tlingit weaver's concept of totemic design is unique. The animal subjects are dissected into their basic parts (eyes, ears, teeth, fins), which have been rearranged. The subjects are presented in both profile and frontal view.

The final creation was the product of a painstaking process. From the spinning of the yarn to the creation of the design, a finely woven blanket could take more than six months to complete.

Costume & Textiles

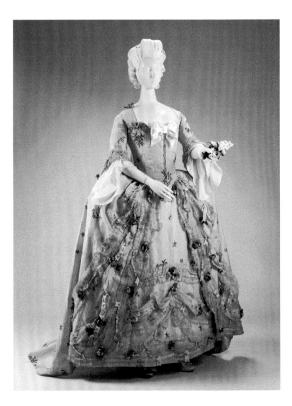

England
Formal Dress and Petticoat, 1770–80
Silk
Museum Purchase: Bequest of R.K.
LeBlond, by exchange, 1987.80a,b

This formal gown, with its bold silhouette, is called a sack or *sacque* in English and in French a *robe la Franaise*. Although it originated in French informal wear, this style became fashionable in the Western Hemisphere from the 1720s through the 1770s. The aesthetics governing formal dress in the 1770s decreed not only a preference for white fabrics, as seen in this gown, but also a particular manner of construction. The style is marked by two sets of box pleats falling from the back neckband into a wide train. The loose pleats conceal the fact that the bodice underneath is fitted tightly to a corseted body. The petticoat or skirt was worn over special narrow, oval-shaped hoops. Suspended from the waist, these hoops created a skirt that was absolutely flat in front and extended as far as two feet on either side of the woman's body. The oversized, artificial shape of the petticoat, the sweeping train, and the obvious cost of such a gown symbolized great wealth and privilege, and represented a society so impressed with artificiality that a woman who wore such a dress could not walk naturally.

Constructed of silk taffeta and delicately embellished with brocaded flower sprigs, printed ribbons, silk gauze, and silk laces, this dress uses approximately 22 yards of costly fabric, a sizable investment on the part of the wearer. It is rare in that it has remained unaltered and has retained all its original trim since it was constructed in the eighteenth century.

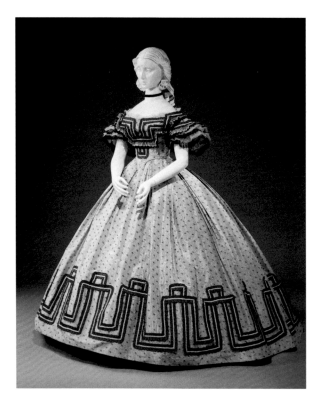

United States (Boston)
Dress: Day Bodice, Evening Bodice, and Skirt, 1862–64
Silk
Museum Purchase:
Gift of Mrs. J. Louis Ransohoff,
by exchange, 1987.83a–c

From the shape of the sleeves and skirt to the fabric and trim, this dress embodies the elegant ideals of the early 1860s and serves as an important document of style. Consisting of a skirt with two matching bodices, this ensemble would have been considered quite economical because it could be worn both for daytime activities and for elegant evening affairs. The day bodice is appropriately modest, with a high neckline and long sleeves. The evening bodice illustrated here has an elegant, low neckline and is trimmed much more elaborately. The short sleeves are very full, creating a visual balance for the volume of the skirt.

Largely because of the invention of the cage crinoline, women's skirts in the 1860s grew larger than at any other time since the eighteenth century. The crinoline, a lightweight support worn under the skirt, was constructed of a series of wire hoops suspended from a waistband by wide cotton bands. This skirt, with a circumference of 180 inches at the hem, is supported by a cage crinoline. The expanse of the skirt provides a perfect background for the bold ribbon trim applied in a Greek key design. This very stylish motif is rendered in magenta, the most fashionable color of the period.

The fabric of this dress is also remarkable. The crisp, silk taffeta is woven in a small black-and-white check. Superimposed on this grid is a floral pattern created by a technically difficult process called chiné, in which the pattern is printed on the threads before the fabric is woven.

Costume & Textiles

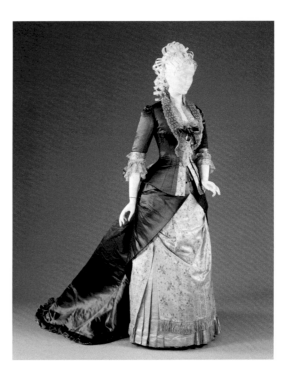

Charles Frederick Worth
(1826–1895)
England (worked in Paris)
Reception Dress:
Bodice and Skirt, 1877–78
Silk
Gift of Mrs. Murat Halstead Davidson,
1986.1200a–c

harles Frederick Worth, considered to be the father of haute couture, was an artist, innovator, and genius. Born in Lincolnshire, England, with aspirations to become a painter, he found himself, by chance, employed at a draper's shop at the age of 11. Immersed in the world of fabrics and women's clothing, he learned all he could and made his way to Paris. As an apprentice in one of the city's finest fabric shops, Worth soon began creating innovative fashions for Marie Vernet, who would become his wife. At his Paris salon, the Maison Worth, he created garments for the wealthiest women in the world, including Eugénie, the Empress of France; Lillie Langtry, a well-known American actress; and Mrs. J. Pierpont Morgan, as well as many fashionable and wealthy Cincinnatians.

The legacy of the "Age of Worth" is represented by 10 examples in the collection of the Cincinnati Art Museum; many were worn by Cincinnati women. This dress, created for Mrs. Joseph Clark Thoms of the Swift family, is a semiformal dress worn at home for receiving visitors. Made of brilliant royal blue silk satin and a delicate silk brocade inspired by the 1760s, it epitomizes the ideal silhouette of the period. The bodice is custom made to fit smoothly over the body. This style, which covers the torso to the hips, was called the *cuirass* bodice because it fit so closely, much like armor. The slim skirt is a simple shell on which a collage of fabrics, trims, and ruffles is tacked. The dress bears the mark of Worth in its fine fabrics, fashionable silhouette, and eighteenth-century panniered look about the hips.

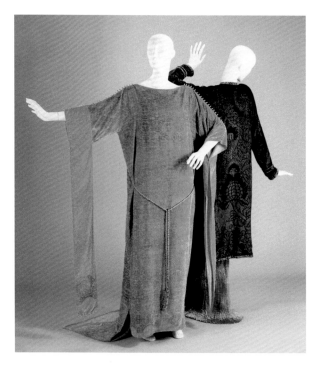

Maria Monaci Gallenga
(1880–1944)

Italy

Dress and Sash,
1920–22

Silk, metallic cord

Gift of Hedda Windisch von Goeben,
1989.117a,b

Mariano Fortuny y Madrazo
(1871–1949)

Italy (Venice)

Evening Coat,
1915–25

Silk, gold and silver, metallic powder

Gift of Patricia Cunningham in honor
of Mrs. Alfred L. Flesh, 1986.1126

A round 1907, Mariano Fortuny perfected a process that enabled him to make fine pleats in lightweight silk satin. He fashioned lengths of this fabric into one of the most revolutionary garments of the twentieth century—the Delphos gown. Inspired by ancient Greece, this columnar dress fell from the shoulders and clung to the body. It was a second skin, a timeless shape, in sharp contrast to the fashions of that period. Along with his dresses, Fortuny designed soft velvet coats and jackets. These were often embellished with gold and silver powders attached to the surface with albumin, a natural paste, in large-scale patterns inspired by historical fabrics. This three-quarter-length coat is decorated with a Renaissance-inspired pomegranate pattern printed with gold metallic powder on dark brown silk velvet.

Fortuny had only one disciple, Maria Monaci Gallenga. Although she did not train or study with him, she developed a style of tea gown made of stenciled velvet which echoed those created by the Venetian designer. At the same time, however, Gallenga gowns made their own statement. They were cut in the style of a medieval tabard: two flat rectangular panels were joined at the top and sides, and the back panel was long enough to form a train. Long paneled sleeves almost touched the floor. Embellishment was limited to tubular Venetian glass beads set along the seams. Both Fortuny and Gallenga were among the most forward-looking designers of the early twentieth century, and their designs were the precursors to the simpler cuts of the 1920s.

Costume & Textiles

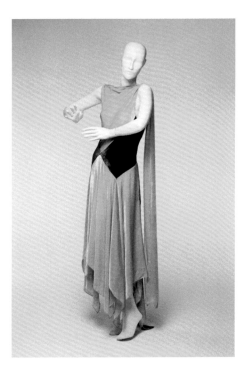

Madeleine Vionnet (1876–1975)

France

Dress, 1926–27

Silk

Gift of Dorette Kruse Fleischmann in memory
of Julius Fleischmann, 1991.199

Madeleine Vionnet is considered by many to be the greatest, most innovative, most intellectual couturier of all time. It was Vionnet who first took a "modern" approach to fabric, and who perfected the bias cut to clothe the body.

Rejecting the traditional method of designing by drawing, Vionnet draped the fabric directly on the human form. By working in the round she could visualize the garment as a whole, and she was able to find solutions to design problems that were unavailable to those who relied on two-dimensional sketches. Her use of the bias cut—cutting the fabric at a 45-degree angle across the grain—allowed her dresses to follow the body's contours like a second skin. This method of construction eliminated the need for multiple seams to fit the cloth to the figure. Vionnet's dresses could be slipped over the head. They needed no fastenings or underpinnings, and they clung to the form of the body.

This Vionnet evening dress is the quintessential example of the bias cut that characterized fashions of the 1930s. Constructed of dark and light green silk velvet, it falls perfectly and softly on the figure. Because of her repeated use of geometric shapes in her garments, Vionnet was known as the Euclid of fashion. In this dress, she has used triangles of contrasting colors that converge just below the waistline. The entire bodice and the floor-length floating panel that hangs down the back are cut from a single piece of fabric. The skirt and its handkerchief hem are made from only three large rectangular pieces of velvet.

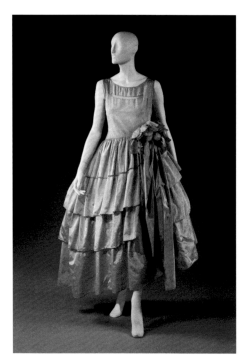

Jeanne Lanvin (1867–1946)
France
Evening Dress and Hoop, 1927
Silk
Gift of Mrs. Raymond M. Lull, 1976.206a,b

Jeanne Lanvin headed one of the premier Paris couture houses of the 1910s and 1920s, even though her "pretty" dresses contrasted sharply with the slim, almost androgynous aesthetic of that period. Lanvin's designs seemed to exist in a time of their own: although modern, they were never governed by the prevailing modes.

Throughout her career, Lanvin was firm in her belief that "women were meant to wear clothes of unabashed femininity." Her work represented the survival of romantic clothing. During periods when fashion offered only a single silhouette, Lanvin always offered a feminine alternative. In the early 1920s, when skirts were slim, she championed the *robe de style,* inspired by eighteenth-century fashions, which featured a full skirt supported by a knee-length oval hoop petticoat. This style was associated so closely with the House of Lanvin that it is still used today on the Lanvin label.

Color was a primary concern of Lanvin's, and she maintained her own dyeworks to achieve the clear, subtle, feminine colors that she favored. This dress of clear peach taffeta is a *robe de style* and features Lanvin's favorite motif, the flower. This single embellishment, with blue streamers falling from its center, is echoed in the tiers of the skirt. When the donor and her sister made their debuts, they both wore this Lanvin design with the colors reversed.

Costume & Textiles

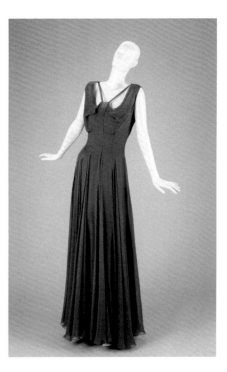

I n the 1930s, when Elizabeth Hawes opened her shop in New York City, American women still looked to Paris for couture garments, and American designers generally copied designs by the famous French couturiers. The young Hawes created original designs for her clients, which uniquely fit the American lifestyle. She is considered to be the first important American designer and was the first to be recognized as an American couturier. In fact, Hawes did nothing but couture work throughout her career. She never created a retail or ready-to-wear line.

Hawes, who trained in Paris, was a great admirer of Madeleine Vionnet, and the line of her garments reflects Vionnet's influence. But Hawes' designs were unique, the cut of her clothes was complex, and the garments were unrestrained and elegant. She created dresses that molded to the body. They were soft and gentle, following the body's natural proportions. Her genius lay not in eye-catching surface embellishment but in the ingenious cut of the clothes.

This innovatively constructed evening dress of soft blue silk chiffon was created for Cincinnati socialite Dorette Kruse Fleischmann. The cowl neckline is pulled up in the center by separate straps, creating a soft fullness around the bust. The back neckline is a deep V, a characteristic Hawes device. The dress is cut in a princess line to fit the body. Multiple triangular pieces or godets, set into the skirt from the waist to the hem, allow the skirt to fall straight when still but reveal a hidden fullness when in movement.

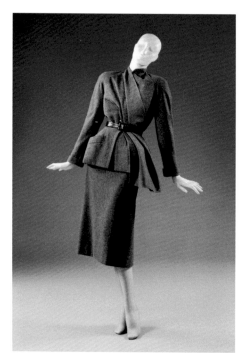

Christian Dior (1905–1957)
France
Suit: Jacket, Skirt, and Belt, 1950
Wool
Gift of Marilyn M. Maxwell, 1987.152a–c

Christian Dior's impact on twentieth-century fashion was inestimable. His first collection, presented in Paris in 1947 and christened the "New Look," was such a success that the name Dior became a household word almost immediately. In a reversal of typical 1940s designs, the New Look featured a cinched waist, padded hips, unpadded shoulders, and yards of fabric.

Dior fueled an era of relentless change in fashion. Throughout his career he created two distinctly different collections every year, each with its own personality, its own innovations, and its own descriptive name. In 1954 he created the "H" line; in 1955, the "Y" line. The "A" line or trapeze line appeared in 1956. Each of these collections was a "new look" emphasizing a new cut or shape to the clothing. Dior's collection for autumn 1950 was the "Oblique" line, named for the asymmetry apparent in each garment. Asymmetrical necklines and bodices, side fastenings, and spiral seams were incorporated in innovative ways into the Oblique designs.

From 1947 to 1956, Dior's designs followed either of two silhouettes. Skirts could be pencil thin or extremely full, but each was paired with a form-fitting bodice with a defined waist. This suit from the Oblique line is no exception. It has no lapels or collar, but features a built-in scarf cut as an extension of the right-hand side of the jacket. The scarf wraps to the left-hand side of the body and is held in place by a leather belt. The jacket flares over padded hips and a slim, straight skirt.

Costume & Textiles

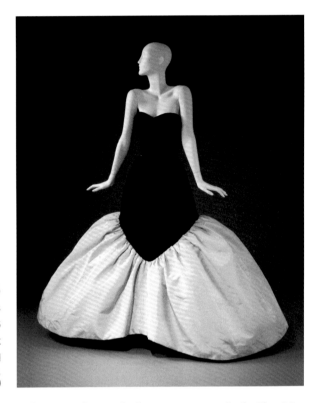

Charles James (1906–1978)
United States
Evening Dress, 1956
Silk
Museum Purchase: Gift of Mr. and
Mrs. J.G. Schmidlapp, by exchange,
1987.79

Trained as an architect, Charles James was credited with raising fashion from an applied art to a pure art form. Cristóbal Balenciaga called him "the world's best and only dressmaker," and Christian Dior credited James with inspiring his revolutionary "New Look" collection. His work was classically couture, but his approach to design was radical. Unlike other designers, James was not confined by fashion trends. Rather than changing his designs every six months, he worked and reworked a single design for decades.

When designing a dress, James created a master pattern, which served as the design module. Interchangeable parts for each section of the garment could be combined to produce thousands of variations. James is best known for his highly structured and engineered ball gowns, which he created with mathematical precision. These grand gowns are sculptures that fit the wearer closely but maintain their three-dimensional form when removed from the body.

This architectural masterpiece, titled *Lampshade*, was one of only 1,000 designs that James completed during his 40-year career. Although a master colorist, James used black and white to realize his purest design concepts. The dress is constructed of black silk velvet and white silk faille; both sections are supported by rigid substructures. The figure-eight-shaped white flounce measures five feet wide at the hem.

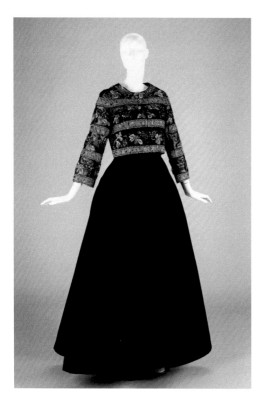

Cristóbal Balenciaga (1895–1972)
Spain (worked in Paris)
Evening Dress, 1960–62
Silk
Gift in memory of Irma Mendelson Lazarus,
1993.189a

Evening Jacket, 1959
Cotton, silk, chenille, metallic thread, sequins
Gift in memory of Irma Mendelson Lazarus,
1993.222

W ithout question, Cristóbal Balenciaga is the most highly regarded couturier of the twentieth century. He was a master of the tailoring and dressmaking skills necessary to achieve his artistic vision. Balenciaga's standards were so high that he reputedly spent days on a single dress, pulling it apart, recutting it, and altering it until it fit to his satisfaction.

Cincinnati socialite Irma Lazarus wore this black strapless evening dress and embroidered jacket to dramatic effect. The dress is severe and sculptured; its drama lies in its complete simplicity. Fabric gathered around the bust forms an empire waist. The A-line skirt falls from below the bust to the floor, fitting the waist closely. Constructed with two linings, one of silk taffeta and the other of horsehair, the skirt maintains its perfect triangular shape.

The jacket, a masterpiece in itself, is constructed of black cotton tulle trimmed with bands of soft blue silk chiffon. It was embroidered by the House of Lesage, still today the most highly regarded French embroidery firm, in an exquisite design of grapes, grape leaves, and floral vines in silk floss, silk chenille, sequins, and metallic threads. The jacket is the perfect accompaniment for the severely simple dress.

Costume & Textiles

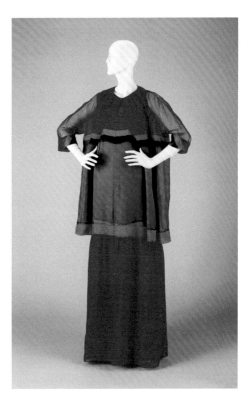

Givenchy (Hubert Taffin de Givenchy) (b. 1927)

France (Paris)

Evening Ensemble: Dress, Overdress, and Jacket, 1968–72

Silk

Museum Purchase: Gift of the Fashion Group, Inc., Cincinnati in honor of the bicentennial of the city of Cincinnati, 1988.2a–c

ivenchy is one of the most respected names in fashion. Beginning his career in Paris at an early age, he formed a close friendship with master couturier Cristóbal Balenciaga, who greatly influenced his work. The basis of Givenchy's success is his superb craftsmanship and the perfection of the cut of his clothes. A designer since 1952, Givenchy continues to create clothing that is elegant, refined, and glamorous.

This three-piece ensemble is an outstanding example of Givenchy's work from the late 1960s. It exemplifies his affinity and exceptional talent for designing separates that one can use to create an individual look. A strapless silk crepe minidress is combined with a full-length silk organza overdress and a thigh-length jacket, each printed with olive green, orange, and red bands. The minidress and the jacket are of the same length and can be worn without the overdress. The ensemble is made in the highest traditions of fine handwork typical of couture clothing. The custom-made fabric is printed expertly so that each color band matches exactly with the underlying layers. It is printed in an abstract, painterly technique evocative of the color field paintings of Mark Rothko, an artist of the same era. This ensemble is an important example of fashion as art on the cutting edge.

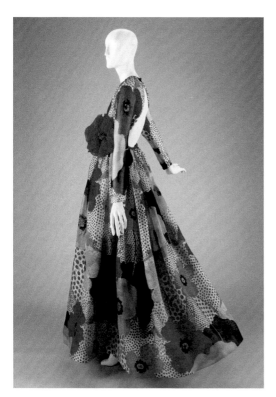

Geoffrey Beene (b. 1927)
United States
Dress, 1969
Silk
Gift of the Judy Robinson Gallery, 1991.92

R egarded as one of America's most forward-thinking designers, Geoffrey Beene established his house in 1962. He was one of several young, pioneering designers in the 1960s who rejected traditional couture and championed ready-to-wear clothing as the wave of the future. Beene's look has always been strong and individualistic. In the tradition of Coco Chanel, he is known for his innovative and complex ways of cutting the fabric, which eliminated the need for bulky seams, facings, and zippers. He is also known for his bold use of color and unusual combinations of fabrics; sometimes he combines as many as four different fabrics in a single dress.

This evening dress typifies the Beene aesthetic in color, pattern, texture, and cut. Boldly printed textiles such as this were seen in his very first collections, and have appeared again and again throughout his career. This dress is fresh, young-looking, and relaxed. Trimmed with a large silk poppy at the waist, it is printed with multicolored poppies on a background of polka dots in varying sizes and shades of pink. The full, fluttering skirt is lined with a slim sheath of silk jersey. The high neckline and long sleeves contrast sharply with the low back, a perfect example of Beene's use of cut to surprise and shock.

Costume & Textiles

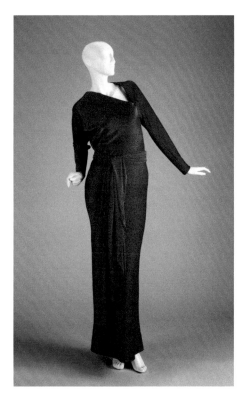

Halston (Roy Halston Frowick) (1932–1990)
United States
Dress and Sash, 1970–75
Silk
Gift of Mrs. George Wile, 1994.76a,b

H alston is recognized unequivocally as one of America's most important designers; his clothes define "the all-American style." Influenced greatly by Madeleine Vionnet's reductionist construction and by the sculptural work of British designer Charles James, Halston created minimalist garments that emphasized line and shape. Like Coco Chanel, he rejected traditional dressmaking and tailoring techniques. Like Vionnet, he reduced clothing to simple planes and clean lines. Halston took the understated, casual, comfortable clothes that American women loved, and raised them to a new level by making them from the most luxurious, most expensive fabrics in sophisticated colors.

Halston created clothing without zippers, pockets, ruffles, or notched lapels, and almost without seams. He avoided any construction technique that created bulk or disturbed the line of the garment. His columnar dresses fall from the shoulders, creating a narrow, elongated silhouette.

This simple, elegant evening dress of brilliant orange silk matelassé epitomizes the Halston look. The distinctive cut of the asymmetrical bodice is one of Halston's major innovations of the early 1970s. Cut on the bias, the entire dress is made of only two pieces of fabric, with virtually invisible seams. One piece forms the left sleeve and the back bodice; the second piece wraps the body and forms the right sleeve, skirt, and front bodice.

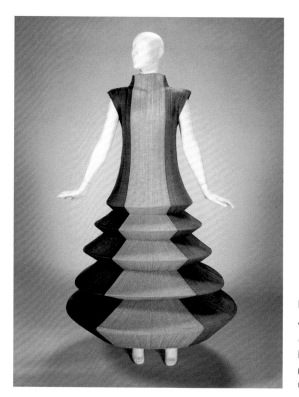

Issey Miyake (b. 1935)

Japan

Minaret Dress, 1995

Polyester

Gift of Miyake Design Studio in memory
of Otto Charles Thieme, 1997.6

More than any other contemporary fashion designer, Issey Miyake is an artist and sculptor who happens to work with fabric. He has been producing groundbreaking collections since 1971. Miyake does not conform to the dictates of seasonal fashion that limit other designers. His designs do not go out of style because they have little relation to contemporary fashion as we know it.

With strong roots in his native Japan, Miyake uses elements of traditional Japanese dress for modern purposes. Utilizing the kimono's basic concept of space between the body and the cloth, his designs allow the wearer and the garment to interact. These designs are not complete until they are placed on a living body. Movement and the wearer's creativity are required to bring the clothing to life. Miyake's fabrics are equally inventive and are an important part of his ideas of adjustability, comfort, and individual expression. His clothes are "sculpted" from permanently twisted, crumpled, wrinkled, pleated, and folded fabrics that he designs himself.

This piece, titled *Minaret Dress*, resembles a minaret—a slender tower with projecting balconies. Constructed of permanently pleated polyester in two shades of orange and green, the garment is made sculptural by a succession of hoops within the structure. When worn, it sways and bounces with the wearer's movements. Essentially it is a kinetic sculpture that happens to be a dress.

Costume & Textiles

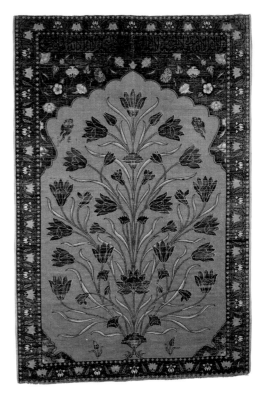

Iran
Prayer Cloth of Shah 'Abbas, ca. 1620
Silk, silver thread
49 x 33 in. (124.5 x 83.8 cm)
Gift of Mr. and Mrs. John J. Emery, 1966.1180

An era of remarkable cultural richness, the Isfahan period in Iran covered some 125 years from 1597, when Shah 'Abbas I established Isfahan as the new capital city, until 1722, when the city was conquered by the Afghans. The city's architecture, as well as its textiles, pottery, paintings, calligraphy, and metalwork, rivaled those produced in Europe, China, or India during this period. This prayer cloth is said to have belonged to Shah 'Abbas himself, although it contains no mention of the ruler. Dated to the early seventeenth century, it was most likely produced in a workshop in Isfahan. It represents the finest of Safavid court weaving.

Like other artistic products of the period, this textile is designed with a brilliant surface. The impact of both color and materials is immediate and dazzling. The design accentuates the play of light, and the motifs are delicate and traditional. The cloth is woven with a brilliant orange field shaped to create a mihrab, the niche in a mosque indicating the direction of Mecca, toward which all Moslems turn in prayer. The orange ground is filled with delicately meandering flowers brocaded in silver threads. The background, also woven with silver threads, is ornamented with flowers woven in orange, blue, and white with green leaves and stems. The inscription at the top, repeated three times, enumerates the Shahada, the fundamental creed of Islam: "There is no God but Allah, and He is one, and He has no equal."

This beaded picture is an unusual piece of Stuart embroidery in a style popular in seventeenth-century England. The figures stand in conventional poses. The picture has a two-dimensional appearance because the figures are outlined with black beads and lack realistic shading. Any feeling of depth results from the overlapping of shapes, but this is negated by the artist's disregard for the conventions of size and perspective: objects or animals in the background are as large as those in the foreground. The scene itself is marked by simplicity, almost naiveté—not surprising, as this type of beadwork was often executed by young English girls.

Exquisitely detailed and worked with expensive imported beads, this piece is of the highest quality. Although there is no way of knowing the subjects' identity, their fine and fashionable clothing shows that they are people of wealth. Often beadwork of this type portrayed Old Testament stories or royal personages. The man's gift of a flowering tree branch to the woman may signify an engagement, a marriage, or a political alliance. In fact, this scene strongly resembles an engraving by Robert van Voerst dating from 1634 and based on a painting by Anthony van Dyke. The engraving portrays Charles I and Henrietta Maria exchanging leafy branches. Although the embroidery shown here is not identical to that in the engraving, the similarity between the poses cannot be discounted. The engraving may have served as the source of this piece, with some artistic license on the embroiderer's part.

England
Beaded Picture,
1650–70
Linen, glass beads
10 3/4 x 13 1/2 in.
(27.3 x 34.3 cm)
Gift of Susan A. Thieme in honor of Otto Charles Thieme, 1993.203

Costume & Textiles

India (southern Coromandel coast)
Palempore, 1700–35
Cotton
109 1/2 x 85 in. (278.1 x 215.9 cm)
Museum Purchase, 1993.77

Traveling on India's west coast in the early seventeenth century, a Frenchman, François Pyrard, recorded in his diary the fabrics he saw. He noted the unique cotton fabrics richly patterned with brilliant colors, which only the richest Europeans could afford. Certainly he was writing about palempores, lengths of cotton chintz painted in exotic patterns. Palempores were used primarily as tent hangings and floor coverings for pavilions, tents, or marble palace floors in India or as bed coverings, formerly exported to Europe. Ornamented completely by hand through a complex series of dyeing and finishing processes, this textile represents the height of artistry and technical expertise. A single piece required up to six months to complete.

This particular palempore represents one of two decorative styles. Featuring a central medallion—a coat of arms held aloft by two lions—set against a fantastic ground of floral and vegetal motifs, it is related to Persian carpet designs probably introduced into India by the Mughal rulers. The exotic motifs show the influences of the far-reaching Indian textile market in Europe, Japan, and Java.

This palempore is an object of great rarity and beauty. It exemplifies the excellence developed in India over hundreds of years, both in design and in the complex technologies needed to produce such a textile.

After **François Casanova** (1727–1802)

France (Royal Beauvais)

The Four Ages: The Marriage of Antoinette de Bertier de Sauvigny to the Marquis de la Bourdonnaye (La Promenade), 1778–80

Linen, wool, silk

122 1/2 x 83 1/2 in. (311.2 x 212.1 cm)

Gift of John J. Emery, 1960.558

This tapestry is part of a set of four tapestries called *The Four Ages,* which also includes *Motherhood and Infancy, The Education of the Children,* and *The Pleasures of Youth.* Woven between 1778 and 1780 at the royal factory at Beauvais, France, one of the leading tapestry workshops of the eighteenth century, these tapestries are unique in many respects and of the utmost importance and beauty.

The tapestries were commissioned by Louis Benigne de Bertier de Sauvigny, Intendent de Paris, for his daughter's marriage. This series is one of the few that were executed only once, and it contains a remarkable set of family portraits. Many members of the de Sauvigny family can be recognized in the tapestries, including de Sauvigny and his father-in-law. These two men were among the first victims of the French Revolution; they were hanged in front of the Hôtel de Ville in Paris on July 18, 1789.

In *The Marriage*, the young bride and groom, Antoinette de Bertier de Sauvigny and the Marquis de la Bourgonnaye, are descending the stairs of a country church. The bride, her hair ornamented with clusters of flowers, is wearing a fashionable pink-and-white dress. Her right hand rests on the arm of her husband, who is wearing the traditional brightly colored clothing of an eighteenth-century bridegroom. Behind the wedding couple are the bride's father, Louis Benigne de Bertier de Sauvigny, and a family member who was an abbot and may have performed the ceremony. They are followed by a group of guests. In the foreground, a beggar asks for alms; in the distance, a pathway leads to a pastoral scene of young men and women dancing to pipes, a drum, and a violin.

Costume & Textiles

William Morris, designer
(1834–1896)
Merton Abbey Works
England, Surrey
Evenlode, 1883–1900
Cotton
50 x 66 1/2 in. (127 x 168.9 cm)
Museum Purchase: Gift of Mr. and
Mrs. Bruce Davies in memory of Carol
R. Guggenheim and Gift of Mr. and
Mrs. Bayard L. Kilgour, Jr., by
exchange, 1993.144

Textiles designed by William Morris are some of the most recognizable of all nineteenth-century designs. Morris, driven by both perfectionism and aesthetic vision, laid the groundwork for the rejection of mass production and the rejuvenation of the idea of the artist as designer. Morris and Co. was founded in 1874, and by the early 1880s, William Morris was one of the most important individuals in English decorative arts. Before the late 1880s, he produced more than 600 designs for wallpaper, embroideries, tapestries, rugs, and woven and printed furnishing fabrics, and trained himself in all related techniques to do so.

Morris' passion was a desire to master the dye process and its application to textile printing. Of all the printing techniques developed at his dyeworks, Merton Abbey, the most important was indigo discharge, a complex process that involved not only printing dye colors but resists and discharges as well. *Evenlode*, designed in 1883, was a pattern derived from Persian and seventeenth-century Italian velvets and is a masterpiece of indigo discharge. The printing of this pattern involved the use of 33 different printing blocks. The dark green background alone required dyeing the cloth blue and overprinting with a strong yellow. This floral pattern is a complex series of printing resists, which kept dye from penetrating the fabric; printing dye, which gave the fabric color; and discharges, which lifted color out of the fabric.

Raoul Dufy (1877–1953),
designer
Bianchini et Ferier,
printer
France
Le Moissonneur
(The Reaper), 1919–20
Cotton
47 x 94 in.
(119.4 x 238.8 cm)
Museum Purchase,
1929.202

Raoul Dufy, better known as a painter and graphic artist, began designing textiles in 1912 when M. Bianchini came to his workshop and offered him a contract to design for Bianchini et Ferier. That firm, located in Lyon, was the premier French textile house, and Bianchini's offer was a testament to Dufy's abilities as a designer. Between 1912 and 1928, Dufy produced more than 225 designs for Bianchini et Ferier, which were translated into both printed and woven textiles.

In this masterpiece of design, the bold brown-and-white image has the directness of a woodcut. Oversized sheaves of wheat surround a horse-drawn harvester, and the repeated pattern is dense and textured. Although the arrangement of elements is complex, no single part of the design dominates. The print suggests a powerful, even movement as the harvester grinds its way through the field.

ALBERT?
DVRER
NORICVS
FACIEBAT
·1504·

Prints

Martin Schongauer
(1445/50–1491)
Germany

Christ Bearing His Cross, ca. 1475
Engraving
11 3/16 x 17 1/16 in.
(28.8 x 43.3 cm)
Bequest of Herbert Greer
French, 1943.79

Martin Schongauer, the most important European engraver of the late fifteenth century, was the first northern printmaker whose work was widely known in Italy and Spain as well as Germany and the Netherlands. His work was imitated and copied by painters, sculptors, goldsmiths, and other printmakers. In 1492 the young Albrecht Dürer was so strongly impressed with Schongauer that he traveled as a journeyman to Schongauer's studio, unaware that the elder man had died the previous year.

Schongauer trained primarily as a painter, but he learned metalwork and engraving from his father, Caspar Schongauer, who was a goldsmith. Consequently he became the first *peintre-graveur*, an artist trained in composition, drawing, form, and color who chose printmaking as the principal medium of expression. Schongauer was greatly admired for his skill with an engraver's burin, a steel-shafted tool with two cutting edges on its diamond-shaped tip, and for his consistently fine printing.

Christ Bearing His Cross is Schongauer's most impressive work and one of the most famous prints in the history of art. This highly complex composition may have been inspired by a lost mural painting by Jan van Eyck or one of his followers. The copper plate, which was the largest engraved at the time of its execution, is filled with tension and drama. With the fallen Christ at the center, a great procession moves across the rough landscape, surrounded by a crowd of thugs and tormentors. This magnificent engraving was signed with the initials *M* and *S*, separated by a goldsmithlike hallmark composed of a cross and a crescent; it is the final, grandest example of Schongauer's formal pictorial style.

B*attle of the Nudes* is Pollaiuolo's sole venture into printmaking during his 40-year career in painting, metalwork, and sculpture. Born in Florence about 1431, he received his initial training as a goldsmith; according to tradition, he worked as an assistant to Lorenzo Ghiberti on the *Gates of Paradise* for the cathedral in Florence. In the 1450s he struck out on his own and executed major ecclesiastical and private commissions—first in Florence and then, in the 1480s, in Rome.

Battle of the Nudes was one of the largest fifteenth-century Italian engravings and one of the earliest to be signed with the artist's name. A famous print in its day, it generated replicas in various media and inspired numerous partial copies. Its reputation during the Renaissance was so great that it was one of the few prints mentioned by Giorgio Vasari in his *Lives of the Artists,* first published in 1550.

Pollaiuolo, with his training as a goldsmith, possessed the skills that allowed him to engrave on copper. His experience as a painter and a draftsman enabled him to design this complex, multifigured composition. Pollaiuolo was one of the first artists to make a serious study of human anatomy and possibly the first to perform anatomical dissections. Therefore he understood what lay beneath the skin's surface, and succeeded in depicting the stress and strain of the human body in movement. His subjects' violent physical activity was accompanied by ferocious facial expressions. The antagonists are arranged in pairs, which ingeniously display the naked male body in 10 different poses.

Antonio Pollaiuolo
(1431/32–1498)
Italy
Battle of the Nudes,
ca. 1489
Engraving
15–16 1/16 x 22 13/16 in.
(39.3–40.9 x 57.9 cm)
Bequest of Herbert Greer
French, 1943.118

Albrecht Dürer (1471–1528)
Germany
Adam and Eve, 1504
Engraving on antique paper
9 5/8 x 7 1/2 in. (24.5 x 19.1 cm)
Bequest of Herbert Greer French, 1943.193

Albrecht Dürer gained an appreciation of the graphic arts from his father, a goldsmith, who taught him how to use tools for working in metal. Later Dürer realized that with the distribution of multiple prints, he could carry his art and his name throughout Europe in a way that was impossible with paintings. Throughout much of his career he concentrated on making engravings and woodcuts, although he experimented briefly with drypoint and etching.

Dürer's engraving of Adam and Eve was inspired by *Battle of the Nudes*, an outstanding print made 15 years earlier by the Italian Renaissance artist Antonio Pollaiuolo. Like Pollaiuolo, Dürer engraved his name in Latin on a *cartello*, or placard, and based his figures on classical prototypes. Dürer began to experiment with the nude form after discovering Renaissance art during a trip to Italy in 1494. By 1500 he was searching seriously for a theoretical, mathematical basis for proportion. Dürer derived Adam's form from the *Belvedere Apollo*; Eve was based on his analysis of the *Medici Venus*.

By depicting Adam and Eve before the Fall, Dürer could emphasize their physical beauty and perfection. *Adam and Eve* was one of the first prints in which Dürer combined his studies of classically inspired male and female nudes into a single composition. The balance of their poses strengthens the suggestion of the ideal life they enjoyed in Paradise. Eve is shown with two pieces of fruit, which she has taken from the Tree of Knowledge to share with the serpent. Adam holds a branch from the Tree of Life, a mountain ash, which was believed to repel snakes. Dürer contrasts the serpent with the parrot, which was associated with Mary and supposedly counteracted Eve's curse. At the foot of the tree, a cat is poised to attack a mouse. A goat, balanced on the rocky cliff in the distance, is a warning of what will occur after the pair have tasted the forbidden fruit.

Jacques Bellange
(1580–1638)

France

The Three Women at the Tomb, ca. 1609–20

Etching, touched with burin

17 3/8 x 11 5/16 in.
(44.2 x 28.8 cm)

Museum Purchase: Gift of John S. Conner and Harry G. Friedman, by exchange, 1982.80

J acques Bellange's career as a printmaker from 1609 to 1620 represents the last manifestations of the late Mannerist style. *The Three Women at the Tomb* is considered his best-known subject. A feat of skill in etching, this work representing Bellange's third phase of development, in which he sacrificed detailed description of flesh and drapery for the dramatic use of light and chiaroscuro and for the exaggerated compositional devices of elongated figures, low eye level, and high horizon.

Although all four gospels record the visit of Jesus' disciples to the tomb, only the Gospel of Mark (16:1–8) includes one angel and the three women: Mary Magdalen, Mary, mother of James, and Salome. The subject was the basis for *Visitatio Sepulchri,* one of the earliest liturgical dramas performed at Easter services. The artist uses a pre-Renaissance narrative device of depicting the three women twice, once at the entrance and then again inside the tomb.

Hercules Segers
(ca. 1589/90–ca. 1638)
The Netherlands
Town with Four Towers,
ca. 1631 or later
Etching and drypoint, printed on prepared green paper with added pink washes
7 15/16 x 12 13/16 in. (20.1 x 32.6 cm)
Bequest of Herbert Greer French, 1943.344

Hercules Segers was a painter of landscapes and still lifes, but today he is revered as one of the most important experimenters in the history of European printmaking. Unlike Segers's usual austere mountain panoramas, his seminal print *Town with Four Towers* is an attempt to reconcile his interest in vast mountain scenery with a landscape defined by human habitation. He combines native Dutch architecture with the tall spire dominating the town at the left. The spire is an allusion to the Church of Our Lady in Amersfoort; the pedimented structure in the middle ground recalls the Church of Santa Maria del Priorato in Rome.

Segers hand colored his impressions and cropped the images, creating a group of prints in which each is unique. There are nine known impressions of *Town with Four Towers*, and seven impressions have been compared to the Museum's work. The impression in London and three of the six impressions in Amsterdam are comparable to the Museum's, while the remaining three impressions in Amsterdam are significantly different. The Museum's impression is printed in green, on paper prepared with an olive green.

Segers, born into a cloth merchant's family in Haarlem in 1589 or 1590, apprenticed with Gillis van Conixloo, the celebrated landscape painter. In 1612 he joined the artists' guild in Haarlem, and in 1614 he moved to Amsterdam. Segers fell into debt in the late 1620s, sold his Amsterdam home in 1631, and moved to Utrecht, where he worked as an art dealer to support his artistic activities. From 1633 until his death in about 1638, he continued to deal on a larger scale in The Hague.

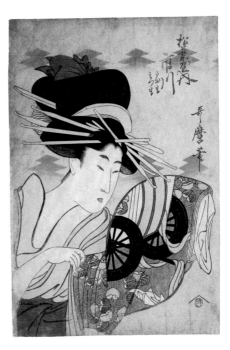

Kitagawa Utamaro (1754–1806)
Japan
*The Courtesan Ichikawa of the
Matsuba Establishment,* late 1790s
Color woodcut
14 15/16 x 10 in. (37.9 x 25.4 cm)
A.J. Howe Endowment, 1913.261

A central figure in the literary and artistic world of Edo (now Tokyo), Kitagawa Utamaro became one of the best-known practitioners of *ukiyo-e* ("pictures of the floating world"). The details of his life are sketchy. His place of birth is uncertain, and during his youth, it is known only that he was a pupil of the Kanō school painter and literatus Toriyama Sekien.

Dissatisfied with the existing styles of depicting beautiful women, Utamaro adopted the Katsukawa school's large-head depictions of actors. His masterpieces are half-length and bust-length portraits of beautiful women (*bijinga*), which he began to produce in the 1790s. Although the highest-class courtesans were his favorite subjects, he also depicted common street prostitutes, teahouse waitresses, geisha, and housewives.

In the Yoshiwara, the government-licensed pleasure district on the outskirts of Edo, art and life were closely intertwined. The *ukiyo-e* print played an important part in publicizing the pleasures of the district and promoting the cult of the courtesan. Ichikawa, a noted beauty, was an *ōrian*, the highest rank of courtesan. *Ōrian* were skilled in the traditional arts of the tea ceremony, flower arranging, calligraphy, *shamisen* playing, singing, dancing, and painting.

The Matsubaya ("Pine Needle House") was one of the most famous brothels in the Yoshiwara during the eighteenth and early nineteenth centuries. Ichikawa's two child attendants, Mitsumo and Tamamo, are not depicted, but their names are inscribed at the upper right along with that of the courtesan and her house.

William Blake (1757–1827)
England
Frontispiece, The Book of Thel, 1789
Hand-colored relief etching
6 11/16 x 4 3/4 in. (17.0 x 12.2 cm) on 11 x 8 13/16 in. (28.1 x 22.5 cm)
Gift of Mr. and Mrs. John J. Emery, 1969.510:1–8

One of five children, William Blake was born in the Carnaby Market area of London. At age 10 he was enrolled by his father in Henry Pars's drawing school for industrial designers. Four months before his fifteenth birthday, Blake began a seven-year apprenticeship with James Basire, engraver to the Society of Antiquaries and the Royal Society of the Arts, who worked in an old-fashioned linear manner. During the early part of his career, Blake experimented with a number of techniques until he found a form of expression uniquely his own: the illuminated book, in which the handwritten texts of his own poems and his designs for the texts were engraved together to form a single decorative unit.

In February 1787, Blake became emotionally distressed by the loss of his younger brother Robert. Shortly thereafter, while working on one of his brother's designs, he resolved the problem of combining his illustrations and poetry on a single copper plate, with guidance, he claimed, from Robert's spirit.

Blake began to etch *The Book of Thel*, a composite work containing eight plates, in 1789, and completed the work approximately four years later. The book is a symbolic fairy tale describing Thel's unsuccessful transition from innocence to experience. The frontispiece (shown in the illustration) depicts Thel as a shepherdess who watches the "loves of the flowers" as well as a smaller version of herself responding fearfully to a man's embrace. According to Laurence Binyon, author of *The Engraved Designs of William Blake*, the Museum's copy of *The Book of Thel* is one of the best of the 16 known copies. It is printed in a rich red-brown and is painted brilliantly in a wide range of watercolors.

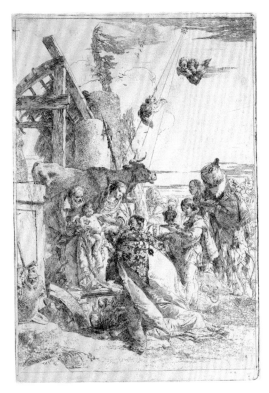

Giovanni Battista Tiepolo (1696–1770)
Italy
Adoration of the Kings, 1740s
Etching
15 x 11 in. (40.3 x 29.2 cm)
Bequest of Herbert Greer French, 1943.404

The last and greatest Venetian decorative artist, Giovanni Battista Tiepolo, whose career spanned more than a half-century, blended high baroque illusionism with the pageantry of religious, historical, and mythological subjects. His patrons—the church, the state, and wealthy patricians—commissioned paintings of gods, saints, and heroes ascending or descending dizzily through space. Tiepolo's work embodies sacred and secular myths in luminous effects and opulent color.

The largest etching plate by Tiepolo, *Adoration of the Magi* is unique among his graphic works because it is believed to represent a lost painting. The subject symbolizes both a philosophical and physical link with classical antiquity, implied by the presence of the satyr vase and the fragmented classical relief, and the New Testament revelation of Christ's divinity, expressed in the attitudes of the Magi and Joseph and in the star's three rays, which may represent the Trinity. Tiepolo has transposed the style and technique of Rococo fresco decoration to etching. His leitmotif of the balanced, triangular figure group, with the Madonna and child as the focus on the raised dais or platform, derives from decorative ceiling schemes. Areas of visual density are counterbalanced by expanses of white paper. A variety of linear vocabulary, hooking, and parallel hatching subtly describes texture and form, light and dark. These traits, along with the signature, link the print to Tiepolo's *Scherzi di Fantasia* series dating from the late 1740s.

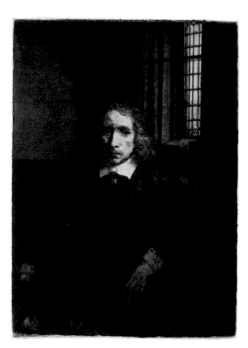

Rembrandt Harmensz van Rijn (1606–1669)
Holland
Jacob Haaringh ("Young Haaringh"), 1655
Etching, drypoint, and burin
7 13/16 x 5 11/16 in. (19.9 x 14.4 cm)
Bequest of Herbert Greer French, 1943.316

Although known as an outstanding painter, Rembrandt was also an extraordinary printmaker, whose etchings became extremely collectable during his lifetime. Born in Leiden, Rembrandt enrolled at Leiden University at age 14 but abandoned his studies to become an artist. In 1624 he moved to Amsterdam to work with painter Pieter Lastman, who introduced him to historical painting. Rembrandt then returned to Leiden, but in 1632 he moved back to Amsterdam to establish his reputation in the largest and wealthiest city in the Dutch republic.

Rembrandt lived and maintained a studio in the home of art dealer Hendrik van Uylenburgh. In 1634 he married Uylenburgh's niece, Saskia, with whom he had four children. Saskia died in 1642 after a long illness. During this period, Rembrandt bought a grand house and became a voracious collector, overextending himself to the point of financial ruin. In 1657 and 1658 he was forced to declare bankruptcy and liquidate his assets.

Jacob Haaringh is one of Rembrandt's most notable prints. The sitter was a lawyer from Utrecht whose father, Thomas Haaringh, bailiff to the court of insolvents, oversaw Rembrandt's bankruptcy proceedings. In this, the second of five states (any stage in the development of a print at which an impression is made), the density of the etched lines surrounding Haaringh's face and left hand and the glimpse of light coming through the window create a mysterious ambiance. The result is a haunting and ultimately very private portrait. The Museum's impression is exceptional because of the velvety sheen, which resulted from the way in which the thick sheet of Japanese paper absorbed the ink.

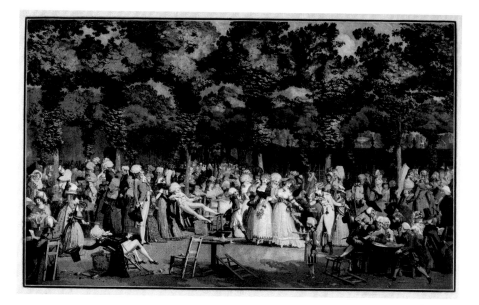

*T*he *Public Promenade*, considered Philibert-Louis Debucourt's masterpiece, is the last and greatest example of multiplate color printing in the eighteenth century. Here the artist portrays members of Parisian society on the grounds of the Palais Royal. He accurately depicts fashions and social customs on the eve of the revolutionary terror of August and September 1792, when the royal family was imprisoned and the massacre of French aristocrats began. Identifiable portraits include the Duc d'Aumont, dressed in pink and sprawled across three chairs, the future Louis XVIII, and the Duc de Chartres, blowing kisses to a group of promenading women; this group includes Manola, wearing a yellow dress with a black bodice, who was Jean Honoré Fragonard's favorite model.

This etching is one of three impressions in the first state, before the addition of all inscriptions and the artist's initials and date. The colors, dominated by patriotic blues, reds, and whites, are at their freshest and most brilliant. Debucourt used subtle aquatint washes and hand tools to create the four large plates—a black "key" plate and red, yellow, and blue color plates—to imitate gouache and watercolor washes.

Debucourt, originally trained as a painter, had executed the first of his 500 prints by the time he was admitted to the Royal Academy in 1781. Although he reproduced other artists' work, he was most successful with color prints designed after his own compositions. His work reflects the changing taste of an era, from portrayals of Parisian society to severe revolutionary allegories to subjects rendered in the manner of early Romantic artists.

Philibert-Louis Debucourt (1755–1832)
France

The Public Promenade, 1792

Color etching, engraving, and aquatint

18 3/16 x 25 1/4 in. (46.3 x 64.2 cm; platemark)

Bequest of Herbert Greer French, 1943.420

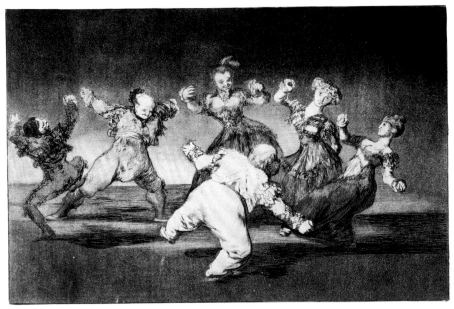

Francisco José Goya y Lucientes (1746–1828)

Spain

Disparate Alegre (Merry Folly), ca. 1816–17

Etching, burnished aquatint, and drypoint

9 1/2 x 13 15/16 in. (24.3 x 35.4 cm; platemark)

Bequest of Herbert Greer French, 1943.526

Francisco José Goya y Lucientes died in Bordeaux in 1828 at age 82 while in exile from his native Spain. He witnessed the Enlightenment's promise of socioeconomic betterment and ecclesiastical reform, which Ferdinand VII extinguished. Against this backdrop, Goya matured into the foremost Spanish painter and one of the world's great printmakers.

The *Disparates* (ca. 1816–17; "Follies" in English) were never published during Goya's lifetime because of the uncertain political climate. They remain shrouded in mystery. In these prints, Goya distills, transforms, and twists a subject's social, political, and religious significance until it defies explanation. The evocative titles and innovative themes are the most ambiguous and most enigmatic of any of his print series. None of the plates were dated, nor can they be identified with external events.

In 1823, fearing that his prints would compromise his safety after Ferdinand VII revoked Spain's constitution for the second time, Goya hid his plates in his country home, along with those for *Disasters of War*. He fled Spain in 1824. The plates were discovered by Goya's grandson in 1854; in 1864 the Academia of San Fernando published an edition of 18 of the *Disparates* plates under the title *Los Proverbios*. The Museum's impression is a proof made before the posthumous 1864 edition; the rich aquatint tones and delicate drypoint lines had not begun to wear away.

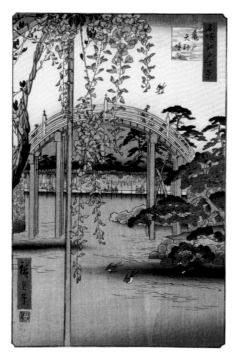

Utagawa Hiroshige (1797–1858)

Japan

No. 57, Grounds of Kameido Tenjin Shrine,
1856 (from One Hundred Famous Views of Edo)

Color woodcut

13 3/8 x 8 13/16 in. (34.0 x 22.9 cm)

Gift of Charles Elam in memory of Mabel McNenny Elam, 1954.378

The last major master of the *ukiyo-e* ("pictures of the floating world") school, Hiroshige lived his entire life in the city of Edo (now Tokyo). The son of an Edo fire warden, he succeeded to his father's hereditary post at an early age. In 1811 he entered the studio of the *ukiyo-e* master Utagawa Toyohiro. In 1831, under Hokusai's influence, he began the first of his series of lyrical, dramatic landscape prints that incorporated pictures of famous places (*meisho*). These evoked the seasonal moods associated, by literary and artistic tradition, with different places during the Edo period (1600–1868).

One Hundred Famous Views of Edo, composed of 119 landscape and genre woodcuts of mid-nineteenth-century Edo, was one of the greatest achievements of Japanese art. This ambitious single-sheet series exhibits the brilliant artistic vision and sound craftsmanship that epitomize the inventiveness of the *ukiyo-e* color woodcut and the cooperatively employed talents of designer, carver, printer, and publisher.

The Kameido Tenjin Shrine was dedicated in the early 1660s (after the devastating Meireki fire of 1657) as part of a campaign to open the east bank of the Sumida River for urban settlement. The view, with its detailed close-up of purple wisteria blossoms falling gracefully along a pole with an arched bridge beyond, identified the place as Edo. This early impression features a printing error in the extension of the water beneath the bridge, which was corrected in later impressions. Japanese prints such as this inspired Claude Monet's paintings of his water-lily garden at Giverny.

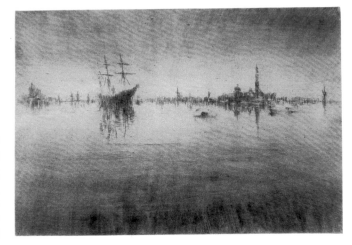

James Abbott McNeill Whistler (1834–1903), United States

Nocturne, 1879–80

Etching and drypoint

7 13/16 x 11 9/16 in. (19.9 x 29.5 cm)

Bequest of Herbert Greer French, 1943.596

The American-born James Abbott McNeill Whistler was one of the best-known figures in the artistic and social world of the mid- and late nineteenth century. In his lifetime he became celebrated in London and Paris for his wit, arrogance, and views as well as for his paintings.

Between 1855 and 1901, Whistler executed nearly 450 etchings and more than 150 lithographs. He was in the forefront of the etching revival in the 1850s, which swept France and Britain with the publication of his popular *French Set* in 1858. He went on to publish the *Thames Set* in 1871 and the two *Venice Sets* in 1880 and 1886.

In 1878 Whistler filed a libel suit against John Ruskin, who accused him of "flinging a pot of paint in the public's face" with his painting *Nocturne in Black and Gold.* This lawsuit and his extravagant lifestyle forced Whistler into bankruptcy. In the following year, the London Fine Art Society commissioned him to travel to Venice, where he was to produce a series of 12 etchings in three months. Whistler's Venice did not include the popular views of his eighteenth-century predecessors Canaletto and Guarde. Instead he captured the essence of anonymous doorways, back canals, palace facades, and picturesque plazas.

Of all Whistler's Venice subjects, his evocative and poetic *Nocturne* shows the most dramatic variation among impressions. The first etched state was executed directly from nature. Because the plate was never steelfaced, the drypoint lines wore down quickly. In the fourth and final state, this impression was printed in brown with a film of ink left on the printing plate. In *Nocturne,* by manipulating this film of ink, Whistler suggested distinctive qualities of light and made allusions to weather at various times of day.

Whistler stayed in Venice until 1880 and completed 50 etchings. The 12 etchings selected for the first *Venice Set* were shown at the Fine Art Society in December 1880. Whistler's contemporaries viewed his Venetian work as modern and revolutionary. His printmaking set the course for future radical experimentation and influenced a generation of artists.

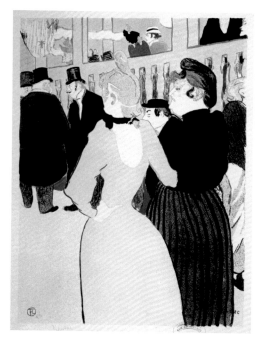

Henri de Toulouse-Lautrec (1864–1901)
France
Au Moulin-Rouge, 1892
Color lithograph (second state)
17 7/8 x 13 1/2 in. (45.4 x 34.3 cm)
Gift of Herbert Greer French, 1940.526

enri Marie Raymond de Toulouse-Lautrec Monfa was the heir apparent of an ancient aristocratic family. In 1878 and 1879, he broke both legs in separate incidents; the injuries left him 4 1/2 feet tall, a cruel genetic legacy due to frequent intermarriages among his ancestors. During his convalescence, Lautrec entertained himself by sketching. With a handicap that rendered the usual occupations of the noble rich unsuitable, he pursued a career as a working artist in Montmartre, the artistic, intellectual, and literary hub of Paris.

In the 1890s, Lautrec was one of a group of young avant-garde artists who used color lithography as a vehicle for innovative printmaking. He received commissions for song sheets, menus, theater programs, journals, and posters. His revolutionary use of color lithography revitalized graphic design. Equally radical was his appeal to mass culture through his art. To reach the public, he did not seek traditional venues nor rogue salons. The intellectual and popular media and the walls of Parisian streets constituted Lautrec's salon.

The thin, erect figure in the foreground of *Au Moulin-Rouge* is La Goulue (The Glutton), also known as Louise Weber. La Goulue began dancing in 1886 and became the dancing star of Paris, appearing at the Moulin Rouge between 1889 and 1894. Her companion has been variously identified as her sister or as La Môme Fromage, another dancer at the Moulin Rouge. The diagonals, the ornamental silhouettes, and the clear, bright colors show the influence of Japanese *ukiyo-e* woodcut prints in this six-color lithograph, executed early in Lautrec's career as a printmaker.

Emil Nolde (1867–1956)
Germany
The Three Kings, 1913
Color lithograph
24 1/4 x 21 in. (64.5 x 53.6 cm)
Mr. and Mrs. Ross W. Sloniker Collection of
Twentieth Century Biblical and Religious Prints,
1955.445

Emil Nolde was one of the most intuitive painters of the early twentieth century. For Nolde, as for many of his German contemporaries, creative printmaking was an important aspect of artistic expression. Between 1898 and 1937 he produced more than 500 etchings, woodcuts, and lithographs.

Nolde, a farmer's son, was born Emil Hansen. He first became a furniture craftsman and then a painter and printmaker. In 1902, at the time of his marriage to Ada Vilstrup, he adopted the more distinctive name of his birthplace as his artist's name. As a printmaker, Nolde had a long, productive career: he made his first important prints in 1905 at age 38, and his last print at age 70.

In 1913 the Cologne Sunderbund, an association of artists and laypersons interested in contemporary art, agreed that the commissioned print they issued annually for their members should be a graphic work by Nolde. At that time, Nolde's new group of 13 large-scale lithographs was being printed at the Westphalen lithography workshop in Flensburg. From these he selected for the Sunderbund the picture of the three kings as they journeyed to see the baby Jesus after news of His birth.

In this series, Nolde attempted to master the difficulties of printing in color. After experimenting with various color combinations, he chose, for the Sunderbund commission, to print the three figures in black. (Also, uncharacteristically, he printed his signature as part of the image.) The tall magus is wearing a robe containing streaks of red; the shoes of the king at the right are covered with splotches of the same color. The rays of light from the star, yellow against the streaky background of light gray-brown, have an expressive quality that Nolde attempted to exploit.

Wassily Kandinsky (1866–1944)
Russia
Kleine Welten, IV, 1922
Color lithograph
10 1/4 x 10 in. (26.6 x 25.5 cm)
The Albert P. Strietmann Collection,
1965.490

Wassily Kandinsky, perhaps more than any other painter and printmaker, is identified with the transition from representational to abstract art that occurred early in the second decade of the twentieth century. Born in Russia in 1866, Kandinsky did not become seriously interested in an artistic career until later in life. Between 1908 and 1914 he formed *Der Blaue Reiter* ("The Blue Rider") group while living in Munich and made important contributions to modern art.

Forced to leave Germany at the beginning of World War I, Kandinsky helped the new Soviet government by setting up cultural institutions and introducing modern ideas. In 1921 he left Russia for Germany to accept an important teaching position in the recently established Bauhaus, the school of visual and social experiment created in Weimar by architect Walter Gropius.

The *Kleine Welten* ("Small Worlds") series, one of the most important productions of the Bauhaus printing workshop, was Kandinsky's most significant statement as a printmaker during the second half of his career. It contained 12 prints: four drypoints, four woodcuts, and four lithographs. Stylistically they move from the intuitive expressionism of *Der Blaue Reiter* to the greater geometric precision of his Bauhaus period. *Kleine Welten IV* can be seen as an elaboration of Kandinsky's interest in the relationship between music and pictorial art. His goal was to stimulate an emotional response through tones and color in the same way as the notes in a piece of music.

Theodore Roszak
(1907–1981)
United States

Staten Island, 1934

Color lithograph and
color stencil

12 3/4 x 14 15/16 in.
(32.4 x 38.0 cm)

Museum Purchase with
funds provided by the Carl
Jacobs Foundation,
1997.148

© Estate of
Theodore Roszak

Theodore Roszak is recognized as a major American sculptor who produced works influenced by the Bauhaus in the 1930s and 1940s. Although less well known as a printmaker, he studied lithography intensively in the late 1920s and became one of America's few lithographic master printers. The exposure to European modernism radically altered his career. In 1931, upon returning to the United States from Europe, he received a Tiffany Foundation grant that allowed him to settle on Staten Island and focus on his art in response to that trip. *Staten Island* is a rare, early example of an American artist's color lithograph.

The simplified subject is adapted from the left-hand half of Roszak's 1933 oil painting, *Staten Island,* and portrays his surroundings in a European modernist style. Unlike the painting, which represents a nocturnal subject, the print suggests a simple daytime view of sea and sky. The geometric style, with its blending of two- and three-dimensional forms and the removal of signs of human habitation, signals the artist's developing interest in Constructivism. During the 1930s Roszak was fascinated with navigational and astronomical instruments, which he incorporated into his composition as allegorical symbols of man's struggle to position himself in the universe.

The lithograph exists in 20 impressions at most; each is a unique color study. Ink extending to the edges, smudges of color, and fingerprints suggest the experimental nature of this lithograph, which was printed from two plates of scrap zinc. The artist applied color accents later, using stencils.

Munakata Shikō
(1903–1975)

Japan

Childbirth, 1959

Woodcut reworked with brush and black sumi ink

31 11/16 x 35 7/16 in. (80.6 x 89.9 cm)

The Howard and Caroline Porter Collection, 1983.177

A devout Buddhist, Munakata Shikō combined inspiration from Buddhist scriptures with a love for folk art traditions to create his distinctive style. Severely nearsighted, Munakata once said, "I don't need my eyes anymore, really. I work from my heart. I see with my mind's eye." With his nose only a few inches from the woodblock, Munakata swiftly carved the images he pictured in his head.

While growing up in Aomori, Munakata always carried a bottle of India ink and an account pad so he could paint when inspired. Though he tried a career as an oil painter in the style of Vincent van Gogh, by 1930 he had found printmaking a more effective means of getting in touch with his Japanese artistic roots. The fresh, naive quality of his prints conveys his Zen Buddhist approach. It captured the attention of Yanagi Soetsu, art theorist and grandfather of the Japanese *mingei* (folk art) movement, earning him a place in Japan's Folkcraft Museum. Often called "the Picasso of Japan," Munakata gained international acclaim by winning competitions in Switzerland (1952), Brazil (1955), and Italy (1965), and thus establishing himself as one of the leading internationally recognized twentieth-century printmakers.

Munakata's series of woodcuts, *Ten Great Disciples of the Buddha (Shaka Ju Dai-deshi),* created in 1939, is considered one of his major achievements. The subjects are modern and personal interpretations of age-old themes. Even a subject that appears secular to a foreign eye is inspired by Buddhist traditions. *Childbirth*, in which a child floating on a pond is surrounded by joyous nudes, echoes the traditional rendering in Japanese Buddhist woodcuts of Buddha's birth, washing, and first steps.

◀ **Jiří Anderle** (b. 1936)

Czechoslovakia

Cruel Game for a Man, 1976

Color drypoint and mezzotint

36 1/8 x 24 3/8 in. (92.0 x 62.0 cm)

Gift of Anne and Jacques Baruch, 1976.332

© Jiří Anderle, courtesy of the Anne and Jacques Baruch Collection, Ltd.

Jiří Anderle, born in Pavlikov, Czechoslovakia, focused on printmaking in his final years of study at the Academy of Fine Arts in Prague (1955–1961). As a member of the Black Theatre of Prague, he toured Europe, Africa, Australia, and the United States, assimilating contemporary art and pursuing printmaking as time permitted. The experience of working with mime theater heightened his awareness of facial expression, gesture, demeanor, and the power to communicate universal themes.

Technically brilliant as both draftsman and craftsman, Anderle uses the classical methods of mezzotint and drypoint. Mezzotint creates rich tonal areas; the drypoint line, immediate and direct, conveys a rich, sensual quality.

Anderle's great masterpiece, *Cruel Game for a Man*, commemorates the thirtieth anniversary of World War II. It was dedicated to Jacques Baruch and all of those who survived the Holocaust to rebuild their lives after the war. The chronicle of events on earth as seen from space appears as a series of film stills, beginning with marching German soldiers destroying cities and human lives, and ending with the victorious Russians hanging their flag in Berlin. Hitler speaking is overlaid by victims of the concentration camps, juxtaposed with a mother, who knows fear, and her child, whose fear is unknowing. Finally, the line of monsters throughout history ends with the German soldier. With its mesmerizing power, the rich, velvety print attracts attention, even as it repels.

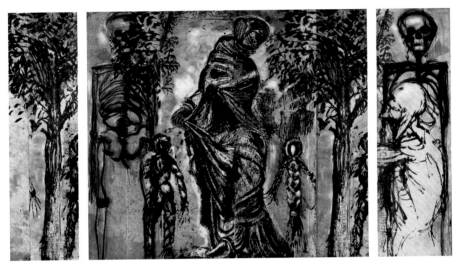

Jim Dine (b. 1935)

United States (Cincinnati)

Youth and the Maiden,
1987–88

Color woodcut, heliorelief,
woodcut, softground and
spitbite etching, drypoint
with additional hand
coloring

a: 78 1/2 x 24 3/8 in.
(199.4 x 61.9 cm);
b: 78 1/4 x 91 1/8 in.
(198.7 x 231.4 cm);
c: 78 1/2 x 24 3/8 in.
(199.4 x 61.9 cm)

Gift of the Artist,
1993.175a–c

© Jim Dine and
Graphicstudio/U.S.F.

Jim Dine, an internationally acclaimed painter, sculptor, printmaker, and draftsman, was born in Cincinnati and received formal training at the Art Academy of Cincinnati, the University of Cincinnati, and Ohio University. In 1958 Dine moved to New York, where his mixed-media constructions and experimentation with happenings quickly established him as a notable young intellectual talent.

Dine explored printmaking as a student, and executed his first professional prints at New York's Pratt Graphic Center in 1960. To date he has completed more than 1,000 editions, working with numerous printers, workshops, and publishers in the United States and Europe. During his career, Dine has employed all the major printmaking media. He has challenged the traditional techniques and has developed unconventional methods of working with printing blocks, plates, stones, and screens.

Youth and the Maiden, the artist's largest print to date, is a powerful mixed-media print completed at Graphicstudio in 1988. Its triptych format conjures up associations with altarpieces. The juxtaposition of skeletons, trees, a flayed figure, and a sheathed woman, with their ritualistic overtones, demonstrates how Dine's exploration in myth, religion, and art history has influenced his evolving artistic vocabulary. At the same time, Dine combines and overlays various etching media, including spitbite, softground, and drypoint, with woodcut. He employs both hand woodcutting and a recently developed photographically derived heliorelief process, which emphasizes the interplay of atmosphere, surfaces, and subject, and showcases Dine's brilliance as a draftsman.

Margo Humphrey
(b. 1942)

United States

The History of Her Life Written Across Her Face,
1991

Color lithograph and foil collage

32 1/8 x 29 11/16 in. (81.7 x 75.4 cm)

The Albert P. Strietmann Collection, 1992.24

© Copyright 1991 Margo Humphrey

W ith wit and pathos, Margo Humphrey has literally written her history—social, political, and personal—directly across her face. The images force us to contend with her existence as a black woman living in a society that has tried unsuccessfully to erase the color of her image. At the bottom of the lithograph, the artist has written "Self Portrait in Rebus." A rebus is a riddle composed of words shown as pictures, which may suggest the sound of the words they represent. Thus an angel is used for "the angels kept her safe," and a rose for "so she rose to the occasion." The commingling of word and picture reminds the viewer that words and symbols are both abstractions. *The History of Her Life Written Across Her Face* instills pride and nobility in black ancestry and culture.

Born in 1942 in Oakland, California, Humphrey has painted and drawn since early childhood. She studied printmaking at the California College of Arts and Crafts and at Stanford University. She has received fellowships from the Ford Foundation and the National Endowment for the Arts. As a teacher and a guest artist, Humphrey has traveled widely to the south Pacific and Africa. Her intense, bright colors are both sensual and provocative; her forms strongly symbolize nature or relationships.

Drawings

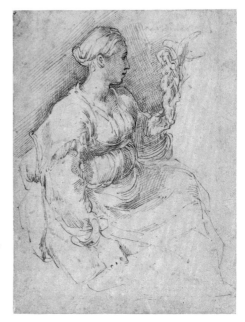

Francesco Parmigianino (1503–1540)
Italy
Woman Seated Holding a Statuette of Victory
Pen and brown ink
8 3/4 x 6 9/16 in. (22.3 x 16.7 cm)
Gift of Emily Poole in memory
of Allyn C. Poole, 1953.115

G irolamo Francesco Maria Mazzola, a native of Parma, is known as Parmigianino after his place of birth. He was a painter, draftsman, and etcher from a family of artists who recognized his precocity as a draftsman at an early age and provided his early training. Correggio's work was an important early stimulus to his development.

In 1523, Parmigianino went to Rome, where he studied the work of Raphael and Michelangelo as well as antique sculpture. These works focused his attention on plastic values and refined elegance, rather than anatomical accuracy, as a means of expressiveness.

After Rome was sacked in 1527, Parmigianino fled to Bologna and remained there until 1530. In 1531 he returned from Bologna to Parma, where he received a commission to paint frescoes in the apse and vault of the church of S. Maria della Steccata. Failure to fulfill the commission led to his imprisonment in 1539 and his subsequent flight to Casalmaggorie, where he died the following year.

Parmigianino's highly individual style, with its elegant, elongated figures and sinuous line, was known through his etchings. They brought him additional recognition as one of the earliest influential "Mannerist" artists in sixteenth-century Italy and France.

In 1524 Parmigianino painted a portrait of Gian Galeazzo Sanvitale of Fontanellato, Naples. At that time, he was involved in painting frescoes in a chamber at Fontanellato. It has been suggested that the statuette in this drawing represents the crest used by the Sanvitale after the defeat of Emperor Frederick II in 1248. The crest represented the goddess of victory, holding a lance in her right hand and a palm branch in her left hand.

J oseph Mallord William Turner, who was born in the Covent Garden area of London, studied and worked under the architectural topographer Thomas Malton during the late 1780s. In 1789 he was accepted as a student in the Royal Academy school; a year later, he exhibited watercolors at the Academy. Turner was elected an associate of the Academy in 1799 and a full member in 1802. He taught perspective there from 1807 to 1838.

In 1825 Turner began the *Picturesque Views in England and Wales* series, one of his most ambitious projects, which has been labeled "the central document in Turner's art." The series called for engravings based on 120 newly commissioned watercolors. By 1838, however, only 96 prints had been issued, and the project was terminated. The stock of engraved plates and prints was auctioned off, and Turner paid more than £3,000 to buy them all back. Although the series never materialized, it inspired some of his finest watercolors, including *Lyme Regis*.

Lyme Regis was based on several sketches in the *Devonshire Coast No. 1* sketchbook, which Turner used in 1811 on his first tour of the southwestern coast of England. On the violent sea, a sailing vessel struggles to retrieve a ship's mast and top, which can be seen above the ship. On the beach, two men drag some wreckage out of the water and prepare to attach a line from a horse to pull it inland. Turner casts the town, Lyme Regis, in brilliant light. The fluid brush strokes and complex composition, techniques that Turner obviously enjoyed, create many sweeping, abstract patterns.

Joseph Mallord William Turner
(1775–1851)
England

Lyme Regis, Dorsetshire, England, ca. 1834

Watercolor

11 1/2 x 18 in.
(29.2 x 44.8 cm)

Gift of Emilie L. Heine in memory of Mr. and Mrs. John Hauck, 1940.953

Pierre-Auguste Renoir (1841–1919)
France
Mlle. Jeanne Samary, ca. 1878
Pastel
27 7/16 x 18 3/4 in. (69.7 x 47.7 cm)
Bequest of Mary Hanna, 1946.107

As famous as Sarah Bernhardt in her day, Léontine Pauline Jeanne Samary was a successful actress at the Comédie-Française when she first sat for Pierre-Auguste Renoir in 1877. Between 1877 and 1880 Renoir recorded the young soubrette's features in oil and pastel at least a dozen times.

The Museum's pastel of Mlle. Samary captures her vivacious personality. With its delicately rendered facial features and spontaneous handling of the pastel, this is a striking example of Renoir's Impressionist portraits. The actress leans on the arm of a chair covered with a red patterned fabric and holds a multicolored feather fan in her right hand. The triangular arrangement of her torso and the fluid contours of her limbs reinforce the serenity of the pose without the distracting theatrical trappings. Here Mlle. Samary wears the same low-cut pink satin ball gown trimmed with white lace as in Renoir's full-length 1878 portrait, which is now in the State Hermitage Museum of Saint Petersburg, Russia.

The son of a tailor and a dressmaker, Renoir initially was apprenticed to a porcelain painter. In 1862 he embarked on a career in painting and was influenced by the Barbizon landscape school of painters. When he came into contact with Claude Monet, Alfred Sisley, Camille Pissarro, and Paul Cézanne, however, he developed a broader approach to the treatment of light and shade. He made his Salon debut in 1864, but exhibited with the Impressionists between 1874 and 1877, and again in 1882.

Renoir was the leading Impressionist figure painter, and the only Impressionist to achieve financial security through the practice of portraiture. In about 1898 he began to suffer from arthritis, but he continued to the end to create private portraits of his family.

Hilaire-Germain-Edgar Degas (1834–1917)
France
Dancer in Her Dressing Room, ca. 1879
Pastel and peinture à l'essence on canvas
34 5/8 x 15 7/8 in. (87.9 x 37.7 cm)
Bequest of Mary Hanna, 1956.114

E dgar Degas is regarded as one of the greatest painters, printmakers, draftsmen, and sculptors of the nineteenth century. His artistic education was based on drawing in the classical tradition of Ingres. In 1872 he abandoned historical and literary themes for scenes of modern urban life.

His work is dominated by figures of milliners, laundresses, and dancers observed in their occupational activities from different angles and in different lights. Although Degas exhibited in the first six and the last of the Impressionist exhibitions, he did not share the Impressionists' enthusiasm for creating landscapes. He sought to combine the best of Impressionism—its vivid rendering of light and atmosphere, acceptance of instantaneous movement, and use of bright, vibrant tone—with the classical tradition of Ingres and the old masters.

Degas is known best for his portrayal of dancers. More than half of his oils and pastels depict ballerinas from the Paris Opéra on stage, in their dressing rooms, in rehearsal, or at rest. In the mid-1870s he turned to pastel—a supple, easily reworkable medium that he ingeniously combined with gouache and tempera, and then applied with a brush.

Dancer in Her Dressing Room displays Degas' attraction to the brilliant decorative lines, bold foreshortening, and nonlinear perspective found in Japanese prints. Spatial recession is conveyed by a series of nonintersecting diagonals implied by the top of the dressing table, repeated by the edge of the open drawer, and opposed by the arm of the armchair. The dancer's toilet is observed from a bird's-eye vantage point and is illuminated by the direct glare of a single gaslight, which strikes the figure frontally and casts amorphous shadows in the background. The illumination changes the color of her flesh to a harsh pink.

Degas worked this canvas with pastel over *peinture à l'essence* (oil colors thinned and mixed freely with turpentine). His successful combination of Japanese decorative design with European realism makes *Dancer in Her Dressing Room* a compelling masterpiece.

Henry Farny
(1847–1916)

United States
(Cincinnati)

The Captive, 1885

Gouache

22 5/16 x 40 1/16 in.
(56.7 x 101.6 cm)

Gift of Mrs. Benjamin
E. Tate and Julius
Fleischmann in memory
of their father,
Julius Fleischmann,
1927.38

Although Henry Farny was born and trained in Europe, his reputation as an artist is based on his paintings of Native Americans and the American West. He was born in Ribeauville in Alsace, France, but in 1853, at age 6, he emigrated with his family from France to western Pennsylvania. There, while living in a remote and primitive area, Farny first encountered Native Americans. Six years later the Farny family traveled by raft to Cincinnati, where Henry began his art training and his career as an illustrator for Harper Brothers. In 1866 he worked in the company's New York office as a cartoonist and engraver.

Farny soon left for Europe and studied in Rome, Düsseldorf, Strasbourg, and possibly Paris. Although he returned to Cincinnati in 1870, he returned twice to Europe to study in Munich. After his first trip to the West in 1881, Farny began his initial group of Native American paintings in his studio in Cincinnati. He traveled west several more times, but remained mostly in Cincinnati for the rest of his life.

The Captive depicts a white prisoner who has been tied to stakes in the ground and is forced to endure the penetrating heat of the sun. It is unlikely that Farny witnessed this scene; probably he based it on the popular Eastern concept of the Native American. In the fall of 1885, Farny submitted this work to the American Art Association's exhibition of watercolors, where it received a prize of $250.

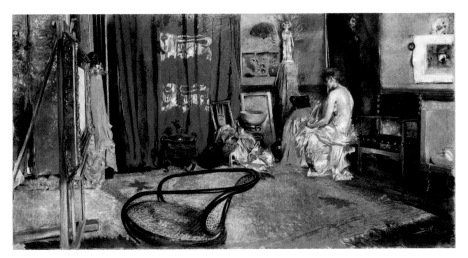

During his lifetime, Robert Frederick Blum was one of America's leading artists. He established his reputation by creating outstanding works in pen and ink, oil, watercolor, and pastel, and by working as a printmaker and muralist. Born in Cincinnati, Blum dropped out of high school at age 16 to become an apprentice at a lithography firm. He attended art classes at the Ohio Mechanics Institute and the McMicken School of Design (now the Art Academy of Cincinnati), studying with Frank Duveneck in 1874 and 1875. After visiting the celebrated Centennial Exposition in Philadelphia, Blum attended the Pennsylvania Academy of Fine Arts. In 1878 he moved to New York to work as an illustrator and watercolorist.

Blum made his first trip to Europe in 1880, joining both Duveneck and James Abbott McNeill Whistler in Venice. He made several more trips to Venice, and in 1890 he took a long-awaited trip to Japan, where he remained for two years. Upon his return to New York, Blum was commissioned to execute several mural decorations. He was working on a mural for the New Amsterdam Theater when he contracted pneumonia and died at age 45.

Blum began *Studio of Robert F. Blum* in early 1883, and it was included in the first exhibition of the Society of Painters in Pastel in the winter of 1884. The work gave him the opportunity to draw his artistic furnishings and to show some of his personal tastes and preferences. Along with the human figure, which played an important role in his art, Blum included his contemporary bentwood chair, a painting after the Spanish painter Diego Velázquez, and one of his own etchings, titled *The Modern Etcher*. With the artist absent from his chair, the viewer is made to feel like a voyeur, entering a private work session between painter and nude model. In this picture, Blum succeeded in combining spatial and psychological tension.

Robert Frederick Blum
(1857–1903)
United States
(Cincinnati)
Studio of Robert F. Blum, ca. 1883–84
Pastel
28 x 53 3/4 in.
(71.1 x 136.5 cm)
Gift of Mrs. Henrietta Haller, 1905.197

Drawings

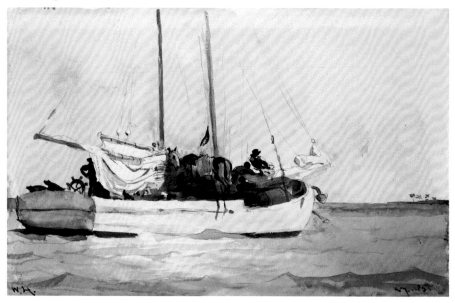

Winslow Homer
(1836–1910)
United States

Hauling in Anchor,
ca. 1903–04

Watercolor

13 15/16 x 21 13/16 in.
(35.4 x 55.4 cm)

Fanny Bryce Lehmer
Endowment, 1906.164

Winslow Homer's watercolors place him among the greatest American painters. Executed over a period of more than 30 years, between 1873 and 1905, these works are unsurpassed for their spontaneity of expression, luminosity, and economy of means. His mother, Henrietta Benson Homer, who was a gifted amateur, introduced Homer to the watercolor medium at an early age. Later, as a young artist, he created watercolors, which could be described more accurately as wash drawings, for the preparation of wood engravings.

Homer was an artist for more than 20 years before he began to use watercolor as a separate means of expression. In the early 1870s he was reasonably well known as an illustrator, but his early promise of outstanding success as a painter had not been realized. In 1873, when the American Society of Painters in Water Colors sponsored their landmark international exhibition in New York and established watercolor as a serious medium, Homer decided to apply himself seriously to watercolor for the first time. *Hauling in Anchor* is one of nine known watercolors Homer created in Key West, Florida. The group, which focuses on the schooners in the harbor, marked the final high point of his career and turned out to be the last series he ever produced. Homer selected *Hauling in Anchor*, with its beautifully painted Bahama island schooner, for the annual exhibition of American art held at the Cincinnati Art Museum in 1906. At that time, broad-beamed schooners traveled frequently as trading vessels between the mainland and the sparse settlements of the neighboring islands. Homer successfully created a sense of continued movement with his use of flowing and rapid brushstrokes. His simplified and muted color scheme presents a brooding, and convincingly stormlike atmosphere.

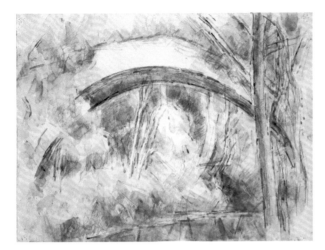

Paul Cézanne (1839–1906)

France

The Bridge of Trois-Sautets,
ca. 1906

Watercolor and pencil

16 1/16 x 21 5/16 in.
(40.8 x 54.3 cm)

Gift of John J. Emery, 1951.298

"Finally I must tell you that as a painter I am becoming more clear-sighted in front of nature, but that with me the realization of my sensations is always very difficult."

During the late summer of 1906, a month and a half before he died, Cézanne made this statement in a letter to his son Paul. He was laboring on *The Bridge of Trois-Sautets*, his most ambitious work. The watercolor, completed just weeks before his death, is the culmination of a 50-year struggle to realize his impressions. The artist positioned himself on the bank of the river, surrounded by dense vegetation immediately below the bridge. He explored the kaleidoscopic play of reflections within the shifting boundaries of his vision. The multiple tack holes in the corners attest to the great number of riverside sessions.

Beginning with a simple pencil sketch, Cézanne then filled the sheet with transparent, overlapping washes applied in chromatic sequences. Space is structured by changes in the density and intensity of color. The skeletal framework and the facets of color complement each other structurally but maintain their integrity. The reflected and penetrated water surface is rendered with rich, resonant red-violet facets, while the cool, shadowy depths of the landscape are suggested by a concentration of blue-violet washes. From this vortex of color activity rises the triangular white mass of the bridge, bleached in the afternoon sun. The structural solidity of the bridge and the tree are negated by the blue dots and dashes approximating their profiles.

The son of a successful merchant turned banker, Cézanne spent his formative years without financial deprivation. After failing the entrance examination for the École des Beaux-Arts in 1862, he frequented the Académie Suisse, where he met Camille Pissarro. Although Cézanne exhibited with the Impressionists in 1874 and 1877, his portraits, still lifes, and landscapes reveal his liking for durable form and basic rhythms in preference to superficial changes of illumination.

Drawings

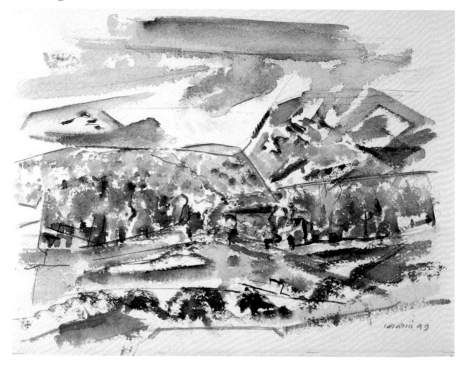

John Marin
(1870–1953)
United States
Tunk Mountain Series
No. 4, 1949
Watercolor and pencil
15 7/16 x 21 in.
(39.3 x 53.3 cm)
The Edwin and Virginia
Irwin Memorial, 1968.262
© 2000 Estate of John
Marin/Artists Rights
Society (ARS), New York

John Marin, best known for his watercolors, belonged to the first generation of American avant-garde painters who were proponents of Modernism in the early twentieth century. Inspired by his love of the visible world and its rhythms, Marin's individual style is both expressionistic and semiabstract. His subjects, whether New York cityscapes, New Mexico landscapes, or scenes from Maine, project a monumental scale reflecting his bravura execution. He combined innovative techniques—blotting, lifting, and scraping—with the use of charcoal, opaque pigments, and traditional transparent washes.

During his travels in Europe, Marin met American avant-garde artist Alfred Stieglitz in Paris. Beginning in 1909, Stieglitz championed Marin's original American vision through his New York Galleries for the next 40 years. Marin was one of the American artists selected for the 1913 Armory Show.

In 1949 Marin, revered as a "grand old man" of American painting, executed *Tunk Mountain Series No. 4,* one of a series of four watercolors exhibited at Stieglitz's "An American Place." The rich reds and yellows suggest that Marin stayed on in Maine to depict the autumn foliage. The bold pencil strokes are countered with overlays of transparent washes; the artist energized the subject with an impending storm and captured the essence of seasonal fluctuations. Throughout his career, Marin sought to synthesize his love of the visible world with the abstraction of Modernism.

I n 1980 Sandro Chia emerged at the Venice Biennale as the best of a new Italian wave of figurative expressionists. Born in Florence in 1946, he moved to Rome around 1970; there he had his first of many solo exhibitions. His work was introduced to American audiences in 1980.

Chia's images are soaked in myth and metaphor. *Light and Cans* is a tempera study for his major painting *Rabbit for Dinner,* now in the collection of Amsterdam's Stedlijk Museum. An outstanding feat of draftsmanship and painting technique, this study is an amalgam of modern and classical styles. The artist attempted to recover grand themes of Italian art by combining imagery and style from Italy's past with the brilliant flamboyance of earlier twentieth-century abstract painting styles. The heroically proportioned figure dominates the drawing as he performs an activity of everyday life.

Sandro Chia (b. 1946)

Italy

Light and Cans, 1981

Tempera, crayon, charcoal, pencil

63 x 88 1/2 in. (160.0 x 224.8 cm)

Museum Purchase: Gifts of previous donors, by exchange, 1988.173

© Copyright Sandro Chia

David Octavius Hill
(1802–1870) and
Robert Adamson
(1821–1848)
Scotland
Mrs. Bell of Madras,
ca. 1844
Salted-paper print from
paper negative
7 13/16 x 5 7/8 in.
(19.8 x 15.0 cm)
The Albert P. Strietmann
Collection, 1976.37

D avid Octavius Hill, an accomplished painter of the Scottish countryside and a founding member of the Scottish Academy of Painting, is known today primarily for his partnership and collaboration with the photographer Robert Adamson. Together they enjoyed the first artistic success with William Henry Fox Talbot's calotype process, the first negative-positive photographic process on paper.

In 1843 Hill decided to paint a group portrait of the 457 men and women present at the convention in Edinburgh when the Free Church of Scotland was founded. To help secure the likenesses of this large number of people, he obtained the services of Adamson, who had opened a photography studio at Rock House, Calton Hill, Edinburgh. The two men continued to work as a team until 1848, when Adamson died at age 27. Hill dealt primarily with the poses and the composition, while Adamson attended to the technical aspects of the calotype. In addition to their work on the painting, they photographed people from all walks of Victorian society, amassing more than 2,500 prints during their six-year collaboration.

Mrs. Bell of Madras was Robert Adamson's sister. As Isabella Morrison Adamson she married Colonel Oswald Bell of Madras in 1847. Hill and Adamson took this portrait outdoors in bright sunlight to keep the exposure time down to a minute, but they included furniture and other props to simulate an interior. They approached the calotype medium intuitively, creating compositions with broad areas of light and dark that reflected, at the same time, the academic painting traditions of the 1840s.

Mathew B. Brady (1823–1896)
United States
John James Audubon, ca. 1847–48
Daguerreotype, half-plate
4 1/4 x 3 1/4 in. (10.8 x 8.3 cm)
Centennial Gift of Mr. and Mrs.
Frank Shaffer Jr., 1981.144

Mathew B. Brady is famous today primarily for his dramatic photographs of the Civil War. During his long career, however, he was also a leading portraitist, especially during the daguerrean era. In the mid-1840s, Brady decided to create *The Gallery of Illustrious Americans.* This series of 24 biographical essays of important people was written by Charles Edwards Lester, the distinguished art critic, and illustrated with lithographs made after Brady's daguerreotypes. The entire concept was inspired by John Longacre's *National Gallery of Distinguished Americans,* which was issued between 1834 and 1839. Brady's project received much critical acclaim; very few subscriptions were purchased, however, and only 12 copies were published, in 1850. Nonetheless, the cast of characters was impressive: Zachary Taylor, John C. Calhoun, Daniel Webster, Henry Clay, and John James Audubon, among others.

Naturalist and wildlife painter John James Audubon, famous for his impressive series *Birds of America* (1830–1839), lived in Cincinnati for a short time before 1820. In the 1840s he began work on *Quadrupeds of America* with his sons. By the time Brady made this daguerreotype, Audubon was about 62 years old and in the later stages of his career. The portrait, which accompanied the seventh biographical essay by Lester in *The Gallery of Illustrious Americans*, is the only known photograph of the naturalist.

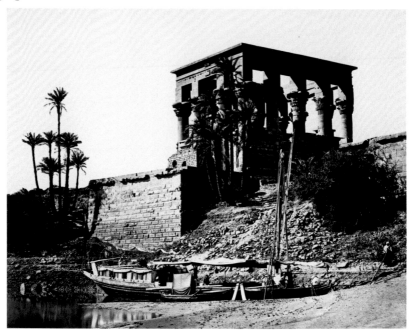

Francis Frith
(1822–1898)
England

The Hypaethral Temple, Philae, Egypt,
1857

Albumen print from wet-collodion negative

14 13/16 x 18 13/16 in. on 21 1/8 x 29 1/16 in. (37.7 x 47.9 cm on 53.7 x 73.9 cm)

Museum Purchase: Gift of Bertha Pfirrmann in memory of Emma Hoeller, Mrs. Joseph Eichberg, Mrs. Frank Shaffer Jr., and Thekla Glemser, by exchange, 1978.245

Francis Frith, a leading topographical and architectural photographer, recognized the money-making possibilities in producing first-rate photographs of exotic places such as Egypt and Palestine. Born into a Quaker family in Devon, Frith was apprenticed to a cutlery firm at age 16, entered into partnership in a wholesale grocery business in Liverpool in 1845, and opened an independent printing firm five years later. He took a serious interest in photography in the early 1850s, when Frederick Scott Archer was introducing the patent-free collodion process.

In March 1853, Frith became a founding member of the Liverpool Photographic Society. Three years later he sailed to Egypt for the first time. Between 1856 and 1860 he made three additional trips. Periodically he returned to England, where his photographs were published and marketed to the public.

The Hypaethral Temple was taken between September 1856 and July 1857, during Frith's first trip to Egypt. Making the negative for this print was especially difficult in the intense heat, dust, and flies of the Middle East because the collodion-coated glass plates had to remain wet during exposure and processing. The temperature inside Frith's traveling darkroom tent, which is visible on the boat in the photograph, often rose above 110 degrees.

The Hypaethral Temple is Plate 10 of *Egypt, Sinai, and Jerusalem: A Series of Twenty Photographic Views by Francis Frith,* which was published in London by W. Mackenzie circa 1860 and republished in London by J.S. Virtue in 1862.

Clarence H. White (1871–1925)
United States
The Orchard, 1902
Vintage platinum print
9 3/8 x 7 9/16 in. (23.8 x 19.2 cm)
Bequest of Herbert Greer French, 1943.1513

During the early twentieth century, Clarence H. White was regarded as one of the most influential pictorial photographers and teachers of photography. Raised in Newark, Ohio, White was inspired to experiment with the camera after viewing contemporary art at the 1893 Chicago Columbian Exposition. In 1897 he began exhibiting his work and won the Ohio Photographers' Association Gold Medal in Cincinnati. Three years later the Cincinnati Art Museum organized an exhibition titled *A Collection of Artistic Photographs by Mr. Clarence H. White of Newark, Ohio, and Others.* In 1902 White was elected as a member of The Linked Ring, a London photographers' society, and was a founding member of the Photo-Secession in New York. His work was featured in five issues of *Camera Work,* the latter group's prestigious publication, between 1903 and 1910.

In 1906 White moved to New York, and soon began teaching photography at Teachers College of Columbia University. Eight years later he established the Clarence White School of Photography, the country's only school of art photography. White was also the founding president, in 1916, of the Pictorial Photographers of America.

From 1893 to 1906, his most productive period, White created beautiful and original compositions placing his family and friends in simple domestic scenes of midwestern middle-class life. *The Orchard,* with its flat perspective, was influenced by Japanese prints. The overall softness and tonality reveal his fondness for James Abbott McNeill Whistler and William Merritt Chase. This print once belonged to Herbert Greer French, the only Cincinnati member of the Photo-Secession.

Émile Joachim Constant Puyo (1857–1933)
France
The Straw Hat, ca. 1905–1910
Oil pigment print
10 7/8 f x 8 1/4 in. (27.6 x 21.0 cm)
Museum Purchase: Gift of John Sanborn Conner,
by exchange, 1981.154

Emile Joachim Constant Puyo was one of the most highly regarded turn-of-the-century French secessionists, a group whose goal was to promote photography as fine art. Born in Morlaix, France, he joined the Photo-Club de Paris in 1894 and exhibited in its annual salon, along with photographers Robert Demachy, Maurice Bucquet, and Rene Le Bègue. Two years later, Puyo wrote *Notes sur la Photographie Artistique*, the first of many articles and books on equipment and processes that he would publish throughout his career. Puyo had joined the French army as a young man but resigned his position as commandant in 1902, when he decided to pursue photography. Several of his images were published by Alfred Stieglitz in *Camera Work (16)*, the periodical of the Photo-Secession in New York. Stieglitz also exhibited Puyo's work in a group show in 1906. In 1931, two years before his death, Puyo was featured in a joint retrospective show with Demachy in Paris.

Puyo developed special lenses to create impressionistic effects in his landscapes, in his genre scenes, and especially in his portraits of fashionable women, of which *The Straw Hat* is an excellent example. This image, with its extensive manipulation, is also typical of his female subjects' elegance and grace.

Puyo was instrumental in developing a number of pigment processes, including gum bichromate, oil transfer, and (in the case of *The Straw Hat*) oil pigment. He included his circular monogram in the lower right-hand corner of this picture, which epitomized his impressionist pictorial aesthetic.

Paul Strand (1890–1976)

United States

Chair Abstraction, Twin Lakes, Connecticut, 1916

Gelatin silver print, ca. 1930s

12 7/8 x 9 9/16 in. (32.8 x 24.3 cm)

Museum Purchase: Gift of the estates of Clara J. Schawe and Mary Louise Burton, by exchange, 1987.96

Paul Strand, one of the most important figures in twentieth-century American photography, was born in New York City. His interest in photography evolved when he was a student at the Ethical Culture School under the influence of Lewis Hine, who later achieved considerable fame as a photographer working for social reform. Hine introduced Strand to Alfred Stieglitz and his Photo Secession Gallery, a groundbreaking exhibition space where Strand was exposed not only to works by the masters of nineteenth- and twentieth-century photography but also to the modernist paintings of Pablo Picasso, Georges Braque, Paul Cezanne, and Henri Matisse. Inspired especially by this latter group of European artists and their experimental use of form and design, Strand attempted to create similar compositions with the camera.

Beginning in 1916, Strand used architectural elements and everyday household objects to make a series of near-abstractions relying solely on the camera's objectivity. Images such as *Chair Abstraction* succeeded because Strand did not manipulate the print. He merely made effective use of the shadows as well as the object's point of view. *Chair Abstraction* is one of only two existing prints from the original negative.

Edward Weston (1886–1958)
United States
Mary Buff, 1921
Vintage platinum print
9 1/2 x 7 1/2 in. (24.1 x 19.2 cm)
Museum Purchase with funds provided
by Carl Jacobs, 1997.30
© Copyright 1981 Center for Creative
Photography, Arizona Board of Regents

Edward Weston, who is renowned as one of the grand masters of twentieth-century American photography, spent most of his career advocating a straight, unmanipulated style of photography. During his first 10 years as a photographer, however, he worked primarily as a Pictorialist, creating beautifully composed soft-focus platinum prints. Beginning in 1911, Weston operated a highly successful portrait studio in Tropico (now Glendale), California. He exhibited in salon shows, and his work won numerous awards.

Weston was influenced by the work of Karl Struss, whose photographs were published in a 1912 issue of *Camera Work.* This magazine was published quarterly by the Photo-Secession, the most important American Pictorialist group, formed by Alfred Stieglitz and his colleagues in 1902 in New York City. Struss's photographs, with their concern for form and abstraction, marked a transition in Weston's eventual move from Pictorialism to Modernism.

In 1920 and 1921, Weston photographed a series of dancers including Mary Buff, for one of his last prints in the Pictorial style. Weston moved closer to his subject in an attempt to probe the depths of her character. With the placement of the decorative plate and the figure, he has created a boldly simple composition with a sense of balance and tonal delicacy that succeeds in drawing the viewer into the picture.

Harold Edgerton
(1903–1990)
United States

Bullet and Apple,
ca. 1964

Dye imbibition
(Kodak Dye Transfer) print

9 13/16 x 11 7/8 in.
(4.9 x 30.2 cm)

Museum Purchase: Gift of
Ruth Friedman, by
exchange, 1981.158

© The Harold & Esther
Edgerton Family
Foundation

Harold "Doc" Edgerton was a scientist who used photography to extend the capabilities of the human eye to microsecond vision. His pioneering research in stroboscopic photography laid the foundation for the development of the modern electronic flash. Edgerton developed the stroboscope in 1933 as a young instructor in electrical engineering at the Massachusetts Institute of Technology. The device established him not only as one of the leading inventors of the twentieth century but also as a giant in the history of photography.

Over the next 60 years, Edgerton's strobe was the first to light up ice skaters and rodeo riders in darkened arenas, to record remarkable multiple exposures of athletes in action and birds in flight, to capture rapid machinery at work, and to freeze the passage of bullets. Edgerton was also the first person to take high-speed color photographs and to record the split seconds of atomic explosions. He made significant contributions to underwater exploration by designing watertight cameras, strobes, and side-scan sonar used by Jacques Cousteau and by the team that found the *Titanic*.

Edgerton first used the startling image of a bullet and an apple to illustrate a lecture titled "How to Make Applesauce at MIT." Almost immediately after the apple was penetrated by the .30-caliber bullet, it disintegrated completely. Surprisingly, the entry of the speeding bullet is as visually explosive as the exit.

Gordon Parks (b. 1912)

United States

Untitled

(Muhammad Ali
and little girl), ca. 1970

Vintage gelatin silver print

9 x 13 1/4 in.
(22.8 x 33.7 cm)

Lawrence Archer Wachs
Trust, 1999.17

© Gordon Parks

Gordon Parks is a renowned photojournalist who has also excelled as filmmaker, novelist, poet, and musician. The youngest of 15 children, he was born in the small town of Fort Scott, Kansas. After his mother's death when he was 15, Parks supported himself by working as a piano player, busboy, dining car waiter, Civilian Conservation Corps member, and professional basketball player. He took up the camera in the late 1930s, when he was living in Chicago. In 1942 he was awarded the first Julius Rosenwald Fellowship in Photography and was invited to work with Roy Stryker on the Farm Security Administration (FSA) photographic survey. After World War II, Parks worked as a freelance fashion photographer for *Vogue* and *Glamour.* Later he joined Stryker again, this time on a documentation project for the Standard Oil Company of New Jersey.

In 1949 Parks joined the staff of *Life* magazine, where he served as one of their primary photojournalists for more than 20 years. During this time, he was assigned on several occasions to photograph boxing champion Muhammad Ali. In 1970 Parks was sent to Miami, where Ali was training for his upcoming bout with Jerry Quarry in Atlanta. Ali was a controversial figure during that period: the Quarry fight would be his first since 1967, when he was stripped of his heavyweight title for resisting the draft.

When he was not at the gym, Ali, a Black Muslim, visited the children in many of the inner-city neighborhoods and taught them about Elijah Muhammad, the leader of the Nation of Islam. This moving image of a reflective Ali holding a young girl was taken during one of those visits.

Sandy Skoglund is a photographer, sculptor, and installation artist, whose tableau environments often combine familiar with disturbing elements set in mundane domestic spaces. *The Green House* includes 28 rather playful-looking purple and green dogs and two people, who appear to be surprisingly at home in a living room completely covered with grass. The title is both literal, as if to reveal part of the story, and open-ended, forcing interested viewers to use their imagination to complete the narrative. Does the name *The Green House* become "the greenhouse" in the viewer's mind, and possibly convey a political statement about global warming and the destruction of the ozone layer? Or is the picture a playful, childlike setting created to make the viewer forget many of the adult terrors that often occur in the "real" world? This ambiguity makes *The Green House* a highly complex and provocative work of art that can be read on many different levels.

Sandy Skoglund
(b. 1946)
United States

The Green House, 1990

Dye-bleach
(Cibrachrome) print

46 15/16 x 58 3/4 in.
(119.2 x 149.2 cm)

The Albert P. Strietmann
Collection, 1991.265

© Copyright 1990
Sandy Skoglund

European
Painting &
Sculpture

**The Master of
San Baudelio**
(and the Master of
Maderuelo?)

Spain

*Falconer, from the
Ermita de San
Baudelio,* ca. 1125–50

Fresco transferred
to canvas

86 5/8 x 78 7/8 in.
(220 x 200.3 cm)

Gift of Elijah B. Martindale
and the Edwin and Virginia
Irwin Memorial, 1962.594

A man on horseback, with sword and falcon, is a secular anomaly in a fresco cycle for a small medieval chapel that includes scenes from the life of Christ and an image of Saint Nicholas of Bari. The decorative scheme of the entire chapel combined scenes of liturgical significance with naturalistic, nonreligious forms such as leaves, dogs, and imaginary animals. The *Falconer* is the most notable of these subjects.

The frescoes were painted in the Romanesque period, so named because the artists and architects of that era frequently attempted to emulate the works of ancient Rome. Romanesque art is characterized by an appreciation of line; in the *Falconer*, this is evident in the bold outlines of the decorative leaf forms below and in the concentric, geometric motif ornamenting the register above the figure. The better-known frescoes from the Italian Renaissance were painted onto wet plaster. (The name of the technique, *fresco*, is the Italian word for *fresh*, describing the plaster.) These earlier Spanish murals, however, were painted directly onto dry walls.

Spain

Tomb Effigy of Don Sancho Saiz Carillo, 1250–75

Wood with polychromy

92 x 23 x 14 1/2 in. (233.7 x 58.4 x 36.8 cm)

Gift of Mrs. Frederick A. Geier in memory of her sister,
Mrs. Emilie Esselborn Crane, 1958.93

The mid-thirteenth century ushered in an era of great prosperity in medieval Spain, epitomized by cathedral building and the founding of universities. From that great epoch dates this moving funerary sculpture portraying Don Sancho Saiz Carillo, who died in 1210. Don Sancho was a magnate of the region of Mahamud in the Spanish province of Burgos. In this memorial, thought for stylistic reasons to have been carved between 1250 and 1275, he bears the accoutrements of a gallant knight: sword, chain, ring, gauntlets, and a spur on his right foot. Originally installed before a large arched niche, the sculpture was set upon a low wooden casket on a stone platform in the Ermita de San Andres. On the casket appeared paintings of the arms of Don Sancho, which bear the twin castles of Castile, and scenes from the life of Christ: the Nativity, the Dormition and Corona-tion of the Virgin, the Crucifixion, and Christ in Majesty. The two most fascinating panels show processions of mourning figures in an exception-ally vivid style. The tomb was disassembled in the eighteenth or early nineteenth century, and the painted panels are now in the Museum of Catalan Art in Barcelona.

The recumbent effigy alone possesses a powerful presence. The narrow, elongated figure shows French influence, which found its way into Mahamud via the pilgrimage route known as the *camino francés*, or French Highway. The angular, simplified folds of the draperies, the bold carving, and the remaining traces of color give Don Sancho a solemn dignity and authority befitting his noble stature.

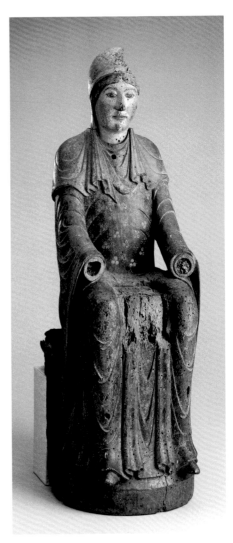

France
Virgin, ca. 1130
Wood with polychromy
34 x 11 1/8 x 13 3/8 in. (86.4 x 28.3 x 34 cm)
John J. Emery Fund, 1946.8

This wood sculpture of the seated Virgin Mary, which once included the Christ Child on her lap, is thought to have originated in Toulouse in southern France and belongs to a type known as the *sedes sapientiae* (Latin for "Throne of Wisdom"). Sometimes it is also called the Maiestas, or the Madonna in Majesty. The full three-dimensionality of these sculptures from the so-called Romanesque period made the humanity of the Virgin and Child physically palpable. At the same time, however, the regal bearing of the figures and the rigid, frontal poses powerfully suggested their divine nature. Intended to be venerated, these works of art were seen as substitutes for the beings represented, and offered the possibility of direct communication with the Virgin and Child themselves.

The Museum's sculpture is a characteristic example. Like many, it was once richly decorated. Traces of gold ornamentation and bright blue and red pigment remain. The rough condition of these portable statues resulted from their frequent relocation within the church and their use in magnificent processions through city streets.

Composed of multiple pieces of wood attached by dowels, elements such as the Virgin's arms and the figure of Christ often became separated. The hole in the back of this sculpture probably did not serve as a reliquary, as has often been postulated, but rather was intended to lessen the weight of the piece and reduce the possibility of cracks developing in the wood. The flattened, rhythmic folds of the cascading garment make this sculpture a particularly elegant illustration of the twelfth-century Throne of Wisdom type.

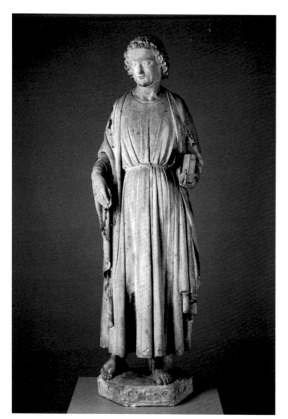

France

Donor Figure, from the Hospice at Salins, 1260–1305

Limestone

69 3/4 x 21 5/8 x 14 3 /16 in. (177.2 x 54.9 x 36 cm)

John J. Emery Fund, 1946.7

This figure is a fine example of French sculpture of the late thirteenth century. Believed to be one of a set of the four evangelists, it was created for the hospice in Salins, in eastern France near Switzerland. It has close affinities to sculpture, particularly to the smiling *Angel of the Annunciation,* executed on the west façade of Reims Cathedral around 1245 to 1255. The sculptor of the Museum's *Donor Figure* may have worked at the great cathedral or at a church influenced by the Reims atelier.

The heavy drapery hangs columnlike on the slender figure, concealing the body underneath. The face is generalized but has an expressiveness that reveals character and mind. The thin lips and deep lines impart an austerity softened by the figure's shift in weight, slight turn of the shoulders, twist of the head, and pensive gaze. Traces of blue on the drapery, later overpainted with a brown or a darker red, show that the statue originally was colored.

A 1994 neutron-activation analysis of the statue confirms the earlier stylistic analysis. The stone is consistent with limestone quarried for Parisian monuments, and minute traces of gilt and cinnabar red are present. Rather than the plain figure seen today, the statue must have been brighter and more lifelike when it still had its original decoration.

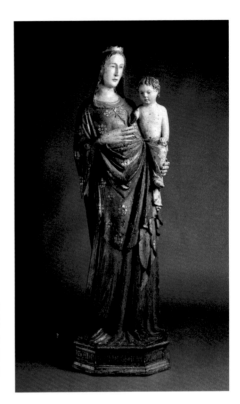

Italy
Madonna and Child, 1370–80
Wood with polychromy
62 1/2 x 19 13/16 x 16 1/4 in. (158.8 x 50.3 x 41.3 cm)
Gift of Mary Hanna, 1953.151

The city of Siena, founded in the third century BC or earlier, flourished during the Middle Ages, when its bankers and merchants established commercial interests throughout Europe and the Near East. Siena was also one of the first cities to feel the stirrings of the Renaissance, when a new attitude towards humankind, nature, and antiquity emerged. In the mid-fourteenth century, the city suffered economic and political catastrophes. It lost at least half of its population to the Black Death, an epidemic of bubonic plague that devastated Europe in 1348. Yet despite the changes in its fortunes, the city was a leading European art center throughout much of the fourteenth and fifteenth centuries, and was noted for its painting as well as its sculpture.

The Museum's Sienese *Madonna and Child* recalls the medieval past and anticipates the glorious Renaissance future. The statue is reminiscent of Gothic style in its elongation and stylization of the human forms and in its air of otherworldliness. Yet both the Madonna and the Child have a grace and humanity that anticipate the achievements of the Renaissance.

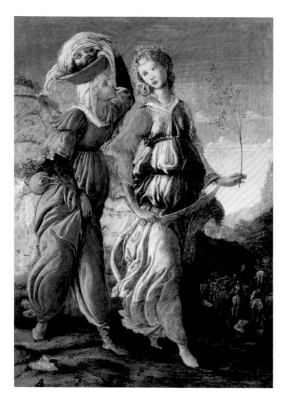

Sandro Botticelli (1445–1510)
Italy
Judith with the Head of Holofernes,
ca. 1469–70
Tempera on panel
11 1/2 x 8 1/2 in. (29.2 x 21.6 cm)
John J. Emery Endowment, 1954.463

This small panel depicts an apocryphal Old Testament story that had meaning for the citizens of Florence. The tale of the pious Hebrew widow Judith, who saved her village by seducing and then beheading the Assyrian commander Holofernes, was viewed in Renaissance Italy as a warning to tyrants who threatened the independence of Italian city-states.

The original function of the picture is unknown today; it may have been made to serve as a door to a small cabinet or even as the cover for a small portrait. On the reverse of the painting is a scene by another hand depicting deer and monkeys, possibly an allegory of virtue. This would have been appropriate for daily contemplation as one opened the cabinet, or as a companion piece to a portrait. The image of Judith's victory would have served as an example to Florentine women.

This picture is a version of a similarly sized painting in the Uffizi in Florence. For this reason, and because of the condition of the Cincinnati picture, the attribution to Botticelli occasionally has been doubted. Recent studies using infrared reflectography, however, reveal underdrawing by a hand extremely similar to Botticelli's, and undamaged areas of the painting likewise compare favorably with Botticelli's work from the late 1460s and early 1470s. Whoever the artist may be, the work is an exceptional document of the Italian Renaissance use of religious imagery for secular inspiration.

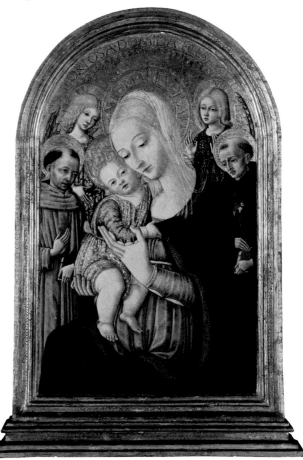

Matteo de Giovanni
(ca. 1430–1495)

Italy

***Madonna and Child
with Angels and Saint
Anthony of Padua and
Saint Nicholas of
Tolentino,*** early 1470s

Tempera and oil on panel

24 x 15 in.
(61.0 x 38.2 cm)

Eva Belle Leyman Fund
and Bequest of
Mrs. Frieda Hauck,
1956.89

With the figures painted in a sensuously curving manner and with its generous use of gold leaf, this small panel is an exceptional example of Sienese Renaissance painting. While the Florentine art of that period reflected innovations in portraying the world more naturalistically, artists in Siena, only about 25 miles away but in a separate city-state, still worked in a style that recalled religious art from a much earlier time. The poses remained stylized, and the gold leaf backgrounds still were decorated with punchwork, but the works had no less spiritual beauty than their counterparts in Florence.

This painting, which is remarkably well preserved, was probably made as a private image for the spiritual inspiration of an individual. The Augustinian Saint Nicholas of Tolentino, to the right of the Virgin, is sometimes encountered in Sienese painting; this suggests that he may have had local followers. Devotion to Saint Anthony, shown on the left, was widespread, but his presence here also may have held a special meaning for the patron of the picture.

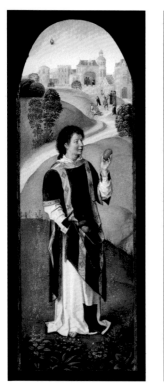
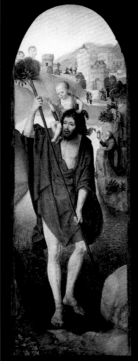

Hans Memling (1430s–1494)

Flanders

(left) *Saint Stephen,*
ca. 1479–80

Oil on panel

18 3/4 x 6 3/8 in. (47.5 x 15.8 cm)

Gift of Mrs. E.W. Edwards, 1956.11

(right) *Saint Christopher,*
ca. 1479–80

Oil on panel

18 13/16 x 6 3/16 in.
(47.9 x 15.7 cm)

Gift of Mrs. E.W. Edwards,
1955.793

O riginally created as the outer doors of a small traveling altarpiece (the central panel and the inside doors are in the Louvre in Paris), these two exquisite paintings portray scenes from the lives of Saint Stephen, the first Christian martyr, and the apocryphal Saint Christopher, whose legend describes his arduous carrying of a mystical child across a river.

As shown here, Saint Stephen delicately holds the stones used for his execution by the Jews for blasphemy. In the far background he is depicted in miniature, disputing with Jewish elders, while his martyrdom is displayed in the near background. The tale of Saint Christopher, whose name derives from the Greek *Christos* (Christ) and *pherein* (to carry), describes a giant who ferried people on his back across a stream. A child appeared to him, asked to be taken across, and proved to be the heaviest burden Christopher had ever carried; his staff nearly broke under the weight. The child declared that Christopher had just carried the weight of the world. The blossoming of the staff into a palm tree confirmed the identity of Christopher's burden as a miraculous apparition of the Christ Child.

Both images are painted as if appearing in the fifteenth century, with typical Flemish medieval architecture in the background. When the panels are seen side by side, the landscape flows from one into the other, creating a unified image for the cover of the closed triptych.

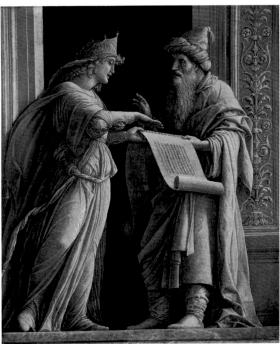

Andrea Mantegna (ca. 1431–1506)
Italy
A Sibyl and a Prophet,
late 1490s or early 1500s
Distemper and gold on canvas
22 1/2 x 19 1/8 in. (56.2 x 48.6 cm)
Bequest of Mary M. Emery, 1927.406

This almost perfectly preserved painting, showing the dialogue between a crowned woman and a bearded, turbaned man, has defied all attempts to discover the subject and the meaning. Painted in a delicate technique and highlighted with actual gold, this picture is an extremely important and precious object, but the reason for its creation remains unknown.

The woman is thought to represent either a queen (perhaps Esther from the Old Testament) or a sibyl. The man is either a prophet, a philosopher, the biblical Mordecai, or Tarquin. They speak together in front of a decorated pilaster reminiscent of ancient architecture but also current in the Renaissance.

Some scholars have suggested that the painting was made for the famous *studiolo*, or private study, of Isabella d'Este. Its dimensions are exactly equal to half of the space over the door, and indeed the right-hand side of the painting has been cut. Others, however, have pointed out that the delicate technique would have been all but invisible above a door. In any case, the paintings that decorated the *studiolo* were still intact in 1603, when this painting, then in another important Italian collection, first became known.

Andrea Mantegna, one of the most important artists of the Italian Renaissance, greatly admired the severity of the art of classical antiquity and expressed this admiration in his work. However, he also painted with a grace and beauty typical of his own time. The elegance and mystery of this creation give the painting its contemporary appeal.

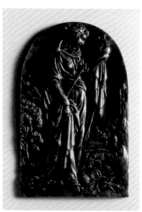

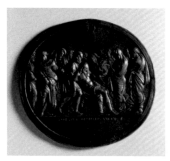

(upper left)
Moderno (possibly
Galeazzo Mondella)
(ca. 1467–1528)
Italy
*Cacus Stealing Cattle
from Hercules,* ca. 1500
Cast bronze
2 5/8 x 1 3/4 in.
(7.3 x 4.5 cm)
Museum Purchase: Gift of
Mrs. Bolton Armstrong, by
exchange, 1992.47

(upper right)
Peter Flötner
(ca. 1485–1546)
Germany
Venus, ca. 1540
Bronze
2 7/8 x 1 5/8 in.
(7.3 x 4.8 cm)
Museum Purchase: Gift of
the George Weidemann
Brewing Co., by exchange,
1992.45

(lower left)
Valerio Belli
(ca. 1486–1546)
Italy
The Entombment,
early sixteenth century
Cast bronze
3 3/4 x 3 7/16 in.
(9.5 x 8.7 cm)
Museum Purchase with
funds provided by Mrs.
Gilbert McCurdy in honor
of Mr. and Mrs. Paul E.
Geier, 1982.28

(lower right)
Leone Leoni
(1509–1590)
Italy
*Charles V, Holy Roman
Emperor,* ca. 1547
Cast bronze
Diam. 2 15/16 in. (7.5 cm)
Museum Purchase: Gift of
Mr. and Mrs. Bayard L.
Kilgour Jr., by exchange,
1992.43

The Cincinnati Art Museum has a small but select collection of bronze plaquettes, medals, and medallions dating from the fifteenth through the seventeenth centuries. Plaquettes were developed in the fifteenth century and served a variety of purposes. Made of bronze, they were less costly than objects made of gold or engraved gems. Usually small enough to be held in the hand, they were worn as brooches, inserted into sword hilts, used as decorations, enjoyed as art objects, and, with religious subjects, used as instruments of meditation or objects of ritual. Their subjects encompassed mythology, history, portraiture, allegory, and religion. Impartially portraying both Christian and secular subjects, plaquettes convey the Renaissance spirit of humanism as well as its rediscovery of antiquity and nature.

Moderno, considered among the most important producers of plaquettes, illustrated an incident from the Tenth Labor of Hercules in his *Cacus Stealing Cattle from Hercules.* The German master Peter Flötner, who worked in Nuremberg, depicted the Roman goddess Venus for one in a series of plaquettes representing the seven celestial bodies. Valerio Belli worked in Rome as a crystal and gem engraver. He may have produced *The Entombment* as a souvenir replica of a rock-crystal plaque in the Vatican. Leone Leoni, one of the greatest of Italian medallists, created a sensitive portrait of the Holy Roman Emperor Charles V.

**Lucas Cranach the
Elder** (1472–1553)

Germany

*Saint Helena with the
True Cross,* 1525

Oil on panel

16 1/8 x 10 5/8 in.
(41 x 27.0 cm)

Bequest of Mary M. Emery,
1927.387

A fashionable lady holds upright a cross, on which nail holes are distinctly visible. This cross identifies her as Saint Helena, the discoverer of the True Cross, on which Christ was executed, and the mother of Constantine the Great, the first Christian Roman emperor. Her expensive and sophisticated clothing, however, identifies her as a German of the sixteenth century. The painting is probably an allegorical portrait, perhaps depicting a member of the court of Wittenberg, in which the sitter is to be associated with Saint Helena's noble qualities. Such historicizing portraits have been popular throughout the history of art and have been created by artists as diverse as Titian, Rembrandt, and Joshua Reynolds. Cranach's celebrated attention to surface detail, flattened forms, and decorative curvilinear lines is quite effective in this portrait.

Although this painting nominally represents the Old Testament scene of Abraham's attempted sacrifice of his son Isaac (Genesis 22:1–13), it testifies to the interest in the physical world in a period of great global exploration. The landscape does not represent a specific place but is a fantasy of jagged mountains, wooded forests populated with a variety of barely hidden creatures, and vistas of distant cities and plains. Pictures such as this would have been made for the pleasure of wealthy patrons; accounts dated shortly after Bles's time indicate their popularity both in the artist's native Flanders and as far away as Italy.

Bles included the figures of Abraham, Isaac, the angel, and the two waiting servants because artists and patrons in the sixteenth century did not understand landscape as a separate category of art. Even today, one should view this painting in the same way as one views the panorama from the top of a mountain, marveling at life in miniature and the wonders of creation.

Herri met de Bles
(ca. 1505/10–ca. 1550)
Flanders

Landscape with the Offering of Isaac,
ca. 1540

Oil on panel

22 1/8 x 33 7/8 in.
(56.2 x 86 cm)

Fanny Bryce Lehmer Endowment, 1944.44

Titian (1477/90–1576)

Italy

Portrait of King Philip II of Spain, ca. 1550–56

Oil on canvas

42 3/16 x 36 1/2 in.
(107.2 x 92.7 cm)

Bequest of Mary M. Emery,
1927.402

With a mixture of expressive, spontaneously applied paint and extraordinary psychological intuition, this image of perhaps the most powerful man in the world during the late Renaissance is one of Titian's finest portraits. Probably it was painted from life in Augsburg, Germany, when it was arranged that Philip would inherit Spain and her possessions after the abdication of Charles V. The portrait never left Titian's studio and remained unfinished; the crown, the chain of the Golden Fleece, and the chair are by a later hand. It may have been intended as a model for future portraits of Philip by Titian, although no others of this format are known. Philip's steely-eyed gaze, rendered by Titan's rapid, decisive technique—a felicitous marriage of sitter and artist—makes this one of the great portraits of the Italian Renaissance.

O ne of the most important and most influential European sculptors of the late sixteenth century, Giovanni da Bologna trained in his native Flanders before traveling to Rome in about 1550. On his way home, he stopped in Florence; there he remained for the rest of his life, creating monumental marble sculptures and small bronze statuettes depicting mythological, allegorical, genre, and animal subjects.

The Museum's extremely fine bronze is a reduction of Giambologna's monumental marble in Florence, which he created, in the words of a contemporary, "solely to prove his excellence in his art." The easy portability of statuettes like this one helped to spread his reputation and influence throughout Europe.

The arrangement of the figures beautifully exemplifies the aesthetic ideals of sixteenth-century Mannerism such as the *figura serpentinata*, a twisting, flamelike line resembling the letter S. Giambologna used this technique to energize each figure as well as the entire group. He imparts a sense of elegance and grace scarcely compatible with the subject.

The *Rape of the Sabines* depicts a legendary event from the history of Rome. To secure wives for his men, Romulus (who founded Rome with his twin brother Remus) invited the neighboring Sabines to witness celebratory games. During the festivities, the Romans stole over to the Sabine town and carried off the women. War followed, and continued until the captured women reconciled the two sides.

Giovanni da Bologna, known as Giambologna
(1529–1608)
Italy
Rape of the Sabines, 1579–83
Bronze
23 1/4 x 8 11/16 x 7 3/4 in. (59.1 x 22.1 x 19.7 cm)
Museum Purchase, 1975.47

Anthony van Dyck
(1599–1641)
Flanders

Portrait of a Man in Armor (member of the
Spinola family?),
ca. 1621–27

Oil on canvas

47 3/4 x 54 in.
(121.3 x 137.2 cm)

Gift of Mary M. Emery,
1927.393

L ike his compatriot and teacher Peter Paul Rubens before him,
Anthony van Dyck traveled to Italy to study ancient classical sculpture
and work by the great artists of the Renaissance. With introductions
from Rubens, he spent much time in Genoa painting portraits of several
noble families; today these are regarded as some of the most striking im-
ages from the Baroque era. The identity of the old man in armor is unknown,
but it is thought that he belongs to either the Spinola or the Balbi family.
Despite his anonymity, the gentleman has commanded attention since the
late 1600s, when the portrait was first recorded in a Genoese collection.

In his large-scale work, van Dyck often posed his figures elegantly and
dramatically. Frequently he enhanced the portraits by allusions to classical
antiquity (in this case, the classical column at the upper right), which re-
flected the sitters' erudition and nobility. He painted them in clear colors
and rich light. These portraits by van Dyck were among the most influen-
tial in Europe over the next 200 years; they are the prototype for grand-
manner portraiture, and his influence is felt even today.

Peter Paul Rubens
(1577–1640)

Flanders

Samson and Delilah,
ca. 1609

Oil on panel

20 1/2 x 19 7/8 in.
(52.1 x 50.5 cm)

Mr. and Mrs. Harry S.
Leyman Endowment,
1972.459

Rubens, the greatest of Flemish artists, traveled in Italy from 1600 to 1608. There he studied classical antiquities, the work of Titian, Michelangelo, and Raphael, and the art of his own contemporaries in Venice and Rome. After his return to his hometown of Antwerp, he was commissioned by Nicolaas Rockox, the burgomaster or mayor, to make a large painting of Samson and Delilah. This story of fatal gullibility may have been intended to point up a significant moral for a politician. As part of the process, Rubens made this small oil sketch so that Rockox could see and approve his ideas for the composition and color. It evidently met with the patron's approval because the finished picture, substantially larger and on display today in the National Gallery in London, hardly differs from the sketch.

In the Cincinnati sketch, Rubens demonstrates why his work was regarded so highly in his own time. His figures recall poses from celebrated works of the past. Samson, for instance, is inspired not only by the powerful works of Michelangelo but also by works that motivated Michelangelo himself, such as the great *Belvedere Torso* from the Vatican collection (first century BC). Rubens' colors recall those used by the great Venetian artists Titian and Veronese. His use of strong contrasts of light and shadow, known by the Italian term *chiaroscuro*, derives from Caravaggio, whose work he would have seen in Rome. Rubens' ability to meld these sources gracefully and beautifully into an expressive, unique style is one reason why he has never fallen out of favor.

Simon Vouet
(1590–1649)
France
The Toilet of Venus,
1629
Oil on canvas
72 3/8 x 60 1/4 in.
(183.8 x 153.0 cm)
Fanny Bryce Lehmer
Endowment, 1970.459

Simon Vouet, who lived the first 37 years of his life in Italy and trained there, was brought back to France by Louis XIII in 1627 to be his principal painter. Vouet was responsible for bringing to France the high Baroque style of painting usually associated with artists such as Caravaggio and Peter Paul Rubens. In *The Toilet of Venus*, the ancient Roman goddess of love admires herself in a mirror, while *amorini* ("little loves" or cupids) play nearby. A clue to the picture's precise meaning comes from a similar work, an *Allegory of Prudence* (Musée Fabre, Montpellier, France). In that painting, the face reflected in the mirror is an idealized image of Anne of Austria, then the widow of Vouet's patron Louis XIII. The same face appears in the Cincinnati picture, which at one time belonged to Madame du Barry, mistress of the eighteenth-century French king Louis XV.

Claude Gellée, who was nicknamed "Le Lorrain" after his native region in France, was the greatest painter of ideal landscapes, a type of art that strove to represent nature as more beautiful and more "ideal" than nature itself. His exquisitely organized paintings are the visual equivalent of pastoral poetry, and often are inhabited (as in pastoral poetry) by shepherds and other country folk.

In *An Artist Studying from Nature*, Claude painted an imaginary harbor dominated by a large tree and a fortified building. The building is similar to the Castle of Palo, a structure in southeastern Italy. There Claude made several drawings outdoors, as does the artist in the lower right-hand corner of this painting. Like Claude, the artist depicted here studies the specifics of nature in order to achieve an ideal result. Claude drew a copy of *An Artist Studying from Nature* in his *Liber Veritatis* or *Book of Truth* (now in the British Museum), in which he recorded all his paintings to guard against forgeries.

Claude Lorrain
(1600–1682)
France
An Artist Studying from Nature, 1639
Oil on canvas
30 3/4 x 39 3/4 in.
(78.1 x 101.0 cm)
Gift of Mary Hanna, 1946.102

Bartolomé Esteban Murillo
(1617–1682)
Spain

Saint Thomas of Villanueva
Dividing His Clothes Among
Beggar Boys, ca. 1667
Oil on canvas
86 1/2 x 58 3/4 in.
(219.7 x 149.2 cm)
Bequest of Mary M. Emery,
1927.412

This large painting was part of a monumental *retablo*, or altarpiece, commissioned by the Monastery of San Agustín in Seville in honor of Saint Thomas of Villanueva's canonization in 1658; the *retablo* illustrates scenes from the saint's life. Three other paintings survive, depicting the saint giving alms (Norton Simon Museum, Pasadena), receiving the announcement of his death (Museo de Sevilla), and healing a lame man (Alte Pinakothek, Munich), but it is not known exactly how many paintings were included in the original setting.

In the nineteenth century Murillo was considered Spain's greatest painter. His influence on European and American artists in the eighteenth and nineteenth centuries was considerable. A native of Seville, Murillo was court painter to King Charles II of Spain and founded the Academy of Seville. His pictures, which were most popular in the nineteenth century, often have a saccharine quality that is somewhat unpalatable today. (This is particularly true of his many images of the Immaculate Conception.) Even so, many of his works are as strong as any created in seventeenth-century Europe.

S aint Peter Nolasco, founder of the Catholic order of Our Lady of Mercy (the Mercedarians), is depicted standing to the right as a relief of the Virgin and Christ Child is presented to King James I of Aragon. The image was said to have been carved by angels from the stone of the Virgin's tomb. It had been buried under a bell at the castle of El Puig, near Valencia, to preserve it from desecration during the Moslem invasion. When James retook Valencia in 1238, Peter Nolasco received a miraculous sign— three groups of stars falling from the sky and disappearing into the ground—which he interpreted as indicating the site of the hidden relief.

This painting was commissioned 400 years after that event by the Merced Calzada monastery in Seville as part of a series intended to celebrate the 1628 canonization of Peter Nolasco. Francesco de Zurbarán, celebrated as one of Spain's most important painters, devoted himself almost entirely to religious work. The painting demonstrates Zurbarán's simple composition, austere naturalism, and mystical intensity.

Francisco de Zurbarán
(1598–1664)
Spain

Saint Peter Nolasco Recovering the Image of the Virgin, 1630

Oil on canvas

65 1/16 x 82 3/16 in.
(165.3 x 208.8 cm)

Gift of Miss Mary Hanna, Mr. and Mrs. Charles P. Taft and Mr. Stevenson Scott in memory of Charles Frederick Fowles, 1917.58

Bernardo Strozzi
(1581–1644)
Italy
***David with the Head
of Goliath,*** ca. 1636
Oil on canvas
60 5/8 x 46 7/8 in.
(154.0 x 119.1 cm)
John J. Emery Fund,
1938.10501

Because of its rich maritime culture, Genoa was an important artistic crossroads where influences from the north and the south of Europe converged. Bernardo Strozzi, a Capuchin friar, was the foremost painter in the city. His work reflected the wide variety of sources typical of such a cosmopolitan center, although early in his career he primarily painted devotional pictures. Later his subject matter broadened; his genre paintings, particularly those of kitchens, are much admired.

The *David* was painted in Venice, where Strozzi lived the last 15 years of his life. David's conquest of the giant Goliath was not only a biblical story but also was viewed as depicting the triumph of good over evil and representing political victory over tyrants. Strozzi's luscious use of color and brushwork to render the feathers and fabrics worn by David—typical of the flamboyant style of contemporary Venetian painting—is contrasted with the dark, ruddy features of Goliath's decapitated head, which is painted with equal vigor.

Stefano Maderno
(1576–1636)

Italy

Hercules and Antaeus,
ca. 1622–25

Bronze

20 1/2 x 9 1/2 x 12 in.
(52.1 x 24.1 x 30.5 cm)

Bequest of Frederick and
Sylvia Yeiser, 1982.30

A n outstanding sculptor in Rome, Stephano Maderno was seminal in the transition from sixteenth-century Mannerism to seventeenth-century Baroque. Like many sculptors, he began his career in Rome by restoring and copying the work of early sculptors. Throughout his life, he created both monumental marble sculptures and small-scale original bronzes, such as the Cincinnati statue.

Maderno originally made *Hercules and Antaeus* in terra cotta as one of a series representing the labors of Hercules. Seventeenth-century sculptors customarily created their works in that less expensive material before recreating them in marble or bronze. Maderno's *Hercules and Antaeus* was quite popular: a number of bronze casts are known.

Recalling antique statuary, Maderno depicted naturalistically the dramatic and violent scene of the straining Hercules crushing the anguished Antaeus. Son of the sea god Poseidon and Mother Earth, Antaeus forced strangers to wrestle and killed them when they grew exhausted. He saved his victims' skulls to roof a temple to Poseidon. Determined to end this barbaric practice, the heroic Hercules wrestled the giant and flung him to the ground, but was surprised to see him rise stronger and fresher. Realizing that Antaeus was strengthened whenever he came into contact with the earth, Hercules held him aloft, cracking his ribs, until he died despite his mother's piteous wails. Certainly the story of Hercules and Antaeus exemplified the triumph of heroic virtue over unmitigated evil.

Guercino (1591–1666)

Italy

Mars with Cupid, 1649

Oil on canvas

70 13/16 x 92 in.
(179.9 x 234.9 cm)

The Edwin and Virginia
Irwin Memorial, 1977.96

Around the beginning of the seventeenth century, Italian religious art moved from the mysterious style called Mannerism toward colorful, naturalistic, dramatic images that an illiterate public could understand more easily. This new style, today called Baroque, was used for secular work as well. Giovanni Francesco Barbieri, who is best known even now by his nickname Guercino ("the squinter"), was one of the finest of these artists. He combined the luminous colors and naturalism of Venetian artists with the dramatic compositions of artists from Bologna. Guercino did considerable work in Rome for the Bolognese Pope Gregory XV.

Mars with Cupid was painted for a military general, for whom an image of Mars, the god of war, might have some significance. The commission also included a *Venus and Cupid*, now lost. The pairing of an image of the goddess of love with an image of Mars, who gazes away (presumably at Venus in the other canvas), suggests that love can conquer even the strongest of men.

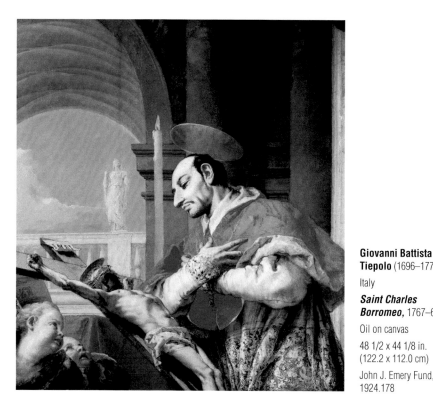

Giovanni Battista Tiepolo (1696–1770)

Italy

Saint Charles Borromeo, 1767–69

Oil on canvas

48 1/2 x 44 1/8 in. (122.2 x 112.0 cm)

John J. Emery Fund, 1924.178

A balding, large-nosed saint, immediately recognizable to seventeenth- and eighteenth-century Spaniards and Italians as Saint Charles Borromeo, adores what appears to be the living body of Christ on the cross. The painting is the only surviving fragment of a large altarpiece, one of seven that Tiepolo made for King Charles III of Spain for the church of San Pascual Baylón in Aranjuez. A preparatory sketch in London's Courtauld Institute Galleries shows the entire composition, in which Saint Charles venerates a crucifix in a manner that is still part of the Roman Catholic Good Friday liturgy. Tiepolo, the greatest of eighteenth-century Italian painters, had been brought to Spain to decorate the royal palaces and other buildings; the Aranjuez altarpieces were intended to be a major statement of the king's patronage. The artist died in 1770, before all the altarpieces had been installed. For reasons that are unclear (but probably political), all the rest of Tiepolo's paintings had been removed from the church by 1776.

Jacob van Ruisdael
(1628/29–1682)

The Netherlands

River Landscape with a Castle on a High Cliff,
1670s

Oil on canvas

39 13/16 x 49 7/16 in.
(101.0 x 125.4 cm)

Gift of Mary Hanna,
1946.98

Beautifully composed and rendered with exquisite attention to nature, Ruisdael's landscapes are almost always pure invention. In this painting, the building on the hill is similar to Bentheim Castle, a structure that appears frequently in Ruisdael's work. The artist, however, has placed the castle in an imaginary river landscape unlike Bentheim's actual setting and has arranged the foliage, paths, and clouds to decorative effect. None of this detracts from the suggestion that Ruisdael is depicting actual things.

The beauty and observation of nature in Ruisdael's work exerted a strong influence, not only on his contemporaries but also on artists throughout the eighteenth, nineteenth, and twentieth centuries. Ruisdael was particularly inspiring to English and American landscape painters.

Frans Hals
(1582/83–1666)

The Netherlands

Portrait of a Dutch Family, ca. 1665

Oil on canvas

44 x 35 3/8 in.
(111.8 x 89.9 cm)

Bequest of Mary M. Emery,
1927.399

F rans Hals was the greatest of Dutch portraitists after Rembrandt. His work combines brilliant handling of paint with an ability to endow his sitters with great vitality. Perhaps more than any other artist, Hals is responsible for the image of the Dutch as cheerful, industrious, prosperous, and content with the world.

This group portrait, the only known work by Hals with figures on a scale smaller than life, represents a now-unknown Dutch family that is posed on a stone veranda with an elegant country house in the distance. The family is obviously wealthy, and Hals has painted them in his typical energetic fashion while filling the scene with symbolic references to family life. Roses represent the joys and trials of love, fruit symbolizes fecundity (the orange in particular refers to marriage), and the foliage clinging to the architectural backdrop is probably an emblem of fidelity.

Dutch artists frequently collaborated on paintings. In this case the background was painted by another hand, perhaps the landscape specialist Pieter Molijn.

Gerard ter Borch
(1617–1681)
The Netherlands
The Music Party,
ca. 1675
Oil on panel
22 7/8 x 18 5/8 in.
(58.1 x 47.6 cm)
Bequest of Mary M. Emery,
1927.421

One of the great masters of seventeenth-century Dutch scenes of everyday life, or "genre painting," ter Borch created works characterized by a rich treatment of fabrics and the subtle drama played out by the figures. *The Music Party* is a masterpiece of this type, in which a richly dressed young lady ignores the earnest glances of a young man with whom she sings.

What appears to be innocent today, however, was charged with moral lessons and symbolic meanings immediately understood in seventeenth-century Holland. The subject of a music lesson, common in Dutch genre painting, not only symbolized the balance and harmony necessary for order in the world but also had a sexual connotation reflecting the harmonious union of a man and a woman in a healthy love relationship. The sexual interpretation of the picture is compounded by the fact that the young woman, although dressed in a luxurious yellow satin gown, is not wearing the black lace shawl that would have covered her shoulders and bosom. Such a shawl was a standard part of a refined lady's wardrobe. Her admirer's gaze, directed at her *décolletage*, leaves little doubt of the interpretation intended by ter Borch.

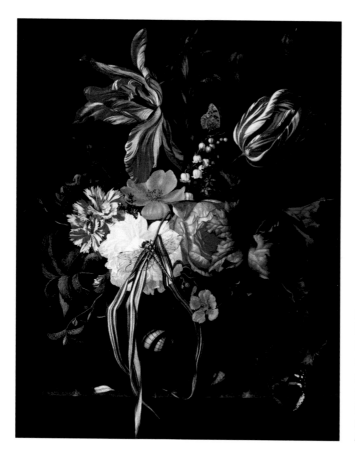

Like so many floral still lifes in seventeenth-century Holland, this painting is not merely an arrangement of spring flowers but is steeped in the symbolism of mortality. The tulips, one fresh and the other about to drop its petals, are a clear reference to the transitory nature of human life. Moreover, even in the seventeenth century, tulips were understood as the Dutch national flower. Thus the picture was also read as an emblem of worldliness and the capriciousness with which fortunes were won or lost. The insects likewise have a meaning. The fly symbolizes decay, and the butterfly resurrection.

Oosterwijck's careful attention to detail and delicate technique earned her the patronage of eminent connoisseurs, and several royal collections included her work. Yet despite her celebrity, little is known of her training and early career, and only about 20 of her works are located today.

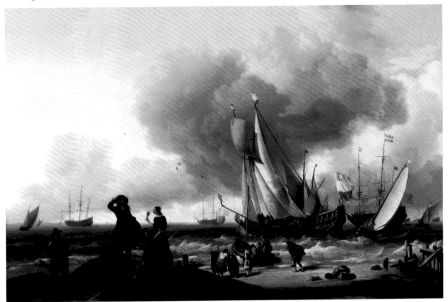

Ludolf Backhuysen (1631–1708)

The Netherlands

Dutchmen Embarking onto a Yacht, 1670s

Oil on canvas

22 1/2 x 33 in. (57.0 x 84.0 cm)

The Edwin and Virginia Irwin Memorial, Fanny Bryce Lehmer Endowment, John J. Emery Endowment, Mr. and Mrs. Harry S. Leyman Endowment, Bequest of Mr. and Mrs. Walter J. Wichgar, and Lawrence Archer Wachs Fund, 1993.140

Trained as a calligrapher, Ludolf Backhuysen today is considered one of the foremost Dutch painters of marine views. He put his training to good use when illustrating the highly decorated ships and their complicated rigging. These marine paintings celebrated the backbone of the Dutch economy, documenting the global mercantile enterprise by capturing the atmospheric wonders of water, air, and shore. In *Dutchmen Embarking onto a Yacht* the artist depicts the departure of a Dutch shipping fleet, which was often accompanied by a flotilla of smaller ships as it left the harbor.

This painting probably depicts the area near the Straits of Texel, where the merchant fleet from Amsterdam joined its military escort before entering the North Sea. Dignitaries enter a small boat, which will take them to a party in progress on board a "state's yacht" as they escort the other ships—cargo-carrying "flutes" and the military "men-of-war"—to open sea. A large gathering of people stands on shore to watch the event, perhaps including the artist (who holds his hat on) and his wife (well-dressed and wearing pearls), who are recognizable from other portraits by the artist.

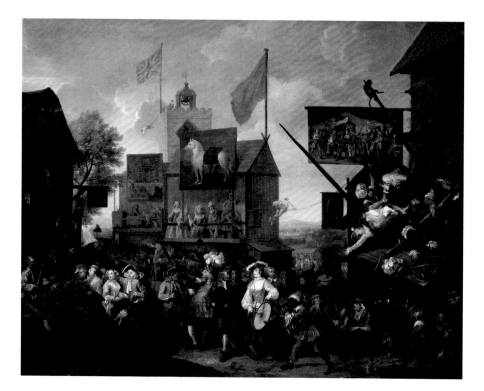

On the surface, this painting presents the chaos and crowds at the annual fair in Southwark, the section of London south of the Thames at London Bridge. The fair finally became so raucous that it was closed in 1762 as a public nuisance. The painting shows (among other distractions) a variety of the theatrical entertainments that were typical of the fair: strolling musicians, a pimp trying to lure away two country girls, a pickpocket, gambling, and a dancing dog dressed up in man's clothing. Hogarth was not so much painting Southwark Fair in particular as, in his words, "the Humours of a Fair" in general.

Many of Hogarth's greatest paintings carry a moral message. At a deeper level, this picture is one of Hogarth's most vibrant statements on the stage as a metaphor for life. Here the artist displays the wicked behavior at the fair, hoping that the spectator will recognize himself in the scene depicted. Among various moral symbols, an advertisement on the right touts a performance of *The Fall of Bajaset*, which materializes in the collapse of the temporary stage into a china shop.

Hogarth spread his messages through the sale of prints reproducing his paintings. *Southwark Fair* was painted specifically for that purpose (the Museum's collections contain a copy of the print). It is one of the artist's clearest statements on human folly and one of his best-known works.

William Hogarth
(1697–1764)
England
Southwark Fair, 1733
Oil on canvas
47 1/2 x 59 1/2 in.
(120.7 x 151.1 cm)
The Edwin and Virginia Irwin Memorial, 1983.138

European Painting & Sculpture

Isaac Oliver (d. 1617)

England

Portrait of a Lady in Masque Costume, ca. 1610

Watercolor on vellum

2 5/16 x 1 7/8 in. (5.9 x 4.8 cm)

Acquired from the Collection of T. Everard Spence (1899–1992) of Belfast, N. Ireland through a gift from Mr. and Mrs. Charles Fleischmann in memory of Julius Fleischmann, and a gift from Stuart T. Spence in memory of T. Everard Spence, 1996.39

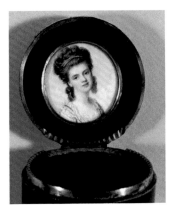

Richard Cosway (1742–1821)

England

Portrait of a Lady, undated

Watercolor on ivory

1 3/4 x 1 5/8 in. (4.4 x 4.1 cm)

Acquired from the Collection of T. Everard Spence (1899–1992) of Belfast, N. Ireland through a gift from Mr. and Mrs. Charles Fleischmann in memory of Julius Fleischmann, and a gift from Stuart T. Spence in memory of T. Everard Spence, 1996.32

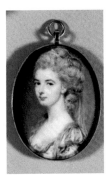

John Smart (1740–1811)

England

Portrait of a Lady, 1782

Watercolor on ivory

2 x 1 5/8 in. (5.1 x 4.1 cm)

Acquired from the Collection of T. Everard Spence (1899–1992) of Belfast, N. Ireland through a gift from Mr. and Mrs. Charles Fleischmann in memory of Julius Fleischmann, and a gift from Stuart T. Spence in memory of T. Everard Spence, 1996.18

Popular throughout the seventeenth, eighteenth, and early nineteenth centuries, portrait miniatures were painted on vellum, enamel, copper, or paper, but ivory was the preferred material. Miniatures, as the name implies, were small in scale, jewel-like, delicately drawn, and brilliant in color. Often they were given as tokens of love or friendship, and the recipients wore them like gems. Others were set into cases, snuffboxes, and other precious objects. Monarchs, nobles, and politicians exchanged them as favors.

The Museum has a large, impressive collection of portrait miniatures. These three are extremely fine examples of works produced in England, where the portrait miniature took hold more firmly than in any other country. Most notable is Isaac Oliver's portrait of a lady, which was painted on vellum and mounted in a turned ivory box. The figure is wearing a costume from the masques (or plays) presented by the court to entertain the king. These costumes are extremely fanciful, but also are frequently identifiable because of the history of the production. Several masques were written by authors such as Ben Jonson, and the stage sets were designed by Inigo Jones.

Richard Cosway was the finest of the eighteenth-century English miniaturists. His portrait of a lady, mounted in a snuffbox, is a most beautiful example of his art. Equally impressive is the oval miniature painted on ivory by John Smart. The work, also a very fine portrait of a lady, was created by an artist well represented in the Museum's collection.

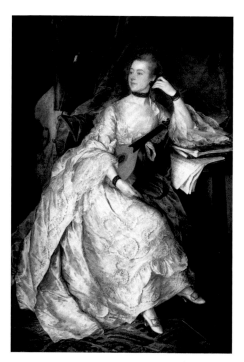

Thomas Gainsborough (1727–1788)
England
Portrait of Ann Ford
(later Mrs. Philip Thicknesse), 1760
Oil on canvas
77 5/8 x 53 1/8 in. (197.2 x 134.9 cm)
Bequest of Mary M. Emery, 1927.396

G ainsborough was a successful and promising artist when he moved to the fashionable spa city of Bath in western England in 1759 at the suggestion of his friend Philip Thicknesse. There he was almost an immediate success. This portrait of Thicknesse's future wife, Ann, a well-known beauty and amateur musician, contributed significantly to his reputation. Gainsborough had made few full-length portraits before that time, and the painting of Miss Ford was his first in Bath. In this picture he combined the current fashions of informality and animated paint handling with the grandeur of Anthony van Dyck, whose portraits were highly regarded in England.

Miss Ford's informal, twisted pose in a picture of such grandeur and scale was revolutionary. One critic praised it as "a most extraordinary figure handsome and bold," but added "I should be very sorry to have anyone I loved set forth in such a manner." The critic may have had some sympathy for Miss Ford as she held her position. Costume historians have pointed out that the sitter's cross-legged pose was considered masculine in the mid-eighteenth century; moreover, the structure of her corset would have made crossing her legs uncomfortable.

Because of its vivacity, the freedom of its brushwork, its large scale, and its affinity with the works of van Dyck, Gainsborough's portrait of Ann Ford is one of the most influential paintings in the history of British art, particularly for British portraitists in the late eighteenth and throughout the nineteenth century.

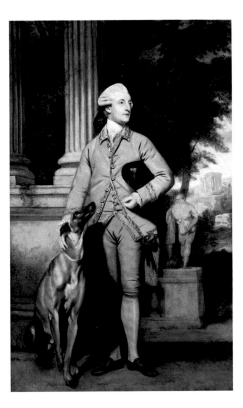

Sir Joshua Reynolds (1723–1792)

England

Portrait of Richard Peers Symons, M.P.
(later Baronet), 1770–71

Oil on canvas

93 1/2 x 57 1/2 in. (237.5 x 146.1 cm)

Museum Purchase: Bequest of Mr. and Mrs. Walter J. Wichgar, The Edwin and Virginia Irwin Memorial, John J. Emery Endowment, Fanny Bryce Lehmer Endowment, Mr. and Mrs. Harry S. Leyman Endowment, and gift of Mary Hanna, by exchange. Acquired in honor of Chairman of the Board John W. Warrington for fifty years' service as Trustee of the Cincinnati Art Museum, 1941–1991, 1991.62

The elegant sitter for this portrait was a 25-year-old member of Parliament when he was painted by Sir Joshua Reynolds. Reynolds's image is a masterpiece of British "grand manner" portraiture, influenced by Anthony van Dyck. For most of the eighteenth century, portraiture was considered the lowest form of art, which required no imagination because the artist merely "copied" the sitter's features. Reynolds set out to enhance the status of portraiture by infusing his portraits with the noble presence of great narrative works that illustrated scenes from classical mythology or the Bible.

A contemporary critic described Reynolds as someone who could make "the exact features of your half-witted acquaintance...[look so] that every muscle in their visage appears to be governed by an enlightened mind." In this portrait, the fashionable young man is represented with two works of classical antiquity, the Farnese Hercules and the Temple of Vesta at Tivoli outside Rome, in allusion to his erudition. He also receives adoration from a dog taken from a well-known portrait by van Dyck. Reynolds's portrayal of Symons as an inquisitive tourist in Italy, one of the most enlightened adventures a cultivated Englishman might undertake, is all artifice; there is no evidence that Symons ever left England.

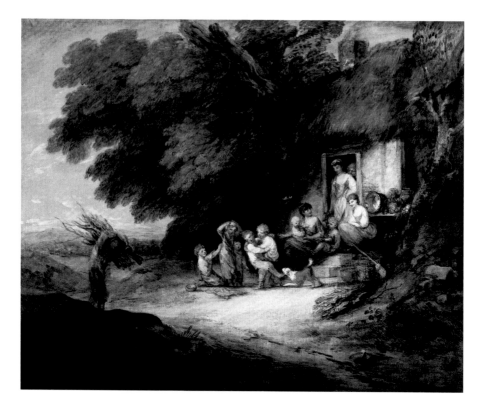

The Cottage Door is one of Thomas Gainsborough's most important subjects. Highly regarded during his life, this painting has been examined by critics both as a testament to Gainsborough's love of the country and as a document of social history. (It was regarded as an image of the rural poor, cleaned up for wealthy art patrons who had no interest in seeing how the poor really lived.) Popular in his day were the more sentimental works, particularly those depicting poor children, of the Spanish seventeenth-century painter Bartolomé Esteban Murillo. Gainsborough's romping peasant children owe as much to Murillo as to any other influence.

The Cottage Door is one of Gainsborough's most ambitious but most lyrical works, with loosely handled and thinly painted foliage, broad composition, and decorative details such as brooms, pots, bundles of firewood, and lively figures. It is an apt visual equivalent to the Georgic mode of literature that prevailed in his day. Unlike pastoral literature, in which the inhabitants of the countryside live freely and without care, Georgic verse described a land where rest and diversions are the rewards for hard work. This point is illustrated perfectly by the boy bringing home the bundle of firewood, which the rural poor had to glean for their daily use, to the happy household.

Thomas Gainsborough
(1727–1788)
England

The Cottage Door,
ca. 1788

Oil on canvas

48 1/4 x 58 3/4 in.
(122.6 x 149.2 cm)

Gift in honor of Mr. and Mrs. Charles F. Williams by their children, 1948.173

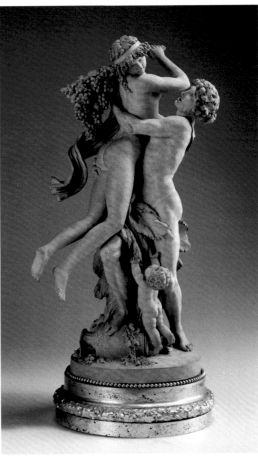

Clodion (1738–1814)
France
Bacchant and Bacchante with a Cupid,
1799
Terracotta
21 5/8 x 12 11/16 x 10 1/8 in.
(54.9 x 32.2 x 25.7 cm)
John J. Emery Fund, 1975.74

C lodion, as Claude Michel was called, is best known for his small clay figure groups, which were in great demand as decorations for domestic interiors. Clodion favored lighthearted classical subjects such as nymphs, satyrs, and fauns. This sculpture depicts two followers of Bacchus, the ancient Roman god of wine, in a drunken, ecstatic ritual dance during which they have dropped their ceremonial tambourine and have knocked over a jug of wine. One figure holds a bunch of grapes, for which an *amorino* ("little love," or cupid) reaches. Apart from the orgiastic subject matter, the most striking features of this work are the exquisitely modeled textures of flesh, drapery, and hair as well as the technical complexity of the figures.

Clodion's frivolous subject matter might suggest a date from the high Rococo period before the French Revolution, but in fact this sculpture was made in 1799. One of a number of technically superior works from this period, Clodion may have created it in an attempt to win back some of his former patrons, who were returning to France after the Reign of Terror.

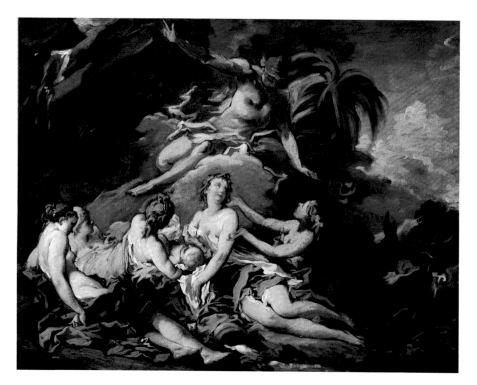

M ore than any other artist, François Boucher defined the graceful sensuality and lighthearted enchantment of the Rococo. A prolific painter and stunning draftsman, the ever-industrious Boucher created works on an astonishing variety of subjects but is best known for his depictions of the female nude. Born in Paris, Boucher left the city only once for an extended period when he studied in Rome from 1727 to 1731. A prodigy who achieved success early, Boucher rose to the position of premier peintre (first painter) to Louis XV and was a favorite of Louis's mistress, the Marquise de Pompadour.

The sketchiness and spontaneity of *Mercury Entrusting the Infant Bacchus to the Nymphs of Nysa* reveal it as a modello, or preparatory oil study, for a larger finished work, which is now in the Wallace Collection (London). Boucher's painterly virtuosity—his sheer enjoyment in and mastery of pushing paint—is seen in his sharp, rapid, expressive strokes, which impart vitality, energy, and a tantalizing suggestiveness.

Boucher took the story of Mercury and Bacchus from the *Metamorphoses,* a series of poems by the Roman poet Ovid. Jupiter, the king of the gods, had ordered Mercury to hide his infant son Bacchus, the result of a tryst with the mortal Semele, from the eyes of Juno, his jealous wife. Boucher depicted Mercury, wearing his winged hat and carrying the caduceus, bringing Bacchus, who grew up to become the god of wine, to the nymphs on the remote Mount Nysa.

François Boucher
(1703–1770)
France

Mercury Entrusting the Infant Bacchus to the Nymphs of Nysa, 1734

Oil on canvas

23 1/2 x 29 in.
(59.7 x 73.7 cm)

John J. Emery Endowment, Lawrence Archer Wachs Trust and Museum Purchase: Gift of Mr. and Mrs. Leonard Minster, by exchange, 1989.24

August von Kreling (1819–1876)
Germany
***Model for the Tyler Davidson
Fountain, Cincinnati,*** ca. 1868
Bronze
41 1/4 x 29 15/16 x 29 1/16 in.
(104.8 x 76 x 73.8 cm)
Bequest of Eugene Booth, 1952.198

A mong the high-rise office buildings of Fountain Square sits the Tyler Davidson Fountain, a graceful reminder of Cincinnati's nineteenth-century heritage and the city's most widely recognized landmark. Henry Probasco commissioned the fountain in memory of Tyler Davidson, his brother-in-law and partner in the hardware business. In 1865 Probasco traveled to Munich; there, at the Royal Bavarian Foundries of Ferdinand von Miller, he saw a drawing made 25 years earlier by sculptor August von Kreling. Objecting to the moral poverty of the frivolous nymphs, sea gods, and mythological creatures found in most fountain designs, Probasco admired von Kreling's realistic vignettes of ordinary citizens engaged in water-related activities. The fountain is surmounted by the Genius of Waters, who dispenses the precious resource to a daughter refreshing her aging father, a farmer waiting for rain, a mother and child about to bathe, and an artisan whose house is ablaze. Probasco believed that young working-class Cincinnatians would benefit by the fountain's message—that virtue brings rewards.

Probasco was involved with the fountain in each step of production. This small-scale model was shipped to him from Munich and displayed in the library of his mansion in the Clifton neighborhood. At a celebration held there, Mayor Charles Wilstach proclaimed that Cincinnatians would be "the pioneers in the country of this mode of dispensing to our people the benefits of one of the great blessings of the earth.... Let us, in the erection of this magnificent fountain, signify that Cincinnati is destined to be not only the seat of learning and of literature, but of high art."

J ohann Eckstein was a German-born painter and sculptor. As a young artist, he joined his brother, sculptor George Paul Eckstein, in England and achieved recognition for relief sculpture. Such were his accomplishments that in 1765 he was invited by King Frederick the Great of Prussia to become court artist.

After the monarch's death, Eckstein found himself increasingly disgruntled with the Prussian government, and in 1794 he and his son, Frederick Eckstein, sailed for Philadelphia. There he became a founder of the Pennsylvania Academy of the Fine Arts. In 1817 the aging sculptor went to Cuba on a commission for a monument, but he died shortly after arriving in Havana.

The Raising of Lazarus may have been made as a design for porcelain under Frederick the Great. This fascinating sculpture, which has been in Cincinnati for more than 150 years, was supposedly brought here in 1826 by the artist's daughter, a Mrs. Addelsterren, who had come to teach art.

Modeling skillfully in the pliable, fragile medium of wax, Johann Eckstein created a theatrical tableau with intricate, convincing detail and a dynamic, spatially complex composition. To dramatize the miraculous event in this biblical story in which Christ raised Lazarus from the dead, Eckstein portrayed the onlookers' varied reactions with highly expressive, gesticulating figures.

Johann Eckstein
(ca. 1735/36–1817)
Germany
*The Raising of
Lazarus,* undated
Wax with polychromy
20 3/4 x 31 1/4 in.
(52.7 x 79.4 cm)
Gift of Frances Eckstein in memory of Frederick Eckstein, 1916.287

John Constable
(1776–1837)
England

Waterloo Bridge,
ca. 1820

Oil on canvas

21 11/16 x 30 11/16 in.
(55.1 x 77.9 cm)

Gift of Mary Hanna,
1946.109

I n 1817, festivities marked the opening of Waterloo Bridge, spanning the River Thames in London, on the second anniversary of the battle that finally defeated Napoleon. This occasion provided Constable with urban subject matter unlike his more usual Suffolk landscapes. He may have been attempting a "historical landscape" in emulation of Claude Lorrain. The finished picture, which hangs in the Tate Gallery in London, is a grand composition documenting a significant moment in London's cultural heritage.

Constable may have made this smaller rendering of Waterloo Bridge in preparation for the painting at the Tate Gallery, or as a separate work in itself. It is far less documentary than the Tate composition, which recalls Canaletto in its arrangement of buildings and figures. In the Cincinnati canvas, Constable experimented with a lower horizon line. A wide expanse of sky and a broad range of the river draw the viewer's eye toward Saint Paul's Cathedral in the distance. Although the urban subject is unusual for the artist, the magnificent clouds and the graceful tree at the left are exceptional examples of his more lyrical work in landscape painting.

J ean-Baptiste-Camille Corot was a transitional figure in the development of landscape painting. Having traveled to Rome several times during his life, he was immersed in the venerable tradition of French artists in Rome who produced idealized Italian views peopled with small biblical or classical figures. Corot also worked directly from nature and was the foremost artist of the Barbizon School of landscape painting. Named after a small village in the Fontainebleau Forest about 30 miles southeast of Paris, the Barbizon School included a group of artists who were dedicated to the direct observation of nature and rural life. That idea was considered avant-garde at the time; Corot and the other members of the school were among the first French artists to work almost exclusively *en plein air*, or outdoors.

The Ruins of the Château du Pierrefonds depicts a small town in northern France where the medieval castle had fallen into ruins. The building's dilapidated condition and the reference to the Middle Ages make it a typical Romantic motif. Themes of decay and a lost past appealed to Corot; they reflected a sense of nostalgia for a way of life rapidly disappearing from nineteenth-century France.

The Museum's painting brings to light Corot's two different styles. He worked in his early *plein air* style in 1830, when he first began the painting. Approximately 30 years later, Corot repainted the foreground in his late style, which was softened and blurred. Some speculate that Corot hoped Napoleon III would purchase the painting, because he had begun restoring the Château in the 1860s to use as an imperial residence.

Jean-Baptiste-Camille Corot (1796–1875)

France

Ruins of the Château du Pierrefonds,
ca. 1830–35,
reworked ca. 1866–67

Oil on canvas

29 5/16 x 41 7/8 in.
(74.5 x 106.4 cm)

Gift of Emilie L. Heine in memory of Mr. and Mrs. John Hauck, 1940.965

Charles François Daubigny (1817–1878)

France

The Pond of Gylieu, 1853

Oil on canvas

24 1/2 x 39 1/4 in. (62 x 99.7 cm)

Gift of Emilie L. Heine in memory of Mr. and Mrs. John Hauck, 1940.969

Charles François Daubigny was a leading painter of the Barbizon School, a group of artists who worked in and around the hamlet of Barbizon in the Forest of Fontainebleau southeast of Paris. They sought to create exact, unprettified renderings of rural life and landscape and often painted outdoors.

The serene *Pond of Gylieu*, depicting a pond located near Lyon in southeastern France, marks an important step in Daubigny's career. The success of the painting at the annual Salon of 1853 secured his reputation and gained him financial security. It won a first-class medal, and the Emperor Louis Napoleon III bought the work.

This work reflects traditions of French landscape painting while foreshadowing Impressionism. Daubigny fuses a progressive, keenly observed naturalism with an almost academic idealization, as seen in the delicate balance, subtle spacing, and anecdotal—perhaps even symbolic—elements such as the herons. His use of a silvery tone may reflect the influence of his older contemporary, the great landscapist Jean-Baptiste-Camille Corot.

More than the other Barbizon artists, Daubigny painted ponds, streams, and waterways. In 1857, four years after he created *Pond at Gylieu*, he launched his studio boat on the river Oise. After that time, he seldom painted anything but landscapes with a water motif.

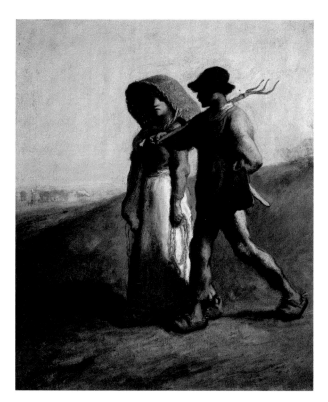

Jean-François Millet
(1814–1875)
France
Going to Work, 1851–53
Oil on canvas
22 x 18 in. (55.9 x 45.7 cm)
Bequest of Mrs. Mary M. Emery,
1927.411

Born in Bruchy, France to a family of farmers, Jean-François Millet referred to himself as the "peasant of peasants." In 1837 he studied with realistic history painter Paul Delaroche and met fellow pupil Théodore Rosseau. Rosseau was the leader of a group of French painters who were working in Barbizon, a village in the Fontainebleau Forest about 30 miles southeast of Paris. Known as the Barbizon School, this group of artists believed in directly observing nature and rural life, an idea that challenged established artistic tradition. Millet, who followed a very similar philosophy, moved to Barbizon permanently in 1849. Although landscape painting was a popular focus of this group, Millet concentrated on rural genre scenes that included peasants and laborers involved in their everyday activities.

Millet began painting *Going to Work* in 1851, several years after he ceased to paint portraits and academic nudes to concentrate on naturalism. Although human beings are central to his art, his portrayals tend to be highly generalized. He was less interested in depicting individual peasants than in humankind and its struggle with the soil. Although Millet was criticized severely for his simplified style, the technique brings a grandeur to his images that compensates for any technical deficiency. To Millet, the peasants' performance of their domestic tasks represented heroic matters, moral virtue, and often a religious message.

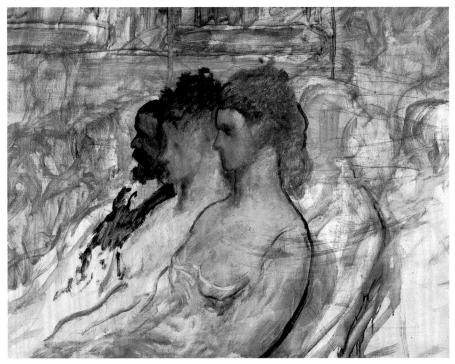

Honoré Daumier
(1808–1879)

France

Orchestra Stalls,
ca. 1865

Oil on canvas

23 1/2 x 33 1/4 in.
(59.8 x 84.3 cm)

The Edwin and Virginia
Irwin Memorial, 1960.22

Born in Marseilles in 1808, Honoré Daumier spent most of his life in Paris. During his career he recorded the revolution in 1848, the rise and fall of the Second Empire, the Crimean and Franco-Prussian wars, and the Paris Commune. Beginning in 1830, he elevated the role of political commentary and the art of lithography by merging aesthetics with function. With swift, incisive satires in crayon, he skewered hypocrisy and awakened the social conscience of the bourgeois masses. He contributed more than 4,000 political and social caricatures to the daily and weekly journals of Paris.

Not until the late 1840s did Daumier gain recognition as a painter of subjects ranging from classical mythology and popular narratives to religious themes. In his paintings, he addressed issues of everyday life, but in a more serious tone than in his lithographs.

Daumier never finished *Orchestra Stalls*. With thin strokes of oil mixed with turpentine, he blocked out the composition in earth tones and muted colors. Then he worked the three central figures further, focusing on the audience rather than the players. The painting's unfinished state provides a glimpse into Daumier's preliminary working method. Unlike his lithographs, this picture expresses no witty social commentary or biting criticism.

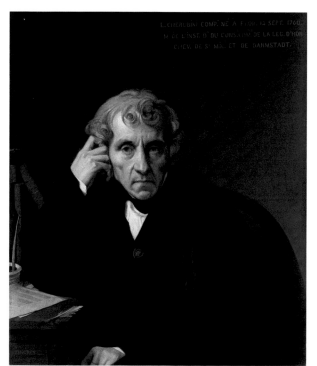

Jean-Auguste-Dominique Ingres
(1780–1867)
France
Portrait of Luigi Cherubini, 1841
Oil on canvas
32 3/4 x 28 in. (83.2 x 71.1 cm)
Bequest of Mary M. Emery, 1927.386

Jean-Auguste-Dominique Ingres was one of the greatest portrait painters and most brilliant draftsmen of the nineteenth century, active from the close of the revolutionary era to the Second Empire in Paris and Rome. Although he regarded his allegories and history paintings as his most important works, he is most admired for his virtuoso depictions of his contemporaries and of beautiful and fashionable women.

Ingres had a passion for music and was a competent violinist. His portrait of the illustrious Florentine composer Maria Luigi Cherubini was painted in Rome in the winter of 1840 until 1841. It is based on an earlier portrait sketch that Ingres began in 1834 in Paris, where the composer had lived since 1788. The artist transformed the first version into an ambitious allegorical painting, now in the Louvre, which he completed in 1842.

The Museum's painting was destined for Cherubini himself. Ingres scrutinized the aging flesh and white hair of the composer, then 81 years old. He portrayed Cherubini seated pensively in his study, about to compose music, rather than in a neo-Pompeian setting with the Muse standing behind him, as in the Louvre version. Sitting on the table at the left are bound scores of Cherubini's most famous operas—*Medée, Ali Baba,* and *Les Deux Journées.* At the upper right, Ingres indicates Cherubini's position as director of the Conservatoire National Supérieur de Musique through which he enjoyed commissions from the Crown and the Church. Cherubini was so pleased with the painting that he composed a cantata in Ingres' honor.

Edouard Manet (1832–1883)
France
Women at the Races, 1865
Oil on canvas
16 5/8 x 12 5/8 in. (42.2 x 32.1 cm)
Fanny Bryce Lehmer Endowment,
1944.105

Son of a well-to-do bourgeois family, Edouard Manet studied with and then outgrew the lessons of the academic painter Thomas Couture. The small but exquisite *Women at the Races* dates from the mid-1860s and defines him as a *flaneur*. Flaneur was the term for the purposeful male stroller of Paris, a cultured sophisticate who observed sharply and commented with ready wit on the flow of events, the city's movements, and changes in fashion—in short, all life.

Manet rejected traditional, elevated subjects, turning to contemporary life in the largely rebuilt and modernized Paris of the Second Empire. *Women at the Races* is a fragment of a larger painting Manet completed in 1864 and then dismembered. In the Cincinnati fragment, Manet coolly observed the life of Parisian society. The two women are at a horse race, a sport imported from England, in the fashionable Bois de Boulogne, outside Paris.

The two ladies wear plain, though luxurious, dresses and hold parasols to protect themselves from the sun. One looks towards the track while the other gazes off into the crowd. Manet captured their character and self-assurance in their poses, demeanors, and actions. One woman even delicately holds the ropes with her little finger raised. He executed the painting with extremely sketchy modeling and used large patches of color and bold silhouettes to create a flickering, flat composition.

Jacques-Joseph (James) Tissot
(1836–1902)

France (worked in England)

Young Women Looking at Japanese Articles, 1869

Oil on canvas

27 3/4 x 19 3/4 in. (70.5 x 50.2 cm)

Gift of Henry M. Goodyear, MD, 1984.217

Tissot is known for his finely detailed paintings of everyday upper-middle-class European life. They frequently provide a glimpse into a vanished era. The two young ladies admiring Japanese artifacts represent not only a fashionable Parisian world of wealth and sophistication but also the emerging craze for *japonisme*, things Japanese or created in a Japanese style. Tissot was one of the earliest artists to admire Japanese culture, and he formed a considerable collection of Japanese objects, costumes, and paintings. His reputation was such that he was appointed drawing master to Prince Akitake, who was visiting Paris in an official capacity for the Universal Exposition held in 1867 and 1868. In fact, the two young ladies are admiring Tissot's own collection in his Paris studio and residence.

Tissot painted a number of Japanese-inspired works, including three on this subject. The models are the same in all three versions (one of which he submitted to the Paris Salon in 1869), but in each the objects and the background are entirely different.

Gustave Courbet
(1819–1877)

France

Sunset, Vevey,
Switzerland, 1874

Oil on canvas

25 3/4 x 32 in.
(65.4 x 81.3 cm)

Gift of George Hoadly,
1887.5

Courbet, the first proponent of Realism in nineteenth-century European painting and often considered the most significant, is known primarily for his dignified, honest, occasionally monumental images of French laborers. Yet he also painted some of the most arresting landscapes of the nineteenth century.

In 1871 the Commune was declared the legitimate government of France, and the column in the Place Vendôme was destroyed. Courbet, who was politically active, went into exile in Switzerland in early July 1873 to escape arrest and to avoid the personal costs of rebuilding the column. He settled outside Vevey on Lac Léman.

In February 1873 Cincinnati judge George Hoadly, an admirer of Courbet's radical politics, wrote to a mutual friend of his and the artist's to commission a painting. In 1874 the friend, Moncure Conway, visited Courbet's studio and chose the sunset view over the lake at Vevey for Hoadly. Conway commented that he found the artist's recent paintings of the lake and mountains "powerful, but with a somber tone."

Hoadly gave *Sunset* to the Museum in 1887, a year after the Museum's new building opened; this was the first painting by Courbet acquired by an American museum. Hoadly's letter to the director contained one warning: "The picture may not please you. Indeed, works of the impressionist school are not likely to give much pleasure."

Claude Monet (1840–1926)

France

Rocks at Belle-Isle, Port-Domois,
1886

Oil on canvas

32 x 25 1/2 in. (81.3 x 64.8 cm)

Fanny Bryce Lehmer Endowment and
The Edwin and Virginia Irwin Memorial,
1985.282

Impressionist Claude Monet is usually associated with dappled, sun-drenched, richly atmospheric landscapes. Yet in autumn 1886, Monet sought out the rugged and barren terrain on the island of Belle-Isle-en-Mer off the coast of Brittany. Centering his activity in the village of Kervilhouven on the Atlantic side of the island, he wrote to fellow impressionist Gustave Caillebotte, "I've been here a month, and I'm grinding away; I'm in a magnificent region of wilderness, a tremendous heap of rocks and sea unbelievable for its colors; well, I'm very enthusiastic." Monet said he was having trouble painting the wild ocean because he was used to painting the calm channel.

In *Rocks at Belle-Isle, Port-Domois*, Monet depicted the grim sea beating away at the barren rocks, a theme he repeated and varied numerous times. He was sensitive both to the geographic change and to the need to change his manner of looking. He wrote to his companion Alice Hoschedé, whom he married in 1892, "I must make great efforts to make them somber, to render this sinister, tragic aspect." He added that he felt "powerless to render the intensity" of the ocean crashing upon the rocky sentinels of the island. Yet he also placed great demands on himself, saying "I'm chasing the merest sliver of color. It's my own fault, I want to grasp the intangible." The rich colors, strong forms, and subtle atmosphere of this magnificent painting demonstrate that he was concerned as much with emotion as with visual accuracy.

Vincent van Gogh (1853–1890)
The Netherlands (worked in France)
Undergrowth with Two Figures, 1890
Oil on canvas
19 1/2 x 39 1/4 in. (49.5 x 99.7 cm)
Bequest of Mary E. Johnston, 1967.1430

In May 1890, Vincent van Gogh left the asylum at Saint-Remy for Auvers-sur-Oise, a small village north of Paris which he described as Edenic. On July 27 van Gogh shot himself; he died two days later. The myth of the suffering van Gogh, whose madness caused him to transcend the limitations of art, has colored perceptions of him ever since his tragic death. Van Gogh himself noted that bouts of madness only spurred him to work during his periods of sanity.

In a letter to his beloved younger brother Theo dated June 30, van Gogh described the structure and brilliant colors of *Undergrowth with Two Figures,* commenting "The trunks of the violet poplars cross the landscape perpendicularly like columns," and added, "the depth of *Sous Bois* is blue, and under the big trunks the grass blooms with flowers in white, rose, yellow, and green."

Van Gogh expressed the fecundity of nature symbolized by the two lovers. His brushwork may be improvised and visceral, his colors strong and biting, his emotion raw and visible, but the canvas reveals no inner torment. He arranged a grid of trees against which he made expressive, rhythmic, colorful marks. The patterning and use of color perhaps reflect his study of Japanese art.

Undergrowth with Two Figures has a silvery tonality characteristic of van Gogh's works from Auvers. It is painted as a double square, twice as wide as it is high, a format the artist used in some of his last paintings.

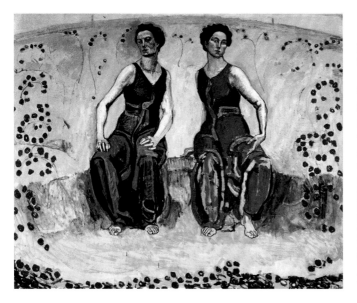

Ferdinand Hodler
(1853–1918)

The Sacred Hour,
ca. 1907–11

Switzerland

Oil on canvas

72 x 89 in.
(182.9 x 226.1 cm)

The Edwin and Virginia
Irwin Memorial, Fanny
Bryce Lehmer Endowment,
Mr. and Mrs. Harry S.
Leyman Endowment, and
Museum Purchase: Gift of
Mary Hanna, Mrs. J. Louis
Ransohoff, and Mary E.
Johnston, by exchange,
1990.1294

T*he Sacred Hour* is an excellent example of the large-scale symbolist figure paintings created by the Swiss artist Ferdinand Hodler during the period from 1890 to his death in 1918. Hodler carried considerable weight in the early development of Expressionism during the first decade of the twentieth century. His influence was felt strongly in the Vienna Secessionist and Jugendstil movements and by artists such as Gustav Klimt, Egon Schiele, and Oskar Kokoschka. Although he was trained in the academic tradition of the nineteenth century and painted landscapes and portraits, Hodler's fame today rests on enigmatic, symbolic works including this one, in which he explored themes such as the universality of human experience and the natural world.

The theme of *The Sacred Hour* occupied Hodler from about 1901 to 1911. Several versions in various degrees of completion are known, with two, four, and six figures. Here, two figures sitting in strongly mannerist poses in an artificial landscape are arranged symmetrically as mirror images of each other. The women, painted from the same model and dressed in eurythmic dance costumes, lean toward but face away from one another. Eurythmic dancing was an improvisational style transforming visual sensations, emotions, and ideas into rhythmical body movements. Hodler integrated this concept easily into Parallelism, his own self-derived philosophy. This brightly colored, repetitive composition illustrates Parallelism, a theory of repetition underlying the order of nature as well as the symmetry of the body and all of human existence. Hodler's symbolist images were not purely decorative and sensuous, as in Art Nouveau. Rather, they translated inner feelings into external gestures.

Oskar Kokoschka (1886–1980)
Austria
The Duchess of Rohan-Montesquieu, 1910
Oil on canvas
37 1/4 x 19 1/4 in. (94.6 x 48.9 cm)
Bequest of Paul E. Geier, 1983.64
© 2000 Artists Rights Society (ARS), New York/
Pro Litteris, Zurich

O skar Kokoschka, one of the leading international figures of twentieth-century Expressionism, studied at the Vienna School of Arts and Crafts and became a member of Josef Hoffmann's Wiener Werkstätte between 1904 and 1909. Kokoschka's early work, with an emphasis on flat ornamental patterns, shows the influence of Gustav Klimt and the Jugendstil movement. In 1906 Kokoschka began a series of portraits in which he strove to express the inner sensibility and emotional state of his socially prominent sitters.

The Duchess of Rohan-Montesquieu was painted in 1910 when Kokoschka's patron, Adolf Loos, took the artist to Leysin, Switzerland to visit Loos's tubercular wife in a sanatorium. There Loos arranged for him to paint several portraits of the patients, including the Duchess, about whom Kokoschka wrote:

"I was moved by her beauty. She reminded me of those aristocratic women who used to seek consolation in their faith, back in the days of religious upheavals when the world was so godless that only mystics still believed in paradise, which they placed in their own hearts. After I returned to Vienna she wrote me several letters, in her touchingly childlike hand, telling about her girlhood. Her husband was not kind to her."

The portrait is one of Kokoschka's most important early works. It demonstrates his desire to employ the viewer's sympathy and expose the sitter's spiritual quality. In the Duchess's downcast eyes and ever-diminishing form, the artist has captured the lingering beauty and the pain of a body and soul ravaged by the effects of tuberculosis.

One of the most important and influential artists of the twentieth century, Pablo Picasso became a prodigy in artistic and literary circles as a student at the Academy of Fine Arts in Barcelona. In 1900 he traveled to Paris and visited the darker sides of the city with Henri de Toulouse-Lautrec as his artistic guide. Picasso created the works of his Blue Period between 1901 and 1904; then, moving from blue to rose, he entered his classical period. In 1907 his interest in African sculpture resulted in *Demoiselles d'Avignon*, one of his pivotal paintings.

Picasso painted *Still Life with Glass and Lemon* during his period of analytic Cubism, one of his most innovative phases. In this style, developed by Picasso and French painter Georges Braque between 1907 and 1912, the artist attempted to break down three-dimensional objects into their basic geometric parts. As the title indicates, the painting contains everyday objects, which are barely identifiable here among the angular and overlapping shapes. The glass, lemon, table, painter's palette, rolls of canvas, and curtained window are fragmented and depicted as if viewed simultaneously from a number of different angles. The multiple viewpoints then are reorganized into a single, two-dimensional composition. The limited color range enhances the subtle interplay of space and form.

Pablo Picasso
(1881–1973)
Spain
Still Life with Glass and Lemon, 1910
Oil on canvas
29 1/8 x 39 13/16 in. (74.0 x 101.3 cm)
Bequest of Mary E. Johnston, 1967.1428

Amedeo Modigliani (1884–1920)
Italy
Portrait of Max Jacob, ca. 1920
Oil on canvas
36 1/2 x 23 3/4 in. (92.7 x 60.3 cm)
Gift of Mary E. Johnston, 1959.43

Modigliani was trained in the style of the nineteenth-century Italian *pleinair* painters. By 1906, however, when he arrived in Paris, he had all but abandoned his traditional academic background in favor of experimental modernism that was sweeping western Europe. Surrounding himself with the intellectual and cultural elite of Paris, he was exposed to other avant-garde artists whose work greatly influenced his own: his soft backgrounds are reminiscent of Paul Cézanne's landscapes, and the rigid poses and angular features of his portraits are related to Pablo Picasso's Cubist compositions. Although affected by these artists, Modigliani's work is unique and defies classification in one art movement. The broken planes and firm compositions of his portraits are based in part on the exaggerated angularity of African sculpture, which served as a stylistic source.

Modigliani painted numerous portraits of contemporary artists and writers, including the French poet Max Jacob, as depicted here. *The Portrait of Max Jacob* is typical of his work in the 1910s and 1920s. Stylish elongations, varied lines of contour, and subtle modulations of background define the portraits he painted at this time. Even within a framework of heightened mannerism, his sitters never lose their individuality nor their composure.

Modigliani's life was short and tragic. Very much the modern bohemian, he found solace in alcohol and drugs, in addition to living with the devastating effects of tuberculosis.

M atisse's *Rumanian Blouse* is a vibrant color study of composition, line, and form. The movement of broad, exuberant brushstrokes across the flat two-dimensional plane of the canvas emphasizes the energy of the overall composition as much as the sitter's individual personality, if not more so. *Rumanian Blouse* is one of several compositions on a single theme—models in various elaborate long Persian coats or Rumanian blouses—executed by Matisse in 1937. The subject matter, the blouse, is based on Matisse's collaboration with the Ballet Russe. In 1919 and 1937, Matisse designed sets and costumes for productions of the ballet. This collaboration led to a profusion of decorative paintings highlighting and exploring the sinuous, graceful lines of the costumes the artist had designed for the dancers.

Matisse was one of the greatest colorists of the twentieth century. Early in his career, he began experimenting with the arbitrary application of various tones and color palettes to his bold and expressive compositions. The artistic movement associated with this form of creative expression is known as Fauvism. When a French art critic used the word fauve—"wild beast"—in describing the work of Matisse and others at an exhibition held in Paris in 1905, it was adopted as the name for the movement.

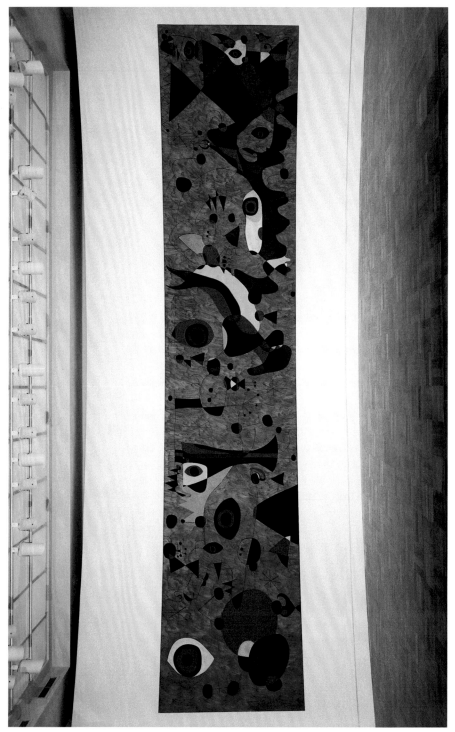

◀ **Joan Miró** (1893–1983)

Spain

Mural for the Terrace Plaza Hotel, Cincinnati, 1947

Oil on canvas

102 x 368 1/4 in. (259.1 x 935.4 cm)

Gift of Thomas Emery's Sons, Inc., 1965.514

In 1941 a retrospective of the paintings of Spanish Surrealist Joan Miró, held at The Museum of Modern Art in New York, sparked widespread enthusiasm in the United States. Although Miró was revered, he was a remarkable choice for the commission, awarded in 1947, to paint a mural for the circular Gourmet Restaurant in the new, ultramodern Terrace Plaza Hotel in downtown Cincinnati. The project fulfilled the artist's ambition to produce a work of public art, and proved decisively that he could adapt his intimate vocabulary of organic forms and delicate linear arabesques to a monumental painting more than 30 feet long.

Miró came to America for the first time in February 1947 and visited Cincinnati to examine the site. The mural, however, was executed in New York in the studio of Carl Holty, who recalled watching the artist "combine and fuse a craftsman's method with artistic adventure." Relating the mural to the blue sky beyond the windows that would surround it, Miró first painted the intensely blue, textured background. He then drew on it in charcoal, "dusting off" several versions until he achieved the desired composition. Objecting strongly to any literal interpretation of his work, Miró created an individual response to natural experiences, such as the spectacle of flying kites that inspired some of the elements in this mural. The painting, completed in October 1947, made its debut at The Museum of Modern Art before coming to Cincinnati. In the hotel it was said to "put café customers in a mood of lighthearted and sophisticated gaiety."

European
Decorative Arts

European Decorative Arts

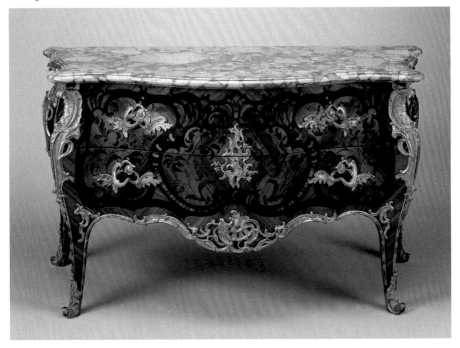

Attributed to **Jean-Pierre Latz** (1691–1754)

Commode, ca. 1745–49

France (Paris)

Marquetry of tulip and other woods on oak carcass, brèche d'Alep marble top, gilt bronze mounts

34 x 60 x 26 in.
(88 x 153 x 67.4 cm)

Museum Purchase, by exchange, and with assistance of funds and gifts from A.J. Howe, Henry Meis, Phyllis H. Thayer Purchase Fund, Gloria W. Thomson Fund for Decorative Arts, Israel and Caroline Wilson, John J. Emery, Dr. and Mrs. Martin Macht, Robert Dechant, George Toewater, in memory of Jane Thomson Herschede, and Mr. and Mrs. Daniel Ransohoff, 1976.435

The commode (chest of drawers), which appeared in France as early as 1700, is regarded as the furniture form that exemplifies eighteenth-century style and taste. As decorative furniture, commodes surpassed tall cabinets in popularity because their lesser height did not interfere with wall decorations such as paintings and tapestries. As well as being highly decorative, they were used for storage.

The Museum's commode is an exceptional example of eighteenth-century furniture. The serpentine bombé (swelling) form and the curving legs undulate in the manner associated with the Rococo style, which emphasized scrolls, C-curves, S-curves, and shell motifs. The curves of the body are echoed in the exquisite floral marquetry (decorative veneer) and inlay work. This decorative abundance is enhanced by the richly mounted gilt bronze scrolled drawer handles, the central cartouche (ornamental panel), the shell-shaped apron ornament, and the knee appliqués and sabots (feet).

This commode is attributed to Jean-Pierre Latz, one of the most distinguished French cabinetmakers of the mid-eighteenth century. Latz was born in Germany, moved to Paris around 1719, and soon thereafter opened his own cabinetmaking shop. He is noted for his mastery of marquetry. Although he specialized in clock cases, he also made commodes, corner cupboards, and desks. Latz rarely marked his work; therefore few pieces are known to be his products. Several works, including this commode, have been attributed to Latz on the basis of design, style, and fabrication techniques.

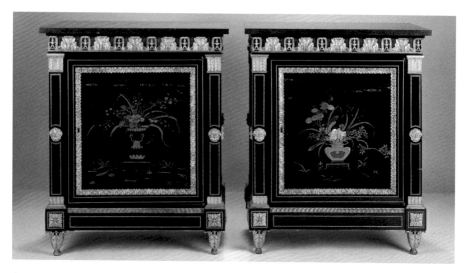

Étienne Levasseur (1721–1798), France (Paris)

Pair of Cabinets, 1767–ca. 1792

Ebony veneer with pewter inlay on oak carcass, mahogany, gilt bronze mounts,
inset Japanese lacquer panels, black marble top

37 9/16 x 30 11/16 x 18 1/2 in. (93 x 78 x 47 cm)
36 7/16 x 30 1/2 x 18 1/2 in. (92.5 x 77.5 x 47 cm)

John J. Emery Fund, 1976.21, 1976.22

Eighteenth-century French furniture is often considered the high point
in the history of furniture. Supported by a wealthy and appreciative
aristocracy and regulated by a powerful guild system under the king's
control, French cabinetmakers produced magnificent objects unrivaled by
any other country or group of artists.

Étienne Levasseur is considered one of the foremost *ébénistes* (cabi-
netmakers) of the eighteenth century. He trained in the workshop of Boulle,
who specialized in sumptuous furniture noted for its elaborate tortoiseshell
marquetry and brass. Levasseur specialized in repairing and copying Boulle
furniture. He was one of the first French *ébénistes* to use mahogany, which
he often inlaid with brass. In 1767 Levasseur was named a *maître* (mas-
ter), and was allowed to stamp his work with his name. This pair of cabinets
carries Levasseur's mark, which dates them to a time after 1767.

The Museum's cabinets embody many of the popular eighteenth-century
French decorative elements. Each cabinet is made of an oak carcass with
ebony veneer and pewter inlay. Japanese lacquer panels on furniture were
in great demand in the middle of the eighteenth century; these cabinets are
inset with Japanese lacquer panels depicting vases of flowers and land-
scapes with mother-of-pearl appliqué. The gilt bronze mounts on the feet
reflect the acanthus motif also seen on the gilt bronze frieze under the black
marble tops.

European Decorative Arts

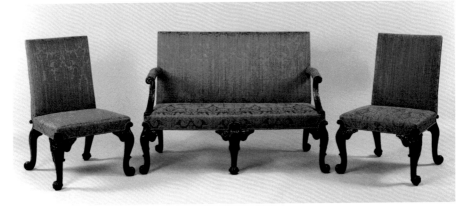

Giles Grendey (1693–1780), England (London)

Settee and Side Chairs, 1740s; mahogany and upholstery (modern)

Settee: 37 1/2 x 55 x 29 in. (95.3 x 139.7 x 73.7 cm)
Side chair: 37 1/2 x 25 x 27 1/2 in. (95.3 x 63.5 x 69.9 cm)

Mr. and Mrs. John J. Emery Memorial gifts, John J. Emery Fund, Bequest of Frederick and Sylvia Yeiser, Bequest of Paul E. Geier, Edwin and Virginia Irwin Memorial, and miscellaneous art purchase funds, 1983.143–1983.145

Giles Grendey, a London cabinetmaker and furniture maker of great repute, was patronized by the English nobility. Grendey also had a flourishing export business, selling primarily to Spain. Little else is known about his life and career except that he retired a very wealthy man some years before his death in 1780.

Grendey was one of the few cabinetmakers of his time to label his work. The Museum's settee and chair still retain their paper trade labels, reading "Giles Grendey, In St. John's-Square, Clerkenwell, London, Makes and Sells All Sorts of Cabinet, Goods, Chairs, and Glasses."

The settee and two chairs are part of a suite that includes two additional chairs. This suite, like almost all furniture in eighteenth-century England, would have been arranged against the walls. The pieces are typical of early Georgian furniture and date from the 1740s. The date of manufacture is further substantiated by the use of mahogany, which became increasingly popular in the 1730s, and by the superb Baroque carving of the knees.

The upholstery of this suite is modern; virtually no furniture from that period retains its original covering. The technique of upholstery was improved during the early Georgian period, as more attention was given to making surfaces soft and yielding. Furniture was covered with needlework or rich fabrics.

The individual pieces of furniture are wide enough to accommodate the hoop skirt, which by that time had assumed outrageous proportions. In addition, the raking arm supports of the settee are swept back to accommodate the dress of the period.

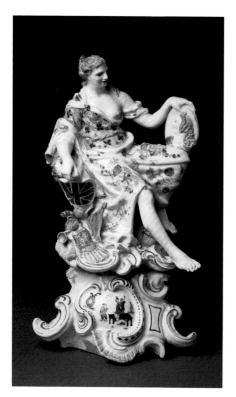

Longton Hall Porcelain Factory (1749–1760)
England (Staffordshire)
Figure of Britannia, ca. 1759
Porcelain
15 1/16 x 8 3/4 x 7 in. (38.3 x 22.3 x 17.8 cm)
Gift of the Museum Shop Committee
and its 100 Volunteers, 1973.107

Britannia, named by the Romans, is the personification of Britain. Here she is seated on a rock; her right hand holds a shield painted with the Union flag, while her arm rests on a lion, the symbol of Britain. Her left hand holds a medallion depicting George II, who was king of England when the figure was made. Some believe that the portrait may represent Frederick Louis, Prince of Wales, the eldest son of George II and father of George III. In this interpretation, Britannia is mourning the death of the Prince of Wales. Father and son resembled each other closely, however, so the identity on the medallion is impossible to determine.

War trophies such as a helmet, the butt of a gun, a rose-colored standard, and a coat of mail lie under the shield, while Britannia's left foot rests on a globe. Together the symbols represent England as a world leader. The Rococo scroll work of the pedestal contains a painted Chinese scene. Among the few Britannia figures known, this decoration appears to be unique. Usually a scene from the Seven Years' War (1756–1763) appears; after that war, England emerged as the greatest power in the world.

European Decorative Arts

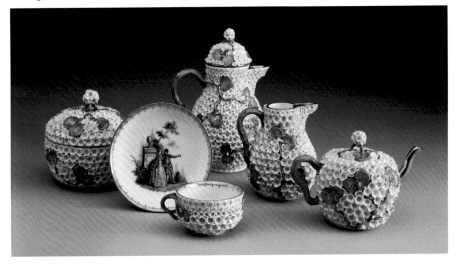

Meissen Porcelain Manufactory (1710–)

Germany (Meissen)

Coffee and Tea Service, ca. 1744

Porcelain

Coffee pot: 8 3/8 (with lid) x 6 (kick to spout) x 6 in. (21.3 x 15.2 x 15.2 cm)

Teapot: 4 3/4 (with lid) x 6 1/4 (kick to spout) x 4 3/4 in. (12.1 x 15.9 x 12.1 cm)

Teacup: 2 1/4 x 4 1/8 (with handle) x 3 3/4 in. (5.8 x 10.5 x 9.6 cm)

Saucer: H. 1 1/4 in., diam. 5 1/2 in. (h. 3.2 cm, diam. 14 cm)

Sugar bowl: H. 5 in. (with lid), diam. 5 in. (h. 12.2 cm, diam. 12.2 cm)

Creamer: 5 x 4 (kick to spout) x 4 1/2 in. (17.2 x 10.2 x 11 cm)

Centennial Gift of the Cincinnati Institute of Fine Arts from the collection of Mr. and Mrs. Arthur Joseph, 1981.83– 1981.113

In 1709, when porcelain was more valuable than precious stones, and no ceramic factory in the Western world knew how to produce it, the Meissen manufactory, located near Dresden, discovered the formula. By the 1720s, Meissen was renowned for its porcelain.

In 1744 Augustus III, King of Poland and Elector of Saxony, needed a royal wedding present and commissioned this coffee and tea service from Meissen. Composed of 31 pieces (teapot, tea caddy, six teacups, dish, coffee pot, creamer, sugar bowl, six coffee cups, waste bowl, and 12 saucers), the service was made for the wedding of Count Johann Friedrich of Schwarzberg Rudolstadt to Bernhardina Christina Sophia on November 29, 1744. It represents the craze not only for porcelain, but also for coffee and tea, which then were considered exotic beverages. Coffee and tea were first introduced to the West in about 1650. At the time of the Count's wedding, they were still luxury items affordable only by the very wealthy.

The delicate snowball decoration was designed in 1740 by Johann Joachim Kändler, Meissen's finest artistic director. Each snowball blossom is applied by hand. The interiors of the cups, saucers, dish, and bowls are painted in sepia with gallants and ladies in parkland, after works by the French painter Jean Antoine Watteau. The coffee pot and teapot at first appear too small to accommodate enough drink for six cups each. At that time, however, these beverages were brewed extremely strong; very small portions were poured into the cups and augmented with hot water.

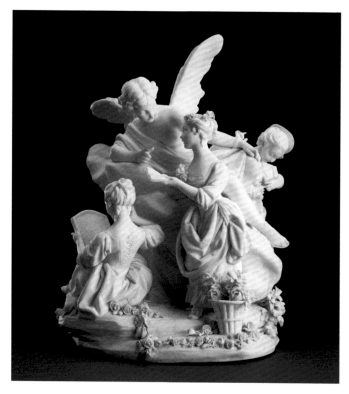

Sèvres Manufactory
(1738–), after a model by
Étienne-Maurice Falconet
(1716–1791), based on a
drawing by François
Boucher (1703–1770)

France

Figurine: The Teaching of Love (L'Education de L'Amour or L'Amour Precepteur), 1763

Soft-paste biscuit porcelain

11 5/8 x 9 7/16 x 9 5/8 in.
(29.5 x 24 x 24.5 cm)

Gift of the Duke and
Duchess of Talleyrand-
Perigord, 1954.523

The porcelain factory at Sèvres was established in 1738. Catering to the luxury trade, it flourished under the patronage of Louis XV and his mistress Madame de Pompadour. In addition to beautiful tablewares, the factory produced statuettes and figurines. The most famous of the statuettes are those of glittering white biscuit porcelain modeled by Étienne-Maurice Falconet, the leading eighteenth-century French sculptor. Falconet was hired by Madame de Pompadour and served as a chief modeler at Sèvres from 1757 to 1766. While employed there, he produced numerous models for biscuit statuettes depicting popular mythological scenes, as well as charming renderings of playful children.

The Teaching of Love, as modeled by Falconet in 1763 after a drawing by French artist François Boucher, is a rustic scene of a group of young, eager subjects being instructed in the tender nature of love. This sentimental subject is based on the theme of an eighteenth-century play. The figures convey fluidity, grace, and movement, characteristics that pay tribute to Falconet's skill as a sculptor and to his reliance on Boucher's playful Rococo drawings.

In addition to Falconet, other notable sculptors who provided models for Sèvres were Jean Baptiste Pigalle, Jean Antoine Houdon, and Clodion. Portrait and figural statuettes remained quite popular throughout the eighteenth and into the nineteenth century.

European Decorative Arts

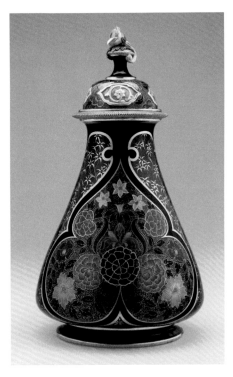

Worcester Royal Porcelain Company Limited
(1751–)
James Callowhill, painter
(active at Worcester ca. 1855–1880s)
England (Worcester)
"Indian" Vase and Lid, 1876
Porcelain
16 (with lid) x 8 3/4 in. (14.6 x 22.2 cm)
Museum Purchase, 1887.20a,b

By the late nineteenth century, porcelain was being used to imitate all kinds of media including metals, lacquer, marble, ivory, horn, precious and semiprecious stones, and enamel. In this stunning example, the Worcester Royal Porcelain Company uses an experimental rich dark green porcelain to imitate India's metal enameled ware. The body, suggesting a green enamel, contrasts dramatically with an exotically colored central floral decoration inside a black band. A gilt outline surrounds the decoration and the band, and the vessel replicates the Indian use of enamel on gold.

In 1876, when the vase was made, the British were fascinated with India and with all things Oriental. English rule had been established in India in 1774 with the appointment of the first British governor general. By the 1860s, Indian imports of furniture and furnishings were so abundant in England that they were considered common household items. Thus it is not surprising that the Worcester Royal Porcelain Company, the finest producer of imitations in porcelain at that time, chose to imitate an Indian product.

This vase, or one just like it, was exhibited in Paris during the 1878 Universal Exposition, and is pictured in *The Art Journal*'s "Illustrated Catalogue of the Paris International Exhibition [of 1878]." The Museum purchased it in 1887 from an English agent representing the Worcester Royal Porcelain Company. In the original invoice it is called the "Indian vase."

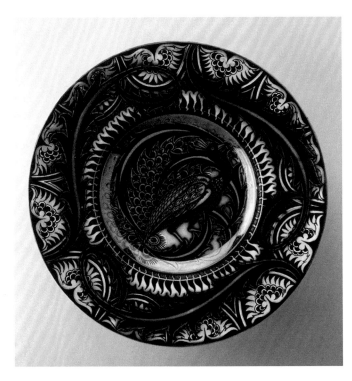

William de Morgan
(1839–1917)
England (Orange House,
Chelsea or Merton Abbey,
Surrey)
Dish, 1880–88
Earthenware:
Copper lustre stain
Diam. 17 in. (44.5 cm)
Gift of Alfred Traber
Goshorn, 1888.759

The coppery-red iridescent or luster appearance on the decoration of this dish reflects Hispano-Moresque and Italian ceramic luster traditions of earlier centuries. Artist William de Morgan accidentally discovered the luster process while working on stained glass, and is given credit for reviving ceramic lusterware during the Arts and Crafts movement of the late nineteenth century. The decorative influence on this dish is clearly Middle Eastern, as shown by the peacock in the center and the Persian flowering foliage motif on the border. De Morgan was associated with English craftsman, poet, socialist, and leader of the Arts and Crafts movement William Morris, and joined him in revolutionizing the art of house decoration in England.

In 1905 de Morgan abandoned ceramics to write novels. His writing career was much more lucrative than his ceramic career, and when he died in 1917 he was noted mainly as a novelist. Today, however, his novels are all but forgotten, while his ceramic legacy endures.

Alfred Traber Goshorn, the first director of the Cincinnati Art Museum, donated this superb dish to the Museum in 1888. He was very knowledgeable about ceramics because his family had acquired its wealth from the manufacture of white lead, a principal ingredient of ceramic glazes.

European Decorative Arts

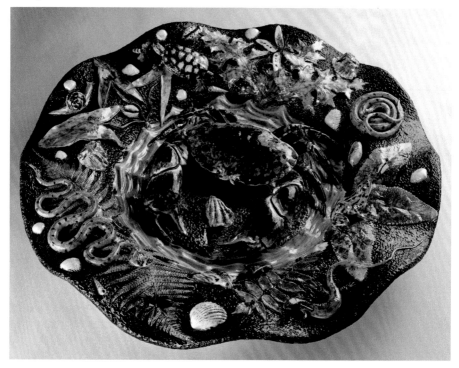

Attributed to **Joseph Landais** (1800–1883)

Charger, ca. 1846–83

France (Tours)

Earthenware

H. 4 3/4 in., diam. 25 1/4, (h. 12.1 cm, diam. 64.1 x cm)

Gift of Mrs. J. Louis Ransohoff, 1923.943

This monumental charger, or large plate, is an outstanding example of Palissy ware, earthenware made in the nineteenth century in imitation of the work of sixteenth-century potter Bernard Palissy. Realistic and representational, Palissy's work was decorated abundantly with high-relief forms of small reptiles, frogs, snakes, lizards, aquatic plants, and other foliage, often cast from life. His wares were decorated in brightly colored glazes that enhanced their sculptural quality.

In the nineteenth century, fascinated by reinterpreting and imitating historic styles and techniques, potters were intensely interested in Palissy's work. The first to revive his style was French potter Charles-Jean Avisseau, who discovered Palissy's techniques in the 1840s after much research and experimentation. Working in the manner of Palissy, Avisseau created exuberant and colorful ceramic wares whose three-dimensional quality was emphasized by casting applied elements directly from nature. Avisseau inspired other potters, including his brother-in-law Joseph Landais, to produce Palissy ware. Landais, who began his career as an assistant to Avisseau, later established his own workshop, where he continued to produce Palissy ware as well as ceramics decorated in the Renaissance style.

The Museum's charger is decorated with a lizard, a turtle, a frog, a snail, snakes, a large crab, various shells, and foliage, all with a rich multicolored lead-glaze finish. It is attributed to Joseph Landais on the basis of stylistic and technical similarities to other examples known to be his work.

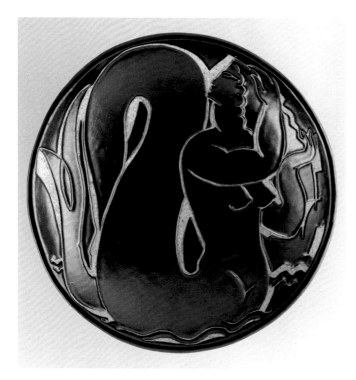

René Buthaud
(1886–1986)
France (Tours)
Bowl, 1931
Stoneware
H. 3 in., diam 10 1/2 in.
(h. 7.62 cm,
diam. 26.7 cm)
Museum Purchase,
1931.44

The French Art Deco style dates from around 1920. Popularized internationally by the well-attended Exposition Internationale des Arts Décoratifs et Industriels Modernes of 1925, it reached its peak in that year. Although Art Deco design relied heavily on historical sources such as Chinese, Japanese, Egyptian, and Persian designs, its proponents considered themselves Modern artists.

The dramatic, stylized approach characteristic of the Art Deco style saw its greatest expression in the decorative arts and architecture. In the field of ceramics, the international Art Deco scene was dominated by French art potters such as René Buthaud, Emile Lenoble, and Emile Decoeur.

Buthaud, one of the most important French artist potters of the twentieth century, trained as a painter at the École des Beaux-Arts in Bordeaux. He began working in ceramics in 1919 and continued into the 1960s. Buthaud's ceramic designs possess a sensuality and an abstract geometricizing that reflect his early training in painting and his awareness of popular modern painting styles such as Cubism.

On the Museum's bowl, the surface is treated like a canvas. The bowl is covered in a thick black glaze, depicting the sinuous but simplified and abstract form of a nude mermaid. This piece represents Buthaud's best-known work: earthenware bowls and vases in simple, massive shapes, decorated with stylized images of nude female figures, foliage, and geometric forms.

European Decorative Arts

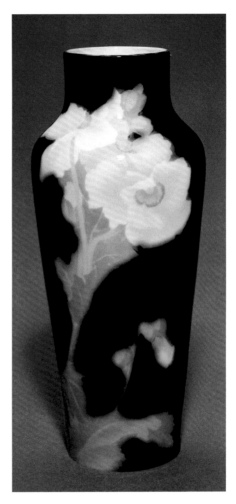

**Rörstrand Porslins Fabriker
(Rörstrand Porcelain Manufactory)** (1726–)
Per Algot Erikson (1868–1937), decorator
Sweden (Stockholm)
Vase, 1904
Porcelain
16 1/4 x 7 1/4 in. (41.3 x 18.4 cm)
Museum Purchase with funds provided by
Mr. and Mrs. William O. DeWitt Jr., 1997.33

The Rörstrand Porcelain Manufactory was established in 1726 under the patronage of the Swedish royal family. Today it is most noted for its Art Nouveau porcelain, made around the turn of the nineteenth century. This vase represents a particularly beautiful Art Nouveau line known as "Rörstrand Black," which fed the demand for high-gloss, black-ground vessels with pastel floral decorations. At that time, black was a new, technically achieved underglaze color; all of the leading potteries, including Rookwood (Black Iris line), Meissen, Sèvres, and Royal Copenhagen, were exhibiting it.

The vase bears a pastel poppy decoration taken from Swedish flora on a black ground, all covered with a high-gloss glaze. The poppy, as seen here, is a common Art Nouveau symbol of sleep or death. It was often depicted on a black ground to reinforce those concepts.

Decorator Per Algot Erikson was one of the finest artists at the factory during that period. A porcelain painter and ceramist, he studied at the Technical School in Stockholm and began working at Rörstrand in 1886. The vase not only has Erikson's painted initials on the bottom, but also bears his full name painted in gold along with the company's name and date. This gold inscription, the importance of the artist, and the size of the vessel suggest that it is a special piece, possibly made for an international exposition. Indeed, in 1904, when the vase was created, Rörstrand participated in the Louisiana Purchase Exposition in St. Louis. The company hoped to penetrate the vast American market, especially the large numbers of Scandinavians who had immigrated to the midwest. The vase probably entered the United States at that time.

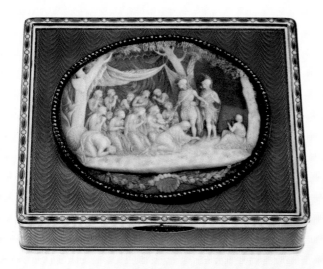

Peter Carl Fabergé was an extraordinary entrepreneur who turned a family business into an internationally successful firm of jewelers known as the House of Fabergé. The firm's success was established in 1881, when Fabergé received the imperial appointment and secured important commissions from Czars Alexander III and Nicholas II. Fabergé's worldwide acclaim is due mainly to the series of enameled and jeweled imperial Easter eggs it created between 1884 and 1916. In addition, however, the company produced dinner services, tea services, jewelry, hardstone figurines, and an impressive variety of novelty items including cigarette cases, picture frames, cane handles, seals, opera glasses, and snuff boxes, all enameled in the eighteenth-century French manner.

Fabergé directed the firm's artistic and commercial concerns while employing workmasters to oversee design and production. The cameo box was designed by one of Fabergé's head workmasters, Henrik Wigström, who was hired in 1903. The box is constructed masterfully, with careful attention to the integration of every element. The oval shell cameo, surrounded by rose diamonds, is an exquisite rendering of Alexander the Great before supplicants. The gray enamel is executed in the guilloché technique, a method of fusing translucent enamels over gold or silver patterned by hand or machine. Fabergé revived and popularized this technique; numerous competitors, however, also produced guilloché enamels. The cameo box is a striking example of Fabergé's commitment to superior craftsmanship and technical and aesthetic brilliance.

European Decorative Arts

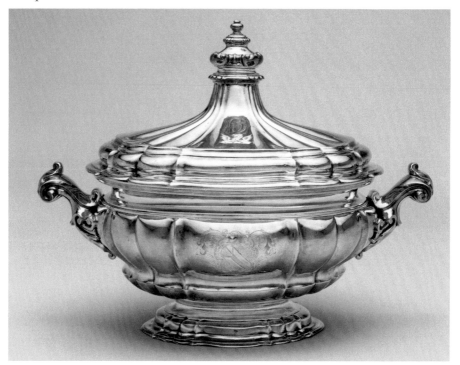

Charles Kandler (active 1727–ca. 1750)

England (London)

Tureen, 1728–29

Silver

13 (with cover) x 16 1/2 (with handles) x 9 1/4 in. (33 x 41.9 x 23.6 cm)

Bequest of Paul E. Geier, 1982.187

A tureen is a deep bowl with a cover, in which soup may be served at the dining table. Smaller tureens traditionally were used for sauces. The word *tureen* came to English from the French *terrine*, a serving bowl made of earthenware; that word derived in turn from *terra,* the Latin for *earth*. Tureens often sat atop matching stands that protected the table underneath from heat and spills, as well as providing a resting place for an accompanying ladle. Because of its size, a tureen was an impressive part of any dinner service.

The mark appearing on this tureen belongs to Charles Kandler, a silversmith whose shop gained a prestigious reputation for its Rococo silver. The tureen, dating to 1728 or 1729, is in the earlier, monumental Baroque style. The base, bowl, and cover are formed into paneled lobes, and the oval shape swells to form a pair of scrolling acanthus-leaf handles. Engraved on the bowl is the coat of arms of the Harford family, the original owners.

The earliest surviving English silver tureen dates from 1703, and the silver tureen was popular from the 1720s. Ceramic forms often imitate silver forms, but this piece may have been inspired by a German porcelain tureen from the Meissen factory.

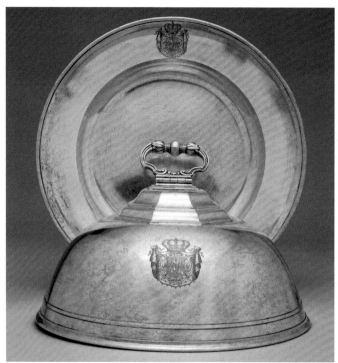

Christian Winter
(active ca. 1730)
Germany (Augsburg)
Dish and Cover, 1730
Silver gilt
7 x 12 7/8 in.
(17.8 x 32.7 cm)
Gift of Paul E. and Gabriele
B. Geier, 1994.372a,b

This silver-gilt serving dish is an outstanding example of the crafts-manship associated with eighteenth-century German silver. The dish was commissioned by Augustus the Strong, Elector of Saxony in the late seventeenth and early eighteenth centuries, as part of a dinner service for the wedding celebration of the Crown Prince in 1717. The original service, not counting later additions, consisted of 270 vessels and 98 pieces of flatware; this was supplemented in the 1720s and 1730s. The Museum's serving dish is one of the pieces added in the 1730s.

The service included serving dishes in at least two sizes. One is 13 inches in diameter, the size of this dish; the other is 16 inches across. This serving dish is typical in that it has a marli (ledge or border) and a shallow well. Most likely it was used to serve meats. Stylistically the dish and its cover exemplify the plainer, more massive style of the early eighteenth century, with their emphasis on line and scale rather than ornament. The marli and cover are engraved with the King's armorial shield.

In addition to his well-known patronage of the Meissen porcelain fac-tory, Augustus the Strong supported the leading silversmiths of his day. Christian Winter of Augsburg, the maker of this dinner service, was one of Germany's most highly skilled silversmiths and helped to establish Augsburg's domination of the silversmithing trade in Germany. Augsburg enjoyed this position until the mid-eighteenth century, when Dresden emerged as the leading site.

European Decorative Arts

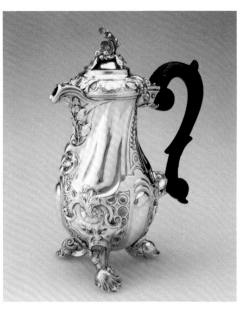

Paul de Lamerie (1688–1751)
England (London)
Coffee Jug, 1738
Silver
10 1/2 x 7 3/4 (from handle to spout) x 5 in.
(26.7 x 19.7 x 12.7 cm)
The Folgers Coffee Silver Collection, Gift of
The Procter & Gamble Company, 1999.659

Coffee jugs, used primarily for Turkish coffee, are distinguished from coffee pots by their short spouts. The spout is fixed to the upper body to ease the pouring of Turkish coffee (coffee blended with sugar syrup) because the thick liquid, full of sediment, tended to clog the spout easily.

Paul de Lamerie, the maker of this coffee jug, was one of the foremost silversmiths in eighteenth-century London. He was born in Holland and brought by his Huguenot parents to London in 1689. His earlier work was in the restrained early Queen Anne style, but by the 1730s he had adopted the Rococo style for domestic articles and large, extravagant pieces such as baskets and wine coolers.

This coffee jug is an exquisite example of Rococo style, which originated in France in the early 1700s and was imitated in England, Italy, and Germany. The jug has all of the principal Rococo features, such as asymmetrical ornamentation, flowing lines, and C- and S-curves. The surface decoration includes a variety of Rococo motifs including a shell, flowers, foliage, and scrollwork. A spray of coffee leaves (indicating the pot's function) rises from a scroll above a grotesque animal's mask with tongue protruding. De Lamerie gave full rein to the playful and the fanciful in executing this whimsically original piece.

The de Lamerie coffee jug is part of a generous gift from The Procter and Gamble Company of more than 90 objects from The Folgers Coffee Silver Collection, started by the late Mr. Joseph S. Atha in 1953. Mr. Atha, former president and chairman of the board of the Folgers Coffee Company, developed one of the world's most significant collections of eighteenth- and early nineteenth-century English silver coffee pots and accessories.

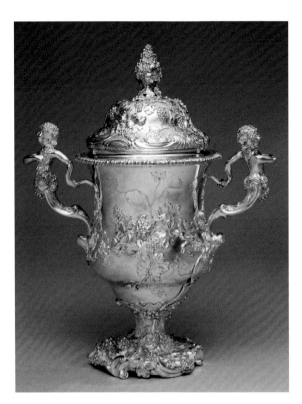

Thomas Heming (active 1745–1783)
England (London)
Two-Handled Cup and Cover,
ca. 1750
Silver
15 1/8 (with cover) x 12 1/4
(with handles) x 6 3/8 in.
(38.4 x 31.1 x 16.2 cm)
Gift of Mrs. Robert McKay, 1960.486

I n 1760, silversmith Thomas Heming, the maker of this cup, was
appointed principal goldsmith to King George III. In 1766, while he
occupied this position, Heming produced his best-known work, a
30-piece toilet service for Caroline Mathilda, the daughter of Frederick,
Prince of Wales and wife of Christian VII of Denmark. The set included a
mirror, a scent bottle, a brush, and a comb. Heming's craftsmanship earned
him numerous other important commissions, including an order from the
Russian imperial court.

The two-handled cup and cover was a particularly popular silver form
in England from the mid-seventeenth to the mid-eighteenth century. Such
cups were used for ornament or display, as well as for special or ceremo-
nial occasions as prizes or awards. Only seven examples of two-handled
cups executed by Thomas Heming are known. All have a spreading foot
and a short stem, on which the cup rests. The Museum's cup is a *bombé*
form: curved, bulging, and convex. Its handles are cast with figures of youth-
ful bacchantes facing in opposite directions.

Heming was an innovator in design and style who revived the early Ro-
coco by using motifs that had appeared on English examples earlier in the
century. This cup is ornately embellished with cast and applied relief deco-
rations in the form of encircling fruit-bearing vines, a favorite motif of
Heming's that appears on other cups as well.

European Decorative Arts

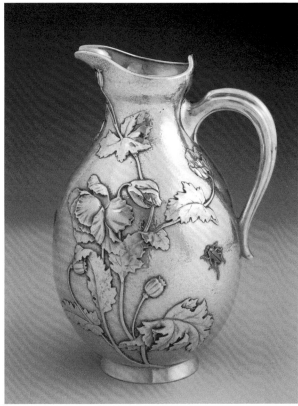

Christofle & Cie (1831–)
France
Milk Pitcher, 1880
Silver, gold, and copper
7 5/8 x 5 3/8 (with handles) in.,
diam. 4 3/4 in.
(19.4 x 13.7 cm, diam. 12.1 cm)
Museum Purchase: John S. Conner
Fund and the Dwight J. Thomson
Fund, 1998.8

The firm of Christofle & Cie, founded in 1831 in Saint-Denis, France, was one of the earliest and most important European suppliers of *japonisme* (Japanese-inspired) metalwork. The firm still flourishes and remains a leading European producer of silver and electroplate. Christofle & Cie displayed this *pot à lait* (milk pitcher) at the Exposition des Arts du Métal, held in Paris in 1880 and sponsored by the Union Centrale des Art Décoratifs. The pitcher is one of the first examples in which Christofle & Cie used mixed-metal decoration applied to silver. It is one of only six such pitchers made by the firm. One is currently in the Musée Christofle, Saint-Denis; another is in the Musée des Arts Décoratifs, Paris. Of the original six, these three are the only specimens known today.

This pitcher is an exquisite example of the Japanese influence on the decorative arts inspired by nature, which emerged during the last quarter of the nineteenth century. This trend came to Paris by way of prints in the late 1850s. The Japanese virtuosity in mixed metalwork, particularly in sword furniture, inspired the use of mixed-metal decorations of copper and gold on silver, as seen in this pitcher. The spot-hammered surface, which suggests that the piece was handmade, is also inspired by the Japanese, as is the applied decoration of gold and copper flowers and insects.

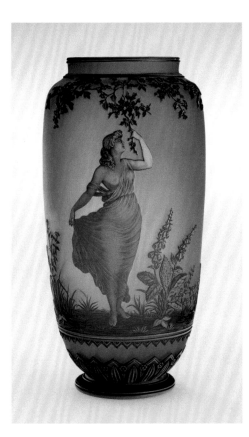

Thomas Webb & Sons (1837–)
George Woodall (1850–1925), engraver
England (Stourbridge)
Vase, ca. 1900
Cameo glass
8 1/2 x 4 in. (21.5 x 10.5 cm)
Museum Purchase, 1887.41

English cameo glass of the late nineteenth century is among the finest of all art glass. In this art form, an object is made of cased (laminated) glass of two or more colors, one forming an overlay on the other. The top layer is engraved or cut away to leave a design in relief against a contrasting color. The process, similar to that used in ancient Egyptian and Roman times to carve cameos, was revived in Europe, especially in England, France, and Bohemia, in the nineteenth century.

This tapering cylindrical vase features a classically inspired semidraped female figure in white on a vibrant blue ground. It was engraved by George Woodall for the English firm Thomas Webb & Sons, one of the most notable producers of cameo glass in the nineteenth century. The firm exhibited its decorative wares at several world's fairs, including the Great Exhibition of 1851 in London and the Paris Exhibition of 1878, where it won a *grand prix*. In 1874 Thomas Webb & Sons hired Thomas and George Woodall, two brothers who were among the finest engravers of cameo glass. Under the Woodalls' supervision the firm produced beautiful art glass of exceptional quality in a variety of forms, including vases, plates, plaques, and scent bottles, with a wide range of motifs such as flowers and figures in classical and Victorian styles.

European Decorative Arts

René Jules Lalique
(1860–1945)
France

Comb, ca. 1900

Horn, glass, sapphire

5 3/4 x 1 1/8 in.
(14.6 x 2.9 cm)

Gift of Mrs. James Leonard, Mrs. Harry Mackoy, Mrs. Samuel Bailey, Mr. John Warrington in memory of their mother, Mrs. Elsie Holmes Warrington, 1940.2

© 2000 Artists Rights Society (ARS), New York/ ADAGP, Paris

Vase, 1921
Glass; 3 3/4 x 4 3/8 in. (9.5 x 11 cm)
Museum Purchase, 1922.376
© 2000 Artists Rights Society (ARS), New York/ADAGP, Paris

Perfume Bottle,
ca. 1920

Glass

4 1/2 x 2 3/4 in.
(11.4 x 7 cm)

Gift of Caroline and Herbert Marcus, 1972.474

© 2000 Artists Rights Society (ARS), New York/ ADAGP, Paris

René Lalique emerged as the leading French Art Nouveau jeweler and glassmaker in Paris at the turn of the nineteenth century. Rejecting the constraints of historicism that had guided the decorative arts throughout the century, exponents of the Art Nouveau style looked to nature as a source of inspiration and used undulating lines, tendrils, flower and leaf motifs, sinuous female nudes with long flowing hair, and extreme asymmetry as favored design elements.

Lalique experimented with numerous forms, materials, and techniques in creating jewelry. The comb in the Museum's collection is made of horn carved into an angel whose wings form the outer teeth of the comb. The successful integration of shape and material with function is a defining component of Lalique's work.

Lalique created a great variety of glass objects. He designed beautifully stylized perfume bottles, such as the Museum's, for scent manufacturers including Coty, Worth, and Nina Ricci. Although most of Lalique's perfume bottles were mass-produced, they still carried an aura of luxury and exclusiveness.

The most highly prized works by Lalique are his one-of-a-kind glass objects such as the Museum's vase, produced in the *cire perdu* or lost wax technique. This method produces unique pieces with the precise size and markings of the artist's wax original. These objects are distinctive because of their rough, unpolished surface and the absence of mold lines. Because the technique exactly replicates every detail of the wax model, the artist's fingerprints can be seen in the finished product.

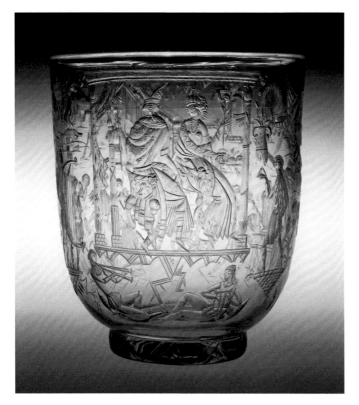

J. & L. Lobmeyr
(1823–), manufacturer

Vally Wieselthier
(1895–1947), designer

Adolf Beckert
(1884–1929), engraver

Austria (Vienna)

**"Queen of Sheba"
Vase,** 1926

Glass

8 1/8 x 7 1/8 in.
(20.6 x 18.1 cm)

Museum Purchase,
1930.48

J. & L. Lobmeyr, a celebrated Viennese firm of glassmakers, was founded in 1823. Throughout the nineteenth century, the firm exhibited successfully and with great acclaim at numerous world's fairs. It established itself as the foremost company producing Bohemian and historical revival-style glass. In the nineteenth century, Lobmeyr products varied from ornate, elaborate items to austere, elegant decorative and functional wares such as vases, drinking glasses, and decanters. Lobmeyr commissioned designs from leading artists in Vienna, including Joseph Hoffmann, who became the firm's co-director in 1902, and Vally Wieselthier, a celebrated designer of Art Deco wares who had worked with the Wiener Werkstätte craft workshop since 1912.

The "Queen of Sheba" vase was designed by Wieselthier in 1923 for Lobmeyr, who exhibited the vase at the 1925 Paris Exposition. The Exposition established Art Deco, which relied on mechanized production and machinelike forms for inspiration, as the prevailing aesthetic. A number of vases were produced from Wieselthier's original design; the Museum's example was engraved in 1926. The wheel-engraved design on the vase depicts King Solomon and the Queen of Sheba enthroned under a canopy, receiving gifts, and listening to music. This is a fine example of the thick-walled, wheel-engraved vases exhibited by Lobmeyr in Paris in 1925.

American Painting & Sculpture

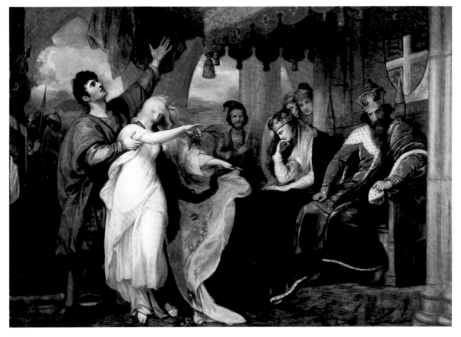

Benjamin West
(1738–1820)
United States

Ophelia and Laertes,
1792

Oil on canvas

109 x 152 1/2 in.
(276.9 x 387.4 cm)

Gift of Joseph Longworth,
1882.230

The American colonist Benjamin West settled in London in 1763 and became the second president of Great Britain's Royal Academy of Arts, an institution devoted to elevating the status of art and artists in the United Kingdom. Among the Royal Academy's pursuits was an attempt to revive the popularity of imaginative "history painting," the name given to illustrations of scenes from the Bible or classical mythology. Biblical scenes did not enjoy much favor in Protestant England because they suggested Roman Catholic imagery. Many artists, however, thought to move beyond the works of antiquity by illustrating Shakespeare, not only the greatest of postclassical writers but also an Englishman.

This picture, illustrating Act 4, Scene 5 from *Hamlet*, was painted for a large speculative project organized in London in the 1790s. Each picture in the project represented a scene from a Shakespeare play. The paintings in turn were reproduced in prints; the collected prints were to be sold to finance the project while the paintings were on public display. The project was a failure, however, and the paintings were sold in 1805.

Ophelia and Laertes was bought by American artist and inventor Robert Fulton. After Fulton's death, his heirs sold it to Cincinnati's Nicholas Longworth. Tales of this picture's voyage on a flatboat down the Ohio River are part of the lore of early Cincinnati. It was the first work by a major artist to come to Cincinnati, and it is the most venerable document of the city's cultural heritage.

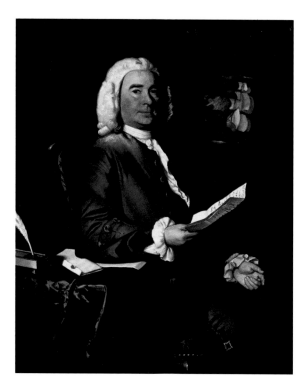

John Singleton Copley (1738–1815)
United States
Thomas Greene, 1758
Oil on canvas
50 x 40 in. (127 x 101.6 cm)
Gift of Mrs. Carlos A. Hepp, 1958.523

The portraits created in New England and New York by John Single-ton Copley, the most gifted painter in colonial America, stand today among the finest ever produced in the nation. Guided only by English mezzotint engravings and by the works of a few less talented paint-ers, Copley was painting sophisticated works such as *Thomas Greene* by the time he was 20 years old. In the portraits he made before 1775, when he moved to England, conventions of English portraiture are meshed with an exacting realism derived from his astounding powers of observation and his ability to replicate the tactile sense and appearance of materials. These qualities attracted Copley's patrons; between 1758 and 1761, these were principally Tories living on the south side of Boston who aspired to the rank of the English aristocracy. The luxuriant stuffs that Copley rendered so ex-quisitely spoke of their owners' status.

Among the Boston patrons was Thomas Greene, a merchant born into a prominent family. Copley portrays Greene as a prosperous businessman, elegantly dressed and surrounded by opulent brocade fabrics and velvet drapery. Seen through the window at the right is a ship in full sail flying the British flag, representing Greene's mercantile pursuits. The date Septem-ber 25, 1758, which appears at the top of the paper in the sitter's hand, is thought to be the date of the painting. The painting is one of a pair, unfor-tunately separated, which also includes a dramatic portrait of the sitter's second wife, Martha Coit Greene. (The latter is now in a private collection.)

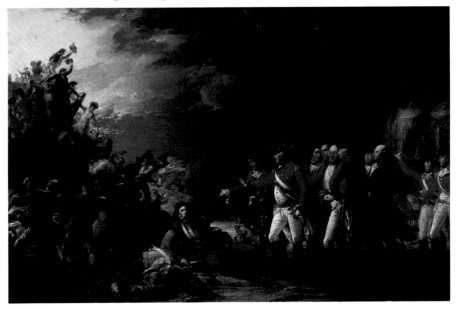

John Trumbull
(1756–1843)
United States

*The Sortie from
Gibraltar,* 1788

Oil on canvas

20 x 30 in.
(50.8 x 76.2 cm)

John J. Emery Fund,
1922.104

Remembered today for his monumental painting *The Declaration of Independence,* on display in the U.S. Capitol, John Trumbull ambitiously recorded on canvas the major events of the nation's founding. Connecticut-born and educated at Harvard, Trumbull served as General George Washington's aide-de-camp. In that position he acquired experiences that contributed to the vividness of his art. In 1786 he embarked on a series of paintings of the American Revolution, to be reproduced in engravings. Because the painting of recent history (as opposed to the ancient past) was a relatively new undertaking, Trumbull's work drew mixed reactions.

In 1784 Trumbull traveled to England in the hope of building a reputation there. Seeking a theme that would show the British in a positive light, he chose to depict the sortie at Gibraltar on the night of November 26, 1781, in which British forces overthrew a Spanish siege, set the Spanish military works ablaze, and mortally wounded their commander, Don José de Barboza. The British general George Augustus Elliott magnanimously offered Barboza sanctuary, but the Spaniard valiantly chose to die at the battle site with his men.

The picture gains veracity from the delicate portraits of the British officers, which Trumbull made from life, and from his attention to the details of their regalia. However, the illumination of the scene by the bloody conflagration and the picture's dynamic composition—with the dying but defiant hero at the center, framed by frenzied action to the left and calm repose to the right—make this one of Trumbull's most exhilarating and most successful paintings.

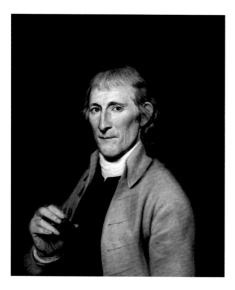

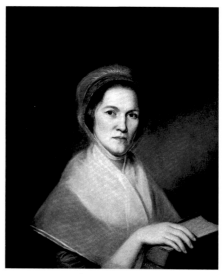

Charles Willson Peale (1741–1827), United States
Portrait of Mr. Francis Bailey, 1791
Oil on canvas; 26 x 21 3/4 in. (66 x 55.2 cm)
The Edwin and Virginia Irwin Memorial, 1957.146

Portrait of Mrs. Francis Bailey, 1791
Oil on canvas; 26 x 21 3/4 in. (66 x 55.2 cm)
The Edwin and Virginia Irwin Memorial, 1957.147

Like his contemporaries Thomas Jefferson and Benjamin Franklin, Charles Willson Peale was a Renaissance man with exceptionally far-reaching interests. Not only did he paint fine portraits such as those of Mr. and Mrs. Francis Bailey, but he was also a respected authority on natural history, who exhumed a mastodon skeleton. In 1786 he established a museum in his hometown of Philadelphia, the first museum on American soil.

Peale was undoubtedly good company for Francis Bailey, with whom he shared political views. A journalist and editor, Bailey was the official printer and publisher for Congress, and patented a new form of type that was difficult to counterfeit. Peale shows Bailey proudly holding up a printing block, an emblem of his preeminence in his profession, for the viewer's admiration.

Peale's images of the Baileys are noteworthy for their apparent honesty and directness. The sitters wear neither jewelry nor any other adornments. Bailey's sharp, crisply delineated features and thin lips suggest a man of piercing intelligence. Eleanor Miller Bailey, who grasps an enormous Bible, peers out at the viewer with an appraising glance. Her portrait sensitively conveys a formidable personality housed in a somewhat frail body. Peale's brilliant characterization of this couple showcases his ability to make the viewer feel as though his subjects could speak at any moment.

After Francis Bailey's death in 1815, Eleanor Bailey moved to Cincinnati with five of her eleven children and presumably brought these portraits. She lived in Cincinnati until her death in 1832.

(top row, left)

Walter Robertson
(ca. 1750–1802)

United States

General George Washington, 1794

Watercolor on ivory

3 15/16 x 3 3/16 in.
(10 x 8.1 cm)

Gift of Mr. and Mrs. Charles Fleischmann in memory of Julius Fleischmann, 1991.415

(top row, center)

James Peale
(1749–1831)

United States

Mary Mitchell, 1795

Watercolor on ivory

3 1/2 x 2 3/4 in.
(8.9 x 7 cm)

Gift of Mr. and Mrs. Charles Fleischmann in memory of Julius Fleischmann, 1990.1852

(top row, right)

Anna Claypoole Peale
(1791–1878)

United States

Marianne Beckett, 1829

Watercolor on ivory

3 1/2 x 2 9/16 in.
(8.9 x 6.5 cm)

Gift of Mr. and Mrs. Charles Fleischmann in memory of Julius Fleischmann, 1990.1523

(bottom row, left)

Benjamin Trott
(ca. 1770–1843)

United States

John Jordan, ca. 1830

Watercolor on ivory

3 x 2 1/2 in. (7.6 x 6.4 cm)

Fanny Bryce Lehmer Fund, 1932.108

◀ **Richard Verbrick**
(1784–after 1860)

United States

Charles Cox, 1836

Watercolor on ivory

2 3/4 x 2 1/4 in.
(7 x 5.7 cm)

Gift of Mrs. Catherine Ward Lord, 1934.206

The painting of portrait miniatures in watercolor on ivory flourished in the eighteenth and early nineteenth centuries. Mounted in simple or ornate cases sometimes designed to be worn on a chain, miniatures were treasured mementos of loved ones. The intimate scale, astounding delicacy of workmanship, and personal significance make miniatures especially precious. They also bring a sense of immediacy to the past: James Peale's vivid portrait of Mary Mitchell, for example, with a plaited lock of her hair seen through a window in the reverse, makes its young subject seem to live and breathe today.

This group of five American portrait miniatures is a small but choice sample of the Museum's stellar collection, which continues to grow and deepen through the generosity of Mr. and Mrs. Charles Fleischmann. It includes images of national icons such as George Washington, whose portrait by Walter Robertson was made from life in 1794 and distributed in a popular engraving. Among the miniatures by Philadelphia's famous Peale dynasty are the above-mentioned *Mary Mitchell* by James Peale, brother of Charles Willson Peale, and *Marianne Beckett* by James Peale's daughter, Anna Claypoole Peale. In the charming and exquisitely painted portrait of Mitchell, the subject is pointing to a hyacinth forced from a bulb. Anna Peale graced Marianne Beckett with a swanlike neck and made a striking contrast between the crimson dress and blue background. Celebrated miniaturist Benjamin Trott is represented by a portrait of New Jersey merchant John Jordan, which is characteristically confident and dashing. Far more tightly executed is *Charles Cox* by Richard Verbrick (or Verbryck), one of Cincinnati's earliest portraitists, who painted Cox in Indianapolis in 1836.

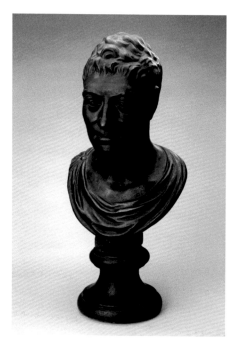

Frederick Eckstein (ca. 1774–1852)
United States (Cincinnati)
Marquis de Lafayette, 1825
Plaster
22 5/8 x 13 3/16 x 9 13/16 in. (57.4 x 33.5 x 24.9 cm)
The Edwin and Virginia Irwin Memorial, 1957.150

Sculptor Frederick Eckstein, called "the father of Cincinnati art," was a native of Prussia schooled at the Berlin Academy of Arts and Sciences. His career was assured because his father, Johann Eckstein, served as court artist to Frederick the Great. In 1794, however, Johann became disaffected with the Prussian court and journeyed with his son to Philadelphia, where they helped to found the Pennsylvania Academy of the Fine Arts.

Frederick married Jane Bailey, the daughter of Mr. and Mrs. Francis Bailey, whose portraits by Charles Willson Peale are part of the Museum's collection. Plagued by financial difficulties, Frederick and Jane moved frequently until 1823, when they settled in Cincinnati. There Eckstein became a catalyst for the city's artistic growth. He opened his own art school and offered the first sculpture lessons ever available in Cincinnati. He also instituted the short-lived but groundbreaking Cincinnati Academy of the Fine Arts and organized its first exhibition in 1828, which included more than 100 paintings by American and foreign artists.

Eckstein's severe bust of the Marquis de Lafayette, the famous French general who fought with the patriots in the American Revolution, was created from life in May 1825. The general made a 13-month tour of the United States, during which he received a hero's welcome. Here Lafayette wears a toga, in keeping with the classical taste of the period, and is thereby associated with the great statesmen of ancient Rome. It is said that Eckstein instructed his student, Hiram Powers, to make this plaster casting from his clay model.

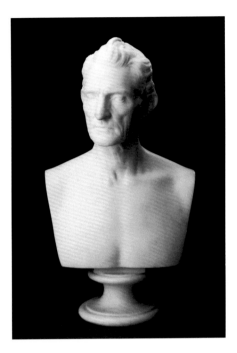

Hiram Powers (1805–1873)
United States (Cincinnati)
Portrait of Judge Jacob Burnet,
modeled 1837, carved 1841
Marble
25 5/8 x 14 1/2 x 8 5/8 in. (65 x 36.8 x 21.9 cm)
Gift of Mary Groesbeck Riker, 1941.8

Sculptor Hiram Powers once said of portraiture "The face is the true index of the Soul, where everything is written had we the wisdom to read it. People think I am needlessly anxious and careful about the small and fine lines in human faces. It is because I know how much each line represents, and what great distinctions dwell in small hiding places." The spiritual qualities that Powers found in the human face were interpreted eloquently in the purest white marble. In his finest and most moving portraits, such as those of Jacob Burnet and Powers' benefactor Nicholas Longworth (also in the Museum's collection), the sculptor melded naturalism with ineffable qualities of character and grace.

From a farm in his native Woodstock, Vermont, Powers moved to Ohio in 1818 and studied from 1823 to 1825 under Frederick Eckstein. Armed with a letter of introduction from Longworth, he traveled to Washington in 1835 and established his reputation with portraits of Andrew Jackson and John Quincy Adams.

Upon returning to Cincinnati, Powers modeled this dignified bust of Judge Jacob Burnet, a paragon of integrity who authored the first constitution of the State of Ohio and sat on the Ohio Supreme Court. After Powers completed the plaster model, he embarked for Florence, Italy to be near the great marble quarries and the most highly skilled marble artisans. The Burnet bust was carved under his supervision and shipped to Cincinnati in September 1842. The most esteemed American sculptor of his generation, Powers remained in Italy until his death more than 30 years later.

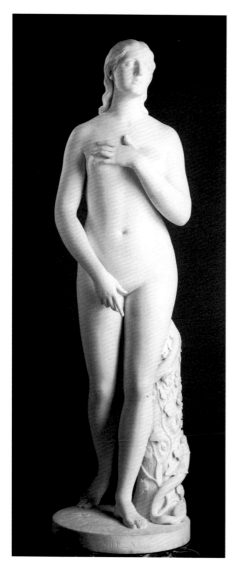

Hiram Powers (1805–1873)
United States (Cincinnati)
Eve Disconsolate, designed 1859–61, carved 1873–74
Marble
76 3/16 in., diam. of base 22 1/16 in.
(193.5 cm, diam. 56 cm)
Gift of Nicholas Longworth, 1888.86

expression of deep contrition; one hand upon her breast, the other pointing down to the serpent, who recoils at her feet as if sensible to the accusation." Powers first called his new Eve *Paradise Lost*, a reference to Milton; later he changed the title to *Eve Disconsolate*. The biblical subject of Eve not only offered Powers marvelous possibilities for a range of emotional expression, but also provided the rationale for a nude female subject within the norms of nineteenth-century American society.

The Museum's marble of *Eve Disconsolate* is one of two from Powers' studio. The first version (Hudson River Museum, Yonkers, NY) was carved in the late 1860s and sold to N.D. Morgan of New York City. Powers made the second marble as a tribute to his beloved Cincinnati patron, Nicholas Longworth, who had died in 1863. (He had given Longworth his first idealized bust, *Ginevra*, also in the Museum's collection.) In 1873, when Powers died, the marble remained half carved in his studio. It was completed by his exceptionally skillful master carvers and shipped in 1874 to Longworth's grandson, Nicholas Longworth II, who donated it to the Museum in 1888.

I n 1858 Hiram Powers began a companion sculpture to his *Eve Tempted* (National Museum of American Art, Washington, DC), his first full-length, idealized nude, modeled in 1842. In the earlier work, Eve turns the apple over in her hand as she contemplates yielding to temptation. For his new sculpture, Powers planned to show the culminating event in the story, Eve after the Fall—in his words (from a letter to Edward Everett), with "her face raised to Heaven with an

Thomas Cole
(1801–1848)
United States

View Across Frenchman's Bay from Mt. Desert Island, After a Squall, 1845

Oil on canvas

38 x 62 in.
(97.2 x 158.8 cm)

Gift of Alice Scarborough,
1925.569

Thomas Cole composed this painting from sketches made in 1844 on Mount Desert Island, on the Maine coast. In a letter to his wife, he vividly described the locale: "The whole coast along here is iron bound—threatening crags, and dark caverns in which the sea thunders. The view of Frenchman's bay and islands is truly fine. Some of the islands, called porcupines,...glitter in the setting sun. Beyond and across the bay is a range of mountains of beautiful aerial hues."

Such poetic observations of natural phenomena permeate this seascape, in which the elongated format creates a sweeping panorama. Cole artfully rearranged the topography to produce a more dramatic, more evocative composition. By showing the bay as a squall is clearing—when sky and sea are at their most theatrical—and by placing at the center a tiny, storm-tossed ship, Cole alludes to the insignificance of man before the awesome power of nature.

Cole used the raw grandeur of the American wilderness to articulate philosophical ideas about the nation's destiny. Here, for example, the bald eagle, a native species found on Mount Desert, may imply that the source of America's greatness lay in its distinctive wildlife as well as its untamed landscape. Cole's works, such as this one, influenced an entire generation of American artists, most notably his protégé Frederic Edwin Church, who painted Mount Desert Island on several occasions. Cole's *View Across Frenchman's Bay from Mt. Desert Island, After a Squall* was purchased in 1847 by William Scarborough of Cincinnati, and has contributed to the city's artistic life for more than 150 years.

Frederic Edwin Church (1826–1900)
United States
The Falls of the Tequendama near Bogotá, New Granada, 1854
Oil on canvas
64 x 40 in. (162.6 x 101.6 cm)
The Edwin and Virginia Irwin Memorial, 1971.30

Accompanied by his friend and patron Cyrus W. Field, Frederic Edwin Church spent six months in 1853 traveling in South America. He had sought out tropical subjects on the advice of Alexander von Humboldt, a German natural scientist whose books were among the most widely read in the nineteenth century. Humboldt believed that South America's extraordinary biological and geological diversity provided the ultimate stimulation to the intellect and emotions. Church followed Humboldt's dictum that objective scientific study of nature could not be separated from one's sensory responses to nature, and he embraced his theory of the unity of the cosmos.

Following the route taken by Humboldt, Church visited the Falls of the Tequendama in New Granada (now Colombia). He expressed his amazement in a letter to his mother, in which he explained that the river "suddenly breaks through a gap in the mountains and falls in one unbroken sheet into a terrific chasm 670 feet and then descends in a series of waterfalls and cascades...." To achieve the low vantage point he desired, it was necessary to cut down trees, but the effect was well worth the considerable effort.

As if one is actually at the site, one gazes at Church's painting in awe at the great cascade above, bathed in radiant light, and with excitement and terror at the torrent rushing below. The painting beautifully illustrates the multifaceted nature of water—its destructive force as it crashes over the rocks as well as the generative power that nourishes the rich, infinitely varied plant and animal life of South America.

James Henry Beard
(1811–1893)
United States (Cincinnati)
The Long Bill, 1840
Oil on canvas
30 3/8 x 24 7/8 in.
(77.2 x 63.2 cm)
Gift of Mrs. T.E. Houston, 1924.186

James Henry Beard arrived in Cincinnati around 1830, and for many years was the most accomplished portrait painter in the city. Moreover, he soon joined a number of artists who, influenced by seventeenth-century Dutch genre paintings, depicted subjects from everyday American life with vivid narrative content and naturalistically rendered details. Such works enjoyed broad appeal with the growing middle class and responded to the prevailing nationalism of the era. After the Civil War, Beard moved permanently to New York City, where he specialized in painting animals in human situations to satirize contemporary society.

Painted in Cincinnati in 1840, *The Long Bill* records with good-natured humor the encounter between an unsophisticated customer distraught by the high cost of groceries and the disdainful shopkeeper who bears the bad news. This subject would have had special meaning in 1840, when rampant inflation was the central issue of the presidential campaign. In this regard, *The Long Bill* functions as a political allegory. The customer may represent Ohioan William Henry Harrison, whom Beard ardently supported, and the shopkeeper his opponent, New Yorker Martin Van Buren, who was pegged as a dandy. In the *Cincinnati Gazette* for January 18, 1840, an admirer of the picture remarked, "The whole scene is very amusing, and painted with uncommon finish and accuracy. It is the best of Beard's we have seen, and would be highly valued by any amateur of painting in the world."

The *Winged Arrow*, portrayed on the right, and the *Southern Cross*, on the left, were built in Boston in the early 1850s, during the glory days of the Massachusetts maritime industry. In 1853 owner Benjamin K. Hough Jr., of Gloucester, Massachusetts, commissioned Fitz Hugh Lane to make this portrait of his new vessels. Hough was engaged in an import-export business that included the acquisition of rosewood from Brazil for use in manufacturing pianos. The ships pictured here sailed principally between Boston, California, and the Far East. The *Winged Arrow* was a particularly fine ship, traveling to the West Coast in noteworthy time. She was sold to a Russian fur-trading company in 1868, five years after the *Southern Cross* was burned by the Confederates.

Fitz Hugh Lane's painting is a ship portrait in the tradition of Robert Salmon, whose works he would have known as a native of the Boston area. Lane's training as a lithographer prepared him well for the astonishingly delicate, precise rendering of ship's anatomy, which he accomplished with true knowledge of nautical science and an exceptionally skilled hand. Although the Cincinnati painting is not the type of work for which Lane is now most esteemed—breathtakingly still harbor views at sunset with evanescent light and contemplative moods—nevertheless it reveals his preoccupation with effects of light and atmosphere. Elements such as the intricate shadows cast on the sails and the pink-tinged silhouette of the Boston skyline beneath the bright, blustery New England sky enliven this painting and make it far more than an accurate depiction of two ships.

Fitz Hugh Lane
(1804–1865)
United States

The Ships "Winged Arrow" and "Southern Cross" in Boston Harbor, 1853

Oil on canvas

24 1/8 x 36 1/2 in.
(61.3 x 92.7 cm)

The Edwin and Virginia Irwin Memorial, 1971.31

Robert S. Duncanson
(1821–1871)
United States (Cincinnati)

Blue Hole, Little Miami River, 1851

Oil on canvas

28 1/2 x 41 1/2 in.
(72.4 x 105.4 cm)

Gift of Norbert Heerman
and Arthur Helbig, 1926.18

On May 30, 1861, the *Cincinnati Gazette* hailed Robert Duncanson as "the best landscape painter in the West." This declaration highlights the remarkable achievement of the son of free African American parents, who succeeded despite tremendous racial discrimination to become a landscape painter in the Hudson River School tradition.

In about 1840 the young Duncanson arrived in Cincinnati, where he would live for most of the rest of his life. By that time the city was becoming established as the western outpost for landscape painting. Numerous artists called the city their home; significant exhibitions included works by the most influential figures, Thomas Cole and Asher B. Durand; and growing wealth supported cultural life. Duncanson's landscapes, such as *Blue Hole,* were inspired by Cole but were distinctively meditative. His landscapes and his equally sensitive still lifes earned him generous patronage, especially among Cincinnati's prominent abolitionist sympathizers.

The wild beauty of the scenery around the Ohio River attracted landscape painters such as Duncanson as well as his colleagues William Sonntag and Worthington Whittredge. The Blue Hole (now part of John Bryan State Park) is a deep, mirrorlike pool on the Little Miami River, a tributary of the Ohio, and had been a favorite spot for artists since the early 1830s. Duncanson's rendering of this popular locale is distinguished by the simple geometry of its composition, its delicate palette of silvery blues and greens, its soft, fluent brushwork, and its sweetly poetic mood.

In 1837 Thomas Worthington Whittredge moved from his hometown of Springfield, Ohio to the burgeoning art center of Cincinnati. Although initially he supported himself by creating portraits and daguerreotypes, this self-taught artist began exhibiting his landscapes in 1839.

Learning from other painters in Cincinnati and studying whatever Hudson River School works were available in local collections and exhibitions, Whittredge developed rapidly. He soon attracted patrons among the city's culturally attuned residents. In 1849, having been paid in advance for landscapes to be painted abroad, Whittredge sailed for Europe. For more than five years he lived in Dusseldorf, Germany, a popular destination for American art students. He returned to the United States in 1859 and became associated with the leading American landscape painters.

This painting had been known by the catchall title *Landscape* since 1886. Research conducted in 1993, however, revealed that it had once borne the name *Landscape in Westphalia*. This was a important picture, described in an 1874 publication as "one of the finest of the works executed by Whitteridge [sic] while he was resident in Dusseldorf." The painting's enchanting vision of rural cottage life is typical of works painted in mid-nineteenth-century Germany by artists such as Andreas Achenbach, in whose attic Whittredge lived and worked. *Landscape in Westphalia*, with its relatively large scale and elegant luminosity, shows the artist's mastery of his craft and his enduring desire to impress his American audience.

Thomas Worthington Whittredge (1820–1910)
United States (Cincinnati)
Landscape in Westphalia, 1853
Oil on canvas
40 3/4 x 52 1/2 in. (103.5 x 133.4 cm)
Gift of Maria Longworth Storer and Margaret R. Nichols, Marquise de Chambrun, 1949.82

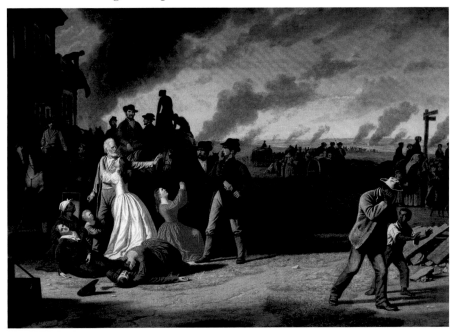

George Caleb Bingham
(1811–1879)

United States

Order No. 11, 1865–70

Oil on canvas

55 1/2 x 78 1/2 in.
(141 x 199.4 cm)

The Edwin and Virginia
Irwin Memorial, 1958.515

Idyllic scenes of boatmen and fur traders at leisure along the Missouri River and boisterous renditions of small-town politics made George Caleb Bingham one of the most celebrated artists of the mid-nineteenth century. The distribution of his paintings and engravings by lottery through the American Art Union to its widespread membership established his works as the quintessential images of frontier life. These works are captivating not only for the many colorful activities and character types they depict, but also for their ordered, geometric composition, the marvelous figure studies incorporated into each, and the unique, velvety qualities of the artist's color and light.

The melodramatic *Order No. 11*, created late in Bingham's career, lacks the finesse and grace of his earlier pictures. Here Bingham was more concerned with the force of his message. The painting dramatizes the inhumanity of the order issued in 1863 by Union Brigadier General Thomas Ewing to squelch the violent skirmishes between Missouri slaveholders and anti-slavery Kansans. Ewing demanded the evacuation of all rural residents of the Missouri counties along the Kansas border.

The painting features a slave-owning family, whose son has been killed, their belongings plundered, and their home and crops set on fire. To emphasize the nobility of the family patriarch, the artist posed him as the *Apollo Belvedere*, a famous ancient Greek sculpture. Bingham, although a Union supporter, could not condone the atrocities legitimized by Order No. 11, and exclaimed "If God spares my life, with pen and pencil I will make this order infamous in history."

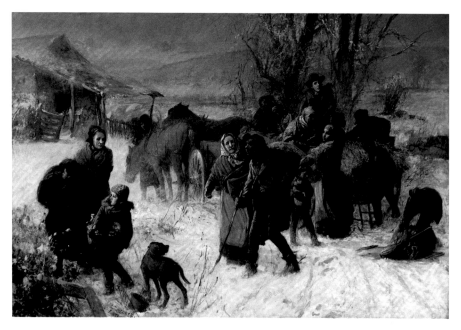

Among the most popular works in the Museum is *The Underground Railroad*, which Charles T. Webber painted for the 1893 World's Columbian Exposition, held in Chicago. Working in the Western tradition of history painting, which was commended because it educated while it entertained, Webber created this picture to celebrate the Abolitionists' heroic efforts in their moral struggle against slavery. He dramatically portrayed his friends, the notable Cincinnati Abolitionists Levi Coffin, Coffin's wife Catharine, and Hannah Haydock, leading a group of blacks to freedom. The artist set the figures at dawn in a wintry field—possibly even at Coffin's farm, which was located between Avondale and Walnut Hills.

Although the term *Underground Railroad* suggests a well-organized subterranean network that transported slaves to freedom, in fact it was a loose, opportunistic collaborative effort that aided runaways. Webber praised the courageous work of the Abolitionists, but the unsung heroes are the slaves, who were often forced to be resourceful and self-reliant in their flight to freedom.

Webber was born in New York State, but from 1860 until his death in 1911 he was active in the Cincinnati art community. He painted hundreds of works—mainly portraits, but also landscapes, genre subjects, and historical scenes.

Charles T. Webber
(1825–1911)
United States (Cincinnati)
The Underground Railroad, 1893
Oil on canvas
52 3/16 x 76 1/8 in.
(132.6 x 193.3 cm)
Subscription Fund
Purchase, 1927.26

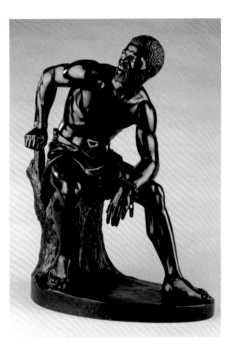

John Quincy Adams Ward (1830–1910)
United States
The Freedman, 1863
Bronze
19 5/8 x 14 5/8 x 7 1/8 in. (49.8 x 37.1 x 18.1 cm)
Gift of Alice Keys Hollister and Mary Eva Keys, 1921.502

E nhanced by a lustrous black patina, the Museum's bronze of *The Freedman* is among the earliest known castings of this successful work by John Quincy Adams Ward. Born in Urbana, Ohio, Ward served an apprenticeship from 1849 to 1856 in the New York studio of Henry Kirke Brown. Brown encouraged him to cast aside the stale neoclassical style in favor of a more realistic treatment of American themes. After the success of *The Freedman* and his popular *Indian Hunter* (Central Park, New York), Ward became a leading sculptor of monuments and the first president of the National Sculpture Society.

Ward surely was stirred to create *The Freedman* by the Emancipation Proclamation, issued by Abraham Lincoln in September 1862. By the following January, the artist had completed the plaster model. In the 1863 exhibition of the National Academy of Design, the sculpture was singled out for high praise. Even the prickly critic James Jackson Jarves stated "We have seen nothing in our sculpture more soul-lifting, or more comprehensively eloquent…It symbolizes the African race of America—the birthday of a new people…"

In *The Freedman*, Ward brought a vigorous naturalism to American sculpture with a virile image of African American masculinity that contrasted sharply with the prevailing stereotypes of the nineteenth century. In addition, he based the man's pose on the famous ancient Greek *Belvedere Torso*, thereby infusing the image with even greater nobility and moral purpose. The muscular figure is poised to rise and assume his rightful place in the world.

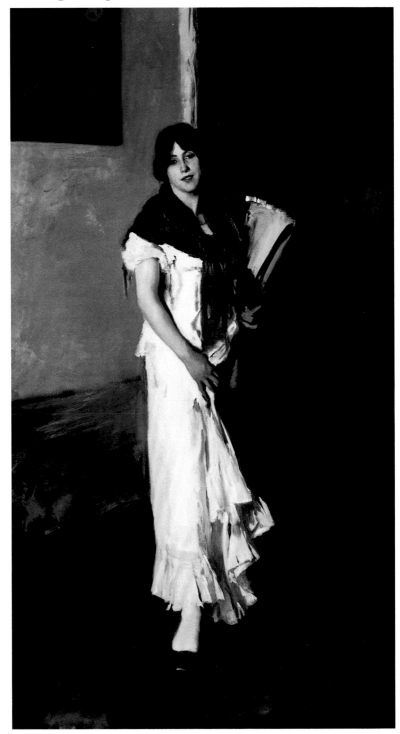

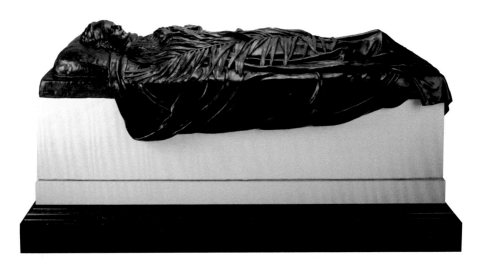

One of the most poignant and greatly admired works of American sculpture is Frank Duveneck's tomb effigy for his wife, Elizabeth Boott Duveneck. Lizzie Boott was born in Boston and grew up in a setting of refinement and erudition at the Villa Castellani, outside Florence, Italy, which was frequented by the expatriate colony of artists and writers. A painter of still-life and genre subjects, educated by William Morris Hunt and Thomas Couture, she sought out Duveneck, whose robust works impressed her, and in 1879 she studied with him in Munich. In 1886 they married despite the protests of her jealous father, Francis Boott, who found Duveneck's manners coarse. Their happiness, however, was short-lived. On March 22, 1888, during a visit to Paris, Lizzie died of pneumonia. The loss devastated Duveneck, whose works never again exhibited their earlier vigor.

In 1891 Duveneck made this plaster model for a bronze effigy to be placed on Elizabeth's grave in the Allori Cemetery, near Florence. Because he had no training in sculpture, he was aided by French-educated Cincinnati sculptor Clement J. Barnhorn. Henry James appropriately described the finished work, which is based on Gothic and early Renaissance tomb sculptures, as "a Knight's Lady in death." The face, with its peaceful expression, appears as if in sleep. Shrouded in simple drapery, the body is adorned with a palm branch to symbolize triumph over death. In 1895 Duveneck donated this plaster to the Museum after creating a marble version for Francis Boott (Museum of Fine Arts, Boston).

Frank Duveneck
(1848–1919)
Clement J. Barnhorn
(1857–1935)
United States (Cincinnati)
Memorial to Elizabeth Boott Duveneck, 1891
Plaster
28 3/4 x 85 9/16 x 40 7/16 in. (73 x 217.3 x 102.6 cm)
Gift of Frank Duveneck, 1895.146

Frank Duveneck (1848–1919)
United States (Cincinnati)
The Whistling Boy, 1872
Oil on canvas
27 7/8 x 21 1/8 in. (70.8 x 53.7 cm)
Gift of the Artist, 1904.196

T*he Whistling Boy* is considered the masterpiece of Frank Duveneck, Cincinnati's most celebrated artist. Duveneck, born in Covington, Kentucky, began as an assistant to a painter of Catholic churches. The son of German immigrants, he traveled to Munich in 1870 for further study in art. At that time, Munich was home to some of the most advanced artists in Europe, including Wilhelm Leibl, whose dark, unsentimental portraits impressed the young American. After returning home, Duveneck became an influential teacher, bringing the liberating aspects of progressive German art to the United States. His students included John Twachtman, Robert Blum, and Joseph DeCamp.

Painted in Munich, *The Whistling Boy* announced Duveneck's brilliant mastery of Munich School realism. This is the first of his several renditions of working-class ruffians—works indebted to the lowlife genre tradition of the seventeenth-century masters Diego Velásquez and Frans Hals. The dark-haired subject of this vital portrait emerges from a rich, shadowy background and is treated aggressively with layers of bold, fully laden strokes and patches. Duveneck was ranked among Munich's most daring artists for his unflinching vision and his unabashed joy in the expressiveness of luscious, undiluted paint brushed directly onto the canvas.

The often-told story that *The Whistling Boy* was once a smoking boy, with a cigarette dangling from his roughly sketched-in hand, has not been corroborated by scientific evidence and may be apocryphal. A touch of youthful vulnerability distinguishes this young man from the cigar-wielding toughs in Duveneck's later interpretations of this theme.

W inslow Homer first visited Virginia during the Civil War as an illustrator for *Harper's Weekly*. He was so deeply moved by the plight of southern slaves that he returned to Petersburg, Virginia in the mid-1870s. The paintings that resulted are remarkable for their sensitive portrayal of the painful uncertainties of African American life during Reconstruction. They answered the call for paintings of a national character but were highly unconventional. His works were set apart by the subtlety with which he told a story, avoiding the obvious narrative and sentimentality that usually accompanied pictures of everyday life. Moreover, unlike earlier painters, Homer did not deride African Americans nor resort to stereotypes.

One of the most powerfully expressive of this group of Homer paintings is *Sunday Morning in Virginia*, set in a slave cabin. A neatly attired young teacher instructs three cold, frightened, impoverished children in reading the Bible. The older boy studies intently, representing the intense thirst for learning among the former slaves. With touches of brilliant red, Homer draws our attention to an elderly woman on the right, whose newfound freedom cannot remedy a life of tremendous suffering and profound sadness.

In this painting, Homer eloquently addresses the politically charged issues of literacy and religion that were of great concern during the 1870s. With frankness and compassion, he encapsulates in a single picture all the aspirations and anxieties of a soul-searching era in United States history.

Winslow Homer
(1836–1910)
United States
Sunday Morning in Virginia, 1877
Oil on canvas
18 x 24 in. (45.7 x 61 cm)
John J. Emery Fund, 1924.247

◀ **John Singer Sargent** (1856–1925)
United States
A Venetian Girl (Gigia Viani), 1882
Oil on canvas
93 3/4 x 52 1/2 in. (238.1 x 133.4 cm)
The Edwin and Virginia Irwin Memorial, 1972.37

T he most cosmopolitan of American painters, John Singer Sargent was born in Florence, Italy to American expatriates who traveled frequently from one European city to another. Sargent sought art instruction in Paris in 1874 under Emile-Auguste Carolus-Duran, and soon began to produce paintings that dazzle the viewer with virtuoso brush handling. The dashingly elegant society portraits with which Sargent established and sustained his reputation seem to encapsulate the opulence and aspirations of the Gilded Age. Yet his genre paintings, landscapes, and watercolors, though less well known, often reveal a more personal, more adventurous nature.

This casual portrait from 1882 was the culmination of the latter of Sargent's two stays in Venice. The model was Gigia Viani, a working-class woman who also posed for several genre paintings in which dark, exotic figures meet in the shadowy recesses of Venetian alleyways and palazzos. The unusually large canvas, nearly eight feet tall, was probably intended for exhibition at the annual Paris Salon but ultimately was not submitted.

An affectionate portrait of a favorite model, this work exhibits an earthy vitality and immediacy rarely equaled in the artist's commissioned portraits, although they are no less brilliant. The subject's direct gaze, as she raises her skirt to reveal an ankle, is an explicit flirtation with the viewer, and the open doorway into a forbiddingly dark space suggests the mysterious world she inhabits. The vivacious brushwork and the delectable combinations of buttery yellow, white, dark magenta, aqua, gray, and black further enhance the painting's evocation of a sensual existence.

Robert Frederick Blum
(1857–1903)

United States (Cincinnati)

Venetian Lace Makers,
1887

Oil on canvas

30 1/8 x 41 1/4 in.
(76.5 x 104.8 cm)

Gift of Elizabeth S. Potter,
1905.8

For elegant draftsmanship, technical fluency, shimmering light, and jewel-like colors, few contemporaries could equal Robert Frederick Blum. The Cincinnati-born Blum, like Frank Duveneck and John H. Twachtman, was of German heritage. After early training and employment as a lithographer, he first studied art in Cincinnati, including classes with Duveneck, and then in Philadelphia. He relocated to New York in 1879 but spent much of the 1880s in Europe, particularly in Venice. There he joined Duveneck and was influenced by James Abbott McNeill Whistler. Blum's work also reveals his admiration for the dazzling effects of Giovanni Boldini and Mariano Fortuny (he was known as "Blumtuny"). In 1890 the artist fulfilled a lifelong desire to travel to Japan on a commission from *Scribner's Magazine*, which resulted in many striking pictures. He spent his last years on mural paintings in New York City.

Venetian Lace Makers was Blum's first important oil painting and is one of his best. He may have been familiar with recent images of Venetian workers by John Singer Sargent, but his emphasis on camaraderie and conventionally pretty types differs markedly from the isolation, nonchalance, and dark exoticism of the women in Sargent's compositions. The graceful charm of Blum's painting gives no hint of the often agonizing two years of labor that led to its creation. Sparkling sunlight intensified by reflection on the canals filters into the dark space, dancing on the women's lovely profiles, hair, and costumes. After Blum completed the canvas he painted a companion picture, *Venetian Bead Stringers* (private collection), which is set outdoors.

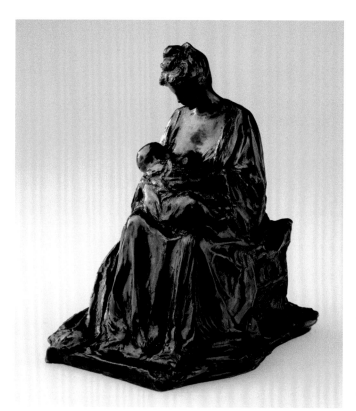

Bessie Potter Vonnoh
(1872–1955)
United States
A Study, modeled
ca. 1898, cast ca. 1903
Bronze
7 7/8 x 5 5/8 x 6 9/16 in.
(20 x 14.3 x 16.7 cm)
Annual Membership Fund
Purchase, 1904.18

D escribed as "an impressionist in plaster," Bessie Potter Vonnoh specialized in statuettes showing everyday themes. She was energized by the dynamic environment of late-nineteenth-century Chicago, and studied at the Art Institute. Vonnoh launched her career as one of five women, whom architect Daniel Burnham dubbed the White Rabbits, chosen to assist with the sculptural decoration for the World's Columbian Exposition of 1892. After the Fair she gained a reputation for vivacious plaster statuettes of women in contemporary dress, modeled with richly textured surfaces.

In 1896 Vonnoh created *A Young Mother*, the first and most celebrated of several sculptures of maternity which were cast in bronze. In *A Study*, her most intimate piece, she limited detail so as to evoke a sense of serenity. Because of such works, Vonnoh was often credited with popularizing fine small bronzes and bringing a female perspective to American sculpture.

Thomas Eakins (1844–1916)
United States
Archbishop William Henry Elder, 1903
Oil on canvas
66 1/8 x 41 1/8 in. (168 x 104.5 cm)
Museum Purchase: Louise Belmont family in memory of William F. Halstrick, bequest of Farny R. Wurlitzer, Edward Foote Hinkle Collection, and bequest of Frieda Hauck, by exchange, 1978.370

In December 1903, at age 84, Archbishop William Henry Elder was approaching the end of a noteworthy career when he sat for Thomas Eakins, who had traveled to Cincinnati to paint this portrait. A vigilant humanitarian, Elder had risked his position and even his life to aid the poor while serving as bishop in Natchez, Mississippi. In 1880 he arrived in Cincinnati, where he restructured the archdiocese.

Elder probably met Eakins in 1898 during a visit to the St. Charles Borromeo Seminary outside Philadelphia. Although an atheist, the artist frequently called on the priests there, whose intellect and character he esteemed greatly. He painted more than a dozen clerical portraits, which he presented to his distinguished sitters as gifts.

Eakins was Philadelphia's best-known and most controversial painter. Although he was discouraged after losing his beloved teaching position at the Pennsylvania Academy of the Fine Arts in 1886 for removing a loincloth from a nude male model before a female class, his work did not decline. He painted some of his most moving portraits after 1900.

As in papal portraits by the old masters, Eakins shows Elder as an imposing character. At the same time, however, the portrait sensitively hints at fragility and isolation. In the exhibition held annually at the Pennsylvania Academy, critic Charles Caffin deemed the painting "quite extraordinary in its cold, deliberate analysis of a human personality. Witness, for example, the wonderful expression of character in the hands!" The exhibition jury awarded the portrait the Temple Gold Medal, which Eakins promptly had melted down.

William Michael Harnett (1848–1892)
United States
The Last Rose of Summer, 1886
Oil on canvas
24 x 20 in. (61 x 50.8 cm)
The Edwin and Virginia Irwin Memorial,
1958.254

I
n the late nineteenth century, William Michael Harnett was America's greatest master of *trompe-l'oeil*, French for "fool the eye." In effective *trompe-l'oeil* painting, an art form that originated in the ancient world, objects are portrayed with startling illusionism. Harnett painted *The Last Rose of Summer* in 1886, shortly after his return from four years in Europe, which he spent principally in Munich. There he shunned the loose, expressive brushwork preferred by his compatriots and their patrons, in favor of tightly controlled paint handling that left his touch nowhere in evidence. Harnett's pristine works, although unappreciated by most art connoisseurs of his time, were relished by American businessmen, who commissioned him to paint the material evidence of their masculine habits and pursuits.

It is not certain for whom *The Last Rose of Summer* was painted. Many of the objects in the picture, including Harnett's own flute, also appear in other compositions. In this work, the playfulness of the illusion is tempered by an almost overwhelming sense of melancholy and loss. The title of the song on the sheet music (on which the painting's title is based), the water-stained paper, the old books including Dante's *Divine Comedy*, the melted candle and the snuffer, and the precarious leaning of objects upon one another suggest, in combination, a meditation on the passage of time. As with the seventeenth-century Dutch artists to whom Harnett was indebted, his concern for symbolic content and the pictorial qualities of composition, light, and color equaled his desire to amaze viewers with his virtuosity as an imitator of appearances.

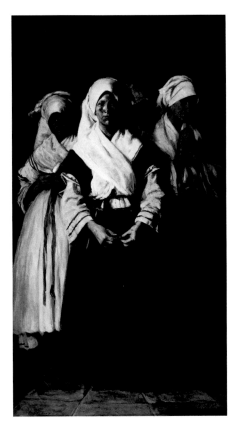

Elizabeth Nourse (1859–1938)
United States (Cincinnati)
Peasant Women of Borst, 1891
Oil on canvas
38 5/8 x 21 5/8 in. (98.2 x 54.9 cm)
Gift by Subscription, 1892.3

Although Elizabeth Nourse, like Mary Cassatt, lived in France for her entire professional life, she remains one of Cincinnati's most cherished artists. Nourse's considerable abilities, honed at Cincinnati's McMicken School of Design and the Académie Julian in Paris, allowed her to rise above the crowd in the international art world. In 1888, for the first time, she submitted a painting to the jury of the Salon, the prestigious annual exhibition of contemporary art in Paris. The painting was not only accepted but was hung "on the line," the location reserved for the most highly esteemed pictures. Many such honors followed, culminating with the purchase of one of her paintings by the French government in 1910.

Nourse's paintings, including the dramatic *Peasant Women of Borst*, belong to a late-nineteenth-century vogue for images of rural peasant life that fulfilled a longing for simplicity in the face of widespread industrialization. Yet Nourse

brought a highly personal viewpoint to this popular theme. The daughter of devout converted Catholics, she sought out remote Catholic villages such as Borst in southern Austria for her protagonists. In this unusual composition, she depicts a religious procession marching directly toward the viewer. Nourse clearly admired the dignity of these hard-working women, who gained formidable strength from the power of their faith. She also delighted in their picturesque costumes, which—with the striking contrasts of dark and light—contribute to this painting's bold design.

Shortly after it was completed, *Peasant Women of Borst* entered the Museum's collections by subscription from a group of prominent Cincinnati women.

I n 1878 George Inness stated that the aim of a work of art "is not to instruct, not to edify, but to awaken an emotion." This comment differs sharply from the philosophical notions of the Hudson River School. Finding the Creator's presence in details of nature, the Hudson River School painters had devotedly recorded dramatic sites and natural effects to deliver moral lessons. Beginning in the 1870s, however, American artists took a cue from the French painters working near Barbizon and developed a preference for more unified, intimate, suggestive images of nature. Their leader was Inness, who produced some of the most powerfully expressive landscapes of any American of his generation.

Near the Village, October is one of an impressive group of refined and contemplative works from the last few years of the artist's life. Inness embraced the Swedenborgian religion, which emphasizes correspondences between the natural world and that of the afterlife. The tenets of Swedenborgianism are not manifested literally in his paintings, but the late works, in which the physical appears to be dematerialized, seem to resonate with his faith. Inness chose to set many of these works in autumn, when nature's colors are most radiant, and often preferred the sharply contrasting light and shadow of late afternoon. *Near the Village, October* is distinguished by dense pigment, bold rich hues, flattened space, and compositional division into horizontal bands punctuated at deliberate intervals by vertical lines. These features create an asymmetrical, decorative pattern that prefigures the abstract paintings of the twentieth century.

George Inness
(1825–1894)
United States
Near the Village, October, 1892
Oil on canvas
30 x 45 in.
(76.2 x 114.3 cm)
Gift of Emilie L. Heine in memory of Mr. and Mrs. John Hauck, 1940.943

Mary Cassatt (1844–1926)
United States
Mother and Child, ca. 1889
Oil on canvas
28 13/16 x 23 9/16 in. (73.2 x 59.8 cm)
John J. Emery Fund, 1928.222

Mary Cassatt, the most daring of the American Impressionists, came from a well-to-do Pittsburgh family and studied at the Pennsylvania Academy of the Fine Arts. An independent spirit, she moved permanently to France and eventually cast aside her training, which she found stifling to creativity. Cassatt's moment of self-discovery came in Paris in the mid-1870s though her friendship with Edgar Degas, who invited her to exhibit with the French Impressionists. The Impressionists (or *Indépendants*) offered an exciting alternative to the conservative, government-sponsored Salon. Cassatt was the only American participant in their vanguard exhibitions, and she was invigorated by contact with them. She embraced subjects from her everyday experience and studied Japanese prints for new pictorial ideas. Her identification with the theme of mother and child, which began around 1880, was fully established by 1900, when her works found a popular audience.

Created around 1889, the Museum's painting is among Cassatt's most monumental renditions of maternity. Here mother and child are a tight unit, enclosed within a single form. To further emphasize their bond, the artist made them identical in hair color and complexion. It is amazing that the painting is such a powerful expression of affection, given that Cassatt has turned the mother's face away from the viewer. The child's casual sucking of his finger reveals his total security as he is wrapped snugly in his mother's arm, his head touching her cheek. The restricted, decorative range of tones and the sketchy, nearly abstract background truly herald Cassatt's modernity.

A mong the American Impressionists, John H. Twachtman may have expressed the most distinctive vision and experimental nature. Born and raised in Cincinnati, Twachtman took full advantage of the city's opportunities for an art education, including evening classes taught by Frank Duveneck. In 1875 he accompanied Duveneck to Munich, where he adopted the vigorous brushwork, somber palette, and gritty subject matter of the most progressive artists in Germany. By the early 1880s, however, the center of European art had shifted from Munich to Paris. Thus in 1883 Twachtman joined the hordes of young American students in the French capital, where he studied at the renowned Académie Julian. Exposed to a broad range of contemporary French art, he abandoned the bravura paint handling and dark tonalities of his Munich-inspired works.

Springtime is among the most accomplished and most radical paintings created by Twachtman while in France. This river view set in Normandy illustrates the artist's fluent absorption and transformation of stylistic sources ranging from the smooth surfaces and muted hues of Jules Bastien-Lepage to the nearly abstract forms and the flattened spaces of James Abbott McNeill Whistler and of Japanese prints. Unique to Twachtman's work, however, are his expressive, delicate touch and his preference for evocative, deeply serene moments.

By an unknown route, *Springtime* entered Frank Duveneck's collection. In 1908 Duveneck donated the painting to the Museum in a fitting tribute to Twachtman, who had died at age 49.

John H. Twachtman
(1853–1902)
United States (Cincinnati)
Springtime, ca. 1884
Oil on canvas
36 7/8 x 50 in.
(93.7 x 127 cm)
Gift of Frank Duveneck,
1908.1218

Childe Hassam
(1859–1935)
United States
Pont Royal, Paris, 1897
Oil on canvas
24 1/2 x 28 1/2 in.
(62.2 x 72.4 cm)
Israel and Caroline Wilson
Fund, 1899.68

Impressionist Childe Hassam came from an old Massachusetts family that traced its arrival in New England to 1631. After his initial trip to Europe in 1883, Hassam painted Boston streetscapes suffused with poetic mood and atmosphere. Exposure to the French Impressionists' work during an 1886 stay in Paris led to a lightening of his palette, a loosening of his brushwork, and reliance on color to suggest form and pictorial design.

On his third sojourn to Europe, Hassam arrived in France in the spring of 1897 and painted *Pont Royal, Paris* from his hotel on the Quai Voltaire. With great immediacy, this painting captures the activities of the city as seen unfolding below a high window or balcony. The elevated vantage point recalls Monet's *Boulevard des Capucines* (The Nelson-Atkins Museum of Art, Kansas City). Yet *Pont Royal* also reveals a distinctive version of Impressionism. Hassam applied the paint rapidly but thinly, sometimes leaving exposed primed canvas as a design element. The high-keyed tonalities, dominated by yellows and greens, brilliantly evoke the vibrancy of early spring. The composition, less spontaneous than it appears, is organized around the central tree, which almost bisects the canvas, and by the perpendicular bands of bridge and sky. *Pont Royal, Paris* won the prestigious Temple Gold Medal at the Pennsylvania Academy of the Fine Arts.

L ike Frank Duveneck, William Merritt Chase spent his formative years as an artist in Munich, assimilating the dark palette and flashy brush work of the Dutch and Spanish masters. Upon returning from Germany in 1878, the Indiana native settled in New York, where he launched a noteworthy teaching career. Chase's studio, filled with *objets d'art*, became a popular gathering spot for artists and literati as well as the subject of his most complex paintings. His works also included portraits, still lifes, and landscapes. By the late 1880s, Chase's palette had lightened dramatically as he experimented with Impressionism. Although he rejected its basis in optical theory, he staunchly advocated painting outdoors to capture the vibrancy of contemporary life in the radiant light of sunny days.

In 1891 Chase opened a summer school for outdoor painting at Shinnecock Hills, near the village of Southampton on southeastern Long Island. With the possible exception of a class taught by John H. Twachtman, this was the first instruction in the United States devoted to outdoor painting.

Summer at Shinnecock Hills is among the earliest of the artist's signature portrayals of the region. With some variations, these works typically include women and children in sparkling white dresses accented with touches of pink or red, on the beach or nestled within the wind-swept grasses of the dunes. The clear vistas unobstructed by trees, the gently rolling contours of the terrain, and the delicate colors of the landscape provided Chase with a wealth of inspiration that was renewed each summer.

William Merritt Chase
(1849–1916)
United States

Summer at Shinnecock Hills, 1891

Oil on canvas

26 1/2 x 32 1/2 in.
(67.3 x 82.6 cm)

Bequest of Mr. and Mrs. Walter J. Wichgar, 1978.334

Henry Farny
(1847–1916)
United States (Cincinnati)

The Last of the Herd,
1906

Oil on canvas

22 x 39 15/16 in.
(55.9 x 101.4 cm)

Farny R. and Grace K.
Wurlitzer Foundation,
1964.321

A leading painter of Native Americans and a perennial Cincinnati favorite, Henry Farny was born in France and sailed for America with his family at about age 6. In 1859 the family settled in Cincinnati; except for the brief pursuit of illustration work in New York, study in Europe, and four trips to the West, this would be the artist's lifelong home. Farny's studio was full of Native American artifacts and photographs from his travels, which he used as memory aids for his paintings. It became such a popular gathering spot that the charismatic artist sequestered himself in Covington, Kentucky to concentrate on painting.

In 1906, when Farny created *The Last of the Herd*, his last westward journey was about 12 years behind him. This hardly mattered, however, because Farny could not have witnessed scenes such as this. The United States government had closed the frontier in 1890, confining the Native Americans to reservations and condoning the mass slaughter of the buffalo that sustained them until none were to be found on the Plains.

In his paintings, Farny typically blended romanticism with fact. (He studied native cultures and spoke several native languages.) The dead buffalo in this work, killed with a rifle acquired by trade with whites, forcefully symbolizes the perishing of the Native American way of life. Set off dramatically against the pale sand, the beast is depicted with a telescopic perspective that brings its shaggy, bloodied head close to the viewer. A superb designer, Farny set this denouement in a spare composition with an oblong format that emphasizes the expansiveness of the Plains.

Joseph Henry Sharp
(1859–1953)
United States (Cincinnati)
Harvest Dance, 1894
Oil on canvas
27 11/16 x 48 5/8 in.
(70.3 x 123.5 cm)
Museum Purchase,
1894.10

The founder of the Taos art colony, Joseph Henry Sharp devotedly recorded the proud faces of Native Americans and their traditional ways of life. Born in 1859 in Bridgeport, Ohio, and deaf as the result of a swimming accident, Sharp joined the highly talented students at the McMicken School of Design at age 14. He later attended the Art Academy of Cincinnati and studied extensively in Europe.

In 1883, persuaded by Henry Farny's example and by an attraction to American Indians from boyhood readings of James Fenimore Cooper, Sharp traveled to Santa Fe. Immediately his romantic notions were supplanted by respect for his native models as individuals, and by a sensitivity to their loss of land and customs. For the rest of his life, Sharp painted Native American subjects around Taos and in Montana, where he made 200 portraits of survivors of Custer's battles. Although his paintings profess his own point of view, the Smithsonian Institution valued them as ethnological records for their accuracy of detail.

Sharp painted *Harvest Dance* at the peak of his artistic powers. In an article in the October 14, 1883 issue of *Harper's Weekly,* he described this splendid ceremony as "a striking scene of gorgeous color":

> The brilliant sunlight illumines the gaudy trappings of the dancers. Rows of gayly [sic] dressed Apaches, Navajos, and Pueblos on horseback encircle in quiet dignity the enthusiastic actors, while a little farther off the whole scene is framed in by the gleaming walls of the white and yellow houses, whose roofs are crowded with men, women, and children.... The dancing was kept up for seven long hours; but there was never any shirking; they stamped as energetically the last hour as the first.

**Augustus
Saint-Gaudens**
(1848–1907)
United States

*Stanley Matthews and
His Wife Mary,* 1904

Bronze

32 5/8 x 47 x 1 in.
(82.9 x 119.4 x 2.5 cm)

Gift of T.S. Matthews,
1955.795

Augustus Saint-Gaudens was born in Dublin and brought to New York City as an infant. An apprenticeship with cameo carvers as a teenager fostered his mastery of portrait relief sculpture. Among the first American sculptors to choose study in France rather than Italy, Saint-Gaudens traveled in 1870 to Paris, the center of a revival of bronze sculpture and Renaissance naturalism. He won admission to the prestigious Ecole des Beaux-Arts, and during a trip to Italy was deeply impressed by early Renaissance art. His return to New York in 1872 heralded a turning point in American sculpture: the previous generation of sculptors had lived as expatriates. Saint-Gaudens became the most influential sculptor in America in the "Beaux-Arts" style. His best-known monumental commissions include memorials to Generals Robert Gould Shaw and William Tecumseh Sherman.

Stanley Matthews and His Wife Mary is a fine example of Saint-Gaudens' low-relief portraiture, characterized by subtle variations in the depth of the relief to create an illusion of space. His portrait plaques are also distinguished by delicate linear treatment and precise ornamentation. Less typical is the three-quarter viewpoint employed here, which presumably was made necessary by the use of photographs.

Cincinnati jurist Stanley Matthews graduated in 1840 from Kenyon College, where a marble version of this relief is on display. In 1881, after serving on the bench in the Hamilton County Court of Common Pleas, he ascended to the United States Supreme Court. On this plaque Matthews appears with his second wife, Mary Theaker of Washington, DC, whom he married in 1887. Matthews died in 1889, and the double portrait was commissioned in 1903 by his daughter Jane.

Thomas Wilmer Dewing (1851–1938)
Maria Oakey Dewing (1845–1927)
United States
Hymen, 1884–86
Oil and gold leaf on panel
31 1/2 x 17 1/8 in. (80 x 43.5 cm)
The Edwin and Virginia Irwin Memorial, 1968.48

Thomas Dewing superimposed the figure of Hymen on Maria Dewing's lush background, the delicate white blossoms and dark green foliage of an orange tree. The image gains a magical quality from the airless density of this background and the vegetation's large scale, as well as the unearthly blue-green where the soil ordinarily would be, the subject's vacant facial expression, and the gold-leaf torchère. These sumptuous decorative effects are parallel to achievements in stained glass by John La Farge. Moreover, the painting is related to works by Albert Moore, an English proponent of the Aesthetic Movement, who painted women in Grecian dress in richly patterned settings.

An allegory of marriage, *Hymen* was conceived as a wedding present for the Dewings' friend, architect Stanford White. Hymen, the Greek patron god of conjugal union, who is usually male, is female here. In nineteenth-century murals, abstract concepts—such as Faith and the Arts—were personified as women in Grecian attire. Thomas Dewing's figure (posed before the orange tree, an obscure symbol of matrimony) thus serves less as a representation of Hymen than as a personification of marriage itself.

H *ymen* represents the collaboration of Thomas Wilmer Dewing and Maria Oakey Dewing, two ambitious, strongly individualistic painters who created a stir in New York when they married in 1881. Maria Dewing had begun as a figure painter, but after her marriage she specialized in close-up views of gardens. She shared her more famous husband's lifelong ambition, the refined expression of beauty in art. His work encompassed both the female subject and the Whistlerian notion of the painting as an object of purely aesthetic contemplation.

John Singer Sargent
(1856–1925)

United States

Two Girls Fishing, 1912

Oil on canvas

22 x 28 1/4 in.
(55.9 x 71.8 cm)

John J. Emery Fund,
1918.39

Exhausted by commissioned portraiture, Sargent after the turn of the century devoted his creative energies increasingly to landscapes and paintings of friends and family at leisure. This enchanting work shows Sargent's nieces, Rose-Marie and Reine Ormond, perched on rocks at water's edge during an August 1912 sojourn to the resort of Abriès in the French Alps. The fashionably attired sisters, city dwellers on holiday, appear in companionable silence, either bored or lost in their own thoughts. In this painting, fishing is not an activity for sportsmen but rather appears to offer relief from the anxieties and the accelerated pace of urban living.

The lightening of Sargent's palette and his interest in painting outdoors in sunlight owe much to Claude Monet. Yet in spite of his rich and varied brushwork, the figures here retain the solidity of an academically trained draftsman. Like many of the American Impressionists, Sargent had little regard for the optical effects of light on color. He was more interested in the expressive potential of light and color to evoke mood and sensation. Composition concerned him as well: although this painting appears casual, in fact it is designed most cleverly. The emphatic diagonal of the riverbank is offset by the opposing diagonals of the parallel fishing poles. The girls are identically posed, one dressed in white, the other in black. This painting was so admired while on display in 1918 in the Museum's annual exhibition of American art that it was purchased at that time.

I n the 1890s and for the first few years of the twentieth century, Maurice Prendergast was the most modern artist in America. The Bostonian painter was unusually receptive to the art of the Post-Impressionists, whose work he saw in Paris. In his art, traditional conceptions of space and naturalistic color gave way to emphasis on the flat surface of the canvas, bold colors, formal simplifications, and decorative outlines and patterns. In a number of oils, such as *New England Harbor*, he charmingly expresses an arcadian world of almost childlike innocence. His favorite subjects, as seen here, were women and children at leisure—picnicking, riding horseback, relaxing.

Prendergast may have exhibited *New England Harbor* at the Art Institute of Chicago in 1919. An early photograph of the picture, however, shows a previous stage in the development of the composition, suggesting that the artist continued to work on the painting. The male figure seated in the foreground is not present in the photograph, nor are most of the patterns of lozenge-shaped dots that adorn the women's dresses. The picture's distinctive tapestrylike effect is heightened by the dissolution of form into these colorful patterns and by the multiple layers of paint that encrust the surface. The decorative appearance is further enhanced by the frame, which was designed by the painter's brother, the artist Charles Prendergast.

Maurice Prendergast
(1859–1924)
United States
New England Harbor,
ca. 1919–23
Oil on canvas
24 x 28 in. (61 x 71.1 cm)
The Edwin and Virginia Irwin Memorial, 1959.51

Paul Manship
(1885–1966)
United States
Lyric Muse, 1912
Bronze
11 3/4 x 6 15/16
x 5 9/16 in.
(29.8 x 17.6 x 14.2 cm)
Wilson Fund, 1916.5

This figure of Erato, the muse of lyric poetry, was made by Paul Manship, the artist most closely associated with American sculpture of the 1920s and 1930s. A native of St. Paul, Minnesota, Manship won the coveted Prix de Rome in 1909. During his three-year residence at the American Academy in Rome, he developed his own distinctive response to European modernism but retained his ties to historical traditions. Manship avoided the expressive modeling and emotionalism of most contemporary American sculpture, preferring decorative lines, geometric patterns, and sleek surfaces. Without literal references, he drew his inspiration from such diverse civilizations as the archaic Greeks, Minoans, Assyrians, and Indians. *Lyric Muse*, modeled in Rome in 1912, showcases Manship's decorative simplifications and his elegant, rhythmic composition.

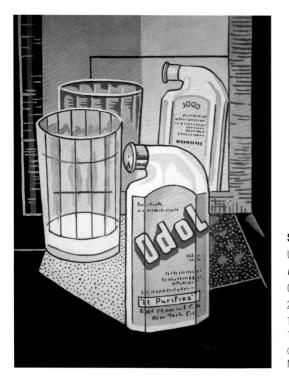

Stuart Davis (1894–1964)
United States
Odol, 1924
Oil on academy board
24 7/16 x 17 5/8 in. (62.1 x 44.8 cm)
The Edwin and Virginia Irwin Memorial, 1972.460
© Estate of Stuart Davis/Licensed by VAGA, New York, NY

D
ecades before Andy Warhol's paintings of Campbell's Soup cans and Brillo boxes blurred distinctions between consumer culture and high art, Stuart Davis made this painting featuring a bottle of Odol mouthwash, a witty emblem of modern society. The "Ashcan" painters Robert Henri and John Sloan encouraged Davis to embrace day-to-day American life in his art. Although he departed from his mentors' realism and experimented with abstraction, he incorporated items of mass culture in his paintings in a buoyant celebration of American leadership in advertising.

In *Odol*, Davis turns the tradition of still-life painting on its ear, both stylistically and thematically. Creating a personal variant of Cubism, he defies the illusionistic tradition of art by alluding to spatial relationships contradicted by the flattened forms. The bold simplifications are quintessentially Davis, as are the arrangements of shapes that produce animated rhythms across the canvas. The elegant utilitarian form of the Odol bottle certainly appealed to the artist, as did the confident graphic style of the label. The creamy, dotted area that begins to the bottle's left cleverly makes it appear to be illuminated by a spotlight, as if on stage. Here Davis replaces the typical café paraphernalia of Pablo Picasso and Georges Braque—including the ubiquitous bottle of Suze liqueur—with a bottle of mouthwash and a glass reflected in a bathroom mirror. One wonders whether this Prohibition-era painting includes a sly reference to the concealment of alcohol consumption.

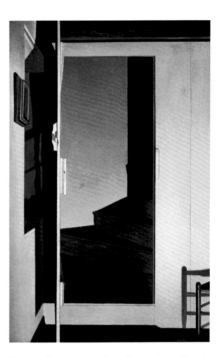

Charles Sheeler (1883–1965)
United States
The Upstairs, 1938
Oil on canvas
19 1/2 x 12 3/4 in. (49.5 x 32.4 cm)
The Fanny Bryce Lehmer Fund, 1938.10557

The functionalism, simplicity, refinement, and craftsmanship of early American and Shaker architecture and furnishings appealed powerfully to the Philadelphia-born painter and photographer Charles Sheeler. He observed admiringly that the Shakers "would seem almost to have had a mathematical basis for their crafts, so knowingly and with such exactitude were their designs planned and realized." One could say the same about Sheeler's paintings. His modernist aesthetic encompassed elegant linearity; precisely defined shapes and contours; thin, even, and painstaking paint application; and an extraordinary sensitivity to geometric order.

The rectilinear elements of interior architecture inspired a number of Sheeler's works, including *The Upstairs*. Here the artist portrays his 1786 farmhouse in Doylestown, Pennsylvania, which he had not seen in many years but had recorded earlier from a different vantage point. His immediate impetus for returning to the theme of early American structures might have been a visit to Colonial Williamsburg in 1935. In any case, the call for distinctly American subjects was renewed vigorously in the 1930s, when Thomas Hart Benton, John Steuart Curry, and Grant Wood were hailed as the "big three" of American art.

Sheeler admired indigenous architecture principally for its abstract formal qualities, but this attraction was not unemotional. In *The Upstairs*, the harsh light creates eerie shadows (particularly those of the unseen window mullions) that endow this interior with a mysterious, unsettling atmosphere. This feeling is heightened by the abrupt cropping of the chair and the invitation to the viewer to climb a staircase to an unknown destination.

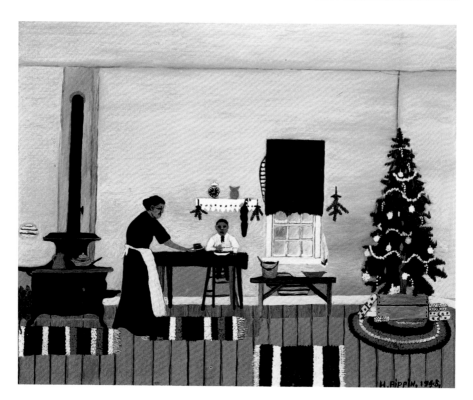

In this nostalgic scene, African American artist Horace Pippin shows the grandeur in the ordinary lives of common folk. Pippin included numerous details that convey sincerity. In a modest room, a mother serves pancakes while her son sits patiently with his hands folded in prayer, waiting to eat breakfast. The poverty of the home is seen in the exposed wallboards where large chunks of plaster have fallen away, and the mother's life of unremitting labor is evident in her bowed back. Yet the painting glows with familial warmth between the two figures, and the neatness of the room suggests domestic order.

The self-taught Pippin, who regarded himself as a realist, stated "I don't go around making up a whole lot of stuff. I paint it exactly the way it is and exactly the way I see it." His method was not academic. "Pictures just come to my mind," he explained, "and I tell my heart to go ahead." Pippin developed a simplified, abstract manner based on a stylization of natural forms arranged in flat patterns. He used delicate line and subtle coloring for his poignant narratives.

Pippin worked at manual labor until age 29, when he enlisted in the army. He was shot in the right shoulder during World War I. Although crippled, he painted his small masterpieces by using his left hand to prop up his right forearm.

Horace Pippin
(1888–1946)
United States

Christmas Morning, Breakfast, 1945

Oil on canvas

21 x 26 1/4 in.
(53.3 x 66.6 cm)

The Edwin and Virginia Irwin Memorial, 1959.47

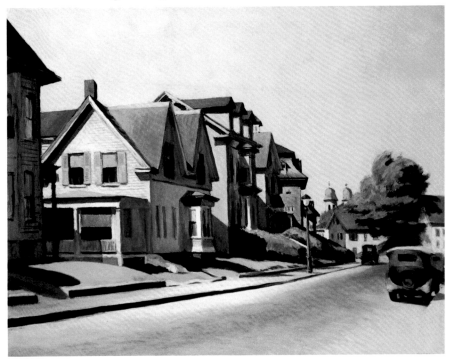

Edward Hopper
(1882–1967)
United States

*Sun on Prospect Street
(Gloucester, Massa-
chusetts)*, 1934

Oil on canvas
28 x 36 1/4 in.
(71.1 x 92.1 cm)
The Edwin and Virginia
Irwin Memorial, 1959.49

The paintings of Edward Hopper speak to viewers as powerfully today as when they were painted. Hopper's philosophy that the key to a national art was the painting of day-to-day American experience was instilled by his teacher, Robert Henri. Hopper, however, rejected Henri's brash, spontaneous technique as the means of capturing the modern spirit. Breaking with Henri's optimism, Hopper expressed with poetic eloquence the twentieth century's profound loss of communication, particularly during the Great Depression.

Hopper painted this 1934 oil from a watercolor he made in 1928 in Gloucester, Massachusetts, a seaside fishing town that had attracted artists since the mid-nineteenth century. The airy freshness of the watercolor is replaced here by the sharp, unforgiving light that pervades his canvases and heightens their enveloping emptiness. The elimination of humanizing details, such as the window grilles and curtains recorded in the watercolor, amplifies this effect and strengthens the composition's abstract geometry.

Hopper was sensitive to old American architecture and recorded the houses on Prospect Street quite accurately. Yet he did not romanticize Gloucester as a quaint New England village. He oriented this work from a motorist's perspective and admired the modern design of automobiles; one in the foreground is described in his record book as a "touring car with canvas top." He also noted the "expanse of pavement, oil stains down the center," an astute and unglamorous observation of the modern world.

O
riginally owned by film actor Edward G. Robinson, *Daughters of Revolution* is one of the most trenchant satirical works of Iowa painter Grant Wood. In this Depression-era painting, Wood skewered the Daughters of the American Revolution (DAR) as absurd, self-righteous, chauvinistic matrons with tight lips and long, chickenlike necks. One of the women stiffly grasps a dainty blue willow teacup in a bony hand as she takes part in the annual colonial tea in celebration of George Washington's birthday. Washington's widely celebrated bicentennial took place in 1932, when this work was painted.

According to legend, Wood made this painting as a delicious form of retaliation against the Cedar Rapids chapter of the DAR. The group had ignited a controversy over the German fabrication of a memorial window designed by Wood to commemorate soldiers lost in World War I. In *Daughters of Revolution,* Wood has placed the matrons before a print of *George Washington Crossing the Delaware*, a national icon painted by the German artist Emmanuel Leutze.

Wood's feelings about the window incident certainly were inflamed by his deeper objections to the DAR's general mission. The socially conscious artist deplored the organization's "great inconsistency." "On the one hand," he observed, "they were trying to establish themselves as an aristocracy of birth, on the other they were trying to support a democracy." Thus Wood deliberately omitted *American* from the marvelously ironic title, which he inscribed on the frame he designed for the painting. Some DAR members found the painting offensive; others, however, like much of the general public, appreciated Wood's sardonic humor.

Grant Wood
(1892–1942)
United States
Daughters of Revolution, 1932
Oil on masonite
20 x 40 in.
(50.8 x 101.6 cm)
The Edwin and Virginia Irwin Memorial, 1959.46
© Estate of Grant Wood/ Licensed by VAGA, New York, NY

*American
Decorative Arts*

American Decorative Arts

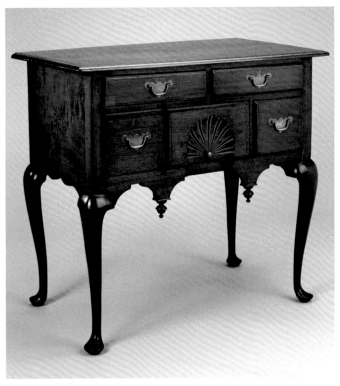

Attributed to **William Parkman** (1685–1776)

United States (Boston)

Dressing Table,
ca. 1730–45

Walnut

29 1/2 x 33 x 19 1/4 in.
(74.9 x 83.8 x 48.9 cm)

Bequest of Edmund C. Kerper, 1959.24

This dressing table, dating from around 1730 to 1745, is in the Queen Anne style. The wealth of the English increased during that queen's reign, as did the demand for new and more sophisticated types of furniture. The Queen Anne style, in fashion between 1720 and 1740, ushered in the eighteenth-century golden age of English furniture.

Many dressing tables were made in this style. Common trademarks are the graceful proportions, a curved cabriole leg with pad feet, and the absence of decorative carving. The dressing table form was adopted enthusiastically by American craftsmen, who learned about it from English design books. It was a companion piece to the highchest.

This table includes a compass star inlay, a motif probably taken from English furniture and used extensively by Americans, especially those working around Boston. Because of the star inlay and the table's resemblance to other documented pieces, it is likely that William Parkman, a Boston cabinetmaker, produced this piece.

Dressing tables (dubbed "lowboys" in the nineteenth century) were usually found in the bedroom or dressing room, and were often fitted with mirrors and drawers divided into compartments. In the early eighteenth century they were also used as writing desks. Because this table lacks a mirror and compartmented drawers, it may have served this function.

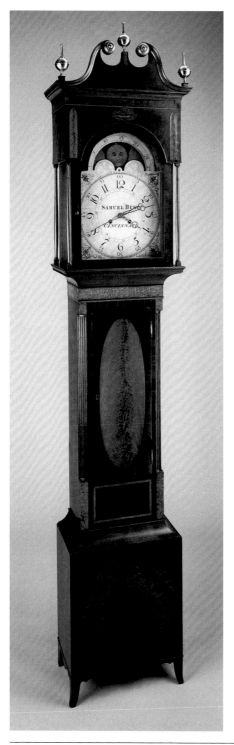

Samuel Best (1776–1859)
United States (Cincinnati)
Tall-Case Clock, 1810–15
Mahogany and cherry with maple veneer and inlay
104 5/8 x 19 3/4 x 11 1/8 in. (265.7 x 50.2 x 28.3 cm)
Museum Purchase, 1966.1175

In the early nineteenth century, Thomas Best and his family—English silversmiths, jewelers, watchmakers, and clockmakers—settled in Cincinnati, then the gateway to the West. Samuel Best, Thomas's eldest son, was the most successful of the family. Having learned his trade from his father, he established a business in Cincinnati in 1802, working out of a log house. There he assembled and repaired watches and clocks, and made items such as silver tumblers, milk and soup ladles, teaspoons, sugar spoons, watch seals, and keys. (In addition to this clock, the Museum has examples of Samuel Best's silverware.) During his career, Samuel Best made approximately 40 clocks.

This tall-case clock, like other clocks of the Federal period, stands tall and majestic with simple but elegant ornamentation, including the delicately scrolled pediment. The patera (decorated oval ornament) above the clock face is inlaid with an urn and flower, a popular classical motif. The mahogany and cherry case is accented with a rich maple veneer and inlay.

In the Federal period, the tall-case clock was the most expensive item in the household. These clocks were displayed in the parlor, where the family did most of its entertaining. Although they remained popular into the mid-nineteenth century, they were supplanted by the less expensive wall or shelf clock.

American Decorative Arts

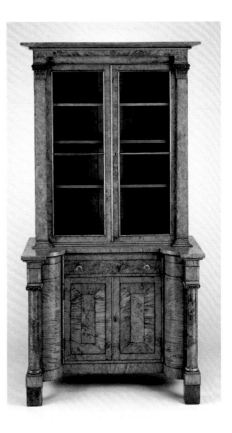

William Hawkins (1807–1839)
United States (Cincinnati)
Bookcase, 1830s
Tiger maple veneer
75 x 38 x 21 in. (190.5 x 96.5 x 53.3 cm)
Bequest of Rose Marion Verhage, 1968.460

W illiam Hawkins was born and trained in Chester County, Pennsylvania, home to many German immigrant craftsmen. There he mastered traditional German cabinetmaking techniques. Hawkins settled in Cincinnati in 1829 and established a cabinetmaking shop, which he operated until 1837. In 1835 he opened a furniture warehouse, and in 1838 he sold the contents to two Cincinnati cabinetmakers. His career ended abruptly with his untimely death in 1839.

Hawkins produced work for some of the most prominent families in Cincinnati. This bookcase, a stylish but refined piece, displays his superior craftsmanship. Its form and decorative sensibilities suggest an adherence to the Empire style, popular in the United States between 1815 and 1835. Hawkins, however, has subdued the elaborate ornamentation usually associated with Empire-style furniture. Pilasters and columns with carved Ionic and Corinthian capitals unify the top and the bottom of the two-piece bookcase, and emphasize its height. The surface is further unified by the overall pattern and rich texture of the tiger maple veneer.

Hawkins's identification, stenciled inside the middle top drawer, reads: *William Hawkins, Manufacturer of the Most Fashionable Cabinet Furniture, on Fourth St. Between Main and Sycamore. Cincinnati, O.*

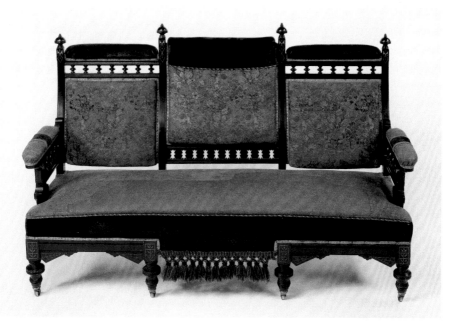

P art of a six-piece parlor suite, this sofa was manufactured by Mitchell and Rammelsberg, Cincinnati's premier furniture company in the nineteenth century. The company's original paper label still adheres to the underside of the seat on each of the four side chairs, and the original upholstery fabric is still intact. The suite is in the modern Gothic style, which was popular in this country in the last quarter of the nineteenth century. The Aesthetic movement jacquard fabric of the upholstery was inspired by exotic patterns from Eastern textiles.

Mitchell and Rammelsberg owed its success to numerous factors. The company used modern technology such as steam-powered machines to cut its manufacturing costs; it offered a wide range of styles including Renaissance revival, Queen Anne, Japanese, Egyptian revival, and neoclassical; it produced a variety of high-quality furniture forms for the home or office and offered them at a variety of prices; and it was located in a prosperous city with a rapidly growing population. By the 1870s, the firm had opened branch retail stores in St. Louis, Memphis, and New Orleans as well as a six-story retail building in Cincinnati's fashionable retail district.

In addition to supplying home and office furniture, Mitchell and Rammelsberg sold furnishings for hotels, stores, churches, and schools. The company retailed furniture, upholstery, and other household accessories made by other American and European manufacturers as well as its own wares. Mitchell and Rammelsberg displayed its furniture at the 1876 Philadelphia Centennial Exhibition, where it was highly praised.

Mitchell and Rammelsberg Furniture Co.
(1847–1881)
United States (Cincinnati)
Sofa, 1876–81
Ebonized wood, upholstery
40 1/2 x 65 x 29 in.
(102.9 x 165 x 73.7 cm)
Henry Meis Endowment, 1987.63.1

American Decorative Arts

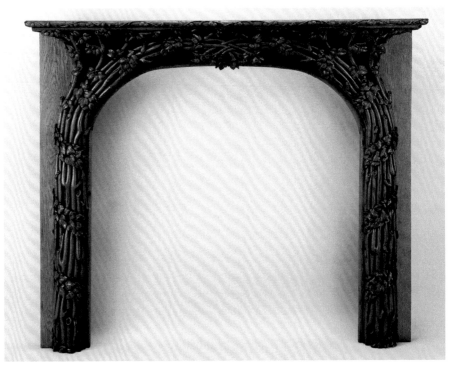

Henry L. Fry
(1807–1895) and
William H. Fry
(1830–1929)
United States (Cincinnati)

Mantel, ca. 1851

Oak

50 x 60 1/4 x 8 1/2 in.
(127 x 153 x 21.5 cm)

Anonymous Gift, 1977.140

The Aesthetic movement flourished in Cincinnati with the production of art furniture as introduced and taught by three English expatriates: Henry L. Fry, his son William H. Fry, and Benn Pitman. Henry Fry had maintained a woodcarving studio in Bath, England and had assisted in important architectural commissions in London. He studied under Augustus Welby Northmore Pugin and Sir George Gilbert Scott; these men were proponents of the Gothic Revival style, which was integral to the Aesthetic movement in England.

The Frys immigrated to America in 1850, settled in Cincinnati in 1851, and soon obtained woodcarving commissions for the house interiors of some of Cincinnati's most prominent citizens. One of the Frys' most important patrons was Joseph Longworth, who helped establish the Cincinnati Art Museum and the Art Academy of Cincinnati. In the 1850s the Frys decorated the interior of Longworth's country villa, Rookwood. The Museum's mantel was located in the hallway, which separated the dining and kitchen facilities from the rest of the house. The carved grapevine motif on the mantel is a tribute to Joseph Longworth's father, Nicholas, who introduced grape cultivation to the United States. Joseph Longworth also commissioned the Frys to decorate the house of his daughter, Maria Longworth Nichols Storer, who founded the Rookwood Pottery Company. The Museum has an outstanding collection of furniture and architectural elements carved by the Frys and their students.

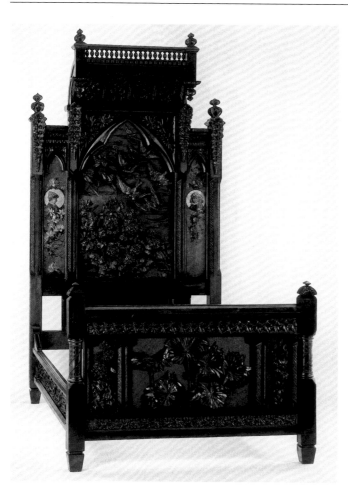

Benn Pitman
(1822–1910), designer

Adelaide Nourse Pitman (1859–1893), carver

Elizabeth Nourse
(1859–1937), painter

United States (Cincinnati)

Bedstead, 1882–83

Mahogany, painted panels

110 x 59 1/4 x 85 in.
(279.5 x 150.5 x 216 cm)

Gift of Mary Jane Hamilton in memory of her mother Mary Luella Hamilton, made possible through Rita S. Hudepohl, Guardian, 1994.61

T his bedstead combines ambitious and extremely successful carving with spirited painted panels in a manner that relies on the accurate expression of nature. It is one of the finest examples of American Aesthetic movement furniture ever produced. The proponents of the Aesthetic movement, which flourished in England and America in the last quarter of the nineteenth century, looked to nature for inspiration in designing household furnishings such as furniture, ceramics, stained glass, metalwork, and textiles.

The bedstead was designed by Benn Pitman, an Englishman who settled in Cincinnati in 1853 and taught decorative woodcarving courses primarily to wealthy young women. Adelaide Nourse Pitman, his wife, carved the naturalistic motifs in low, medium, and high relief. Representations of hydrangeas, azaleas, and sparrows in flight are set within a Gothic revival frame. Elizabeth Nourse, Pitman's sister-in-law, painted the panels on either side of the headboard with images of Night and Morning. Pitman exhibited the bedstead at the Cincinnati Industrial Exhibition of 1883.

American Decorative Arts

Paul Theodore Frankl
(1876–1962)

United States

Pair of Skyscraper Bookcases, 1920s

California redwood with nickel-plated steel

90 x 35 1/2 in.
(228.6 x 90.2 cm)

Gift of the estate of Mrs. James M. Hutton II, 1969.417, 1969.418

Austrian-born Paul Theodore Frankl became a major spokesman for the Modern movement. Trained as an architect in Vienna, he moved to New York in 1914. In the 1920s he began designing Art Deco furniture, which he exhibited to great acclaim at the 1925 Paris Exposition. A prolific writer, Frankl published works on Modern design theory, including his seminal 1928 text *New Dimensions*.

Architecture and the decorative arts responded dramatically to the urban sensibility that flourished between the world wars. The new materials and mechanization techniques of the twentieth century demanded new forms. Furniture designers were inspired by the skyscraper building boom of the 1920s; Frankl in particular incorporated the new aesthetic of architecture into his furniture designs. He is best known for his "skyscraper" furniture of the 1920s and 1930s. These pieces incorporate elements of various heights in desks, cabinets, and bookcases in imitation of the skyscraper. Frankl imagined this furniture as solving the problem of cramped apartment living in the same way as the skyscraper solved the problem of urban growth. The Cincinnati Art Museum holds the largest public collection of Frankl furniture.

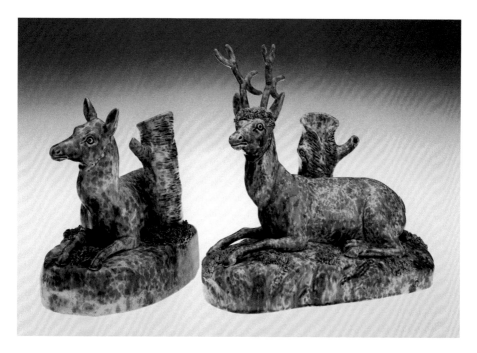

I n the mid-nineteenth century, Bennington was one of the leading centers of pottery production in the United States. It was home to Lyman, Fenton & Company, established in 1848 by Christopher Webber Fenton and A.P. Lyman. This firm, which took the name United States Pottery Company in 1853, was one of the most prolific potteries in Bennington until 1858, when it closed.

As artistic proprietor, Fenton won a respectable position for the pottery in the booming American ceramic industry by producing a variety of decorative porcelain and domestic earthenware. These wares were especially popular with a buying middle-class American public. The favorite Bennington products were utilitarian objects such as pitchers, table articles, and kitchen and household accessories, as well as fancy articles such as vases, trinket boxes, statuettes, animals, and novelty items. These were decorated with a variety of glazes including (but not limited to) brown Rockingham and flint enamel. Rockingham is the trade name for wares with a streaked reddish-brown or chocolate-brown glaze, normally with a mottled effect. Flint enamel is similar to brown Rockingham but with the addition of flecks, spots, or streaks of color, usually blues, greens, yellows, and oranges. A green flint enamel glaze decorates the surface of the doe and the stag. Bennington produced the recumbent doe-and-stag form in limited numbers; therefore very few examples exist today.

Bennington Ware

Lyman, Fenton & Co.
(1848–1853)

United States (Bennington, Vermont)

Figures: Doe and Stag,
1848–53

Earthenware

Doe:
8 3/8 x 11 1/8 x 6 3/4 in.
(21.2 x 28.3 x 15.9 cm)

Stag (with horns):
15 1/2 x 11 3/8 x 6 in.
(38.4 x 28.9 x 15.2 cm)

Gift of Mrs. William T. Earls, 1997.71a–c, 1997.67

American Decorative Arts

Mary Louise McLaughlin (1847–1939)
The Cincinnati Pottery Club (1879–1890)
Frederick Dallas Hamilton Road Pottery
(1865–1882)
United States (Cincinnati)
"Ali Baba" Vase, 1880
Earthenware
37 1/2 x 16 1/2 in. (94.6 x 41.9 cm)
Gift of the Women's Art Museum Association, 1881.239

When created in 1880, the "Ali Baba" vase was the largest vase ever made with a decoration. Beside the technical problem of making such a large vase, painting a decoration under the glaze was revolutionary. This technique, which had been developed centuries earlier, was rediscovered by the French ceramist Ernest Chaplet around 1872. He sold his secret to Haviland & Co. of Limoges, France, which featured it at the 1876 Philadelphia Centennial Exhibition.

Louise McLaughlin visited the exhibition and was inspired to discover this sensational technique, known only to Haviland at the time. She acquired the proper coloring agents in September 1877, and in January 1878 she fired her first successful piece. What had taken the Western world hundreds of years to produce, McLaughlin created in four months, and she was the first in the United States to do so.

Her good friend Clara Chipman Newton relates how the vase came to be called "Ali Baba": "As I came into the work room one morning I saw Miss McLaughlin mounted on a chair before a huge vase with a proportionately huge brush with which she was laying on a background, handling the color very much after the manner in which a scene painter works. Being at that time of an age when familiarity with fairy tales was not in the very remote past, the tale of the forty thieves and the jars in which they concealed themselves flashed through my mind and I exclaimed, 'You are painting a regular Ali Baba vase.'"

Cordelia A. Plimpton
(1830–1886), decorator

Lucien F. Plimpton
(1856–1931), designer

Frederick Dallas Hamilton
Road Pottery (1865–1882)

United States (Cincinnati)

"Alhambra" Vase, 1881

Earthenware

16 1/2 x 12 3/16 (with
handles) x 10 1/8 in.
(41.9 x 31 x 25.7 cm)

Gift of the Women's Art
Museum Association,
1881.61

Cordelia Plimpton was one of a group of Cincinnati women who, in the 1870s and 1880s, helped to found the art pottery movement in America. Her vase was obviously inspired by Hispano-Moresque examples such as one found at the Palace of the Alhambra in Granada, Spain. "Alhambra" vases, with typically flat, winglike handles, were extremely popular at the end of the nineteenth century and were often copied by European potters as well as Americans.

Plimpton's vase, designed by her architect son Lucien, appears to be unique because of its inlaid clay decoration. Using clay in shades of brown and yellow from Ohio and a black clay from Indiana, Plimpton inlaid decorations in imitation of Arab script, as well as a Cairo street scene on one side of the vase and a camel rider on the other. The date 1881 is inlaid at the base of one of the winged handles. Considered sensational in its time, Plimpton's Alhambra vase was exhibited in the Cincinnati Room of the Woman's Building at the 1893 World's Columbian Exposition.

American Decorative Arts

The Rookwood Pottery Company (1880–1967)
Carl Schmidt (1875–1959), decorator
United States (Cincinnati)
Vase, 1907
Stoneware
14 1/4 x 6 1/4 in. (36.2 x 15.9 cm)
Barney Hugger Memorial, 1975.344

In 1894 Rookwood introduced a new glaze line called "Iris." The iris plant was a motif used often in this line; in addition, Rookwood claimed that the iris glaze is as luminous and opalescent as an iris petal held to the light. Indeed, during its time, the glaze was internationally famous for its highly refractive, colorless translucency. Any decoration underneath was enhanced by its deep, crystal clear quality. The decorations are mostly flowers in pastel shades, which create an elegant softness. Atmospheric ground colors fade almost imperceptibly from dark to light. This soft gradation of ground colors, a Rookwood signature, adds to the watercolor effect of the Iris glaze line.

The flower on this vase is a wisteria painted by Carl Schmidt, one of the finest painters at Rookwood. His skilled use of composition and shading gives the subject a depth and quiet beauty virtually unsurpassed in all ceramics.

The Iris glaze line won the grand prize for Rookwood at the 1900 Paris Universal Exposition. Thus the Cincinnati pottery received the highest honor at the greatest international exposition ever held.

The Rookwood Pottery Company (1880–1967)
Carl Schmidt (1875–1959), decorator
United States (Cincinnati)
Vase, 1920
Porcelain
H. 21 1/2 in., diam. 8 1/2 in. (h. 54.6 cm, diam. 21.6 cm)
Museum Purchase with funds provided by the Oliver
Charitable Lead Trust, 1995.24

This vase is the finest known vessel example of Vellum, one of Rookwood's greatest glaze lines, decorated by the recognized master of Venetian seascapes. When the Vellum line was introduced in 1904 at the St. Louis Louisiana Purchase Exposition, it was hailed as the only new advance in world ceramics. Vellum is technically a mat glaze, with a revolutionary characteristic. Mat glazes are naturally opaque; Vellum is translucent. As a result of this unique feature, the Vellum glaze created a sensation when introduced, and helped the pottery win yet another grand prize in international competition.

Because of the soft sheen created by the glaze, Rookwood artists found that they could decorate pieces in the Vellum line with landscapes or seascapes in a quiet mood that would be enhanced by the mat glaze. As early as 1904, decorator Carl Schmidt, one of the greatest artists at Rookwood, began decorating such vases with peaceful scenes of Venice. The Vellum specimens are now known as Venetian Vellums; their tranquility and serene beauty have made Vellum one of the most desirable glaze lines ever produced by Rookwood. Indeed, the Vellum line, with its subcategory of Venetian seascapes such as the one depicted on this vase, is considered one of Rookwood's greatest contributions to ceramic history.

American Decorative Arts

Duhme & Co.
(ca. 1842–1907)

United States (Cincinnati)

Tea and Coffee
Service, ca. 1870s

Silver

Teapot: 9 1/4 (with lid)
x 8 1/2 (spout to handle)
x 5 5/8 in.
(23.5 x 21.6 x 14.3 cm)

Coffee pot: 10 1/2
(with lid) x 9 (spout to
handle) x 6 1/4 in.
(26.7 x 22.9 x 16 cm)

Creamer: 5 1/4 x 5 1/4
(spout to handle) x 5 in.
(14 x 13.3 x 12.7 cm)

Waste bowl: 5 1/4 x 6 1/2
(with handles) x 5 1/2 in.
(13.3 x 16.5 x 14 cm)

Sugar bowl: 8 x 5 1/2
(with handles) x 5 in.
(20.4 x 14 x 12.7 cm)

Gift of Dr. and Mrs. James
L. Hecht, 1984.198–
1984.202a,b

Duhme & Co. of Cincinnati was one of the finest silver manufacturers and jewelry retailers in the midwest during the late nineteenth century. The company was founded in the early 1840s by Herman Duhme, a German immigrant who had settled in Ohio in 1834. The company established a reputation for producing handmade objects of high quality at a time when most manufacturers of silver relied on machines for production. Duhme's dedication to hand workmanship anticipated the basic tenets of the Arts and Crafts movement, which dominated the production of the decorative arts just a few decades later.

This tea and coffee service reflects the various design currents prevalent in American decorative arts during the 1870s, when the revival of motifs from one or more historical styles was common practice. Here the curvilinear elements of the Rococo revival and the naturalistic images of the Arts and Crafts movement are merged into a coherent whole. The cartouche, composed of C-scrolls and the repoussé floral decoration that covers much of the body, is distinctly Rococo revival. The expressive rendering of the flowers, the accurately depicted flora and fauna, and the intersecting-disk finials show the adoption of later Arts and Crafts ideas.

Produced as a set, all of the pieces in this service are decorated in identical style. Matched services originated in the late eighteenth century. Before that time, pieces in different styles, produced by different makers at different times, were acquired one by one.

Maria Longworth Storer (1849–1932)
United States (Cincinnati)
Plaque, 1900
Basket, ca. 1897–1900
Copper electroplated on tin, semiprecious stones
Plaque: Diam. 13 3/16 in. (33.5 cm)
Basket: 4 7/8 x 10 1/4 x 9 1/8 in. (12.4 x 26 x 23.2 cm)
Gift of M.L. Storer, 1903.395, 1903.396

Although best known as a ceramic decorator and as the founder of the Rookwood Pottery Company in Cincinnati, Maria Longworth Storer experimented with metal between 1897 and 1900. Storer created small- and large-scale decorative objects made of tin with copper and silver electroplated surfaces. She employed a metalworker from Kanazawa, Japan to assist with the metal fabrication techniques.

The largest single collection of Storer's metals is housed in the Cincinnati Art Museum. The collection includes this plaque and basket as well as dragon-shaped vase stands, vases, pitchers, paperweights, a chalice, and luster-glazed ceramic vases with metal mounts. Storer produced the objects while living in Brussels and in Madrid. Before donating the works to the Museum, she displayed many of them at the 1900 Universal Exposition in Paris, where they received a gold medal.

The decorative subject matter is derived from classical, Art Nouveau, and Japanese sources, especially the latter. Storer's fascination with the grotesque, seen in her earlier pottery designs, is evidenced further in her metalwork. Many of the objects' surfaces are decorated with monkeys and grotesque aquatic animals, enhanced with patination and with encrusted pearls and semiprecious stones. Such treatment of the decorative motifs produced a body of work with richly textured surfaces and a three-dimen-

Tiffany & Co. (1853–)

United States (New York)

Vase and Dedication Medallion, 1878

Silver

17 1/4 x 9 1/2 (with handles) x 8 1/2 in. (43.8 x 24.2 x 21.5 cm)

Bequest of Reuben R. Springer, 1884.483

R euben R. Springer was awarded this sterling silver vase and dedication medallion at the inaugural performance of Cincinnati's Music Hall on May 14, 1878. A retired Cincinnati merchant and philanthropist, Springer proposed the building of Music Hall and contributed a challenge gift of more than half the money needed for its construction. Cincinnati citizens donated the remaining funds.

A year before the presentation, an order for the vase was placed with Tiffany & Co. of New York, one of the country's largest and most prestigious silver manufacturers. The vase displays both neoclassical and Japanese elements. A simple amphora (a vessel with a narrow neck and two handles), it is decorated with applied lyres and laurel leaves. These attributes, associated with Apollo, god of music and poetry, are accompanied by the mask of Melpomene, the muse of tragedy, located on the neck. Such references to music and theater are most fitting for a presentation piece related to Cincinnati's performing arts center.

The hammered surface of the vase and the stylized chrysanthemums between the lyres reflect the influence of Japanese art and craft, popular during the last quarter of the nineteenth century. Tiffany displayed many pieces in the Japanese style at international expositions.

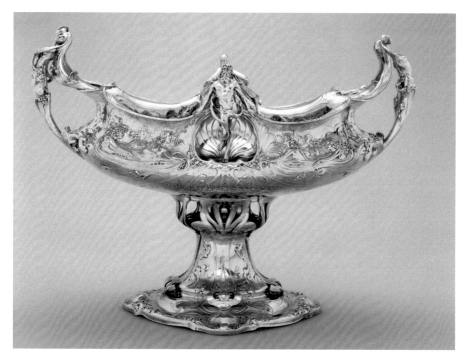

G orham Manufacturing Company of Providence was one of the leading American silverware firms of the nineteenth and twentieth centuries, creating stylish and exquisitely crafted silver objects. In the late nineteenth and early twentieth centuries, Gorham produced stunning wares in the neoclassical, Japanese, Colonial revival, Gothic revival, and Art Nouveau styles. Gorham's most successful line, *Martelé*, was developed in 1896. *Martelé* is French for "hammered" or "hand-hammered"; Gorham chose this name because it exemplified the ideals and traditions of the English Arts and Crafts movement and the return of hand-crafted objects that would be both beautiful and useful. Employing popular Art Nouveau motifs, the *Martelé* designs were inspired by nature with an emphasis on curvilinear forms, and they were distinguished by sensuality and elegance. Gorham introduced *Martelé* commercially by showcasing the line at the 1900 Paris Exposition; there the company won numerous awards.

This centerpiece is one of Gorham's most spectacular *Martelé* objects. It was completed in 1903 and exhibited at the St. Louis World's Fair in 1904. The surface, with its swelling boat shape, is decorated with mermaids and mermen swimming among waves and seaweed. The lip is surrounded by fully modeled figures of Neptune, Venus, and mermaids. The dramatic, graceful curved lines exemplify high-style Art Nouveau. Impressive in size and scale, and unrivaled in technical excellence and craftsmanship, the centerpiece is a masterwork of hand-crafted silver, produced by one of America's most prestigious silver manufacturers.

Gorham Manufacturing Company (1831–)

United States
(Providence, RI)

Centerpiece, 1903

Silver

17 3/4 x 25 in.
(45 x 63.5 cm)

Museum Purchase:
Lawrence Archer Wachs
Trust, Dwight J. Thomson
Endowment, Phyllis H.
Thayer Purchase Fund and
various funds, 1999.1

American Decorative Arts

Vase, 1892–1897

Glass

14 x 6 1/4 in.
(35.6 x 15.9 cm)

Gift of Alfred Traber
Goshorn, 1897.136

Tiffany Glass & Decorating Co. (1892–1900)
United States (Corona, New York)
Vase, 1892–97
Glass; 9 5/8 x 7 1/4 in. (24.5 x 18.4 cm)
Gift of Alfred Traber Goshorn, 1897.131

Vase, 1892–1897

Cameo glass

7 3/8 x 4 7/8 in.
(18.7 x 12.4 cm)

Gift of Alfred Traber
Goshorn, 1897.135

Louis Comfort Tiffany was the leading exponent of the Art Nouveau style of glassware in the United States. Inspired by the work of Emile Gallé, he produced a great variety of extraordinary art glass. In 1885 he established the Tiffany Glass Company in Corona, New York, which was renamed Tiffany Glass & Decorating Co. in 1892. Tiffany gave his glassware the name *Favrile*, derived from the word *fabrile* ("hand-wrought"), to signify its handmade quality.

Tiffany, like other glassmakers of his time, was stimulated by the public's interest in exotic forms and materials. He imitated the unique colors and shapes of Islamic, Bohemian, Venetian, and ancient glass. The Art Nouveau influence can be seen in his use of flowing abstract patterns, which suggest waves, leaves, or peacock feathers, and in naturalistic and organic forms, which suggest the growth and movement of flowers and plants. Many of his vases, with the forms of budding and blossoming flowers, achieve an organic effect. The name Tiffany is synonymous with the unique iridescent glasswares designed by Tiffany in shades of red, green, and gold. The iridescent appearance was achieved by exposing the molten glass to metallic oxides. More rare than the iridescent wares are Tiffany's cameo-cut pieces: the carving on these objects was difficult and time-consuming.

The Museum has a large, comprehensive collection of Tiffany glass. It was one of the few museums in the country to acquire wares from Tiffany Glass & Decorating Co. when they were produced. The cameo-cut vase and the iridescent vases seen here, acquired in 1897, still bear the original price and company logo stickers.

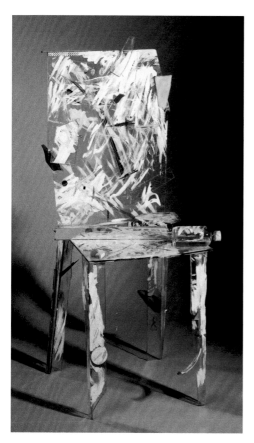

Therman Statom (b. 1953)
United States
Untitled (chair), 1983
Glass, paint, wood, paper
42 x 22 x 19 in. (106.7 x 55.8 x 48.2 cm)
Gift of David and Nancy Wolf, 1996.42

Therman Statom, one of America's most renowned contemporary glass artists, studied at the famous Pilchuck Glass School in Stanwood, Washington. Then he attended the Rhode Island School of Design, where he received his bachelor of fine arts degree in 1974. Statom has received numerous prestigious awards including a Ford Foundation Fellowship and a National Endowment for the Arts Fellowship. Today he is based in Los Angeles.

In the early 1980s, Statom established a body of work in what became his signature style. He is best known for painted and assembled glass in large-scale installations, and for nonfunctional furniture forms such as chairs, tables, and ladders, in various sizes. Although these works often represent utilitarian forms, they are unique, expressive works of sculpture. They are composed of bonded sheets of window glass, enhanced with random splashes of paint in various colors. Many, including the chair in the Museum's collection, are further embellished with various applied found and fabricated objects of wood and paper. This type of mixed-media sculpture was very popular in the late 1970s and early 1980s. Statom's work is noted for its playful, childlike quality.

American Decorative Arts

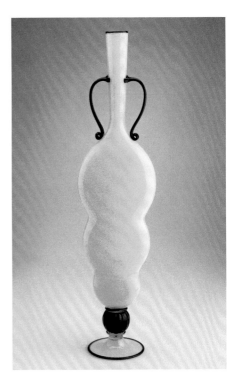

Dante Marioni (b. 1964)
United States
Yellow Leaf Vase, 1994
Glass
32 1/4 x 7 1/2 x 2 1/4 in., diam. (foot) 6 in.
(80.6 x 18.8 x 5.6 cm, diam. (foot) 15 cm)
Gift of Joan Cochran Rieveschl, 1998.74

Over the past two decades, Seattle has established itself as the center of the American studio glass movement, and Seattle-based Dante Marioni has contributed greatly to the city's reputation. The son of Paul Marioni, himself a prominent glass master, Dante Marioni has become a leader in studio glass production with no appreciable formal training. His works are elegant and uncomplicated.

Marioni's work is distinguished by large-scale Greek pottery forms, such as amphoras and kylikes, in hand-blown glass and strong, bold, uniform shades of aqua, yellow, and chartreuse. He relies on traditional Italian glassmaking techniques and traditional shapes. Marioni uses techniques similar to those employed by his mentors, glass masters Dale Chihuly, Richard Marquis, Fritz Driesback, and Benjamin Moore. Free from elaborate surface decoration, his work appears simplistic; yet the techniques used to create these elegant forms are exacting and difficult.

Employing the hand-blown technique and a modern aesthetic, Marioni transforms classical forms into contemporary language. Under his control, relatively minor elements gain new importance. The illusion of monumentality is suggested by the attenuation and elongation of his forms. The yellow leaf vase, for example, has an elongated neck and graduated curves, enhanced by a bold yellow body with black accents. At a time when conceptual and visually complex glass forms are the norm, Marioni's work stands apart as classic and elegant.

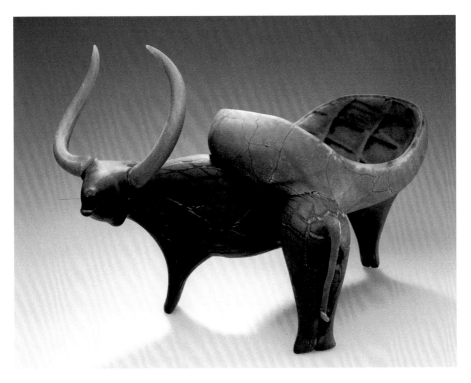

Williliam Morris has been one of the dominant American studio glass artists for more than a decade. After completing his artistic studies at the prestigious Pilchuck Glass School in Stanwood, Washington, Morris took a teaching position there. Glass artist Dale Chihuly, the founder of Pilchuck, has been his mentor and close friend. The two have traveled all over the world to survey archeological sites, and Morris explores his findings in his recent work.

This vessel was created in 1998 as part of Morris's *Rhyton* series. Like his earlier series of canopic jars, inspired by Egyptian funerary containers, this series recalls the ancient world and expresses Morris's fascination with archeology and prehistoric art. Rhytons, drinking vessels in the shape of animals, were used by ancient peoples. Morris's rhytons are drawn from mammals such as the bull, the stag, the antelope, and the elk. This work is in the shape of a bull, and exhibits Morris's trademark: a perfected use of highly textured surfaces and muted, warm earth tones, all of which give his work a naturalistic, excavated quality. The vessel was created in blown glass; the surface decorations were applied in a reverse transfer technique using powdered glass and sand. The result is an exquisite surface resembling prehistoric cave drawings, which plays against the reflective quality of the glass.

William Morris
(b. 1957)
United States
Rhyton Vessel, 1998
Glass
13 x 16 x 19 in.
(32.5 x 40 x 47.5 cm)
Museum Purchase with funds provided by Mr. and Mrs. Robert E. Boeh, 1999.5

Contemporary

REDS

PETE RO

Arshile Gorky
(1904–1948)
United States

Virginia Landscape,
1944

Oil on canvas

40 x 51 in.
(101.6 x 129.5 cm)

Gift of Mrs. Benjamin Tate,
Peter Gibson and Horace
Carpenter, by exchange,
and the Edwin and Virginia
Irwin Memorial, 1979.220

A mong the Museum's greatest acquisitions of the 1970s was *Virginia Landscape,* a masterpiece by one of the most influential artists of the twentieth century. Born Vosdanik Manoog Adoian in Armenia, Gorky began to draw as a small child. During the Turkish invasion of 1916, he suffered tragedy and upheaval, and in 1920 he immigrated to the United States. Here he changed his name to Arshile Gorky, meaning "bitter one," and soon rose to prominence in the New York art world.

Gorky firmly believed that painting could be an end in itself, in opposition to the view of the Social Realists who dominated in the 1930s. In his quest for personal expression, he turned to Paul Cézanne and Pablo Picasso as well as the old masters. Surrealism had a liberating effect on Gorky; he embraced the notion that art could unveil the unconscious through "automatism," the freeing of the imagination and the hand from conscious control. Gorky adapted the Surrealists' fluid, biomorphic, and erotic shapes, but relied less strongly than the Surrealists on imagery from the observable world. During World War II, the Surrealists exiled in New York influenced him to become more painterly and more improvisational, although he would always plan his compositions carefully.

Unlike the Surrealists, Gorky found inspiration in sensory experiences of nature. This is evident in paintings such as *Virginia Landscape,* one of a series of majestic works stemming from a visit to his in-laws' farm. With his concern for the formal problems of abstract painting and his love for the physical qualities of paint, Gorky served as a bridge between the masters of the century's first half and the Abstract Expressionists.

Elizabeth Catlett
(b. 1915)

United States and Mexico

Phillis Wheatley, 1973

Bronze

21 1/4 x 13 x 12 1/2 in.
(54 x 33 x 30.5 cm)

Museum Purchase: Dr.
Sandy Courter Memorial
Fund, Lawrence Archer
Wachs Trust, A.J. Howe
Endowment, Henry Meis
Endowment, Phyllis H.
Thayer Fund, Israel and
Caroline Wilson Fund, and
On to the Second Century
Endowment, 1999.215

© Elizabeth Catlett/
Licensed by VAGA,
New York, NY

A frican American sculptor and printmaker Elizabeth Catlett, born in Washington, DC, studied first at Howard University and later with painter Grant Wood and sculptor Ossip Zadkine. Dedicated to making art relevant to the disempowered and economically deprived, she has specialized in glorious images of African American and Mexican women. Catlett, a distinguished teacher, in 1959 became the first woman to head the Sculpture Department at the University of Mexico. Since 1982 she has divided her time between Mexico and New York City.

Phillis Wheatley dates from 1973, when Catlett was invigorated by the black power and feminist movements. Wheatley was an eighteenth-century poet who, as a young child, had been taken from Africa to Boston as a slave. She was educated and freed by her masters, who helped her to publish a collection of her poems in 1773.

Two hundred years later, at a conference on women poets, writer Margaret Walker suggested to Catlett that she make a sculpture of Wheatley. Using as a guide the only known portrait of the poet, the engraved frontispiece to her book, the sculptor simplified and modernized Wheatley's attire and altered her features to resemble an African mask. The striking sculpture that resulted is both sensitively contemplative and powerfully expressive.

Richard Diebenkorn (1922–1993)
United States
Interior with View of Buildings, 1962
Oil on canvas
84 x 67 in. (213.4 x 170.2 cm)
The Edwin and Virginia Irwin Memorial, 1964.68
© Courtesy Lawrence Rubin Greenburg Von
Doren Fine Art, New York

San Francisco painter Richard Diebenkorn was born in Portland, Oregon and studied art at Stanford University and the University of California, Berkeley. In the late 1940s, through contact with Mark Rothko and Clyfford Still, who were working in California, Diebenkorn turned from his early figurative style, reminiscent of Edward Hopper, to vigorous abstraction with allusions to landscape. By the mid-1950s, Diebenkorn had returned to representation and had restrained the emotionalism of his earlier abstractions. Because of this change he was grouped with other San Francisco artists, including Elmer Bischoff and David Park, whose figurative styles became associated with the Bay area.

In *Interior with View of Buildings*, Diebenkorn explores the nature of painting at a crossroads in art history. The painting shows an interior or balcony, beyond which appears a long, low series of buildings illuminated by brilliant California sunlight. Although representational, the work creates a tension between abstraction and figuration. The multilayered surface is rendered with large expressive brush strokes that do not always conform to the pictorial elements. In addition, space is flattened into a series of horizontal bands of radiant color.

The presence of a painting within the painting, showing a woman posed before the same view as we see beyond the balcony or window, confounds the viewer's sense of what is real and what is illusion. The artist brilliantly exploits this idea further by depicting on the table a reducing glass that he used frequently; the glass shows the main bands of color that appear in the painting, but in inverted order.

The most meaningful childhood experiences of abstract painter Ellsworth Kelly included identifying birds by color and shape with his grandmother and encountering the prints of John James Audubon, in which variously shaped birds are arranged on a page in a sensitive formal design. Service in a camouflage unit during World War II proved important to Kelly in the 1950s, when he began reducing form and shadows to even patterns and flattened space. Kelly's exposure to the Surrealist concept of automatic drawing, in which the artist draws without looking at the paper to create an unpredictable and unpremeditated image, revealed expansive possibilities for what art could be. Yet he rejected the new expressionism practiced by Jackson Pollock and Willem de Kooning, who responded to the Surrealistic exploration of the unconscious. Instead Kelly produced hard-edged abstract paintings in which relationships between fields of unmodulated color and simple shapes constitute the sole subject of the work. Brushwork, the traditional mark of artistic genius, is nowhere in evidence.

Green Panel with Orange Curve represents a distillation of ideas that Kelly had begun exploring more than 30 years earlier. Kelly is one of several artists who broke away from the constraints of the rectangular canvas. In this work, the adjoining of two canvases, one square and the other an unconventional pie-wedge shape, suggests a dynamic relationship. This relationship is enhanced by the vibration of the electric green and the orange against one another and against the white of the wall, which also plays a crucial role in this sparely elegant piece.

Ellsworth Kelly (b. 1923)
United States
Green Panel with Orange Curve, 1989
Oil on two joined canvases
98 3/4 x 131 in.
(250.8 x 332.7 cm)
Gift of PNC Bank, by exchange, 1996.447
© Ellsworth Kelly

Mark di Suvero (b. 1933)

United States

Atman, 1978–79

Corten steel, steel, steel cable,
California redwood

408 x 9,144 x 468 in.
(1,036.3 x 23,225.8 x 1,188.7 cm)

The Edwin and Virginia Irwin Memorial,
1986.36

© Courtesy of Gagosian Gallery

S ince 1985, when it was installed, the grand and monumental *Atman* (Hindu for "world soul") has been a welcoming, pylonlike marker for visitors to the Museum. By setting *Atman* on a grassy knoll in Eden Park, di Suvero followed in the Western tradition, dating back to the ancient Greeks, of placing sculpture in public places. The artist also breaks with tradition, however, because he created an abstract sculpture rather than a naturalistic statue that offers a narrative or memorializes an event or person.

In *Atman*, di Suvero manipulated materials, structure, relationships, and space to create a subtly balanced work. He created *Atman* from industrial I-beams, using a backhoe and two cranes to prepare the site and arrange the girders. The three-sided shape of the sculpture, with its great height and broad expanse, should aggressively express architectural scale, overwhelming mass, and colossal weight. Yet *Atman* is inviting. The work is graceful in its linearity, elegant in its subtle design, spontaneous in the jutting girders, open in its placement in an ever-changing environment, playful in its color (originally rust-colored, but painted red in 1988), and intimate in its swinging platform bed.

Di Suvero was born in Shanghai to Italian parents who immigrated to San Francisco in 1941. Arriving in New York City in 1957, he achieved critical success with his first show in 1959. Since then he has developed into one of the foremost sculptors of the late twentieth century.

Nam June Paik (b. 1932)

United States

Powel Crosley, Jr., 1992

Mixed media including parts
from various Crosley products

96 x 68 x 24 in. (248.9 x 172.7 x 61.0 cm)

John J. Emery Endowment and the Edwin and
Virginia Irwin Memorial, 1992.140

© Nam June Paik/Carl Solway Gallery

When approached by the Museum, the Korean-born Paik suggested a video sculpture to honor Powel Crosley Jr., one of the city's foremost inventors and entrepreneurs. Assembled in Cincinnati, the whimsical *Powel Crosley, Jr.* is created from a variety of Crosley products: TV and radio cabinets, car hubcaps and handles, radios, freezer doors, and radio transmission tubes. The boxy-looking "portrait" is related to a family of human-looking robots that Paik created in 1986. In this sculpture, he used eight television monitors to project two different programs recorded on laser disk. The programs include material taken from a television profile, combined with popular imagery flashed so quickly as to be hypnotic. In contrasting the antiquated Crosley parts with contemporary laser disks, Paik made an oblique comment on technological evolution.

Crosley was born in 1886 in Cincinnati. After working in advertising and auto building, he discovered the new technology of radio and brought it to millions through build-it-yourself kits. He also started radio station WLW, founded public television station WCET, made the first car radio, built the first compact car, and owned the Cincinnati Red Stockings baseball team.

Paik studied music and art history in Tokyo before traveling to Germany in 1958. There he met the innovative composer John Cage, who became a lasting influence. In the 1960s, Paik became fascinated with television and video. He exploited the medium to assert his belief that the human spirit is ascendant over technology, no matter how sophisticated.

Andrea Zittel (b. 1965)

United States

A to Z Comfort Unit,
1994

Steel, birch plywood, velvet, plexiglass, foam mattress, objects

Bed 48 x 78 x 52 in. (121.9 x 198.1 x 132.1 cm); each of four units 54 x 18 x 25 in. (137.2 x 45.7 x 63.5 cm)

Museum Purchase: Gift of RSM Company, by exchange, 1995.13.1–5

© Courtesy the artist and Andrea Rosen Gallery, New York

A to Z Comfort Unit is a sculpture that functions as a total living environment. Andrea Zittel designed it as five separate elements: a bed, a dining unit, a vanity dresser, an office, and a library. This work evolved from a product that Zittel conceived in 1992 to organize her chaotic life. At that time she was living in a 200-square-foot storefront in Brooklyn with a large dog and other animals. She viewed the finished unit as a nucleus, compact and efficient as a pop-up trailer, that could be moved wherever she lived. The prototype unit was like a womb, creating feelings of security and nurturing.

The Museum's unit was never intended to have a single owner. The Museum made it personal by filling it with objects from the permanent collections.

Zittel is not only an artist but also the founder of A to Z Administrative Services, which is both a conceptual work of art and a real business. A to Z offers a variety of customized products that help people organize their domestic situations. Zittel was inspired by the optimistic Bauhaus idea that a spare, pure design would simplify life and bring spiritual improvement. She believes that the artist must directly engage and serve the community, not merely stand back and comment or criticize.

Andy Warhol (1928–1987)

United States

Pete Rose, 1985

Acrylic on canvas with screen-printed image

Four panels, each 54 x 44 in. (137.2 x 111.8 cm)

Museum Purchase: Bequest of Mr. and Mrs. Walter J. Wichgar, 1985.208 a–d

© 2000 Andy Warhol Foundation for the Visual Arts/Artists Rights Society (ARS), New York

The Museum commissioned Andy Warhol to create this portrait commemorating baseball player Pete Rose, who broke Ty Cobb's long-standing record of 4,191 lifetime hits. Derived from a picture taken by Cincinnati photographer Gordon Baer, the painting is designed to resemble baseball cards. The Cincinnati Reds' player-manager was honored for his feat, but his stature was diminished by his later involvement in a sports-betting scandal. Rose recently has been at the center of a controversy regarding his admission to baseball's Hall of Fame.

As one of America's great Pop artists, Andy Warhol revived the genre of portraiture with his paintings of world-famous personalities such as Marilyn Monroe and Chairman Mao. Born Andrez Warhola near Pittsburgh, he studied pictorial design at the Carnegie Institute of Technology. After graduation he moved to New York; while working there as a fashion illustrator, he began to incorporate multiple images into his paintings.

Seeking an "assembly-line" effect, Warhol chose the screen printing technique, a process generally associated with commercial art and mass production. In applying this technique to his portraits, he offered his subjects a promise of immortality—a recognition lasting much longer than the proverbial 15 minutes of fame. *Pete Rose* exemplifies Warhol's belief that fame and fortune are fleeting and ambiguous.

Internationally acclaimed artist Jim Dine, who was born and educated in Cincinnati, recently informed an audience that the Museum's collections played a formative role in his artistic development. *The Sound of Your Cold Voice* supports his statement that Frank Duveneck's *The Whistling Boy,* with its vigorously expressive brushwork, made a particularly lasting impression. A tragic childhood (including the loss of his mother at age 12) and an introspective nature have led Dine on a journey of self-discovery in which each work of art is a crucial part. Dine's rise to fame coincided with the emergence of Pop art, but his concerns diverged sharply from those of the Pop movement. While the Pop artists explored Americans' love affair with consumer culture, Dine looked inward, infusing objects with autobiographical significance and expressive power.

The Sound of Your Cold Voice was the third painting by Dine acquired by the Museum. (The first, *Light Over My Bed Coming Through Nassau Pink,* was purchased in 1966.) Rich in personal symbolism and dreamlike imagery, the piece is composed of four monumental canvases, each dominated by a commanding figure: a skeleton, a man who may be walking on a tightrope, a woman whose head has been replaced by a blood-red heart, and a dark self-portrait. The accumulation of suggestive images and the aggressive physical quality of the artist's techniques—which include building up layers of paint, attacking them with a grinding device, and building them up again—make *The Sound of Your Cold Voice* one of Dine's most intensely haunting works.

Anselm Kiefer (b. 1945)

Germany

Monsalvat, 1996

Acrylic, emulsion,
shellac on canvas

72 7/8 x 129 3/4 in.
(185.1 x 329.6 cm)

John J. Emery Endowment,
1997.8

© Courtesy of
Gagosian Gallery

Anselm Kiefer grew up surrounded by the profound physical and spiritual devastation of postwar Germany. In response he turned away from the dominant, American-born art movements, Minimalism and Conceptualism, toward expressive, gestural execution of emotionally charged paintings—what is now known as Neo-Expressionism. It has been Kiefer's greatest desire that his majestic, heavily encrusted canvases, which suggest ravaged landscapes, such as *Monsalvat*, should lead to healing for those who behold them.

The five names superimposed on this powerful, sweeping landscape—Parsifal, Amfortas, Gurnemanz, Titurel, and Monsalvat—reinforce Kiefer's meaning, which is comprehended intuitively. They relate to the legend of Parsifal, retold in Richard Wagner's opera of that name. In a world dominated by evil, the young, naive Parsifal embarked on a journey during which he met the wounded Amfortas and his father Titurel. From a castle at Monsalvat, Amfortas ruled the kingdom that preserved the Holy Grail. Parsifal also encountered Gurnemanz, a knight of the Grail. Witnessing tremendous pain, weakness, and suffering, Parsifal acquired the knowledge and compassion to heal Amfortas and restore the Grail's enlightening powers. Kiefer makes dramatic use of simple one-point perspective (all lines meet at the approximate center of the very high horizon line) to lead the viewer on Parsifal's journey to Monsalvat.

Donald Sultan (b. 1951)
United States
Forest Fire, June 23, 1983, 1983
Oil, watercolor, tar, and plaster on vinyl tile over wood
96 x 48 in. (243.8 x 121.9 cm)
Gift of the Douglas S. Cramer Foundation, 1998.66

A native of Asheville, North Carolina, Donald Sultan grew up during the heyday of postwar abstraction. He draws on the full range of abstract painting—from the physical, emotional work of Jackson Pollock to the subtle shape and color relationships of Ellsworth Kelly. Sultan also makes imaginative use of a broad spectrum of art historical sources, as well as contemporary popular culture. As a result, his works are exceptionally rich in layered meaning.

Forest Fire, June 23, 1983 is one of a number of Sultan's works inspired by newspaper photographs of cataclysmic events of present-day life. The modernity of these works is reinforced by the use of mundane industrial materials. In place of traditional canvas, Sultan mounted vinyl floor tiles to a frame. He then built up his complex surface with layers of roofing tar, plaster, and paint. This elaborate process often included burning areas of tar off of the tiles with a blowtorch, a method compatible with the painting's fiery subject. The contrasts between the sky-blue tiles, the rich black of the tar, and the brilliant orange flames create a striking abstract pattern and generate excitement and drama.

Index

F

Fabergé, Peter Carl, House of, 231
Falconer, from the Emita de San Baudello, 162
Falcon-Headed God in Pose of 'Soul of Pe', 8
Falls of the Tequendama Near Bogotá, New Granada, 251
Farny, Henry, 142, 274
Fashion Group, Inc., Cincinnati, 102
Female Attendants Clapping Hands, 3
Female Figure (African), 70
Female Figure (African), 73
Female Figure (Classical), 30
Figure of Britannia, 223
Figures: Doe and Stag, 295
Figurine: The Teaching of Love, 225
The Fisherman Unable to Hold the Giant Fish, 61
Five-Faced Lingam, 59
Fleischmann Foundation, 67
Fleischmann, Dorette Kruse, 96, 98
Fleischmann, Julius, 142
Fleischmann, Mr. and Mrs. Charles, ix, 65, 192, 246
Flötner, Peter, 171
Flower Still Life, 189
Force, General M.F., 86
Ford, Mary Mills, 76
Forest Fire, June 23, 1983, 321
Formal Dress and Petticoat (English), 92
Fortuny y Madrazo, Mariano, 95
The Four Ages: The Marriage of Antoinette de Bertier de Sauvigny to the Marquis de la Bourgonnaye (La Promenade), 109
The Four Sages of Shangshan, 49
Fragment of a Medallion Rug, 24
Fragmentary Head of a King, 7
Frankl, Paul Theodore, 294
The Freedman, 258
French, Herbert Greer, 114–116, 118–120, 123–124, 126–127, 153
Friedman, Harry G., 117
Friedman, Ruth, 157
Frith, Francis, 152
Fry, Henry L. and William H., 292

G

Gainsborough, Thomas, 193, 195
Gallenga, Maria Monaci, 95
Galt, Mrs. William M., 82
Geier, Mrs. Frederick A., 163
Geier, Paul E., 212, 222, 232
 and Gabriele B., 233

General George Washington, 246
George Weidemann Brewing Co., 171
Giambologna (Giovanni da Bologna), 175
Giovanni, Matteo de, 168
Givenchy, Hubert Taffin de, 102
Going to Work, 203
Goodyear, Henry M., MD, 207
Gorham Manufacturing Company, 303
Gorky, Arshile, 310
Goshorn, Alfred Traber, 227, 304
Goya y Lucientes, Francisco José, 124
The Green House, 159
Green Panel with Orange Curve, 313
Grendey, Giles, 222
Guan Jar, 51
Guercino (Giovanni Francesco Barbieri), 184

H

Haller, Mrs. Henrietta, 143
Hals, Frans, 187
Halston, 104
Hamilton, Mary Jane, 293
Hanna, Mary, 12, 140–141, 166, 179, 181, 186, 194, 200, 211
Harnett, William Michael, 267
Harvest Dance, 275
Hassam, Childe, 272
Hauck, Mrs. Frieda, 168, 266
Hauling in Anchor, 144
Hawes, Elizabeth, 98
Hawkins, William, 290
Head of a God, 4
Head of a Mourning Woman, 35
Hecht, Dr. and Mrs. James L., 300
Heerman, Norbert, 254
Heine, Emilie L., 139, 201–202, 269
Helbig, Arthur, 254
Hell Scroll, 55
Heming, Thomas, 235
Hepp, Mrs. Carlos A., 243
Hercules and Antaeus, 183
Hill, David Octavius, 150
Hinkle, Edward Foote, 266
Hiroshige, Utagawa, 125
The History of Her Life Written Across Her Face, 135
Hoadly, George, 208
Hodler, Ferdinand, 211
Hogarth, William, 191
